Fossil Design

Zeichen versteinerten Lebens
Signs of Petrified Life

photographiert und herausgegeben von
Photographs and editing by

Hillert Ibbeken

mit Beiträgen von
with contributions by

Hillert Ibbeken
Helmut Keupp
Rudolf zur Lippe
Katja Schoene

Edition Axel Menges

© 2009 Edition Axel Menges, Stuttgart / London
ISBN 978-3-936681-24-6

Druckvorstufe / Prepress: Reinhard Truckenmüller
Druck und Bindearbeiten / Printing and binding:
Everbest Printing Company, Ltd., China

Übersetzung ins Englische / Translation into English:
Anne Beck, Michael Robinson
Design: Axel Menges

Inhalt

Contents

Hillert Ibbeken
Fossil Design – Zeichen versteinerten Lebens

Fossil Design, was ist das, oder, genauer, was heißt Fossil, was bedeutet Design, und was macht den möglichen ästhetischen Reiz von Fossil-Photographien aus, könnte man sie sogar als »schön« bezeichnen? Fossil ist etwas Ausgegrabenes, nicht aus der menschlichen Erinnerung, sondern aus dem Boden, dem Erdreich. Fossilien sind die zumeist versteinerten Überreste von Lebewesen der Vorzeit, der geologischen Vergangenheit, die viele hundert Millionen Jahre zurückreichen mag. Der Maler oder Bildhauer setzt die von ihm wahrgenommene Wirklichkeit mit den Mitteln der Verfremdung in sein Gemälde, seine Skulptur um, Werke, die von der Wirklichkeit nur noch wenig verraten mögen. Auch die Fossilisation ist ein Verfremdungsprozeß, er beginnt unmittelbar mit dem Tode des Lebewesens und führt über viele Stufen des Zerfalls, der chemischen und mechanischen Verformung zu dem Fossil, eingebettet in die kalkigen, schlammigen oder sandigen Sedimente eines Sees, eines Meeres oder in ein Kohleflöz, Zeugnis ehemaliger unermeßlicher Wälder. Die Verwitterung löst das Fossil aus dem Gesteinsverband heraus oder der Bergmann mit dem Preßluftgerät, der Paläontologe mit Hammer und Meißel, der Präparator mit der vibrierenden Nadel. Fossilisation ist in jedem Fall ein Verfremdungsprozeß, weil das tote Lebewesen nie vollständig abgebildet und überliefert wird, sondern lediglich in seinen Teilen, zumeist nur Skelett oder Schale. Darüber hinaus erfährt es fast immer eine stoffliche Umwandlung, Knochen, Zähne und Schalen versteinern, Weichteile haben oft höchstens einen Abdruck im Substrat hinterlassen, bevor sie verwesten. Das fast durchgängige Fehlen von Weichteilen, von Häuten, Muskeln und Eingeweiden, läßt die sie tragenden und stützenden Hartteile, die Skelette und Schalen, um so deutlicher, aber eben auch einseitiger hervortreten.

Alle diese rigiden Elemente haben Bauformen, sie besitzen Strukturen, sinnvoll oder zweckmäßig zusammengefügte Teile, »entworfen« von der Natur im Zusammenspiel von Mutation und Selektion; für diesen Prozeß der Gestaltung steht das Wort Design. Fossil Design meint etwas natürlich Gewordenes, nicht menschlich Gewolltes, weil Menschen mit der Entstehung eines Fossils nichts zu tun haben. Auf keinen Fall ist hierbei an ID gedacht, an Intelligent Design, die religiöse Auffassung der Neokreationisten, daß hinter der Evolution eine intelligente, zielvoll planende Instanz stünde.

Die überlieferten Strukturen machen das Wesen von Fossilien aus. Sie ermöglichen die Rekonstruktion des ehemaligen Lebewesens, seine taxonomische Einordnung, will sagen seine Zugehörigkeit zu den Stämmen des Tier- und Pflanzenreichs bis hin zu den Sediment bildenden Bakterien und damit überlieferungsfähigen Gesteinsbildungen.

Der biologische Wert der Fossilien liegt in dem gewaltigen Zeitraum von vielen hundert Millionen Jahren, über den sie Zeugnis ablegen, und damit über die Entwicklung des Lebens auf der Erde, von den Cyanobakterien der Stromatolithen vor 2,5 Milliarden Jahren bis zum Frühmenschen vor einigen wenigen Millionen Jahren. Auch ohne die Erhaltung der Weichteile bezeugen die Strukturen der Skelette und Schalen viele ehemalige Funktionen und Aufgaben in der Organisation des Lebewesens, bis hin zu den Lebensspuren und Fährten, die manche Tiere im Schlick ihres Lebensraumes hinterließen.

Der geologische Wert der Fossilien liegt darin, daß sie für bestimmte Lebensräume charakteristisch sein können, Festland oder Meer, Süßwasser oder Salzwasser, Flachmeer oder Tiefsee, warme oder kalte Umgebung. Ihr jeweiliges Auftreten signalisiert die Existenz eines solchen Lebensraumes und zeigt im Wechsel der Fossilien in der Schichtfolge dessen Entwicklung an, die Verteilung von Land und Meer in der geologischen Vergangenheit und deren Wandel in der Erdgeschichte, zusammen mit den wechselnden Klimaten. Manche Fossilien treten nur relativ kurzfristig in der Erdgeschichte auf, dafür aber weltweit verbreitet, das sind die sogenannten Leitfossilien.

Dies herauszuarbeiten und darzustellen, ist aber nicht das Ziel dieses Buches. Hier geht es vielmehr um den Versuch, sich mit dem ästhetischen Zeichencharakter der organischen fossilen Strukturen zu beschäftigen. In diesem Zusammenhang stellt sich die Frage, warum viele dieser fossilen Strukturen oder zumindest ihre photographischen Abbilder »schön« genannt werden können, sich gern anschauen lassen und Assoziationen anregen. Es ist klar, die Natur mit ihren Fossilien ist a priori nicht schön, sie ist zweckhaft. Man kann aber die Zweckhaftigkeit eines Lebewesens, wie sie sich in einer fossilen Struktur erweist, durchaus als schön empfinden. Schinkel, der preußische Baumeister, bezeichnete seinerzeit die vollendete Zweckhaftigkeit eines Gebäudes als seine eigentliche Schönheit. Die Vermutung liegt nahe, daß er diese Auffassung von Immanuel Kant aus dessen *Kritik der Urteilskraft* (1790) übernommen hat. Kant formuliert dort vier Momente zur Erklärung des Schönen, zum dritten Moment heißt es: »Schönheit ist Form der Zweckmäßigkeit eines Gegenstandes, sofern sie, ohne Vorstellung eines Zwecks, an ihm wahrgenommen wird.« Für unser Problem, der möglichen Schönheit von Fossilien oder deren Teilen, sind zwei Gesichtspunkte aus diesem Moment besonders wichtig: einerseits die Rolle der Zweckmäßigkeit und andererseits der Umstand, daß diese Zweckmäßigkeit als solche nicht erkannt oder gewußt werden muß, um etwas als schön zu empfinden. Mit anderen Worten: Es reicht die Erfüllung eines Zwecks, er muß aber nicht als solcher erkannt und verstanden werden, man muß also kein Paläontologe sein, um ein Fossil schön zu finden.

Damit ist aber doch nicht alles gesagt, weil alle Fossilien und ihre Bauelemente zweckhaft sind oder waren, weil sie zu ihrer Zeit ihren Zweck im Bauplan des Tieres oder der Pflanze voll erfüllten. Trotzdem wird beileibe nicht alles Fossile als schön empfunden. Man könnte die regelhafte Anordnung von Bauelementen als schön bezeichnen, ihren Anblick als irgendwie befriedigend, wenn es nicht gerade die kleinen Abweichungen von einem solchen Schema wären, die das Bild lebendig machen. Wie die Wellen am Strand des Meeres, die alle gleich sind, aber eben doch jede ein wenig anders, ein Anblick und Eindruck, dessen »Schönheit« sich kaum jemand zu entziehen vermag. Demgegenüber stehen Oberflächen mit vollkommen unregelmäßigen, ja chaotischen Strukturen, wie hingemalt aus den Farbtuben eines ungegenständlich arbeitenden Künstlers, und man kommt auch hier nicht darum herum, sie als schön zu empfinden, als packend und anregend.

Bislang war nur ein wenig abstrakt vom Design, von den fossilen Strukturen sozusagen »als solchen« die Rede und ihrer Schönheit, nicht aber von den Abbildungen, wie sie in diesem Buch versammelt sind. Zwischen dem realen Handstück mit dem Fossil und seinem photographischen Abbild liegt eine Fülle von Entscheidungen und Manipulationen, die das Objekt mitunter ebenso verfremden wie die vorausgegangene Fossilisation. Davon soll abschließend die Rede sein.

Der erste Eingriff ist die Auswahl. Aus etwa 7000 Objekten der Sammlung des Instituts für Paläontologie der Freien Universität Berlin wurden knapp 200 Stücke ausgewählt und photographiert. Die Auswahl ist für nichts repräsentativ, außer für die Möglichkeit, ein interessantes Bild abzugeben. Die erste photographische Manipulation sind die Positionierung des Fossils und die Wahl des Ausschnitts, entscheidend für die spätere Vergrößerung. Die meisten Fossilien sind nicht ganzheitlich dargestellt, sondern nur in vergrößerten Ausschnitten. Die Kamera geht sozusagen in das Objekt hinein. Das ist den Begriffen »Design« und »Struktur« geschuldet, denn hier wird kein Bestimmungsbuch für Fossilien vorgelegt. Unverhüllt durch die Weichteile werden die verschiedensten Muster sichtbar, einfache oder spiegelnde Symmetrien, Reihungen, Serien, netzförmige Verknüpfungen und Wiederholungen. Der Ausschnitt abstrahiert, er setzt graphische Akzente und reizvolle Farbkompositionen.

Die zweite Manipulation ist die Beleuchtung mit ein, zwei oder drei Lichtquellen, um den Eindruck von Relief zu forcieren oder abzumildern, auch Blende und Belichtungszeit sind das Bild bestimmende Faktoren.

Die dritte, gravierende Manipulation ist die digitale Bildbearbeitung am Computer, deren Möglichkeiten fast unermeßlich sind. Bei der digitalen Bearbeitung wird das ganze Bild in Frage gestellt. Der Ausschnitt wird korrigiert, Kontrast und Schärfe werden modifiziert, ebenso die Schatten und Lichter, die Farben werden differenziert. Das Bild erhält dabei ein Eigenleben, das seine Herkunft vom Objekt, vom Fossil aber niemals ganz verleugnet, auch wenn es höchst künstlich zustande kam. Die Frage, ob die Perzeption des Photographen das Bild »schön« macht, muß allerdings jeder Betrachter für sich selbst entscheiden.

Dem Konzept des Buches folgend, sind die 176 Bilder nicht gemäß einer paläontologischen Systematik gegliedert, sondern mit zunehmender Abstraktion oder Verfremdung, von der realistischen Koralle Diploctenium bis hin zu einem Radiolarit, einem von Tausenden von kleinsten Radiolarien aufgebauten und meist umkristallisierten Gestein, an dem sich ohne Mikroskop nichts mehr individualisieren läßt. Es könnte ein abstraktes Gemälde sein.

Die Aufnahmen wurden mit einer digitalen Kamera gemacht, einer Nikon D200 mit dem AF-S VR Micro-Nikkor 105 mm, und einer Kaltlichtleuchte 3200 Kelvin mit drei Schwanenhals-Glasfaserbündeln.

Hillert Ibbeken
Fossil design – signs of petrified life

What is fossil design? Or rather: what is a fossil, what does design mean, and what creates the aesthetic attraction, if any, in fossil photographs? Might they perhaps even be described as »beautiful«? A fossil is something that is dug up. It does not come from the human imagination, but from the ground, the earth's realm. Fossils are the mostly fossilized remains of living organisms from prehistory, from a geological past that may stretch back many hundreds of millions of years. In a painting or sculpture, a painter or sculptor translates the reality perceived by him using the instruments of alienation. These are works which may betray very little of the reality. Fossilization is also an alienation process. It begins immediately with the death of the organism, with many stages of decay and chemical and mechanical deformation creating the fossil embedded in the chalky, silty or sandy sediment of a lake, a sea or a coal bed, a witness to former immeasurable forests. Erosion, a miner with a pneumatic drill, a palaeontologist with a hammer and chisel, or a taxidermist with a vibrating needle releases the fossil from the conglomeration of stone. Fossilization is invariably a process of alienation, because the dead organism is never reproduced or preserved entirely, but only in parts, usually only the skeleton or shell. In addition to this, it almost always experiences a compositional metamorphosis. Bones, teeth and shells become petrified. At most, soft parts have left behind an impression in the substrate before decomposing. The almost universal absence of soft parts – of skin, muscles, and intestines – places an emphasis on the hard supportive and protecting parts, skeletons and shells, which is as striking as it is one-sided.

Each of these rigid elements has a formal construction. They have structures, rationally or purposefully joined parts »designed« by nature in the interplay of mutation and selection. This constitution process is what is meant by »design«. Fossil design means something which has come to be naturally, rather than through human intention, as humans have nothing to do with the creation of a fossil. In no way does this relate to ID, Intelligent Design – the religious concept of neo-creationists involving an intelligent, purposefully planning agency behind evolution.

The preserved structures make up the fossils' character. They make it possible to reconstruct the former living organisms, their taxonomical classification, their affiliation with animal and plant kingdom phyla, extending to the sediment-forming bacteria and thereby to the preserving rock formations.

The value of fossils in biological terms lies in the immense timespan of many hundreds of millions of years throughout which they bear witness to the development of life on Earth, from stromatolith cyanobacteria of 2.5 billion years ago to early humans of a few million years ago. Even without the soft parts being preserved, the structures of skeletons and shells are proof of many functions and tasks performed in the living organism's constitution, including signs of life and tracks left by some animals in the mud of their habitat. The value of fossils in geological terms is that they may be characteristic of certain habitats: solid ground or sea, freshwater or saltwater, shallow or deep sea, warm or cold environments. Each appearance signals

the existence of such a habitat, with the variation of fossils in the layer sequence showing its development; the distribution of land and sea in the geological past and changes in it throughout the Earth's history, coupled with changes in climate. Some fossils only appear relatively briefly in geological history, but can be found all over the world. These are the so-called index fossils.

However, to explore and represent this process is not the aim of this book. Rather, it is an attempt to examine the organic fossil structures' character as aesthetic signs. In this context, the question arises: why can many of these fossil structures or at least their photographic representations be described as »beautiful«, being pleasing to look at and awakening associations? It is clear that nature and its fossils are not beautiful a priori, they are functional. However, one can certainly perceive the functionality of a living organism, as shown in a fossil structure, as beautiful. In his day, Schinkel the Prussian master architect described a building's perfected functionality as its real beauty. It is reasonable to assume that he was thinking of Immanuel Kant's *Kritik der Urteilskraft* (1790). In this book, Kant formulates four moments in the explanation of beauty. Of the third of these, he says: »Beauty is the form of functionality in an object, so far as perceived in it apart from the representation of an end«. Two aspects of this moment are particularly important for our problem of fossils' possible beauty; on the one hand the role of functionality and on the other hand the fact that this functionality does not need to be recognised or known as such in order for an object to be considered beautiful. In other words: the fulfilment of a purpose is sufficient, without it being recognised and understood. One does not have to be a palaeontologist to find a fossil beautiful.

However, this is not the whole story. All fossils and the elements of their construction are or were functional. In their own age they fulfilled their purpose in the animal or plant's makeup. In spite of this, by no means all of these fossils are considered beautiful. One could characterise their regular arrangement of elements as a beautiful and somehow pleasing sight, if it was not precisely the small departures from such a schema which give the image life. This is like waves on the seashore, which are all the same, but all a little different, a perception and impression whose »beauty« can barely be isolated. The contrast to this is given by surfaces with entirely irregular, indeed chaotic structures, which appear to have come from the paint tubes of a non-representational artist. These also one can not help but perceive as beautiful, striking and compelling.

So far only the design and beauty of the fossil structures as such, so to speak, have been discussed, in a somewhat abstract way, and not their images as collected in this book. An abundance of decisions and manipulations separate the actual rock specimen containing a fossil from its photographic image. These may sometimes alienate the object just as much as the preceding fossilization. The concluding part of this discussion concerns this.

The first intervention is selection. Out of approximately 7000 objects in the Institut für Paläontologie at the Freie Universität Berlin's collection, just over 200 specimens were chosen and photographed. This selection is in no way representative, except in the interests of rendering an interesting overall picture. The first photographic manipulation occurs with the posi-

tioning of the fossils and the choice of details, decisive for later magnifications. Mostly the entire fossil is not shown, only enlarged details. The camera moves in to the object, so to speak. The terms »design« and »structure« demand this. The intention here is not to produce an identification guide for fossils. Unobscured by the soft parts, the most diverse patterns are visible, simple or reflective symmetries, arrays, series, net-like connections and repetitions. Showing a detail abstracts, creating graphic emphasis and attractive colour compositions.

The second part of the manipulation involves lighting with one, two or three light sources, in order to reinforce or to tone down the impression of relief. Aperture and exposure time are also factors that determine the image obtained.

The third, very significant stage of manipulation involves computerised digital image editing. The possibilities offered by this are almost unlimited. In digital editing, the whole image is open to question. The detail is corrected. Contrast and definition are modified, as are light and shade. Colours are differentiated. Through this process, the image gains a life of its own, which, however, never entirely obscures its origin – the object, the fossil – even when the image was created in a highly artificial way. However, the question of whether the photographer's perception makes the image »beautiful« is one which every observer must decide for himself.

In accordance with the book's concept, the images are not structured according to a palaeontological classification system, but according to their increasing abstraction or alienation, progressing from the realistic Diploctenium coral to a radiolarite, a largely crystallised rock constructed of thousands of tiny radiolarians, in which nothing can be seen individually without a microscope. It could be an abstract painting.

The photographs were taken using a Nikon D200 AF-S VR Micro-Nikkor 105 mm digital camera and a 3200 Kelvin cold light source with three gooseneck fibre-optic bundles.

Katja Schoene
Zwischen Wissenschaft und Kunst – Fossilien in der frühen Neuzeit

»Auf Schieffer Gott oft schnitzt und mahlt / Fisch, Menschen und andrer Tiergestalt.« Martin Rinckhardt, *Mansfeldischer Bergreigen*, 1613.

Frühe Theorien über die Entstehung von Fossilien

»Was die Ursach sey solcher Impressionen, disputiren die Gelehrten.« Martin Luther, *Genesis-Vorlesung*, 1535 bis 1545.

In der Renaissance ließ sich die von urzeitlichen Versteinerungen ausgehende Faszination nur schwer mit nüchterner naturwissenschaftlicher Erkenntnis vereinbaren. Zu wunderbar erschienen die im Stein eingeschlossenen Pflanzen und Tiere, als daß man sie für etwas anderes als ein »Spiel der Natur« (lusus naturae) halten mochte (Schlosser 1978, S. 19). Der Vielfalt ihrer Erscheinungen entsprach die Vielfalt der Erklärungen zu ihrer Entstehung: Sollte es sich etwa nicht um göttlich geschaffene Abbilder handeln? Waren nicht unterirdische Keimungen ihre Ursache? Waren sie nicht Reste im Wasser zugrundegegangener Lebewesen und damit Beweis der großen Sintflut? Noch im 18. Jahrhundert kann sich der Naturaliensammler und Jurist Gottlieb Friedrich Mylius (1675–1726) nicht entscheiden, ob Fossilien nun Naturspiele, Keimungen, spontane Zeugungen oder »überbleibende Dinge der Sündfluth« seien (*Des Unterirdischen Sachsens Seltsamer Wunder Der Natur*, Leipzig 1709/18; Barthel 1994, S. 709 f.).

In Deutschland ging mit dem im 16. Jahrhundert aufblühenden Bergbau das Interesse an Mineralien einher. Dabei gerieten auch Fossilien in den Blick. Bereits Martin Luther (1483–1546), der seine Kindheit im Bergbaugebiet der Grafschaft Mansfeld verbracht hatte, machte sich 1535–45 in einer Vorlesung zur Genesis über Kupferschieferfossilien Gedanken: »Und wie Gott und die Natur ihre lustige Kurtzweile auch unter der Erden haben, bilden sich allerley Fisch-Gestalt in den Schieffer.« Ihr Einschluß in das Gestein kam ihm als Beweis für den biblischen Sintflutbericht gelegen (Langer 1994, S. 127).

1546 erschienen in Basel die *De natura fossilium libri X* von Georg Agricola (1494–1555). Der sächsische Humanist, Mediziner und Naturforscher hatte 1527–31 in der Bergbaustadt Joachimsthal in Böhmen gelebt, Gesteinsproben aus ganz Europa gesammelt und sich eingehend mit Berg- und Hüttenwesen befaßt. Mit seinem Werk begründete er die Mineralogie als wissenschaftliche Disziplin. Er legte die erste systematische Kennzeichenlehre vor, mit der sich Steine und Erze identifizieren ließen. Entgegen der heutigen Bedeutung des Begriffs *Fossil* als Lebenszeugnis vergangener Erdzeitalter, etwa als Versteinerung oder Abdruck, bezeichnete Agricola sämtliche aus der Erde gegrabenen Objekte als *Fossilien*. Im Wortsinn des lateinischen *fodere* für *ausgraben* zählte er mithin auch Mineralien, Erden und Artefakte wie zum Beispiel Urnen dazu. Doch immer wieder kommen bei Agricola echte Fossilien im modernen Sinn vor, wenn er Ammoniten oder Belemniten, versteinerte Hölzer, Fische oder Haizähne beschreibt.

In seiner *Cosmographey* (Basel 1550) deutete Sebastian Münster (1488–1552) die Fische und Frösche im Mansfelder Kupferschiefer als »Gleichnis« oder »Bildnis«,

die der Schiefer »gebiert« – Spuren ehemaligen Lebens erblickte er offenbar nicht in ihnen. Johann Mathesius (1504–1565) sah Versteinerungen als »wunderbarliche Gewächse« der Erde an (*Sarepta oder Bergpostill sampt der Joachimßthalischen kurtzen Chronicken*, Nürnberg 1564; Langer 1994, S. 128). Der Leibarzt Herzog Friedrichs I. von Württemberg Johann Bauhin (1541–1613) hielt Ammoniten, Belemniten und Muscheln für »wunderbare Kunststücke in und unter der Erde« (*Historia novi et admirabilis fontis balneique Bollensis*, Montbéliard 1598; deutsche Ausgabe: *Ein New Badbuch und Historische Beschreibung von der wunderbaren Krafft und würckung des Wunder Brunnen und Heilsamen Bads zu Boll*, Stuttgart 1602).

Leonardo da Vinci (1452–1529) dagegen hatte bereits 1505 die organische Herkunft der in den Bergen von Parma und Piacenza gefundenen fossilen Muscheln und Korallen vermutet und sie als einstmals lebende Meerestiere beschrieben (Roberts, Pedretti 1981, S. 37 f.). Später erkannten auch der französische Naturforscher und Keramiker Bernard Palissy (1510–1590) (*Discours admirables*, Paris 1580) und der neapolitanische Arzt Ferrante Imperato (1521/22–1600/09) die tatsächliche Natur von Fossilien (*Dell' historia naturale libri XXVIII*, Neapel 1599). Imperato beschäftigte sich unter anderem mit den unterschiedlichen Erscheinungsformen von verkieseltem Holz (Seipel 2006, Nr. 3.30). Der dänische Arzt, Anatom und Geologe Nicolaus Steno (1638–1686) knüpfte an Leonardos Beobachtungen an (*De solido intra solidum naturaliter contento dissertationis prodromus*, Florenz 1669). Ihm war die Ähnlichkeit einiger Steine mit Haizähnen aufgefallen. Daraus hatte er geschlossen, daß es sich um die Überreste lebender Organismen handeln müsse.

Athanasius Kircher (1602–1680), jesuitischer Universalforscher und Naturgelehrter, schrieb mit dem reich illustrierten Monumentalwerk *Mundus subterraneus* (Amsterdam 1664/65) den Bestseller unter den geologisch-mineralogischen Büchern der Zeit. Naturwissenschaftliche Erkenntnis verbindet sich bei Kircher mit der scholastischen Tradition des Mittelalters und dem Glauben an den biblischen Schöpfungsbericht zu einem eigenen geologischen Weltbild. Backenzahnlamellen des Mammuts, die man aufgrund ihrer Ähnlichkeit mit der menschlichen Hand *Chiriten* oder *Handsteine* nannte, deutete Kircher »wegen der Monumentalität der Klumpen [als] Knochen von Riesen« (Okrusch und Kelber 2002, S. 146–148). Hiermit folgte er Giovanni Boccaccios (1313–1375) Bericht der Entdeckung der angeblichen Knochenreste von Zyklopen in einer Höhle bei Trapani auf Sizilien. »Dentes Gigantes« – Mammut- als Riesenzähne – bildete auch Ulisse Aldrovandi (1522–1605) ab (*Monstrorum Historia cum paralipomenis historiae omnium animalium*, Bologna 1642). Andere Fossilien sah Kircher als Zufallsbilder der Natur an. Deren Formen, in denen er eingeprägte Zeichen und Bilder erblickte, stellten für ihn Symbole göttlichen Schöpfertums dar.

Auch für Friedrich Heyn (1695–1715) waren die Pflanzenfossilien aus den Kohleflözen in Manebach durch göttlichen Willen entstandene Bilder von Gewächsen und keine Überbleibsel realer Pflanzen, da es sich um ganze »Kräutergebirge« gehandelt haben müßte (*Bericht Einer herrlichen Berg-Situation und Ertz-Gebürges in dem Thüringer Walde [...]*, Leipzig 1695). Johann Jacob Baier (1677–1735) bezeichnete Drusen, Belemniten oder Trochiten als »gestaltete Steine« bzw. »Figurensteine« (*Oryctographia Norica sive Rerum fossilium in Territorio*

Norimbergensi Descriptio, Nürnberg 1708). Zugleich erkannte er jedoch, daß es sich bei Ammonshörnern, fossilen Muscheln, Fischresten und Knochen nicht um »Spielereien der Natur, sondern [um] wahrhafte Schalen von Schaltieren« handele, also wirkliche Überbleibsel einst lebendiger Tiere (Hölder 1960, S. 363 f.).

In den Figurensteinen nahm die Phantasie Nachbildungen von unbelebtem technischem Gerät und von belebter Natur wahr. Noch heute ist für die Körper versteinerter Kopffüßler, der Belemniten, der Begriff *Donnerkeil* gebräuchlich. Man glaubte, sie seien Geschosse, *Pfeilsteine*, des Gottes Donar (Thor). In der ersten Hälfte des 18. Jahrhunderts erklärte Franz Ernst Brückmann (1697–1753) Belemniten für Stacheln von Seeigeln (*Thesaurus subterraneus Ducatus Brunsvigii*, Braunschweig 1728). Louis Bourguet (1678–1742) hielt sie für Reptilien- bzw. Krokodilszähne (*Lettres philosophiques sur la formation des sels et des crystaux [...]*, Amsterdam 1729; *Traité des pétrifications*, Paris 1742). Ammoniten wurden wegen ihrer Spiralform mit Drachen oder Schlangen verglichen. »Vielleicht sind es auch Schalen gestorbener Tiere, die nicht mehr in Windungen zusammengehalten, auf dem Erdboden schlotternd umhertrieben und durch die Versteinerungsmasse begraben wurden«, schrieb J. F. Krüger 1823 (»Gegliederte Ammoniten«, *Archiv für die neuesten Entdeckungen aus der Urwelt V*, Quedlinburg 1823; Hölder 1960, S. 371). Bereits Plinius der Ältere (um 23–79) bezeichnete versteinerte Haizähne als Steinzungen (*Glossopetrae*, griech. *glossa* = Zunge, *petra* = Fels). Im Mittelalter sah man in ihnen zu Stein gewordene Schlangenzungen, die sogenannten *Natternzungen*, die als Amulett oder pulverisiert zu Heilzwecken benutzt wurden (Hiller 1941, S. 84; Mannheim 2000, S. 199). Natternzungenkredenzen wurden zur Giftprobe verwendet, man meinte, die Zungen würden in der Nähe von Gift zu schwitzen beginnen. Als Heil- und Glücksmittel dienten die fünfeckigen, quergeschnittenen, sternförmigen Trochiten (versteinerte Stielglieder der Seelilie), die als vom Himmel gefallene Sterne angesehen wurden. Austernschalen verglich man mit Teufelskrallen, Brachiopoden (versteinerte tentakeltragende Meerestiere) mit Tauben bzw. anderen Vogeltieren, aber auch mit Öllampen.

Die Arbeiten des englischen Naturhistorikers, Geologen und Arztes John Woodward (1665–1728) (*Essay towards a Natural History of the Earth*, London 1695; *Fossils of All Kind*, London 1728) und von Johann Jacob Scheuchzer (1672–1733) (*Piscium Querelae et Vindiciae*, Zürich 1708; *Herbarium diluvianum*, Zürich 1709) trugen wesentlich zur Erkenntnis bei, daß es sich bei Fossilien um die Überbleibsel von Tieren und Pflanzen handele. Dennoch vertraten beide die Sintfluttheorie (Barthel 1994, S. 711). Der Arzt und Naturforscher Christian Friedrich Schulze (1730–1775) wendete sich gegen diese biblische Erklärung (*Kurtze Betrachtung derer Kräuterabdrücke im Steinreiche*, Dresden 1755; Barthel 1994, S. 711 f.). Ihm folgte Johann Ernst Immanuel Walch (1725 bis 1778) (*Naturgeschichte der Versteinerungen*, Nürnberg 1768–73). Im 19. Jahrhundert wurden die Fossilienhypothesen endgültig entmythologisiert: Für Ernst Friedrich von Schlotheim (1764–1832) waren Fossilien zweifelsfrei Reste und Zeugnis der Entwicklung von Organismen einer früheren Erdperiode (*Beiträge zur Naturgeschichte der Versteinerungen in geognostischer Hinsicht*, München 1820; Barthel 1994, S. 713). Die Bezeichnung *Fossil* verengte sich allein auf Objekte mit organogener Herkunft.

Fossilien in Kunst- und Wunderkammern

»Naturwunder aller Art.« Julius Schlosser, *Die Kunst- und Wunderkammern der Spätrenaissance*, 1908.

Die Begeisterung für gemusterte, bunte oder besonders geformte Fundstücke aus der Erde – Steine, Mineralien oder Fossilien –, ihr materieller Wert, ihre Entstehungsmythen und die ihnen nachgesagten medizinischen und magischen Wirkungen machten sie zu beliebten Sammelobjekten in den Kunst- und Wunderkammern der frühen Neuzeit. Dort wurden Kunstwerke und Kuriositäten aus den Bereichen Natur, Kunst und Technik vereint, welche die enzyklopädische Sammellust und das Bedürfnis nach Selbstdarstellung ihrer Besitzer befriedigten, seien es Herrscher, Adlige, reiche Bürger, Gelehrte oder Künstler. Berühmtheit erlangten die Sammlungen der Habsburger, vor allem die des Erzherzogs Ferdinand II. (1529–1595) auf Schloß Ambras und des Kaisers Rudolf II. (1552–1612) in Prag. Francesco de'Medici (1541–1584), Landgraf Wilhelm IV. von Hessen (1532–1592), Herzog August der Jüngere von Braunschweig-Wolfenbüttel (1597–1666) und seine Söhne oder Ernst I. von Sachsen-Gotha (1601–1675) frönten dieser Leidenschaft ebenso wie Ärzte und Apotheker, deren Sammlungen eine Mischung aus Museum, Labor, Atelier und Bibliothek waren.

Das breite Spektrum der Objekte regte unterschiedliche Sortierungen an, vor allem nach ästhetischen Kriterien. Neben standesgemäßer Repräsentation war es ein Ziel der Kunst- und Wunderkammer, den Makrokosmos der äußeren Welt im Mikrokosmos der Sammlung nachzubilden. Das Sammeln und Ordnen sollte helfen, hinter die Geheimnisse der Natur zu kommen. *Artificialia*, *Naturalia* und *Scientifica* bildeten die von Samuel Quiccheberg (1529–1567) erdachten Kategorien der Sortierung, die um die *Exotica* ergänzt werden konnten (*Theatrum sapientiae*, München 1565). Die vier Elemente oder die Kontinente boten weitere Möglichkeiten der Einteilung. Solange sich die Erkenntnis der Fossilien als versteinerte Lebewesen noch nicht durchgesetzt hatte und noch keine wissenschaftliche Systematik entwickelt worden war, galten sie als *Zufallsbilder* und *Figurensteine*, die zufällig Lebewesen oder Teile von ihnen abbildeten. Je nachdem, für was sie gehalten wurden, waren sie Naturding, aber auch Artefakt.

Bereits eine der ersten fürstlichen Sammlungen, die des Herzogs Jean de Berry (1340–1416) in seinem Schloß in Mehun-sur-Yèvre, verfügte über Naturalien, zu denen auch ein »Riesenknochen« gehörte, vermutlich der Knochen eines urzeitlichen Mammuts (Schlosser 1978, S. 40). Die Inventare der Kunstkammer auf Schloß Ambras von 1596, 1603 und 1621 nennen das »Kinn eines Riesen«, bei dem es sich tatsächlich um den Unterkiefer eines europäischen Mammuts handelte (heute Naturhistorisches Museum Wien; Seipel 2006, Nr. 2.93), sowie die vermeintlichen Schienbeine und den Hüftknochen eines Riesen. Ein 1543 datiertes Plattenkalkstück mit einem fossilen Fisch aus dem Oberen Jura, gefunden bei Solnhofen in Bayern (heute Naturhistorisches Museum Wien), verweist mit seiner lateinischen, aus *Aeneis* und *Georgica* des Vergil (70–19 v. Chr.) kompilierten Inschrift auf die Sintfluttheorie: »Hierauf begibt der allmächtige Vater in wildem Zorn sich vom hohen Äther: Er gießt in die Wogen das Land, schickend die Flut [...] Nichtet die Äcker, vernichtet die Fluren [...] Es füllen Gräben sich, Flußläufe schwellen, und alles Leben dem Tod übergibt er« (Langer 1994,

S. 127; Rauch 2007, S. 29; Seipel 2006, Nr. 3.26). Reste urweltlicher Tiere wurden auch in Kirchen und Rathäusern verwahrt. Oftmals waren sie im Innern an Ketten aufgehängt wie der von einem Mammut stammende »Riesenknochen« im Wiener Stephansdom (Schlosser 1978, S. 19).

Zufallsbilder und Figurensteine oder die Natur als Künstlerin

»so das ars und natura mit ain ander spilen.« Philipp Hainhofer, 1627.

»Das menschliche Herstellen bringt Gebilde der Natur teils zum Abschluß, nämlich dort, wo sie die Natur selbst nicht zu einem Abschluß zu bringen vermag; teils bildet es Gebilde der Natur nach«, definiert Aristoteles (384 bis 322 v. Chr.) den Begriff *techne* in seiner *Physik*. Die von der Natur geschaffenen Werke vervollkommnet der Mensch als Künstler und vermag es gar, die Natur als Schöpferin zu imitieren. Der Neoplatoniker Marsilio Ficino (1433–1499) erkannte Natur und Kunst als gleichberechtigte Kräfte der Formgebung: »Was ist die menschliche Kunst? Eine gewisse Natur, die die Materie von außen behandelt. Was ist die Natur? Eine Kunst, die die Materie von innen gestaltet.«

Agricola sah die Natur als Schöpferin von Kunstwerken (Ernsting 1994). Er bestaunte die Bilder auf Mineralien, »die aber nicht irgendein Künstler, sondern die Natur selbst gezeichnet hat« (Agricola/Fraustadt 2006, S. 226). Oft handelt es sich bei diesen Bildern um Fossilien: »Nicht wenige [Mineralien, K. S.] geben durch auseinanderlaufende Linien, die oft in der Farbe wechseln, Bilder von Gegenständen wieder: [...] von Fischen, nämlich vom Hecht, Barsch und Plattfisch der Stein von Eisleben, von Tieren, nämlich dem Hahn und dem Salamander, derselbe Stein« (Agricola/Fraustadt 2006, S. 28). Naturwissenschaftliche Beobachtung und Sinn für den ästhetischen Reiz von Mineralien und Fossilien gehen bei Agricola Hand in Hand. Noch mehr als 100 Jahre später gruppierte Kircher in *Mundus subterraneus* Steine nach ihren bildlichen Motiven, geometrischen Figuren und den Buchstaben des Alphabets (Baltrušaitis 1984, S. 55). Gebildet habe sie der Zufall, die Beschaffenheit des Bodens, die Anlage der Formen und Flüssigkeiten zur Versteinerung, Magnetismus oder göttliche Verfügung.

Den von der Natur erzeugten Zufallsbildern wurden gern gemalte Figuren, Landschafts- oder Architekturelemente hinzugefügt. Es entstanden reizvolle Kompositionen, bei denen die Kunst die Hervorbringung der Natur ergänzt. So meißelte ein unbekannter Künstler einen Schlangenkopf mit Mund und Augen in einen Ammoniten, der im Ambraser Inventar von 1596 als »ain schlangen, so zu ainem stain worden« bezeichnet wird (heute Naturhistorisches Museum Wien; Seipel 2006, Nr. 3.29). Versteinerte Haizähne umzüngeln als Schmuck eine Kredenz aus dem 15. Jahrhundert, die ebenfalls zur Ambraser Kunstkammer gehörte (heute Kunsthistorisches Museum Wien, Kunstkammer; Schlosser 1978, S. 66). Bernstein, ein fossiler Kiefernharz, wurde gern zu Schmuckstücken oder kleinen Skulpturen verarbeitet. Eine aus Schloß Ambras stammende Bernsteinarbeit, wohl aus dem 15. Jahrhundert, zeigt die Geburt Christi, bei der Joseph sowie Ochs und Esel hinter der liegenden Muttergottes dem Geschehen beiwohnen (heute

Kunsthistorisches Museum Wien; Seipel 2006, Nr. 3.25). Der Kunstschrank Gustavs II. Adolf (1594–1632), den der Augsburger Humanist und Kunsthändler Philipp Hainhofer (1578–1647) in den Jahren 1625–32 konzipiert und an den Schwedenkönig vermittelt hatte, wird von einem Seychellennußpokal bekrönt. Dieser steht auf einem Berg, der neben Kristallen, Blutsteinen, Amethysten und Korallen auch aus Konchylien besteht (heute Uppsala, Kunstsammlung der Universität). Der Goldschmied Anton Schweinberger (gest. 1603) komponierte für Kaiser Rudolf II. kunsthandwerkliche Prunkstücke, für die er Rhinozeroshörner, versteinerte Haizähne oder Wildschweinhauer verwendete. Mit einem Rahmen versehen an die Wand gehängt, konnten die Zeugnisse frühen Lebens als reine Kunstobjekte definiert werden: Eine wie ein Gemälde präsentierte Kalksteinplatte aus der Kunstkammer Herzog Anton Ulrichs (1633–1714) auf Schloß Salzdahlum zeigt gut erkennbar einen fossilen Kugelzahnfisch aus Solnhofen (heute Naturhistorisches Museum Braunschweig; Weltenharmonie 2000, Nr. 121).

Illustrationen von Fossilien zwischen Wissenschaft und Ästhetik

»das mans clarlich erkennen kan / was jedes für ein fisch bildnuß oder figur ist.« Sebastian Münster, *Cosmographey*, 1550.

Da Agricola sein Werk *De natura fossilium* nicht illustrieren ließ, kommt Sebastian Münster das Verdienst zu, in der *Cosmographey* von 1550 die älteste bekannte Abbildung eines Fossils in einem gedruckten Buch veröffentlicht zu haben. Sie zeigt einen Mansfelder Kupferschieferfisch. Ein Jahr später folgten die ersten vier Holzschnittdarstellungen von fossilen wirbellosen Tieren bei Christoph Entzelt (1517–1583) (*De re metallica*, Frankfurt / Main 1551; Langer 1978, S. 263).

1565 erschien in Zürich *De rerum fossilium, lapidum et gemmarum maxime, figuris et similitudinibus liber* des schweizerischen Naturforschers und Arztes Conrad Gessner (1516–1565). Das Nachschlagewerk über Mineralien ist durchgängig illustriert: 72 Holzschnitte zeigen Gestein, Fossilien und prähistorische Steinwerkzeuge. Bilder von Belemniten, Crinoidenstielen, Jura-Ammoniten oder Haizähnen (Seipel 2006, Nr. 3.27) entstanden nach Vorlagen aus Gessners erdwissenschaftlicher Sammlung. Viele davon stammen wohl von ihm selbst und dem Dresdener Arzt Johannes Kentmann (1518 bis 1588). Die Originalzeichnungen haben sich in der Universitätsbibliothek Basel erhalten (Ms. K I 2). 1598 erschien die ebenfalls mit zahlreichen Holzschnitten von Fossilien ausgestattete *Historia novi et admirabilis fontis balneique Bollensis* von Bauhin, die Ammoniten und Lamillibranchiaten aus dem Posidonienschiefer von Bad Boll in Schwaben abbildet (Hölder 1960, S. 360).

Imperatos 1599 erstmals aufgelegtes Werk *Dell' historia naturale* beschreibt die Sammlung des Autors, die er zum Zweck der Forschung und zur Herstellung von Arzneien zusammengetragen hatte. Die reiche Bebilderung zeigt unter anderem versteinertes Holz (Seipel 2006, Nr. 3.30). Das Buch gehört zu den letzten, die in Holzschnitttechnik gefertigte Illustrationen mit Fossilien enthalten. 1616 benutzte etwa Fabio Colonna (1567–1640) den Kupferstich, der detailreichere, plastischere Darstellungen erlaubte (*De purpura – De Glossopetris Dissertatio*, Rom 1616; Langer 1978, S. 364).

Doch schon um 1580 hatte der westfälische Goldschmied und Kupferstecher Antonius Eisenhoit (1553/1554–1603) eine Serie von knapp 130 Kupferstichen nach Mineralien aus dem Vatikanischen Belvedere geschaffen, die der Direktor der botanischen Gärten und der naturwissenschaftlichen Sammlungen des Vatikans Michele Mercati (1541–1593) zusammengetragen hatte. Sie waren gedacht als Illustrationen von Mercatis Sammlungskatalog *Metallotheca Vaticana*, der jedoch mit dem Tod des Autors unvollendet blieb und erst 1717 von Johannes Lancisi (1654–1720), einem der Amtsnachfolger Mercatis, in Rom publiziert wurde (Holländer 2003). Eisenhoits präzise Stiche stellen Muscheln, Steine und Versteinerungen wie Ammoniten oder Bernsteine mit ihren organischen Einschlüssen dar. Mercatis Vorwort macht deutlich, daß das minutiöse, wissenschaftlichen Ansprüchen genügende Abbild mit dem Wunsch nach ästhetischer Raffinesse verbunden wurde: »Ich habe dafür gesorgt, daß die Bilder der einzelnen Dinge mit bewundernswerter Kunst in Kupfer gestochen werden, weder Kosten scheuend noch Mühen. Oftmals bin ich dem Zeichner, während er diese Bilder ähnlich machte, nahe gewesen, um ihn auf die Dinge, die in den einzelnen Darstellungen mit Sorgfalt zu beobachten sind, hinzuweisen« (Stiegemann 2003, S. 149).

Eine Bebilderung ganz eigener Art sah der Zürcher Stadtarzt, Lehrer und Kurator der Bürgerbibliothek Johann Jacob Scheuchzer für ein geplantes Lexikon von Mineralien und Versteinerungen vor (*Icones pro lexico dilviano*, 1716/30, Zentralbibliothek Zürich, Handschriftenabteilung; Felfe 2003, S. 246–254). Die Manuskripte und Bildersammlungen sind als Klebebände gestaltet. Manche der Collagen übertragen ins Zweidimensionale, was Kunst- und Wunderkammern vereinen: Naturalien und Artefakte als sinnstiftende Ensembles. In einen Titelholzschnitt mit der lasziv lagernden Kleopatra nach Hans Holbein dem Jüngeren (um 1465–1524) klebte Scheuchzer einen eigenhändig gezeichneten Ammoniten (Felfe 2003, Abb. 13). Ein anderes Blatt führt Ammoniten und eine römische Ruinenlandschaft zusammen, wodurch der Vergleich zwischen den Zeugnissen der naturgeschichtlichen Vergangenheit und den Überresten einer früheren Zivilisation angeregt wird (Felfe 2003, Abb. 14). Indem er die Fossilien jeweils zum Hauptthema macht, stellt Scheuchzer die Produkte bildender Natur über die vom Menschen geschaffenen Kunstwerke.

Ausblick

»*Aber ihr habt doch einen Schatz gefunden*, sagte die Ratte feierlich. [...] *Dieser Stein ist mehr als hundert Millionen Jahre alt.* Sie polierte den Stein an ihrem Ärmel bis er schimmerte.« Max Velthuijs, *Frosch findet einen Schatz*, 2003.

Einhergehend mit neuen wissenschaftlichen Erkenntnissen und dem Streben nach immer genaueren Darstellungen, wurde seit etwa 1800 die Lithographie als Abbildungsmedium geschätzt, seit dem letzten Drittel des 19. Jahrhunderts Heliogravüre und Lichtdruck. 1854 fand erstmalig die Photographie für die Paläontologie Verwendung: Neun Abzüge auf Chlorsilberpapier von Wilhelm Thomas bebildern die *Beiträge zur näheren Kenntnis der urweltlichen Säugethiere* (Darmstadt 1854) von Johann Jakob Kaup (1803–1873) (Langer 1978, S. 366). 1859 kam Abramo Bartolommeo Massalongos (1824–1860)

Specimen photographicum animalium quorumdam plantarumque fossilium agri Veronensis mit 40 Photographien von Moritz Eduard Lotze (1809–1890) in Verona heraus. Offensichtlich war es dem Verlag wichtig, neben dem wissenschaftlichen Anspruch auch einem künstlerischen zu genügen: Der in München lebende Lotze war als Landschafts- und Tiermaler begehrt und wirkte als herzoglicher Hofmaler von Sachsen-Coburg und Gotha.

Kunstformen der Natur (Leipzig 1899–1904) von Ernst Haeckel (1834–1919), *Urformen der Kunst* (Berlin 1928) von Karl Bloßfeldt (1865–1932) – die Titel dieser beiden populären Bildbände umreißen eine der Richtungen, die wissenschaftliche Naturbeobachtung und ihre künstlerische Umsetzung bis heute gehen. Harmonisch geordnete Zeichnungen von Tieren und Pflanzen, bei denen es sich zumeist um mit dem bloßen Auge in ihrer Komplexität nicht wahrnehmbare Mikroorganismen handelt, untermauern Haeckels Plädoyer: »Die Natur erzeugt in ihrem Schoße eine unerschöpfliche Fülle von wunderbaren Gestalten, durch deren Schönheit und Mannigfaltigkeit alle vom Menschen geschaffenen Kunstformen weitaus übertroffen werden.« Bloßfeldt photographierte Pflanzen mit seiner selbstgebauten Plattenkamera und zeigt bis zu 30fach vergrößerte Blüten und Blätter, Stengel und Knospen. In der Betonung ihrer Einzelheiten und Oberflächen werden sie zu geometrisch-ornamentalen Strukturen, die an Kunstwerke erinnern. Die Stilstufen der Vergangenheit sah Bloßfeldt im Design der Pflanzen vorgebildet.

Mit seinen Photographien von Fossilien des Instituts für Paläontologie der Freien Universität Berlin richtet auch Hillert Ibbeken einen ästhetisierenden Blick auf die Natur. Ziel war es nicht, ein paläontologisches Bestimmungsbuch zu schaffen, sondern die vielgestaltigen Formenreize der versteinerten Spuren vergangenen Lebens als *Fossil Design* zu würdigen. Die allein nach ästhetischen Kriterien ausgewählten Objekte haben Ibbeken zu künstlerisch anspruchsvollen Kompositionen angeregt. Erneut dürfen, wie Philipp Hainhofer 1627 formulierte, Kunst und Natur miteinander spielen.

Literatur

Agricola, Georgius, *De Natura Fossilium. Handbuch der Mineralogie* (1546), übersetzt von Georg Fraustadt, Wiesbaden 2006.

Baltrušaitis, Jurgis, *Imaginäre Realitäten. Fiktion und Illusion als produktive Kraft. Tierphysiognomik, Bilder im Stein, Waldarchitektur, Illusionsgärten*, Köln 1984.

Barthel, Manfred, »Von Mylius bis Schlotheim. Paläobotanische Sammlungen des 18. Jahrhunderts aus Manebach, Thüringer Wald«, in: Andreas Grote (Hrsg.), *Macrocosmos in Microcosmo. Die Welt in der Stube. Zur Geschichte des Sammelns 1450 bis 1800*, Opladen 1994, S. 707–720.

Ernsting, Bernd, »Die Natur als Künstlerin: Assoziation und Abstraktion«, in: derselbe (Hrsg.), *Georgius Agricola. Bergwelten*, Ausstellungskatalog Essen 1994, S. 131–134.

Felfe, Robert, »Umgebender Raum – Schauraum. Theatralisierung als Medialisierung musealer Räume«, in: Helmar Schramm, Ludger Schwarte und Jan Ladzardzig (Hrsg.), *Kunstkammer – Laboratorium – Bühne. Schauplätze des Wissens im 17. Jahrhundert*, Berlin und New York 2003, S. 226–264.

Hiller, Johannes E., »Die Mineralogie Anselmus Boetius de Boodts«, *Quellen und Studien zur Geschichte der Naturwissenschaften und der Medizin*, 8, 1941, Heft 1, S. 1–215.

Hölder, Helmut, *Geologie und Paläontologie in Texten und ihrer Geschichte*, Freiburg und München 1960.

Holländer, Hans, »Ein Museum der Steine. Die *Metallotheca* des Michele Mercati und die Ordnung des Wissens«, in: Stiegemann 2003, S. 19–30.

Langer, Wolfhart, »Die paläontologische Buchillustration«, in: Claus Nissen (Hrsg.), *Die zoologische Buchillustration. Ihre Bibliographie und Geschichte*, Bd. 2, Stuttgart 1978, S. 361–409.

Langer, Wolfhart, »Kenntnisse über Fossilien im deutschen Kulturraum zur Agricola-Zeit«, in: Friedrich Naumann (Hrsg.), *Georgius Agricola – 500 Jahre*, Basel, Boston und Berlin 1994, S. 123–130.

Mannheim, Christiane, »Edelsteine und Mineralien: Symbole theologischer Spekulationen und mystischer Naturverehrung werden zu Objekten wissenschaftlicher Forschungen«, in: Hans Holländer (Hrsg.), *Erkenntnis, Erfindung, Konstruktion. Studien zur Bildgeschichte von Naturwissenschaften und Technik vom 16. bis zum 19. Jahrhundert*, Berlin 2000, S. 197–222.

Okrusch, Martin, und Klaus-Peter Kelber, »Erkenntnisse – Phantasien – Visionen. Athanasius Kirchers geologisches Weltbild im Lichte heutiger Anschauungen«, in: Horst Beinlich, Christoph Daxelmüller, Hans-Joachim Vollrath und Klaus Wittstadt (Hrsg.), *Magie des Wissens. Athanasius Kircher 1602–1680. Universalgelehrter, Sammler, Visionär*, Ausstellungskatalog Würzburg und Fulda, Dettelbach 2002, S. 131–160.

Rauch, Margot, »Natur zur Kunst: Mineralien in der Sammlung Erzherzog Ferdinands II.«, *Studia Rudolphina*, 7, 2007, S. 22–33.

Roberts, Jane, und Carlo Pedretti, *Leonardo da Vinci. The Codex Hammer formerly The Codex Leicester*, Los Angeles 1981.

Schlosser, Julius, *Die Kunst- und Wunderkammern der Spätrenaissance*, Braunschweig ²1978.

Seipel, Wilfried (Hrsg.), *Die Entdeckung der Natur. Naturalien in den Kunstkammern des 16. und 17. Jahrhunderts*, Ausstellungskatalog Innsbruck und Wien, Wien 2006.

Stiegemann, Christoph (Hrsg.), *Wunderwerk. Göttliche Ordnung und vermessene Welt. Der Goldschmied und Kupferstecher Antonius Eisenhoit und die Hofkunst um 1600*, Ausstellungskatalog Paderborn, Mainz 2003.

Weltenharmonie. Die Kunstkammer und die Ordnung des Wissens, Ausstellungskatalog Braunschweig 2000.

Katja Schoene
Between science and art – fossils in the early modern age

»Auf Schieffer Gott oft schnitzt und mahlt Fisch, Menschen und andrer Tiergestalt.« (God often etches and paints fishes, men and other animal forms in slate.) Martin Rinckhardt, *Mansfeldischer Bergreigen*, 1613.

Early theories of the origin of fossils

»Was die Ursach sey solcher Impressionen, disputieren die Gelehrten.« (The cause of these impressions is debated by the learned.) Martin Luther, *Genesis-Vorlesung*, 1535–45.

In the Renaissance, fascination with primordial petrifactions did not readily translate into prosaic natural science insight. The plants and animals enclosed in stone appeared too fantastical for anyone to consider them as anything other than »freaks of nature« (*lusus naturae*, Schlosser 1978, p. 19). Explanations of their origin were as multifarious as their different manifestations. Surely these were divinely created images? Were subterranean generations not the cause? Were they not the remains of organisms which had perished in water, and therefore proof for the Great Flood? In the 18th century, the collector and lawyer Gottlieb Friedrich Mylius (1675–1726) was still unable to decide whether fossils were freaks of nature, generations, spontaneous creations or »things remaining from the Great Flood« (*Des Unterirdischen Sachsens Seltsamer Wunder Der Natur*, Leipzig, 1709/1718; Barthel 1994, pp. 709 f.).

An increase in mining in Germany in the 16th century led to increased interest in minerals. This led to fossils receiving attention as well. In composing a lecture on Genesis from 1535–45, Martin Luther (1483–1546), who spent his childhood in the Grafschaft of Mansfeld, a mining area, meditated on fossils in copper shale: »As God and nature engage in their amusing pastimes even underground, all manner of fish-shapes are formed in the shale«. Their being embedded in the stone struck him as proof for the biblical account of the Flood (Langer 1994, p. 127).

In 1546, *De natura fossilium libri X* by Georg Agricola (1494–1555) was published in Basel. From 1527–31, the humanist, physician and naturalist from Saxony had lived in the mining town of Joachimsthal in Bohemia, collected mineral samples from across Europe and concerned himself extensively with mining and metallurgy. His work founded the scientific discipline of mineralogy. He produced the first systematic theory of mineral properties, allowing minerals and ores to be identified. In contrast to the modern meaning of the term *fossil* as evidence of life, for instance a petrifaction or an impression, Agricola described all objects dug out of the earth as *Fossils*. He also described minerals, soils and artefacts, e.g. urns in this category, using the Latin word *fodere,* meaning »dug up«, literally. However, Agricola constantly returns to actual fossils in the modern sense, describing ammonites, belemnites, petrified wood, fishes and shark's teeth.

In his *Cosmographey* (Basel, 1550), Sebastian Münster (1488–1552) interprets the fishes and frogs in the Mansfeld copper shale as »likenesses« or »images«, »borne« by the shale – clearly he does not see them as traces of extinct life. Johann Mathesius (1504–1565) saw

petrifactions as »wonderful growths« of the earth (*Sarepta oder Bergpostill sampt der Jochimßthalischen kurtzen Chronicken*, Nuremberg, 1564; Langer 1994, p. 128). Johann Bauhin (1541–1613), Herzog Friedrich I von Württemberg's personal physician, considered ammonites, belemnites and bivalves to be »wonderful works of art in and beneath the earth« (*Historia novi et admirabilis fontis balneique Bollensis*, Montbéliard, 1598; German edition: *Ein New Badbuch und Historische Beschreibung von der wunderbaren Krafft und würckung des Wunder Brunnen und Heilsamen Bads zu Boll*, Stuttgart, 1602).

Leonardo da Vinci (1452–1529) on the other hand had guessed the organic origins of the fossil bivalves and corals found in the mountains of Parma and Piacenza as early as 1505, describing them as now-extinct sea creatures (Roberts, Pedretti 1981, pp. 37 f.). Later, the French naturalist and ceramicist Bernard Palissy (1510 to 1590) (*Discours admirables*, Paris, 1580) and the Neapolitan doctor Ferrante Imperato (1521/22–1600/09) also recognized the real nature of fossils (*Dell' historia naturale libri* XXVIII, Naples, 1599). Among other things, Imperato concerned himself with the different manifestations of fossilized wood (Seipel 2006, no. 3.30). The Danish doctor, anatomist and geologist Nicolaus Steno (1638–1686) followed on from Leonardo's observations (*De solido intra solidum naturaliter contento dissertationis prodromus*, Florence, 1669). He noticed the similarity of some stones to shark's teeth. This led him to conclude that he must be dealing with the remains of living organisms.

Athanasius Kircher (1602–1680), a Jesuit generalist scientist and student of natural science, wrote the richly illustrated landmark work *Mundus subterraneus* (Amsterdam, 1664/65), the bestseller among the geology and mineralogy books of his age. Kircher's individual geological worldview united physical science insights with the scholastic tradition of the middle ages and a belief in the biblical account of the Creation. The lamellae of mammoths' molar teeth, called *chirites* or *Handsteine* (»handstones«) in German due to their similarity to the human hand, were interpreted by Kircher »as the bones of giants, due to the massiveness of the pieces« (Okrusch and Kelber 2002, pp. 146–148). In this he followed Giovanni Boccaccio's (1313–1375) account of alleged Cyclops bone remnants discovered in a cave at Trapani on Sicily. »Dentes Gigantes« – giants', or rather, mammoths' teeth – were also depicted by Ulisse Aldrovandi (1522–1605, *Monstrorum Historia cum paralipomenis historiae omnium animalium*, Bologna, 1642). Kircher saw other fossils as chance shapes created by nature. For him, their forms, in which he saw imprinted signs and images, represented symbols of divine creative activity.

Friedrich Heyn (1695–1715) also considered plant fossils from the Manebach coal seams to be images of natural growths created by divine will and not remains of actual plants, as »plant mountains« would have been required (*Bericht Einer herrlichen Berg-Situation und Ertz-Gebürges in dem Thüringer Walde* [...], Leipzig, 1695). Johann Jacob Baier (1677–1735) described geodes, belemnites and trochites as »gestaltete Steine« (shaped stones) or »Figurensteine« (effigy stones, *Oryctographia Norica sive Rerum fossilium in Territorio Norimbergensi Descriptio*, Nuremberg, 1708). At the same time, however, he recognized that ammonites, fossilized bivalves, fish remains and bones were not »freaks of

nature, but actual shells of shelled animals«, i.e. actual remains of once-living animals (Hölder 1960, pp. 363 f.)

In the »Figurensteine«, the imagination perceived images of non-living technology and living nature. The bodies of petrified cephalopods are still known in German as *Donnerkeil* or thunderbolts. It was believed that they were shot, arrowheads, from the god Donar or Thor. In the first half of the 18th century, Franz Ernst Brückmann (1697–1753) declared belemnites to be the spines of sea urchins (*Thesaurus subterraneus Ducatus Brunsvigii*, Braunschweig, 1728). Louis Bourguet (1678 to 1742) thought they were reptile or crocodile teeth. (*Lettres philosophiques sur la formation des sels et des crystaux* [...], Amsterdam, 1729; *Traité des pétrifications*; Paris, 1742). Due to their spiral formation, ammonites were associated with dragons and snakes. »Perhaps they are the shells of deceased animals, which, no longer held together in convolutions, crept shivering across the surface of the Earth and were buried by the masses of petrifaction«, wrote J. F. Krüger in 1823 (»Gegliederte Ammoniten«, *Archiv für die neuesten Entdeckungen aus der Urwelt V*, Quedlinburg, 1823; Hölder 1960, p. 371). Pliny the Elder (around 23–79) described petrified shark's teeth as »stone tongues« (*Glossopetrae*, Greek *glossa* = tongue, *petra* = rock). In the Middle Ages, they were seen as snakes' tongues turned to stone, so-called *Natternzungen*, which were used in pulverized form or as amulets for healing purposes (Hiller 1941, p. 84; Mannheim, 2000, p. 199). *Natternzungen* goblets were used to test for poison; it was believed that the »tongues« would sweat in the presence of poison. The pentagonal trochites (petrified crinoid stem sections), which showed a star shape in cross-section and were believed to be fallen stars, served as healing and good-luck charms. Oyster shells were connected with devil's claws, and brachiopods (petrified tentacled sea creatures) with doves and other birds, but also with oil lamps.

The works of the English natural historian, geologist and doctor John Woodward (1665–1728) (*Essay towards a Natural History of the Earth*, London, 1695; *Fossils of All Kind*, London, 1728) and Johann Jacob Scheuchzer (1672–1733) (*Piscium Querelae et Vindiciae*, Zurich, 1708; *Herbarium diluvianum*, Zurich, 1709) contributed significantly to a recognition that fossils were the remains of animals and plants. However, both were proponents of the Flood theory (Barthel 1994, p. 711). The doctor and naturalist Christian Friedrich Schulze (1730–1775) objected to this biblical explanation (*Kurtze Betrachtung derer Kräuterabdrücke im Steinreiche*, Dresden, 1755; Barthel 1994, pp. 711 f.). Johann Ernst Immanuel Walch (1725–78) (*Naturgeschichte der Versteinerungen*, Nuremberg, 1768–73) agreed with him. In the 19th century, the fossil hypothesis was finally de-mythologised. For Ernst Friedrich von Schlotheim (1764–1832), fossils were without a doubt the remains of and evidence for the development of organisms from an earlier period of the Earth's history (*Beiträge zur Naturgeschichte der Versteinerungen in geognostischer Hinsicht*, Munich, 1820; Barthel 1994, p. 713). The description *fossil* became restricted to objects with an organic origin.

Fossils in cabinets of art and curiosities

»Naturwunder aller Art.« (Wonders of nature of all kinds.) Julius Schlosser, *Die Kunst und Wunderkammern der Spätrenaissance*, 1908.

The enthusiasm for patterned, bright or peculiarly formed finds out of the Earth – stones, minerals or fossils – their material value, their legendary origins and the medical and magical effects ascribed to them made them popular objects for collection in the *Kunstkammer* and *Wunderkammer* (art and curiosity cabinets) of the early modern age. There, artworks and curiosities from the realms of nature, art and technology were united, satisfying an encyclopaedic urge to collect and a need to impress on the part of their owner, whether ruler, nobleman, wealthy burgher, academic or artist. The Habsburg collections, especially those of Erzherzog Ferdinand II (1529–1595) at Schloss Ambras and Kaiser Rudolf II (1552–1612) in Prague became famous. Francesco de' Medici (1541–1584), Landgraf Wilhelm IV von Hessen (1532–1592), Herzog August the Younger von Braunschweig-Wolfenbüttel (1597–1666) and his sons, and Ernst I von Sachsen-Gotha (1601–1675) all indulged in this passion, as did doctors and apothecaries, whose collections were a combination of museum, laboratory, studio and library.

The broad spectrum of objects created a variety of classification systems. Usually they were arranged according to aesthetic criteria. Alongside making an impression appropriate to one's social standing, a goal of the *Kunstkammer* and *Wunderkammer* was to emulate the macrocosm of the outer world in the microcosm of the collection. Collection and organization was supposed to assist in revealing nature's secrets. *Artificialia, naturalia* and *scientifica* were the categories devised by Samuel Quiccheberg (1529–1567). This could be expanded to include *exotica* (*Theatrum sapientiae*, Munich, 1565). The four elements or the continents offered further possibilities for classification. Before the universal recognition of fossils as petrified organisms and the development of a scientific system, they were considered chance shapes or »Figurensteine« (effigy stones) that coincidentally resembled organisms or parts of them. They were natural objects, but could also be artefacts, depending on what they were considered to be.

One of the first rulers' collections, that of Herzog Jean de Berry (1340–1416) at his palace in Mehun-sur-Yèvre, included natural objects, including »giants' bones«, presumably the bones of a primordial mammoth (Schlosser 1978, p. 40). Inventories of the art collection at Schloss Ambras from 1596, 1603 and 1621 mention a »giant's chin«, actually the lower jaw of a European mammoth (today in the Naturhistorisches Museum in Vienna; Seipel 2006, no. 2.93), as well as the presumed shinbones and hipbone of a giant. The inscription on a piece of limestone with a fossilized fish from the Upper Jurassic, found in Solnhofen in Bavaria (today in the Naturhistorisches Museum Vienna), taken from Vergil's *Aeneid* and *Georgics* (70–19 BC), refers to the Flood theory: »Hierauf begibt der allmächtige Vater in wildem Zorn sich vom hohen Äther: Er gießt in die Wogen das Land, schickend die Flut [...] Nichtet die Äcker, vernichtet die Fluren [...] Es füllen Gräben sich, Flußläufe schwellen, und alles Leben dem Tod übergibt er.« (At this, the almighty Father descends from the heights of the ether: he plunges the land in waves, sending the flood [...] destroying the acres, utterly destroying the meadows [...] ditches fill, rivers burst their banks and all life is delivered unto death.) (Langer 1994, p. 127; Rauch 2007, p. 29; Seipel 2006, no. 3.26). The remains of primordial animals were also stored in churches and town halls. Often, they were hung up inside on chains, like the »giant's bone« originating from a mammoth, in the Stephansdom (St Stephen's Cathedral) in Vienna (Schlosser 1978, p. 19).

Chance shapes and effigy stones, or nature as artist

»so das ars und natura mit ain ander spilen.« (In such a way that art and nature play together.) Philipp Hainhofer, 1627.

»Art partly completes what nature cannot bring to a finish, and partly imitates her.« This was how Aristotle defined the expression *techne* in his *Physics*. Man the artist perfects the works created by nature, and is even able to imitate nature's role as creator. The neo-Platonist Marsilio Ficino (1433–1499) considered nature and art to be equal formative powers: »What is human art? A certain nature that handles material from the outside. What is nature? An art that designs material from the inside.«

Agricola saw nature as a creator of works of art (Ernsting 1994). He admired the images in minerals »which were not framed by some artist, but by Nature herself« (Agricola/Fraustadt 2006, p. 226). These images are often fossils: »Not a few [minerals, K.S.] depict images of objects, in diverging lines which often change in colour: [...] fishes, specifically pikes, bass and flatfish in the Eisleben stone, animals, such as the cockerel and salamander, in the same stone« (Agricola/Fraustadt 2006, p. 28). Agricola unites observation of nature and a sense of minerals' aesthetic charm. More than 100 years later, in *Mundus subterraneus*, Kircher grouped stones according to their pictorial motifs, geometrical figures and letters of the alphabet (Baltrušaitis 1984, p. 55). They had supposedly been formed by coincidence, the composition of the soil, the aptitude of forms and fluids for petrifaction, magnetism or divine decree.

Painted figures, landscapes or architectural elements were often added to these naturally produced chance shapes. Enchanting compositions were created, in which art complemented the products of nature. For instance, an unknown artist chiselled a snake's head with a mouth and eyes into an ammonite, described in the Ambras inventory of 1596 as »ain schlangen, so zu ainem stain worden« (a snake turned into stone) (today in the Naturhistorisches Museum Wien; Seipel 2006, no. 3.29). A credence from the 15th century, also from the Ambras Kunstkammer, has a decorative trim of fossilized shark's teeth (today in the Kunsthistorisches Museum Wien, Kunstkammer; Schlosser 1978, p. 66). Amber, a fossilized pine resin, was often worked into jewellery or small sculptures. A piece of amber work from Schloss Ambras, probably from the 15th century, shows the birth of Jesus, with Joseph, the ox and the ass present behind the reclining Mother of God (today in the Kunsthistorisches Museum Vienna; Seipel 2006, no. 3.25). The crowning glory of the *Kunstschrank* of Gustav II Adolf (1594–1632), designed and delivered to the Swedish king by the Augsburg humanist and art dealer Philipp Hainhofer (1578–1647) from 1625–32, is a cup made from a coco de mer. This is standing on a mountain which includes fossilized shells as well as crystals, hematite, amethysts and corals (today in Uppsala, in the university's art collection). The goldsmith Anton Schweinberger (died 1603), crafted ornaments for Kaiser Rudolf II using rhinoceros horns, petrified shark's teeth and the tusks of wild boar. Framed and hung on the wall, these traces of earlier life could be defined as art objects in the pure sense: a piece of flat-cleaving limestone from Herzog Anton Ulrich's (1633–1714) Kunstkammer, from Schloss Salzdahlum shows an easily recognizable fossilized *Gyronchus* fish from Solnhofen (today in Naturhistorisches Museum Braunschweig; Weltenharmonie 2000, Nr. 121).

Illustrations of fossils: between science and aesthetics

»das mans clarlich erkennen kan was jedes für ein fisch bildnuß oder figur ist.« (So that one can clearly make out what kind of fish likeness or figure each is.) Sebastian Münster, *Cosmographey*, 1550.

As Agricola did not have his *De natura fossilium* illustrated, Sebastian Münster has the distinction of publishing the oldest known depiction of a fossil in a printed book, in his *Cosmographey* (1550). It shows a Mansfeld copper shale fish. A year later, Christopher Entzelt's first four woodcut representations of fossilized invertebrates followed (1517–1583) (*De re metallica*, Frankfurt/Main, 1551; Langer 1978, p. 263).

In 1565, *De rerum fossilium, lapidum et gemmarum maxime, figuris et similitudinibus liber* by the Swiss nature researcher and doctor Conrad Gessner (1516 to 1565) was published in Zurich. This reference work on minerals is illustrated throughout. 72 woodcuts show rock types, fossils and prehistoric stone tools. Images of belemnites, crinoid stems, Jurassic ammonites and sharks' teeth were taken from Gessner's geological collection. Many of them were most likely drawn by him and by the Dresden doctor Johannes Kentmann (1518–1588). The original drawings are preserved at the Universitätsbibliothek Basel (Ms. K I 2). In 1598, *Historia novi et admirabilis fontis balneique Bollensis* by Bauhin, also accompanied by numerous fossil woodcuts, was published, showing ammonites and lamillibranchiates from the Posidonienschiefer (or Posidonia oil-shale) at Bad Boll in Swabia (Hölder 1960, p. 360).

Imperato's book *Dell' historia naturale*, first published in 1599, describes the author's collection, which he amassed for purposes of research and manufacture of remedies. The lavish illustrations show fossilized wood, among other things (Seipel 2006, no. 3.30). This book was one of the last to contain woodcut illustrations of fossils. In 1616, for instance, Fabio Colonna (1567–1640) used copperplate engraving, which allowed more detailed and plastic representations (*De purpura – De Glossopetris Dissertatio*, Rome, 1616; Langer 1978, p. 364).

As early as 1580, the Westphalian goldsmith and copperplate engraver Antonius Eisenhoit (1553/1554 to 1603) had created a series of just over 130 copper engravings of minerals from the Belvedere in the Vatican, collected by the director of botanical gardens and natural science collections Michele Mercati (1541–1593). They were intended as illustrations for the catalogue of Mer-

cati's collection, *Metallotheca Vaticana*, which however was left incomplete when the author died and was eventually published in Rome by Johannes Lancisi (1654 to 1720), one of Mercati's successors in office, in 1717 (Holländer 2003). Eisenhoit's painstaking engravings display bivalves, rocks and petrifactions such as ammonites or amber with organic inclusions. Mercati's foreword makes it clear that meticulous illustrations allowing scientific enquiry were united with a desire for aesthetic refinement: »I have ensured that the images of individual items were engraved in copper with an astounding degree of art, with no expense or pains spared. I was often present while the illustrator corrected these pictures, in order to point out things which should be paid special attention to in individual representations« (Stiegemann 2003, p. 149).

The Zurich city doctor, teacher and curator of the civic library Johann Jacob Scheuchzer arranged a unique form of illustration for a planned lexicon of minerals and petrifactions (*Icones pro lexico dilviano*, 1716/30, Zentralbibliothek Zurich, manuscript section; Felfe 2003, p. 246–254). The manuscripts and image collections are arranged as albums. Some of the collages render in two dimensions the things *Kunstkammer* and *Wunderkammer* have in common: natural and man-made objects in a meaningful ensemble. Scheuchzer stuck an ammonite he had drawn himself into the title woodcut – Hans Holbein the Younger's (1465–1524) lasciviously reclining Cleopatra (Felfe 2003, illustration 13). Another page marries ammonites and a landscape of Roman ruins, evoking a comparison between evidence of the natural-historical past and the remains of a bygone civilization (Felfe 2003, illustration 14). By consistently making fossils the main theme, Scheuchzer places the products of creative nature before humanly devised artworks.

Prospects

»Aber ihr habt doch einen Schatz gefunden, sagte die Ratte feierlich. [...] *Dieser Stein ist mehr als hundert Millionen Jahre alt.* Sie polierte den Stein an ihrem Ärmel bis er schimmerte.« (*But you have indeed found a treasure*, said the rat solemnly [...] *This stone is more than a hundred million years old.* She polished the stone on her sleeve until it shone.) Max Velthuijs, *Frosch findet einen Schatz*, 2003.

As a consequence of new scientific insights and the drive towards ever more accurate reproductions, lithography came into favour around 1800 as a means of representation. Heliogravure and carbon printing came in around the final quarter of the 19th century. In 1854, photography was used in palaeontology for the first time. *Beiträge zur näheren Kenntnis der urweltlichen Säugethiere* (Darmstadt, 1854) by Johann Jakob Kaup (1803–1873), is illustrated with nine prints on silver chlorate paper (Langer 1978, p. 366). In 1859 Abramo Bartolommeo Massalongo's (1824–1860) *Specimen photographicum animalium quorumdam plantarumque fossilium agri Veronensis* was published in Verona with 40 photographs by Moritz Eduard Lotze (1809–1890). It was clearly important to the publishers to satisfy the demands of art as well as those of science. Lotze, who lived in Munich, was a sought-after landscape and animal painter and was the ducal court painter for Sachsen-Coburg and Gotha.

Kunstformen der Natur (Leipzig, 1899–1904) by Ernst Haeckel (1834–1919), *Urformen der Kunst* (Berlin, 1928) by Karl Blossfeldt (1865–1932) – these two popular illustrated books indicate one direction which still defines scientific observation of nature and its translation into art. Harmoniously regular drawings of animals and plants, mainly microorganisms whose complexity cannot be observed with the naked eye, serve to support Haeckel's argument: »An inexhaustible wealth of wonderful shapes, whose beauty and variety exceed all man-made works of art, are spawned in the lap of Nature.« Blossfeldt photographed plants with his home-made plate camera, portraying flowers and leaves, stems and buds magnified by a factor of 30. The emphasis on their details and surfaces turns them into geometrical, ornamental structures resembling works of art. Blossfeldt saw the different styles of the past mirrored in plants.

With his photographs of the Freie Universität Berlin's Institut für Paläontologie's fossils, Hillert Ibbeken also looks at nature through an aesthetic lens. The aim was not to create a palaeontological identification book, but to pay tribute to the fascinating formal diversity of these petrified traces of extinct life as *fossil design*. Ibbeken has brought these objects, chosen solely on aesthetic grounds, to life as artistic composition. As Philipp Hainhofer expressed it in 1627, nature and art can play together once again.

Bibliography

Agricola, Georgius, *De Natura Fossilium. Handbuch der Mineralogie* (1546), translated by Georg Fraustadt, Wiesbaden, 2006.

Baltrušaitis, Jurgis, *Imaginäre Realitäten. Fiktion und Illusion als produktive Kraft. Tierphysiognomik, Bilder im Stein, Waldarchitektur, Illusionsgärten*, Cologne, 1984.

Barthel, Manfred, »Von Mylius bis Schlotheim. Paläobotanische Sammlungen des 18. Jahrhunderts aus Manebach, Thüringer Wald«, in: Andreas Grote (ed.), *Macrocosmos in Microcosmo. Die Welt in der Stube. Zur Geschichte des Sammelns 1450 bis 1800*, Opladen, 1994, pp. 707–720.

Ernsting, Bernd, »Die Natur als Künstlerin: Assoziation und Abstraktion«, in: same author (ed.), *Georgius Agricola. Bergwelten*, exhibition catalogue Essen, 1994, pp. 131–134.

Felfe, Robert, »Umgebender Raum – Schauraum. Theatralisierung als Medialisierung musealer Räume«, in: Helmar Schramm, Ludger Schwarte and Jan Ladzardzig (eds.): *Kunstkammer – Laboratorium – Bühne. Schauplätze des Wissens im 17. Jahrhundert*, Berlin and New York, 2003, pp. 226–264.

Hiller, Johannes E., »Die Mineralogie Anselmus Boetius de Boodts«, *Quellen und Studien zur Geschichte der Naturwissenschaften und der Medizin*, 8, 1941, no. 1, pp. 1–215.

Hölder, Helmut, *Geologie und Paläontologie in Texten und ihrer Geschichte*, Freiburg and Munich, 1960.

Holländer, Hans, »Ein Museum der Steine. Die *Metallotheca* des Michele Mercati und die Ordnung des Wissens«, in: Stiegemann 2003, pp. 19–30.

Langer, Wolfhart, »Die paläontologische Buchillustration«, in: Claus Nissen (ed.), *Die zoologische Buchillustration. Ihre Bibliographie und Geschichte*, vol. 2, Stuttgart, 1978, pp. 361–409.

Langer, Wolfhart, »Kenntnisse über Fossilien im deutschen Kulturraum zur Agricola-Zeit«, in: Friedrich Naumann (ed.), *Georgius Agricola – 500 Jahre*, Basel, Boston and Berlin, 1994, pp. 123–130.

Mannheim, Christiane, »Edelsteine und Mineralien: Symbole theologischer Spekulationen und mystischer Naturverehrung werden zu Objekten wissenschaftlicher Forschungen«, in: Hans Holländer (ed.), *Erkenntnis, Erfindung, Konstruktion. Studien zur Bildgeschichte von Naturwissenschaften und Technik vom 16. bis zum 19. Jahrhundert*, Berlin, 2000, pp. 197–222.

Okrusch, Martin, and Klaus-Peter Kelber, »Erkenntnisse – Phantasien – Visionen. Athanasius Kirchers geologisches Weltbild im Lichte heutiger Anschauungen«, in: Horst Beinlich, Christoph Daxelmüller, Hans-Joachim Vollrath and Klaus Wittstadt (eds.), *Magie des Wissens. Athanasius Kircher 1602–1680. Universalgelehrter, Sammler, Visionär*, exhibition catalogue Würzburg and Fulda, Dettelbach, 2002, pp. 131–160.

Rauch, Margot, »Natur zur Kunst: Mineralien in der Sammlung Erzherzog Ferdinands II.«, *Studia Rudolphina*, 7, 2007, pp. 22–33.

Roberts, Jane, and Carlo Pedretti, *Leonardo da Vinci. The Codex Hammer formerly The Codex Leicester*, Los Angeles, 1981.

Schlosser, Julius, *Die Kunst- und Wunderkammern der Spätrenaissance*, Braunschweig, ²1978.

Seipel, Wilfried (ed.), *Die Entdeckung der Natur. Naturalien in den Kunstkammern des 16. und 17. Jahrhunderts*, exhibition catalogue Innsbruck and Vienna, Vienna, 2006.

Stiegemann, Christoph (ed.), *Wunderwerk. Göttliche Ordnung und vermessene Welt. Der Goldschmied und Kupferstecher Antonius Eisenhoit und die Hofkunst um 1600*, exhibition catalogue Paderborn, Mainz, 2003.

Weltenharmonie. Die Kunstkammer und die Ordnung des Wissens, exhibition catalogue Braunschweig, 2000.

Rudolf zur Lippe
Formen versteinerten Lebens

Unterschiedliche Vorgänge der Natur in unvordenk-
lichen Zeiten haben uns anschaulichste Zeugnisse
einstiger Lebewesen und Pflanzen hinterlassen. Ver-
steinerungen unter dem Druck neuer Meere. Abdrücke,
vollkommen wie die Gipssammlungen griechischer
Skulpturen im Hause der Humboldts, die ausgefüllt
haben, was vergangene Lebewesen als Hohlform hin-
terließen.

Hillert Ibbeken hat photographiert, was in einer pa-
läontologischen Sammlung ihn am lebhaftesten ange-
sprochen hat, nicht was ihm wichtige Beweisstücke für
eine geologische Forschungsfrage waren. Die Stücke
liegen als ganzes Objekt oder in einem Schnitt vor, der
das Innere freigibt, oder in einem Ausschnitt, den der
Blick des Photographen, der uns zu den nächsten
Betrachtern machen will, gewählt hat. Wir ahnen, wie
all die Gegenstände auf den übervollen Brettern end-
loser Regale in einem wissenschaftlich veranstalteten
Winterschlaf miteinander dahindämmern. Ibbekens
Hand hat sie da herausgelöst wie, vor ein paar Jahren,
Jahrzehnten oder Jahrhunderten, systematische Geo-
logen oder aufmerksame Wanderer aus den Tiefen
des Gesteins, die Orte ihres zweiten Lebens geworden
waren. Im abgesunkenen Sediment eines Meeresbo-
dens, den vielleicht vulkanische Verwerfungen umge-
schichtet und bis an die Erdoberfläche geschoben
haben. Eingeschlossen in spätere Gesteinsbildungen,
die aufgebrochen sind unter der gigantischen Gewalt
von Bewegungen in der Tiefe des Magma, unter der
Gewalt des Abbaus in einem Steinbruch oder durch
die gezielten Schläge eines Hammers aus dem Gepäck
eines Geologen.

Wie sehen diese Abbildungen uns an? Über dem
Reiz der Formen und Farben und im Eifer unserer Fra-
gen fällt uns am wenigsten auf, was sich am entschie-
densten uns mitteilt. Um ihre frühen Lebensgeschich-
ten zu untersuchen, haben wir sie der Orte dieser Ge-
schichten beraubt. Sie liegen da vor uns, mit kleinen
Hinweisen versehen nicht etwa auf die Biotope, die wir
ihre Heimat nennen müßten, sondern auf die »Fund-
orte«. Der ursprüngliche Kontext ist zwar wesentlich
für die Forschung, tritt aber zunächst hinter den mo-
dernen Zugriff zurück. So, wie seit Carl von Linné das
Leben der Pflanzen auf zwei Zugehörigkeiten redu-
ziert wird und den Stempel eines binären Namens
erhält. Die Botaniker nehmen sich seither sogar das
Recht, den von ihnen zuerst wissenschaftlich beschrie-
benen Arten ihren eigenen Familiennamen zu verpas-
sen.

Ich denke daran, weil ich gefragt habe, wie diese
Objekte mich ansehen. Offensichtlich muß ich zuerst
fragen, wie es um mein Sehen bestellt ist. Was hat die
Geschichte des wissenschaftlichen Zugriffs mit meiner
Wahrnehmung gemacht, seit sie die Versteinerungen
in den Status von Objekten versetzt hat? Diese Frage
wird durch die Begeisterung von Hillert Ibbeken für die
Schönheit der Formen und Farben in den Hintergrund
geschoben, und wir sind wie er von der Brillanz seiner
Aufnahmen beherrscht. Spielt sie aber deshalb keine
Rolle? Wie kann die Versteinerung, einmal zum Ob-
jekt gemacht, uns noch ansehen? Wie sehen wir, ver-
lockt und vielleicht auch verleitet durch den photo-
graphischen Blick und seine Vorstellung von Schön-
heit?

Formengeschichte und Formendenken

Die Geschichte unserer Distanzierungen gegenüber
den naturgeschichtlichen Phänomenen habe ich an-
gedeutet, um mir begreiflich zu machen, warum wohl
unsere verbreitete Reaktion auf sie, insbesondere auf
ihre so schöne photographische Wiedergabe, so stark
vom Denken in Formen bestimmt ist. So stark, daß ich
den Ausruf höre, wie man denn sonst reagieren könne?
Es könnte einfach ein Staunen gegenüber dem so Fer-
nen sein, ein Erschrecken vielleicht sogar vor der für
uns überwältigenden Tiefe der Zeit, von der diese
Zeugnisse sprechen. Ich finde, es ist vor ihnen ange-
messen, erst einmal ohne den Versuch zu verharren,
sie einzuordnen, zu klassifizieren, zu beurteilen, zu ver-
gleichen.

Allerdings ist genau dies das Arsenal von Einstellun-
gen und Methoden, mit denen unsere Kunsthistoriker
an ihre Gegenstände herantreten. Bestimmte fließen-
de Mäander lassen nach einer kretischen Herkunft fra-
gen. Bestimmte überdehnte Leiber rücken ein Bild in
die Epoche des Manierismus, etwa in die Nähe von
El Greco. Bestimmte Farben lassen sofort an Picas-
sos blaue Periode denken.

Aber Formendenken und Formengeschichte beherr-
schen keineswegs nur die kritische Betrachtung von
Kunst. Ganz im Sinne der abendländischen Tradition
platonischer Ideenlehre und ihrer Trennung zwischen
Form und Material nimmt die Form den ersten Rang
ein. Das Material dient dann ihrer greifbaren Umset-
zung. Was darüber ins Hintertreffen gerät, ist die vor-
rangige Aufmerksamkeit auf die Vorgänge der Form-
werdung oder Formierung. Ihr Resultat bietet den fes-
ten Anhalt für einen Wahrnehmungsstil, der darauf ge-
schult ist. Phänomene aber sind keine Resultate, son-
dern ereignen sich, solange sie wahrgenommen wer-
den können. Das Phänomen lebt in der jeweiligen Ge-
genwart und Begegnung. Und es offenbart allgemei-
nere gesetzmäßige Wirkungszusammenhänge. Diese
erst schlagen sich in der vergleichenden und erprob-
den Beobachtung als abstrakte Vorstellungen und Ge-
setzeshypothesen nieder.

Um die ungewohnte Betrachtungsweise deutlicher
zu charakterisieren, will ich Vergleichbares aus einem
ganz anderen Feld der Kultur schildern. Wir haben eine
Reihe tänzerischer Aufführungen aus Asien und Europa
beobachtet und mit den Künstlerinnen und Künstlern
besprochen. Ein eingehenderes Verständnis hat eine
interessante Polarität zum wichtigsten Thema gemacht.
Die eine Seite heißt Form.

Eine Form, von deren Vorstellung eine bestimmte
choreographische Entwicklung ausgeht. Veränderun-
gen dieser Form durch die Situationen, die sich im Lau-
fe der Entwicklung ergeben. Die andere Seite kann ich
wohl am besten mit einem sehr weiten, vitalen Begriff
von Energie benennen. Die europäische Tradition,
durchaus bis in den Modern Dance und manche zeit-
genössische Choreographien, ist darauf gerichtet, For-
men zu schaffen, ob sie nun einem historischen Kanon
entnommen oder neu erfunden werden. Die asiatischen
Tänzer, ganz besonders der Schulen des japanischen
buto, arbeiten an der Kunst, sich von eigenen Absich-
ten frei zu machen und zu befähigen, auftauchende
Energien zu spüren, wirken zu lassen und den eigenen
Leib ihrem Wirken Ausdruck geben zu lassen.

Hält man einen Anblick fest, wie in einer photogra-
phischen Aufnahme, so zeigt sich zweifellos eine Form.

Aufführungen von Stücken zeigen auch, soweit das
überhaupt möglich ist, in den gleichen Phasen immer
wieder gleiche Formen. Worum es aber geht, ist eine
Disziplin, die nicht Körperenergie benutzt, um geistige
Form zu verwirklichen – so hat es einmal eine große
deutsche Tänzerin gesagt –; vielmehr wird asiatisch –
das meint auch China, Indien und andere Kulturen –
asketisch geübt, die eigene Existenz frei werden zu las-
sen, um bestimmte Impulse sich manifestieren zu las-
sen. Diese Tänzerinnen und Tänzer werden, sei es im
vollen Bewußtsein oder dieses transzendierend, um
ein Bild von Paul Valéry aufzunehmen, zu Quallen: De-
ren Bewegungen sind Ausdruck der Bewegungen des
Wassers um sie, und ihre Gestalt ist Ausdruck dieser
Bewegungen. Wie die Energien zu verstehen sind, de-
nen die Tänze Ausdruck geben, ist an anderer Stelle
auszuführen.

Neben dieser Beobachtung in den Künsten sei noch
eine Alltagsgewohnheit erwähnt. Viele Menschen fin-
den ein großes Vergnügen daran, in Wolken, in Holz-
scheiten, in Steinen Gesichter zu entdecken. Natürlich
packt uns bei mancher Gelegenheit die Faszination für
das Prinzip des Vexierbilds. Wenn aber dieser Sport
so weit geht, geradezu zwanghaft das Unbekannte in
den Bann zu schlagen, indem man Formen des Be-
kannten darauf projiziert, dann wird Wahrnehmung im
Grunde versäumt. Der Drang danach, Bekanntes wie-
derzuerkennen selbst und gerade am Unbekannten,
läßt den Geist so starr werden wie die vermeintlich
bekannte Form. Das bringt uns in Sicherheit vor jenem
Erschrecken gegenüber dem Unfaßlichen von Him-
melsfernen und Erdzeitaltertiefen. Es beschädigt un-
ser Vermögen, zu staunen.

Morphologie

Morphologie ist eine Lehre, die sich mit der Entstehung
und Bedeutung von Formen befaßt, des Lebendigen,
wie Zoologie oder Botanik es als ihren Gegenstand
betrachten. Geschickter wäre es schon, sie eine Lehre
der Formen zu nennen, während das Lexikon erklärt,
daß sie von »Strukturen des Lebendigen« handelt.
Goethe, einer der großen Wegweisenden für die Mor-
phologie, hat bereits gegen den Begriff der Gestalt so
polemisiert, wie wir es gegenüber der Struktur tun
müssen. Ein Denken in Gestalten, also den Ergebnis-
sen abgeschlossener Gestaltungen, muß das Wesent-
liche von Leben ausblenden: seine Geschichten und
seine neuen Veränderungen. Goethe setzt deshalb
Bildung als bestimmenden Begriff in sein Denken und
seine Rede über Tiere und Pflanzen. Unmittelbar ver-
bindet sich mit dem Begriff die Frage: Wie hat sich
dies gebildet? Ihr folgen Überlegungen, wie dies sich
weiter- und umbilden könnte. Wenn Heckel seine
mikroskopischen Schnitte des menschlichen Embryos
so angeschaut und interpretiert hätte, wäre ihm nicht
die Fehlinterpretation unterlaufen, die dann später
durch die dynamische Embryologie von Erich Blech-
schmidt umgeworfen wurde. Heckel nahm die Form
von Hautfalten bzw. Schlitzen, die sich am Embryo
seitlich nach der vorgeburtlichen Streckung und wie-
der eingenommenen Einrollung bilden, für das, was er
von anderen Wesen kannte, nämlich Kiemen. Blech-
schmidt hielt dagegen: »Formen entstehen nicht für
Funktionen, sondern in Funktionen und durch Funk-
tionen.«[1]

So etwas wie ein Atem findet da nicht statt. Also sind es keine Kiemen. Die Hautfalten hat er folglich anders erklärt. Die Frage lautet eben nicht, wie sieht das aus? Die Frage ist möglicherweise auch interessant. Aber wir müssen ohnehin sofort hinzufügen und mitdenken, wie sieht das für mich oder für meine Disziplin aus?

Die Frage lautet, was ist da geschehen? In diesem Sinne wird die versteinerte Erscheinung zu einem Text, mit dem ich mich noch lesend beschäftigte. In einer Chiffre, die von einer Geschichte spricht, freilich in dem historischen Augenblick, in dem diese zum Stillstand gekommen ist.

Wie können wir durch unsere Lektüre der Strukturen zugleich deren Entstehungsgeschichte am Entstandenen und das die Zeiten Überdauernde ablesen? Die gewissermaßen semantische Lesart wäre zu sprachlich im engeren Sinne gedacht. Außerdem bedarf sie ja auch, besonders im Falle sogenannter toter Sprachen intensiver hermeneutischer Empathie. Hier schauen wir uns gegenwärtige Formen daraufhin an, welche Bewegungen in ihnen zum Stillstand gekommen sind. Morphologisch zu denken, bedeutet, in Bewegungen zu denken. Dazu gehört nicht nur die vergangene Geschichte dieser feststellbaren Gegenwart, vielmehr auch deren Zukunft. Wir müssen versuchen, eine Einbildungskraft zu entwickeln für mögliche Um- und Weiterbildungen.

Gregory Bateson führt uns, wie seine damaligen Studenten, auf diesen Weg und zu dem zweiten entscheidenden Begriff. Er legte seinen Studenten das Gehäuse einer Languste auf den Tisch und fragte, woran sie ohne jedes Wissen von diesem Objekt würden erkennen können, daß es sich um ein einstiges Lebewesen handle. Er erwartete von ihnen ausschließlich ästhetisch begründete Reaktionen, das heißt solche von »recognition and empathy«, des Erkennens und der Empathie. Langsam tasteten die verblüfften jungen Leute sich an dieses Erkennen heran. Schließlich wurde ihnen bewußt, daß die beiden Scheren der Languste und ebenso auch noch ihre Beine in Beziehung zueinander stehen. Der Schlüsselbegriff heißt Kontext. Hier sogar in der übergreifenden Figur eines »context of contexts«; denn nicht nur bilden die Teile, wir können jetzt sagen Glieder, der Scheren oder der Beine jeweils »ein Muster, das verbindet« – »the pattern which connects« –, sondern dieses Muster wiederholt sich so, daß auch Scheren und Beine miteinander verbunden sind.

Eine reine Formenlehre fordert uns auf, Objekte nach physikalisch beschreibbaren Gesetzen und Typen zu betrachten und zu interpretieren. Morphologie wird die Lehre von lebenden Formen genannt. Das Prinzip des Kontexts, des Kontexts von Kontexten, also das Muster, das verbindet, stellt Bateson auf der Suche nach Kriterien des Lebendigen dar. Es scheint mir aber, ohne daß ich dem etwa als Kristallograph nachgehen könnte, Zugänge überdies zu den Reichen der Natur anzubieten, die wir, sicher ohnehin höchst problematisch, die »tote« zu nennen gewohnt sind.

Jedenfalls sprechen die toten Zeugen von vergangenem Leben. Wir sehen das, indem wir die erhaltenen Strukturen und Gestalten als die Materialisierung der Bewegungen, eben der Wachstumsbewegungen erleben, die zu ihnen geführt haben, und als die Organbewegungen, in deren Funktionen sie existiert haben. In der Lebensgeschichte jedes zoologischen Organismus

haben sich dessen Organe aus der Intensität eines Geschehens, eines Stoffwechsels gebildet, und zwar in der Folge eines Stoffwechselgefälles. Blechschmidt sagt: »Differenzierung vollzieht sich stets in Stoffwechselfeldern mit räumlich geordneten submikroskopischen Teilchenbewegungen. Sie sind, bis ins Unsichtbare geordnet, Komponenten der Gestaltungsbewegungen ...«[2] Diese antworten auf die bereits entstandenen Bewegungsflüsse einerseits und auf deren Bedingungen, das heißt, deren Lage zu schon ausgebildetem Gewebe usw. andererseits. Der Organismus bildet sich – wohlverstanden artspezifisch – aus, indem das Wachstum seiner Teile, die vielleicht noch nicht Organe genannt werden können, aufeinander reagiert. Das nennt die Kybernetik Rückkoppelung; die anthropologische Medizin zieht es vor, von Rückbeziehungen zu sprechen, wie sie auch den Begriff von »lebenden Systemen« als unangemessen mechanisch ablehnt.[3] Die Frage für uns, angesichts der Aufnahmen von versteinerten Organismen, oder deren Abdruck, ist: Kann man Rückbezüglichkeit sehen? Wer sich geübt hat darin, in Kontexten von Kontexten zu denken und deren Niederschlag in den erstarrten Formen wiederzuerkennen – so wie es die Studenten mit Gregory Bateson gelernt haben –, wird genau dies wahrnehmen.

Was uns in den anschaulichen, vermeßbaren, erfahrbaren Zeugnissen entgegentritt, sind materialisierte Erinnerungen der einstigen Wesen. Nicht allein an diese Vorgänge in inneren Rückbezüglichkeiten. Diese Organismen haben ja ebenso auf ihre äußere Umgebung und deren Veränderungen geantwortet. Wie Valéry sagt, ist die Gestalt der Qualle, in Wirklichkeit ihre Bewegungsgestalt, ihre Antwort auf das Wasser, in dem sie eben nicht nur lebt. In diesem Wasser ist diese Species durch unzählbare Reaktionen so geworden, wie wir sie heute beobachten können. Gleichzeitig haben sich viele andere Organismen mit diesem einen Typus zusammen entwickelt, in wechselseitigen Reaktionen. Diese Art von Geschichte in der Natur nennt Bateson co-evolution.[4] Doch wäre es grundverkehrt, wenn der Eindruck entstünde, als gäbe es da immer den inneren Faktor Rückbezüglichkeit einerseits und andererseits den äußeren Faktor Co-Evolution. Beide sind zwar unterscheidbare Seiten der einen Geschichte; die Geschichte ist aber vor allem die der Vermittlungen der einen mit der anderen. Sicher ist die Abhängigkeit vom Meer, in der die Species der Qualle sich bis hierher ausgebildet hat, stärker und sichtbarer als die Einflüsse der Species Qualle durch ihre vielen Generationen von Individuen auf ihre Umgebung. Deshalb hat sich Verhaltensforschung lange auf das Phänomen konzentriert, das sie Anpassung nennt. Das ist aber unzulässig einseitig gedacht. Ökologische Betrachtungsweisen sind inzwischen immer entschiedener gezwungen, auch auf der Ebene von ganzen Umwelten in vielstufigen Kontexten zu denken und zu forschen.

Nicht als isolierter Faktor, sondern als Glied solcher Kontexte. Das fordert aber, zu betonen, was Humberto Maturana die »Autopoiese« nennt. Damit betont er eben die Seite der inneren Vorgänge. Anpassung oder, richtiger gesagt, Reaktion, Antwort auf die äußeren Bedingungen und deren Veränderungen können Organismen nur leisten, weil sie in der Geschichte ihrer inneren rückbezüglichen Gestaltungen bestimmte Organe mit deren Funktionsweisen und -bedingungen ausgebildet haben und unbestimmte, aber nicht unbe-

grenzte Funktionsmöglichkeiten in diesem Bedingungsgefüge angelegt sind. In seinem Begriff Autopoiese faßt Maturana alles zusammen, was die spezifischen Reaktionen eines bestimmten Organismus auf äußere Einflüsse, Veränderungen oder Zwänge ausmacht. Wer nicht reagiert im Zusammenspiel der Co-Evolution, ist schon tot oder stirbt daraufhin. Schließlich ist ja schon jeder übliche Stoffwechselvorgang eine solche Reaktion – oder Folge von Reaktionen. Wie die einzelnen Beteiligten reagieren, ist eine Funktion der Anlagen ihrer Species und deren Ausprägungen in dem jeweiligen Individuum. Die Selbstgestaltung, Autopoiese, ist gerade nicht ein autistischer Vorgang, wie modische Interpretationen der »Gene« genannten Funktionen gelegentlich suggerieren. In ihr drücken sich ebenso die Geschichten der Mitspieler in der Co-Evolution und in der gegenwärtigen Mitwelt aus.

Wenn wir die Aufnahmen von den Versteinerungen anschauen, sieht uns all dieses vergangene Leben an. Und sicher beschleicht uns ein eigenartiges Gefühl angesichts dieser toten Formen, die wir erst durch unsere »Anerkennung und Empathie« zu den Zeugen vergangenen Lebens machen, die sie zugleich sind.

Wie uns diese Bilder treffen, ist, so gesehen, eine gewisse Fortsetzung oder auch ein neuer Ausdruck von Co-Evolution. Bateson fragt: »Liegt die Ursache dafür, daß wir eine Chrysantheme bewundern, darin, daß sie in ihrer Form, ihrem Wachstum, ihrer Färbung, ihrem Tod die Symptome der Lebendigkeit zeigt? Was wir an ihr schätzen, ist, soweit, ihre Ähnlichkeit mit uns selbst.«[5]

Daran möchte ich das Plädoyer des großen Biologen und Lebensforschers Adolf Portmann anschließen: »Die ästhetische Funktion soll geübt werden, und zwar in ihrer aufnehmenden und nachschaffenden (rekreativen) Seite wie in der produktiven Seite. Sie ist in allen gegenwärtig, in allen zur Entfaltung des Humanen notwendig.« Portmann forderte die Verbindungen theoretischer Lebensforschung mit den praktischen Erlebensweisen, um dies Ästhetik zu nennen. Er entschied sich für eine Ästhetik, die ihre Kategorien in den Ereignissen des Lebens selbst sucht.[6]

Natur und Schönheit

Der Begriff Schönheit hat in der europäischen Geschichte so grundsätzliche Wandlungen durchgemacht, daß es notwendig wird, uns, wenn nicht auf eine neue Bestimmung zu einigen, so doch der Unterschiede ums Ganze bewußt zu werden. Gerade im Zusammenhang mit Natur ist doch in der griechischen Antike Schönheit von der Weltdeutung nicht zu trennen, die von »Kosmos« sprach, um deren Ordnung zu beschwören. Kosmologie ist eine Lehre vom, mit Bateson zu sprechen, Kontext der Kontexte der Kontexte. Während die Vokabel mit Schmuck übersetzt wird, beschwor der griechische Begriff auf mythische Weise das Zusammenspiel der Evolution, um ein angemessenes Verhalten der menschlichen Gemeinschaften darin auszuloten. Umgekehrt wurde damit auch ein menschlicher, geschichtlicher Beitrag zum Weltengang eingesetzt, um diesem eine gewisse Sicherheit, in ihm aufgehoben zu bleiben, abzugewinnen. Das ist das aufklärerische Moment von Mythos.

Kosmische Ordnung kann nur als ein Zusammenspiel von Bewegungen verstanden werden, die in be-

stimmten und wiederkehrenden Beziehungen zueinander sich entwickeln. Noch Kepler spricht von den »revolutionibus« der Himmelskörper und sucht nach dem sie tragenden Bezugsprinzip: »mysterium cosmographicum«. Die griechischen Skulpturen der archaischen Periode erscheinen dem neuzeitlichen Betrachter im allgemeinen als statisch. Sie werden gesehen als ungeschlachtere Vorstufen zu den brillant individualisierten und in Bewegungen dargestellten Figuren der attischen Klassik. An dem Schnitt, der unter einer solchen Interpretation verborgen bleibt, kann aber gut eine veränderte Auffassung von Schönheit verdeutlicht werden. In den archaischen Skulpturen ist die Bewegtheit eine innere. Deren Teilhabe an umfangender und tragender Bewegtheit, einer kosmischen, ist genau das, was ihnen die Wirkung des Ruhens erlaubt. Das wird aufgebrochen mit der Einführung des Kontraposts zu Beginn des fünften Jahrhunderts: Spielbein, Standbein und alle Drehungen und Streckungen des Leibes, der nun sozusagen bewegt dasteht. Die innere Bewegtheit, die noch in den statuarischen Kuroi erinnert wird, löst sich auf in äußere Bewegungen. Existentielle Gegenwart von Bewegtheit löst sich auf in äußere Darstellung von bestimmten Bewegungen. Deren künstlerisches Arrangement erschafft eine köstliche, raffinierte Harmonie, die aber von den nun allzu erdhaft, triebhaft erlebten Energien sich abstößt. Nietzsche hat das Apollinische entschieden genug charakterisiert.

Die Rezeptionsgeschichte seit der Renaissance hat dann eine Lehre von klassischen Proportionen daran angeschlossen, in der Proportionen immer weniger von den besonderen Beziehungsgefügen ihrer Wirkungen her begriffen werden und immer mehr als idealisierende Darstellungsprinzipien. Deren Mathematisierung durch die Dürersche Proportionenlehre ist einer der weiteren Meilensteine in dieser Richtung. Das Verfahren der Projektion ist dabei seine wichtigste Methode und zeigt deutlich, wohin die Reise geht. Dieser Exkurs scheint mir nützlich, um den Hintergrund zu vergegenwärtigen, vor dem Ästhetik heute ihren Weg sucht, wie Portmann ihn beschreibt und Bateson ihn beschreitet.

Schönheitsbegriff und Wahrnehmungspraxis sind in der europäischen modernen Welt nicht nur in einen Rechtfertigungszwang gegenüber einer kausal argumentierenden und durch Messung verifizierenden Rationalität geraten, der gegenüber sie gewissermaßen Sondererlaubnisse erhalten. Vielmehr haben beide auch eine innere Anpassung erfahren, indem sie immer stärker und vorherrschender visuell definiert werden. Dem ist auch der Begriff Bild verfallen. Nicht alles Visuelle ist ein Bild; eher im Gegenteil. Immer mehr verdrängen Abbildungen das Bild, dem eine eigene Seinsqualität zukommt, für das eine Künstlerin, ein Künstler Zeugnis leisten. Im Gegensatz zu Reklamewänden und Videoclips, die uns fixieren, sind Bilder nicht nur da, um gesehen zu werden. Sie wahrzunehmen, bedeutet – wie ich gern auch mit Gottfried Böhm sage – auch, uns angesehen zu wissen. Das muß man sich wohl entschieden genug klar machen, um sich noch einmal einer ganz anderen Auffassung zuwenden zu können, die sich zugleich auch völlig frei macht von der kantischen Begründung von Urteilen eines Publikums über Werke der Kunst, also von der Seite der Rezeption her und ihren Mechanismen der Intelligenz und der sozialen Geltung.

Gehen wir zurück zu Goethe: Schönheit in der Natur ist »Notwendigkeit mit Freiheit«. Offensichtlich entspricht diese Polarität derjenigen, die wir mit Kontinuität auf der einen Seite und Zufall oder Veränderung auf der anderen kennengelernt haben. Von der Notwendigkeit spricht der Naturforscher Goethe vorsichtig in der Form von Gesetzmäßigkeiten. In seiner phänomenologischen Erkenntnistheorie entwickelt er diese Vorstellung als die allgemeinen Aussagen, die sich aufgrund zunächst gelegentlicher Wahrnehmungen, dann aber aus systematischer Beobachtungen formulieren lassen. In der Morphologie der Pflanzen hält er entsprechend fest, wie Steigerung von Wirkkräften und ihren Manifestationen durch Pressung, Verengung bewirkt wird. So sieht er die extensivere Gestalt von Blättern nach der Engführung unter dem Knospenansatz sich zu der intensiveren Bildung von Blütenblättern und Geschlechtsorganen herausbilden. Für seine Beobachtungen von spiraligen Bildungen, zum Beispiel bei Kletterpflanzen, aber auch im inneren Aufbau der Löwenzahnstiele, spricht er von einer »Spiraltendenz in der Natur«. Er hat sie dann auch auf diesem Stadium der Wahrnehmungen liegen lassen. Von Gesetzen im Sinne Newtons spricht Goethe ganz bewußt nicht, weil er sich, darin der strengere Wissenschaftler, nachdrücklich bewußt ist, daß derartige Behauptungen objektiver, also vom menschlichen Vermögen unabhängig geltender »Wahrheiten« allen Begrenztheiten widersprechen, die Kant mit seiner »kopernikanischen Wende« der Erkenntnislehre und heute noch einmal Heinz von Foerster und seine Nachfolger als Konstruktivisten zur Grundvoraussetzung aller Aussagen machen. Am konkretesten kann ich mir solche Notwendigkeit in der Natur vorstellen, wenn ich an die Bedingungen denke, die in einer co-evolutiven Geschichte entstanden sind. Bedingungen für Kontinuität einerseits, Bedingungen aber auch für Kommunikation irgendeiner Stufe. Stufe, das ist ein Begriff, den man am besten wieder mit Bateson erläutert. Alle Vorgänge irgendeines Austauschs werden ausgelöst dadurch, daß ein Unterschied ins Spiel kommt *und* dadurch, daß auf irgendeiner Seite dieser Unterschied eine Reaktion bewirkt. Unterschiede können dann selbstverständlich ganz verschieden differenziert in sich selbst sein. In die Muschel dringt ein Sandkorn ein. Das Wasser erwärmt sich. Ein Tier dringt ein. Die Muschel wird weggeschwemmt. Ablagerungen dichten sie gegen das Wasser ab. Schwere Schichten üben Druck auf sie aus. Aber gerade auch innere Unterschiede sind von größter Bedeutung. Bei einer gewissen Ausdehnung eines Organismus verändert sich das Stoffwechselgefälle, ebenso wenn sich innere Organe gebildet oder umgebildet haben. Die pulsierenden Spannungen, etwa an den Oberflächen einer Zelle und zu ihrem Kern, verändern sich, sowohl als Differenzierung wie auch aufgrund von Differenzierung. Ein elementares Modell ist das Geschehen, in dem sich die Teilung einer Zelle vorbereitet und in dem zugleich die neuen, dann zwei Zellen umspannenden Energieflüsse ebenso in Vorbereitung sind.

Der Gegenbegriff zu Notwendigkeit ist Freiheit, und zwar eine notwendige Freiheit. Totale Determination in einem Organismus und seinem Verhalten dem Äußeren gegenüber würde zum raschen Abbruch jeden Austauschs führen und damit tödlich sein. Spielräume, Freiheitsgrade sind unbedingt erforderlich, wenn die Existenz eines Wesens – und seiner Gemeinschaften – sich fortsetzen soll. Existenz ist immer *co-existence*, wie Maturana auch sagt. In jeder Co-Existenz verändert sich das Gegenüber. Das erfordert veränderte Reaktionen. Auch dieser Zusammenhang ist auf allen Stufen der Differenziertheit und Komplexität der gleiche. Schon in der nicht organisch organisierten Natur. Das eindrucksvollste Modell ist sicher das Wasser, in dem so vieles sich lösen kann, das verbinden und umformen kann wie kein anderes Element. In seinen Molekülen herrscht eine stete Fähigkeit, seine *cluster* immer wieder umzubilden, weil immer Bindungsfähigkeiten offen bleiben. Ein Element der Freiheit. Der Mensch ist wohl der am höchsten differenzierte Organismus und damit von einmal erreichten Komplexitäten seiner Organe besonders abhängig. Aber auch in unserer Physiologie gilt der Grundsatz aller Existenz und Co-Existenz: Nur indem innerlich Veränderungen, wie kaum oder gar nicht wahrnehmbar auch immer, zum gewohnten Gang gehören, bleiben die Organe fähig, äußere Veränderungen aufzunehmen und zu integrieren. Die Immunologen weisen als Beispiel gern auf winzige Sprünge des Herzrhythmus hin, die den gesunden Menschen charakterisieren, weil er nur so von außen provozierte Frequenzsprünge in seine, autopoietischen, Funktionen umsetzen kann.

Selbstverständlich gilt dieses Prinzip gerade auch da, wo sich wesentliche Veränderungen ergeben, bis hin zu Mutationen der Art, wenn sie auf der Ebene der Einzelwesen häufig und zahlreich genug, gewissermaßen, erprobt worden sind. So entstehen neue Arten und Unterarten, in Reaktion auf andere Mitwelten oder Veränderung der ursprünglichen.

Goethe nennt nun eben dieses Spannungsfeld und seine verbindenden Beziehungen Schönheit. Schönheit ist dann viel weniger Eigenschaft einer Form und viel mehr Ausdruck der Qualität einer Funktion – eben eines differenzierten Zusammenspiels von Spannungen in Bewegung. Schönheit als eine Qualität unseres Wahrnehmens bezieht sich dann auf ein seinerseits komplexes Geschehen in dem Vermögen unseres Bewußtseins. Wir sind ebenso damit beschäftigt, in dem Gegenüber »Muster, die verbinden«, zu entdecken, wie wir zugleich an jedem neuen Fall uns hineingezogen fühlen in das erregende Wechselspiel der Reduktionen und der Erweiterungen dieser Muster. Durch die jeweils andere Ausformung wird unser Verständnis von einem Phänomen immer reicher. Durch die unendliche Folge der Vielfalt dieser Ausformungen hindurch wird uns ihr Gemeinsames, das Muster, immer eindrucksvoller – statt daß es uns als Abweichung von einem starren Schema stört.

Auf die Gefahr hin, mit weiteren ungewohnten Beobachtungen noch mehr zu verwirren, muß noch hingewiesen werden auf die Bedeutung von Zeit. In den Organismen, deren Abbilder wir hier betrachten können, ist Zeit vergegenständlicht. Selbstverständlich ist nicht eine Angabe von Dauer und Zeitpunkten gemeint, wie das paläontologische Glossar sie hergibt. In den Bildungen ist Zeit als die Geschichte anwesend, in der sie sich gebildet haben. Auch auf seiten der Betrachter ist Zeit im Spiel. Wiederum nicht gemessen nach Minuten und Sekunden, die wir gebraucht haben, um uns die Gegenstände oder ihre Abbildungen anzusehen, sondern die vielleicht kurze, vielleicht über viele Wiederholungen sich hinziehende Geschichte der Begegnung, die wir Wahrnehmung nennen. Wir sehen hin. Wir wandern durch die Gegenden des Gegenstands. Wir stellen Beziehungen zwischen ihnen her oder fest. Die Eindrücke tun etwas in uns. Fragen

ergeben sich. Empfindungen und Gefühle tauchen auf. Wir übergehen sie. Wir kommen auf sie zurück.

In diesem Wechselspiel ist solche Wahrnehmung durchaus dem Hin und Her zu vergleichen, als das Kant die Arbeit seiner Mechanismen des Verstandes oder des Urteils darstellt. Wir nennen es allerdings besser Begegnung, weil unser Muster des Verbindens eben mehr mit der Biographie eines Phänomens und seiner Wahrnehmung als mit einem Mechanismus letztlich ungeschichtlicher Herkunft zu tun hat.

Sind die Versteinerungen schön?

Auf Anhieb werden wir das alle bejahen, dankbar dafür, daß diese Anschauungen uns vermittelt worden sind. Manche werden dann unterscheiden und einige Anblicke unheimlich nennen. Andere werden sich erinnert fühlen an Malereien, die zum Surrealismus gezählt werden. Ich vermag die Frage nicht ernstlich zu beantworten. Und dafür gibt es verschiedene Gründe.

Der inzwischen offensichtlichste liegt darin, daß der Begriff Schönheit höchst verschieden bestimmt wird. So verschieden, daß eine derart exemplarisch ästhetische Kultur wie die japanische einen solchen Begriff früher nicht besaß und eine Entsprechung erst zum Zweck der Übersetzung westlicher Texte entwickelt hat. Auf die merkwürdige Frage, ob die Venus von Lespugue – unserer Venus von Willendorf nicht unähnlich – ein afrikanisches Schönheitsideal darstelle, hat Leopold Sedar Senghor geantwortet, ihre Formen seien gewiß nicht, was afrikanische Männer sich wünschen, sie bedeuten vielmehr, daß die Fruchtbarkeit der Natur auch im Menschlichen anwesend und wirksam ist: »Und was bedeutet die Venus von Milo außer sich selber?« Sollte ich also fragen, was die einen und die anderen der hier uns gezeigten Versteinerungen bedeuten?

Als nächstes kommt jetzt der Zeitpunkt, zu dem wir dem Problem nicht länger ausweichen können, daß wir über den Anblick von Versteinerungen nicht angesichts ihrer selbst, sondern angesichts photographischer Wiedergaben sprechen. Sind die Photographien schön? Bis hierher habe ich so getan, als vermittelten sie uns, was wir auch selber sehen würden, lägen die Versteinerungen vor uns oder gar in unserer Hand. Wir vertrauen darauf, daß ein international wirkender Geologe und Photograph richtig gewählt hat, um uns die besten Eindrücke zu vermitteln. Und was sind die besten? Mindestens zwei von einander ganz unabhängige Kriterien sind bei seiner Wahl und Wiedergabe ausschlaggebend. Zweifellos sind sie in erster Linie davon bestimmt, was ihn beeindruckt hat. Dann aber hat er sich auch überlegt, welche Wirkungen die Photographien haben werden und haben sollen. Dem entsprechen Ausschnitte und Vergrößerungen vor allen weiteren Möglichkeiten. Die Aufnahmen sind nicht Werkzeug einer wissenschaftlichen Erforschung, wie es die Röntgenbilder der Nautilusschnecke in Ghikas berühmten Untersuchungen zum »Goldenen Schnitt in der Natur« sind; wie es andererseits die Zeichnungen von Pflanzen sind, in denen Alexander von Humboldt oder Goethe sich mit dem Zeichenstift in der Hand Gewißheit vom Aufbau eines Organismus zu verschaffen suchten. Eher wird Karl Blossfeldt ein Wegbereiter sein mit seinen Aufnahmen von Kastanienzweigen und Blüten, lebenden Pflanzen also, die in den 1930er Jahren entstanden und seither in Kunstgalerien zu finden sind. Mir scheint, sie sagen uns, daß sie von der staunenswerten Schönheit vegetativer Formen zeugen wollen. Will uns Ibbeken, ihm ähnlich, eine Idee von Schönheit nahelegen? Die vollkommene Perfektion seiner Technik spricht dafür – in dem Wunsch, auf Schönheit einer eigenen Art aufmerksam zu machen. Sie spricht dagegen, insofern sie einfach den Phänomenen dient, denen wir ohnedies nicht begegnet wären. Und dafür, daß es nicht nur Abbildungen, sondern selber Bilder geworden sind, spricht die entschiedene Vermutung, daß wir ihnen so schon gar nicht begegnet wären.

Ich überlasse es jedoch den Kennern der Photographiegeschichte, dies deutlicher herauszuarbeiten, und kehre zur Ästhetik der Versteinerungen zurück mit der anfänglichen Frage: Wie sehen sie uns an?

Anders als bei Kristallen oder auch bei Landschaften und Bauwerken sind wir unwillkürlich, das heißt ohne Wissen von paläontologischer Zoologie und Botanik, in die Erscheinungen existenziell hineingezogen. Längst bevor wir uns sagen können, daß dies Formen des Lebens sind, letztlich wie wir selbst, und bevor wir diese erschreckende Beziehung abwehren können im Gedanken an die Jahrmillionen, die zwischen jenen Lebensformen und der Geburt der Menschheit liegen, hat uns etwas getroffen. Geradezu physiologisch wissen wir um eine tiefe Verwandtschaft. Alle bewußtere Beschäftigung mit den Erscheinungsbildern geschieht in einem inneren Monolog zugleich, der eigentlich Dialog ist zwischen dem nicht wegzudenkenden Wissen, den bewußteren Beobachtungen und Überlegungen und eben den unwillkürlichen Eindrücken. Wir weisen die Verwandtschaft immer wieder ab, weil wir uns sagen und sagen können, daß keine dieser Formen dem menschlichen Organismus irgendwie entsprechen kann. Zugleich bleibt das elementare Empfinden, daß unser Organismus, unsere Organe sich nicht wesentlich anderen Gestaltungsbewegungen verdanken.

Vielleicht kann ästhetisches Erfahren und Gestalten wesentlich überhaupt aus dem Grundbewegungsmuster der Peristaltik entfaltet werden; jedenfalls ist dies wohl das geeignetste Modell. Zusammenziehung und Ausdehnung. Pressung und Weitung. Kompression und Expansion. Im Atmen erleben wir deren Wechsel als einen elementaren Rhythmus unseres Lebens. Das Pulsen des Blutes und der Adern, des Herzens selber. In ihnen, wie in tausenden weiterer, nur weniger spürbarer, Kreisläufe spielt sich ab, was wir unser Leben nennen. Nicht zufällig wird nicht nur bei den alten Griechen die Seele insbesondere auf dem Zwerchfell und dem Herzen gewußt. Wir brauchen nicht im einzelnen die Strukturen, die uns da aus paläontologischen Zeiten entgegentreten, auf die Wirksamkeit des peristaltischen Prinzips zu prüfen. Aus Millionen Jahren eigener Teilhabe an der Evolution schwingen diese Bewegungsmuster in uns. Unendlich schwer zu sagen, wie weit und in welcher Weise diese elementaren Beziehungen uns bestimmen, wenn uns eine Gestalt besonders unheimlich ist, eine andere als unverfänglich schön erscheint. Ein Ammonshorn oder eine Muschel sind vielleicht zu starr und zu anders ausgebildet, als daß wir uns unmittelbar in ihnen leben sehen. In anderen sind uns Asseln und Gewürm gegenwärtig und die heimliche Furcht, so aufwachen zu müssen, wie Kafkas Mann als Käfer – oder wie Ionescu die Metamorphose zu Nashörnern auf die Bühne bringt. Meta-morphose. Abendländisches Urmodell die Bauern bei Ovid, die solange im sumpfigen Wasser treten, bis sie selber zu Fröschen geworden sind – »subaqua, subaqua ...«

Was uns so intensiv bewegt, ist die unbewußte, auch im Sinne von Freud unbewußte, nämlich verdrängte Vertrautheit mit dem Fremden. Um so heftiger wollen wir es als vollkommen anderes einordnen. Anders als Paul Valéry hat Theodor W. Adorno eine mimetische Begegnung mit den Quallen mit der Empfindung von Abscheu und Angst verbunden und sie genau damit begründet, daß wir den Drang zu einer gewissen Identifikation abwehren müssen gegenüber einem Wesen, das ohne jede feste Gestalt für uns die Auflösung bedeuten müßte. Und ist diese Verbindung wirklich so absurd? Wir wissen doch schließlich nur zu gut, daß die beiden Organe, die den Kopf und den Bauch ausmachen, auch bei uns Menschen in peristaltischen Wachstums- und Gestaltungsbewegungen entstanden sind und unser Leben bestimmen: Darm und Gehirn sind die Ausbildungen, die Ein- und Ausstülpungen, des einen embryonalen Hauptorgans, das die Embryologie ein »Neuralrohr« nennt. Und doch fragen unsere Blicke auf diese Gestalten, in sie hinein, welchen Gesetzmäßigkeiten sie zu verdanken sind und welche Freiheiten in dem einzelnen Wesen, ja, in den Unterschieden und Verschiebungen unverkennbarer Muster zugleich im Spiel gewesen sind. Eine Frage, die diese uralten Zeugnisse der Naturgeschichte unmittelbar in die Gegenwart holt: Wären dies die lebenden Organe dieses Wesens, wie würden sie sich bewegen, welche neuen Gestalten könnten sie hervorbringen?

Schönheit hängt mit all dem auch deshalb zusammen, weil unser Wahrnehmen und seine Organe aus diesen Naturgeschichten hervorgegangen sind. Angesichts aber gerade dieser toten Formen, der Versteinerungen und ihres für menschliche Geschichte unvordenklichen Alters liegt der Begriff des Erhabenen viel näher: Vertraut zu sein mit einem unfaßlich Fremden. Welche Dauer über den Tod hinaus gegenüber Menschen, deren Knochen nach dreißig Jahren nicht mehr friedhofsrelevant sind. Welch Leben bedeutende Formen in vollkommenster Starre!

Anmerkungen

[1] Rudolf zur Lippe, *Sinnenbewußtsein. Grundlegung einer anthropologischen Ästhetik*, Hohengehren 2000.
[2] Ebd., S. 190 f.
[3] Ludwig von Berthalanfi und Alfred Prinz Auersperg, »Grünwalder Gespräche«, ebd.
[4] Gregory Bateson, *Mind and Nature. A Necessary Unity*, New York 1979.
[5] Ebd., S. 162.
[6] Adolf Portmann, »Biologisches zur ästhetischen Erziehung«, *Leben und Umwelt* (Aarau), 5. Jg. (1949), S. 97 bis 113.

Rudolf zur Lippe
Forms of petrified life

Various natural processes in time immemorial have left behind very clear proof of one-time living organisms and plants. Objects petrified under the pressure of new oceans. Impressions, as perfect as the Greek sculpture casting collections in the Humboldts' house, which have filled out what departed living organisms left behind as hollow forms.

Hillert Ibbeken has photographed the items from a palaeontological collection which spoke to him most vividly, not those that were significant to him as pieces of evidence in a geological research matter. These pieces are presented in their entirety or in cross-sections which reveal the interior, or focusing on details chosen by the eye of the photographer, who aims to make us direct observers. We imagine all the objects drowsing together in a scientifically-induced hibernation on endless overfilled shelves. Ibbeken has released them, just as, a few years, decades or centuries ago, methodical geologists or sharp-eyed travellers released them from the depths of the rock, which had become the sites of their second life. In the sunken sediment of the seabed, whose layers may have been shifted by volcanic faults and pushed up to the surface. Enclosed in more recent stone formations, which have been broken open under the gigantic force of movements in the depth of the magma, under the force of quarrying or by the well-directed blows of a hammer from a geologist's toolkit.

How do these depictions glance at us? In the enchantment of forms and colours and the enthusiasm for our own questions, we notice least what communicates itself to us most clearly. In order to investigate their histories of early life, we have stolen from them the locations of these histories. We see them before us, each with a label indicating not the biotope which we should think of as their home, but the »place where they were found«. It is true that the original context is significant in research, but it became in the first instance subordinate to the modern approach. Just as ever since Carl von Linné the life of plants has been reduced to two affinities and stamped with a binary name. Ever since, botanists have even assumed the right to give their own surnames to species first scientifically described by them.

This occurs to me because I asked how these objects glance at me. Obviously, I must first ask what the nature of my seeing is. What has the history of the scientific approach done to my perceptions, since it imposed the status of objects on these petrifactions? Hillert Ibbeken's enthusiasm for the beauty of their forms and colours pushes this question into the background. Like him, we are swayed by the brilliance of his depictions. However, does this mean that this question has no role? How can a petrification, once it has been made into an object, still look at us? Beguiled and perhaps misled by the photographic eye and its perceptions of beauty, how do we see?

Form history and thinking in forms

I have referred to the history of our distancing from natural-historical phenomena in order to make comprehensible to myself why what is probably our prevalent

reaction to them, and to their beautiful photographic reproductions in particular, is influenced so strongly by form-based thinking. So strongly that I hear you cry: how else would one react? Perhaps simply with astonishment at something so remote, perhaps even shock at the overwhelming depths of time which these exhibits bear witness to. My own view is that, when viewing them, it is appropriate to initially refrain from attempting to designate them, to classify, to judge, to compare.

This, admittedly, is precisely the arsenal of attitudes and methods with which our art historians approach their objects. Certain flowing meanders raise the possibility of a Cretan origin. Certain expanded bodies assign a picture to the Mannerism epoch, perhaps close to El Greco. Certain colours immediately suggest Picasso's blue period.

However, it is by no means only in the critical observation of art that formal thinking and formal history hold sway. In the spirit of the Occidental Platonic ideas doctrine tradition and the division it makes between form and material, the form comes first. The material then allows it to be rendered tangibly. What this neglects is any significant attention to the form-assuming or formation processes. The results of this approach offer good purchase for a style of perception that has been trained to it. However, phenomena are not results, but continue to happen as long as they can be perceived. The phenomenon lives in the present moment and in the encounter. It also reveals more general normative correlations of effects. These initially appear in comparative and investigative observation as abstract concepts and natural law hypotheses.

In order to characterize this unaccustomed method of observation more clearly, I would like to describe a comparable situation from an entirely different area of culture. We observed a series of dance performances from Asia and Europe and discussed them with the artists. A fuller understanding exposed an interesting polarity as regards the most important theme. One side of this is form.

A form, the concept of which gives rise to a certain choreographical development. Changes to this form in the situations which arise in the course of this development. The other side I can best describe as energy in a broad, vital sense. The European tradition, which definitely includes Modern Dance and some contemporary choreographies, aims to create forms, whether taken from a historical canon or created spontaneously. Asiatic dancers, especially the different schools of Japanese *buto,* strive towards the art of freeing themselves from their own intentions and enabling themselves to become aware of emerging energies, letting them take effect and allowing their own bodies to express their effect.

If they were to pause for a moment, as in a photographic image, a form would certainly be shown. Dance performances also consistently show, as far as is possible, the same forms in the same phases. However, at the centre of this is a discipline that does not use physical energy to express spiritual form – as a great German dancer once said. Rather, the Asiatic style – by which China, India and other cultures are also meant – involves an ascetic exercise of freeing one's own existence in order to allow certain impulses to manifest. Whether fully aware or in a state transcending awareness, these dancers, to use Paul Valé-

ry's image, become jellyfish. Their movements are an expression of the movement of the water around them, and their form is an expression of these movements. How the energies that the dancers express are to be understood should be explored in detail elsewhere.

As well as these observations from the art world, I could also mention an everyday commonplace. Many people greatly enjoy discovering faces in clouds, in logs or in stones. It is natural for a fascination with the picture-puzzle principle to seize us in some situations. However, when this sport goes so far as to compulsively cast a spell over the unknown by projecting familiar forms on to it, then perception fails in a fundamental way. The urge to project the familiar onto the unknown causes the spirit to become as rigid as the supposedly known form. This puts us at a safe distance from any fear at the incomprehensibility of cosmic vistas and the depths of geological ages. It harms our ability to marvel.

Morphology

Morphology is a science involved with forms' origin and significance; with living organisms as seen by zoology and botany. It would be more apt to describe it as the study of forms, while the Lexicon states that it is concerned with »the structures of living organisms«. Goethe, one of the great pioneers of morphology, was as polemical about the term »form« as we must be towards the term »structure«. Thinking in forms, that is, the results of concluded shapings, inevitably leaves out life's significant quality: its histories and its fresh alterations. Goethe therefore uses *Bildung* (formation, formative process) as the decisive term in his thoughts and discourses on animals and plants. The question: How did this form come about? is directly connected with this term. Speculations follow on how its formation might continue or be reversed. If Heckel had looked at and interpreted his microscopic sections of the human embryo in this way, he would not have been led to the false interpretation which was later overturned by Erich Blechschmidt's dynamic embryology. Heckel considered the form of folds or tucks in the skin that form laterally on the embryo following prenatal stretching and curling to be the same as what he knew from other organisms, i. e., gills. Blechschmidt, on the other hand, believed that: »Forms are not created for functions, but in functions and through functions.«[1]

Nothing which could be described as breath takes place here. Therefore, these are not gills. He therefore found a different explanation for the skin folds. So, the question is not, what does this look like? This question may also be of interest, but in any case we must immediately add the accompanying thought: how does that look for me or for my study discipline?

The question is: What happened here? In this sense, the petrified manifestation becomes a text, which I engaged with while still reading. In a code, which speaks of a history, admittedly in the historical moment in which it was frozen.

In our reading of the structures, how can we simultaneously deduce the history of their creation from what has been created and what has survived the ages? This somewhat semantic reading would be too linguistic in the narrowest sense. It also requires an

intensive hermeneutical empathy, especially in the case of so-called dead languages. We look at forms as they are today, to see what movements have been arrested in them. To think morphologically means to think in movements. This involves not only the past history of this verifiable present, but also its future. We must try to develop the ability to imagine possible reversals and continuations of the formative process.

In this and in finding the second decisive term, Gregory Bateson is our guide, as he was for his students of the time. He placed a spiny lobster shell on the table in front of his students and asked how, without any knowledge, they would be able to recognize this object as a former living organism. He would only accept aesthetically reasoned answers, those based on »recognition and empathy«. Puzzled, the young people slowly felt their way towards this realisation. Finally, they realised that the lobster's two claws and also its legs stood in relation to each other. The key term is »context«. Here this term actually appears in the overarching figure of a »context of contexts«. Not only do the parts, in this case the limbs, the claws or legs each form »the pattern which connects«, but this pattern is repeated so that there is also a connection between the claws and legs.

A pure science of forms demands that we consider and interpret objects according to physically describable laws and types. Morphology is called the study of living forms. The principle of context and the context of contexts, the pattern which connects, was presented by Bateson in the search for criteria to define a living thing. However, it also seems to offer a bridge to the areas of nature which we are accustomed, problematic as it is, to describe as »dead« although I could not, for instance, pursue this through crystallography.

In any case, these dead witnesses speak of past life. We see this when we experience the preserved structures and shapes as materialisations of movements, including growth movements, which led to them, and as the organ movements in whose functions they existed. During the life history of every zoological organism, its organs have been formed by an event, a metabolism, as a consequence of a metabolic gradient. Blechschmidt says: »Differentiation always takes place in metabolic areas with spatially organised sub-microscopic particle movements. They are components of formative movements, with an organization too small for the eye to see ...«[2] These respond to the currents of movement already created on the one hand and their conditions – that is, their relationship to the tissue already created etc. – on the other hand. The organism develops itself – depending on its species – as the growth of its parts, which perhaps cannot yet be called organs, react to one another. Cybernetics describes this as feedback. Anthropological medicine prefers to speak of reciprocities, also rejecting the expression »living systems« as inappropriately mechanical.[3] The question for us to consider, with regard to the photographs of petrified organisms, or their copy, is: Can one see reflexivity? This is precisely what anyone who has become accustomed to thinking in contexts of contexts and recognizing their expression in the frozen forms, as Gregory Bateson's students learned to, will perceive.

What we encounter in these comprehensible, measurable, tangible pieces of evidence are materialised memories of the one-time organism. And not only of

these internal reflexive processes. After all, these organisms also responded to their external environment and its changes. As Valéry says, the shape of the jellyfish is actually its formative motion, its response to the water in which it does more than simply live. In this water, this species has become how we see it today through countless reactions. At the same time, many other organisms have developed in parallel with this single type, in reciprocal reactions. This kind of history in nature was called »co-evolution«[4] by Bateson. However, the impression that there is always on the one hand the internal factor of reciprocity and on the other hand the external factor of co-evolution would be fundamentally incorrect. It is true that both are distinguishable sides of a single history, but this history is above all one of interference with each other. Certainly the dependence on the sea with which the jellyfish species has developed so far is stronger and more visible than the influence of the jellyfish species on its environment through many generations of individuals. This is why behavioural research has long concentrated on the phenomenon it refers to as adaptation. This is, however, unreliably one-sided thinking. Ecological viewpoints are now ever more emphatically forced to think and research in many-tiered contexts, even on the level of whole environments.

Not as an isolated factor but as a member of such a context. This, however, demands that they emphasise what Humberto Maturana calls »autopoesy«. It is the internal processes aspect that he emphasises with this expression. Adaptation, or, better put, reaction, response to external conditions and their changes, is only possible for organisms because in the history of their internal reflexive shaping certain organs have developed with this way of functioning, under these conditions, which have uncertain, but not unlimited functional possibilities in this framework of conditions. Maturana's term »autopoesy« encompasses everything which goes to make up the specific reactions of a certain organism to external influences, changes or constraints. Those who do not react according to the interplay of co-evolution are dead already, or will subsequently die. After all, every normal metabolic process is such a reaction, or the consequence of reactions. How the individuals concerned react is a function of the species' faculties and how they are expressed in an individual. Self-shaping, autopoesy, is therefore specifically not an autistic process, as fashionable interpretations of the functions known as »genes« sometimes suggest. In this process, the histories of the other participants in co-evolution and the present state of the shared world are also expressed.

When we look at the images of the petrifactions, all this past life looks at us. A peculiar feeling inevitably comes over us in connection with these dead forms, which through our »recognition and empathy« become the witnesses to past life which at the same time they are already. Seen in this way, the way these images affect us is in some sense a continuation or perhaps a new manifestation of co-evolution. Bateson asks: »Is the reason that we admire a chrysanthemum that its form, its growth, its colouring, its death show symptoms of life? What we value in it is, to this extent, its similarity with ourselves.«[5]

To this I would like to add the great biologist and researcher of life processes Adolf Portmann's argument: »The aesthetic function should be cultivated, in

its receptive and recreative aspect as well as in its productive aspect. It is immanent in everything, and is necessary to the unfolding of what is human in everything.« Portmann demanded that theoretical life research be linked to practical forms of experience, in order that this could be called aesthetics. He resolved on an aesthetic which looks for its categories in the events of life itself.[6]

Nature and beauty

Throughout European history, the concept of beauty has gone through such fundamental changes that it is necessary, if not to actually agree on a new definition, to be aware of these differences in their entirety. However, in Greek antiquity, it is in connection with nature that beauty cannot be separated from the worldview that evoked its sense of order with the word »cosmos«. Cosmology is a doctrine of, to paraphrase Bateson, the context of contexts of contexts. While the word is translated as »ornament«, the Greek expression invoked the interplay of evolution in a mystical way, in order to divine from it an appropriate behaviour for human societies. Conversely, this introduced a human, historical contribution to the workings of the world, in order to gain a certain assurance of humanity being preserved. This is the impulse towards enlightenment in mythology.

Cosmic order can only be understood as an interplay of movements which develop in predetermined and repeating relations to each other. Kepler also refers to the »revolutionibus« of the heavenly bodies and searches for its fundamental interrelationship principle: »mysterium cosmographicum«. Greek sculptures of the archaic period generally appear static to a modern observer. They are seen as rough preliminary stages to the brilliant individualized figures of the Attic classical age, represented in movement. However, the turning point that lies hidden beneath such an interpretation serves to illustrate a changed conception of beauty. The movement in the archaic sculptures is internal. Their partaking of an encompassing and fundamental motion, a cosmic motion, is precisely what grants them the impression of stillness. This is interrupted by the introduction of the contrapposto at the beginning of the 5th century. The free leg, the standing leg and all the body's turns and stretches now stand, so to speak, in an animated way. The inner animation still remembered in the kouroi statues is dissipated by external movement. The existential presence of movement is dissipated by external representation of definite movements. Their artistic arrangement creates a delectable, refined harmony, which however distances itself from the all too earthly energies, those felt as impulses. Nietzsche characterized this Apollonian mode with sufficient clarity.

The history of reception since the Renaissance then deduced from this a science of classical proportions in which proportions were understood ever less in terms of the peculiar interrelations of their effects and ever more as idealized principles of representation. Their mathematical representation through Dürer's doctrine of proportions marks an advanced stage of this journey. In this, projection is his most significant method, and shows eloquently what the destination of this journey is. This digression seems necessary to me, in order

to visualize the background against which aesthetics today seeks its path, as described by Portmann and travelled by Bateson.

In the modern European world, the concept of beauty and the praxis of perception have not only been forced to justify themselves against a causally argued rationalism verifiable by measurement, which has certain privileges in relation to them. It is rather that both have experienced an adaptation from within, making them ever more strongly and predominantly visually defined. The concept of the »image« has also lapsed. Not everything visual is an image; quite the contrary. Increasingly, the image with an individual, intrinsic quality borne witness to by an artist is forced out by representations. In contrast to billboards and video clips, which fixate us, images are not there merely to be seen. To perceive them – to agree with Gottfried Böhm – means to know that we are being seen. One must be very clear and definite about this in order to embrace an entirely different concept, which simultaneously liberates itself from the Kantian explanation of judgements made by an audience on works of art, i. e., relating to the aspect of reception and its mechanisms of intelligence and social worth.

To return to Goethe: beauty in nature is »Notwendigkeit mit Freiheit« (necessity with freedom). This polarity self-evidently echoes the one we have become familiar with between continuity on the one hand and chance or change on the other. As a natural scientist, Goethe refers to necessity cautiously, in the form of laws. In his phenomenological perception theory, he develops this concept into the general statements, which can be formulated based on initially casual perceptions, but later on systematic observations. In plant morphology, he therefore believes in a heightening of influences and their manifestations effected through compression, constriction. For instance, he sees the more extensive shape of leaves develop into the more intensive formation of petals and sexual organs with the setting of buds. His observations of spiral formations, for instance in climbing plants, but also in the internal structure of the dandelion stalk cause him to speak of a »tendency towards spirals in nature«. He then attributed it to this stage of perceptions. Goethe deliberately does not refer to laws in the Newtonian sense. In this respect a more purist scientist, he is very much aware that such an assertion of objective »truths«, valid independent of human faculties, would contradict all the limitations that Kant with his »Copernican revolution« of the science of perception and, in the modern day, Heinz von Foerster and his Constructivist successors take as the basic precondition for all statements. I can imagine such a necessity in nature in a more concrete way if I think about the conditions that arise in a co-evolutionary history. On the one hand, conditions for continuity, but also conditions for communication on some level. »Level« is a term that, once again, is best explained with reference to Bateson. Exchange processes of any kind are initiated by a difference coming into play, *and* by this difference causing a reaction in one side of the relationship. Obviously, the differences themselves can be very different to each other. A sand grain forces its way into a shell. The water gets warmer. An animal intrudes. The shell is washed away. Deposited layers seal it off from the water. Heavy layers exert pressure on it. But internal differences are also of the greatest significance. When an organism expands to a

certain degree, or when internal organs are formed or change their form, the metabolic gradient changes. For instance, the pulsating tensions on the surface of a cell or in relation to its nucleus change. This is a differentiation as well as being due to a differentiation. An elementary model for this is the chain of events leading up to the division of a cell, in which the new currents of energy, encompassing two cells, are also in preparation.

The opposing term to necessity is freedom. To be specific, a necessary freedom. For everything about an organism and its relationship with the external world to be determined would lead to the abrupt termination of any exchange, and therefore be deadly. Area of play, degrees of freedom are absolutely essential if an organism's existence – and its communities – are to continue. Existence is always co-existence, as Maturana also stated. In any co-existence, the opposite changes. This demands a changed reaction. This correlation is the same on all levels of differentiation and complexity. Even in non-organically organized nature. The most spectacular model is surely water, in which so many things can dissolve. It can connect and re-shape like no other element. Its molecules are dominated by the constant ability to re-constitute their clusters because possibilities for bonding are always open. An element of freedom. The human being is surely the most differentiated organism, meaning that we are especially dependent on the complexities our organs have achieved. However, the basic principle of all existence and co-existence holds true even in our physiology: only while internal changes, imperceptible or barely perceptible as they are, are a part of the normal course of things do organs remain able to take up and integrate external changes. Immunologists often point out tiny breaks in the heart's rhythm, which, as health is required to translate externally produced frequency variations into one's own aotopoetic functions, characterize healthy people, as an example of this.

Of course, this principle does not cease to apply where significant changes occur, up to and including species-founding mutations, if they have, so to speak, been put to the test frequently and numerously enough at the level of individual organisms. This is how new species and subspecies arise, in reaction to new shared worlds or to changes in the original one.

It is precisely this polarity and its connective relationships that Goethe calls »beauty«. This makes beauty less a property of a form and more an expression of a function's quality – a differentiated interplay of tensions in motion. By this token, beauty as a quality of our perception is related to an event in our conscious faculties which is complex in its own right. We are equally concerned with discovering from the duality »patterns which connect«, how it is that with every new case we feel drawn into the exiting interplay of reductions and expansions in this pattern. Due to their varying forms, our understanding of a phenomenon grows ever richer. Due to the endless parade of diversity in these forms, their common factor, the pattern, becomes ever more impressive, rather than an aberration from a rigid schema which disturbs us.

At the risk of causing still more confusion through further unaccustomed observations, the significance of time should be pointed out. In the organisms whose reproductions we can see here, time is objectified. Self-evidently, this does not mean an indicator of duration

and time index, as provided by the palaeontological glossary. Time is present in these configurations; their formation's history. Time also plays a role for the observer. This also cannot be measured in the minutes and seconds it has taken us to look at these objects or their depictions, but by the history of the encounter we call perception, which may be short or involve many repetitions. We inspect. We wander through the regions of the object. We create or determine relationships between them. The impressions have an effect on us. Questions arise. Responses and emotions surface. We pass over them. We return to them.

Certainly, this interplay makes such a perception comparable with the »to and fro« with which Kant represented the workings of his mechanisms of understanding or judgement. However, it would be better to call it an encounter, as our pattern of connection has more to do with the biography of a phenomenon and its perception than with a mechanism of an ultimately ahistorical origin.

Are the petrifactions beautiful?

At first blush we would all agree with this, grateful for being given access to these views. Some of us would then make a distinction, calling some of the views unsettling. Others would be reminded of surrealist paintings. I myself cannot confidently answer the question. And there are a variety of reasons for this.

The immediately obvious one is that the concept »beauty« can be defined in very different ways. So different that such a quintessentially aesthetic culture as the Japanese one traditionally did not have such a term, and only developed a corresponding term in order to translate Western texts. Leopold Sedar Senghor answered the curious question of whether the Venus of Lespugue – not dissimilar to our Venus of Willendorf – represents an African ideal of beauty by saying that her shapes are certainly not those desirable to African men. Rather, they signify that nature's fertility is also present and active in human beings. »And what does the Venus de Milo signify other than itself?« Does this mean I should ask what one or the other of the petrifactions shown to us here means?

The next point: the time has now come when we can no longer evade the problem that we are talking about the views of petrifactions not in their own right, but in relation to photographic reproductions. Are the photographs beautiful? Up to now I have spoken as if they conveyed to us the same things that they would in the flesh, if the petrifactions were placed before us or we held them in our hands. We expect an internationally known geologist and photographer to make the right choices in conveying to us the best possible impressions. But which ones are the best? At least two entirely independent criteria are decisive in their choice and reproduction. Certainly they are primarily determined by what made an impression on him. However, he also considered what effect the photographs would have, and should have. Details and enlargements primarily represent further possibilities. These representations are not a tool for scientific research, like the x-ray pictures of the nautilus in Ghika's famous investigations of »the Golden Mean in nature«, or the drawings of plants with which Alexander von Humboldt or Goethe, pencil in hand, attempted to ascertain the construction of an

organism. A more appropriate role model would be Karl Blossfeldt with his representations of chestnut twigs and blossoms, i. e. living plants, created in the 1930s and still seen in art galleries. It seems to me that they are telling us that they wish to bear witness to the astounding unity of vegetative forms. Does Ibbeken, in a similar way, wish to suggest an idea of beauty to us? The consummate perfection of his technique implies this – the wish to draw attention to beauty of a peculiar kind. It also argues against this, in that it is subordinated to phenomena which, without it, we would not have encountered. The forceful impression that we would not have encountered them in this way before argues that they are not only depictions, but images in their own right.

However, I will leave it to experts in photographic history to examine the implications of this, and return to the aesthetics of petrifactions, with the initial question: how do they glance at us?

Unlike crystals, landscapes or constructions, we are existentially drawn into these manifestations despite ourselves, that is, without any knowledge of palaeontological zoology or botany. Long before we are able to say to ourselves that these are forms of life ultimately like ourselves, and before we can deny this shocking relationship by thinking about the millions of years which lie between these lifeforms and the birth of humanity, something has reached us. We are aware, in a specifically physiological way, of a deep kinship. All the more conscious engagement with these manifestations takes place simultaneously in an internal monologue. The real dialogue is between the inescapable knowledge, the more conscious observations and deliberations and likewise the involuntary impressions. We deny the relationship, telling ourselves and being able to tell ourselves that none of these forms can correspond to the human organism in any way. At the same time the elementary feeling remains that our organism, our organs are owing to formative movements which are not significantly different.

Perhaps aesthetic experience and composition in general can be largely deduced from the basic peristaltic movement pattern; in any case, surely this is the most appropriate model: drawing together and opening out, pressure and expansion, compression and expansion. Breathing, we experience their alternation as one of life's elementary rhythms. The pulsing of the blood and the veins, the heart itself. In these, and in thousands of other circulations which are simply less noticeable, what we call our life is acted out. It is no coincidence that the soul is particularly associated with the diaphragm and the heart, and not only by the ancient Greeks. We do not need to individually examine the structure's we encounter in palaeontological ages to see if the peristaltic principle is in action. This pattern of movement resonates in us from millions of years of participation in evolution. It is infinitely difficult to say to what extent and in what way these elementary relationships determine for us whether one shape is particularly unsettling, or another harmlessly beautiful. An ammonite or shell are possibly too rigid and differently formed for us to easily see life in them. In others, we see woodlice and worms and the secret fear of waking up, like Kafka's character, as a beetle – or the metamorphosis into rhinoceri that Ionescu portrays on stage. Metamorphosis. The occidental archetype for this is the peasants in Ovid, who walk in swampy water until they have become frogs – »subaqua, subaqua ...«

What moves us so intensely is the unconscious – unconscious in the Freudian sense also, i. e., repressed – familiarity with the alien. This makes us want to place it in an entirely different category all the more. Unlike Paul Valéry, Theodor W. Adorno connected a mimetic encounter with jellyfish with feelings of revulsion and fear, justifying this with the very fact that we must resist the urge to a certain identification with a creature which, without any form, has to signify dissolution for us. And is this connection really so absurd? After all, we know only too well that the two organs which constitute the head and the stomach in us humans arise through peristaltic growth and formative movements, and determine our lives; the gut and the brain are the developments, the invaginations and evaginations of the single embryonic main organ, described in embryology as the »neural tube«. And yet as we look at and into these shapes, we ask what laws gave rise to them and what freedoms in the individual organism or in the differences and shifts of unmistakable patterns simultaneously played a role. A question which these ancient witnesses to natural history bring directly into the present: if these were the living organs of these creatures, how would they move, what new shapes would they produce?

Another reason why beauty is associated with all this is that our perception and its organs derive from these natural histories. However, when faced with these dead forms in particular, the petrifactions and their age, unimaginable in terms of human history, the expression »sublime« suggests itself more readily. To be familiar with something incomprehensibly alien. What a power to last beyond death in contrast to human beings, whose bones are no longer housed in cemeteries after thirty years. What a living wealth of significant forms in total stillness!

Notes

[1] Rudolf zur Lippe, *Sinnenbewußtsein. Grundlegung einer anthropologischen Ästhetik*, Hohengehren, 2000.
[2] Ibid., pp. 190 f.
[3] Ludwig von Berthalanfi and Alfred Prinz Auersberg, »Grünwalder Gespräche«, ibid.
[4] Gregory Bateson, *Mind and Nature. A Necessary Unity*, New York, 1979.
[5] Ibid., p. 162.
[6] Adolf Portmann, »Biologisches zur ästhetischen Erziehung«, *Leben und Umwelt* (Aarau), vol. 5, (1949), pp. 97–113.

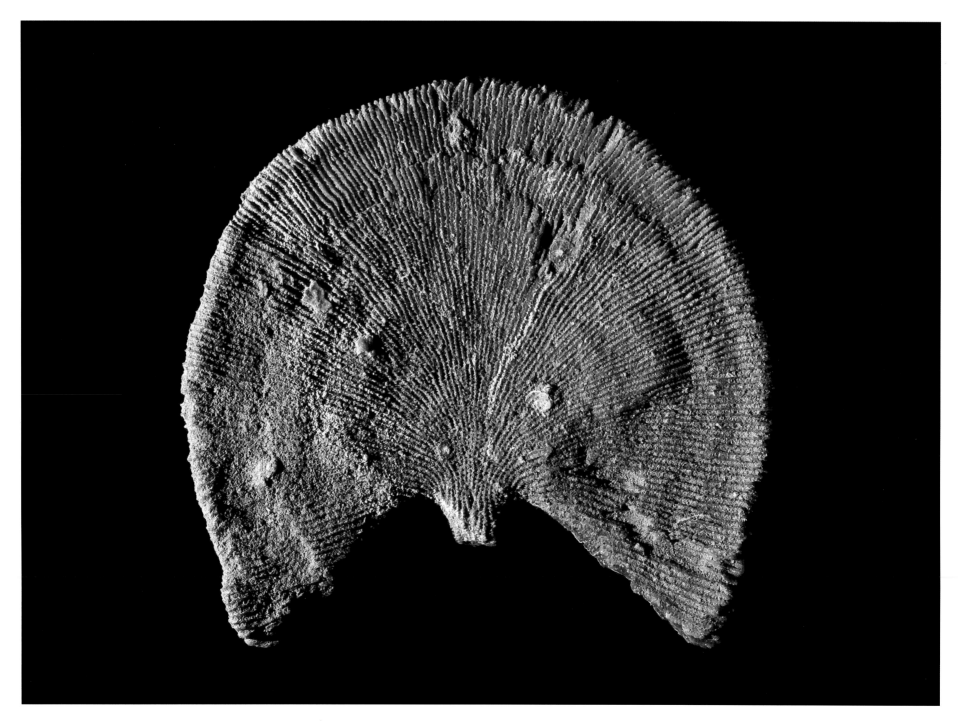

Diploctenium
Oberkreide, etwa 84 Ma
Montsech, Spanien
Vergrößerung: etwa 5,6 x
Glossar: Korallen / Scleractinia

Diploctenium
Late Cretaceous, approx. 84 Ma
Montsech, Spain
Enlargement: approx. 5,6 x
Glossary: corals / Scleractinia

Placosmilia
Oberkreide, etwa 84 Ma
Montsech, Spanien
Vergrößerung: etwa 4 x
Glossar: Korallen / Scleractinia

Placosmilia
Late Cretaceous, approx. 84 Ma
Montsech, Spain
Enlargement: approx. 4 x
Glossary: corals / Scleractinia

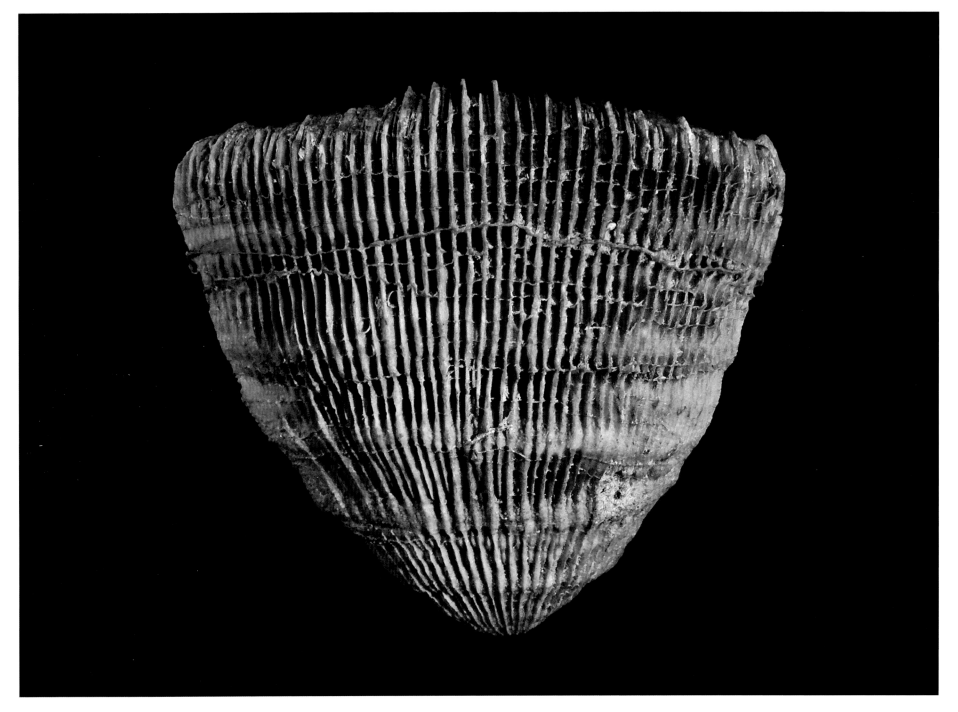

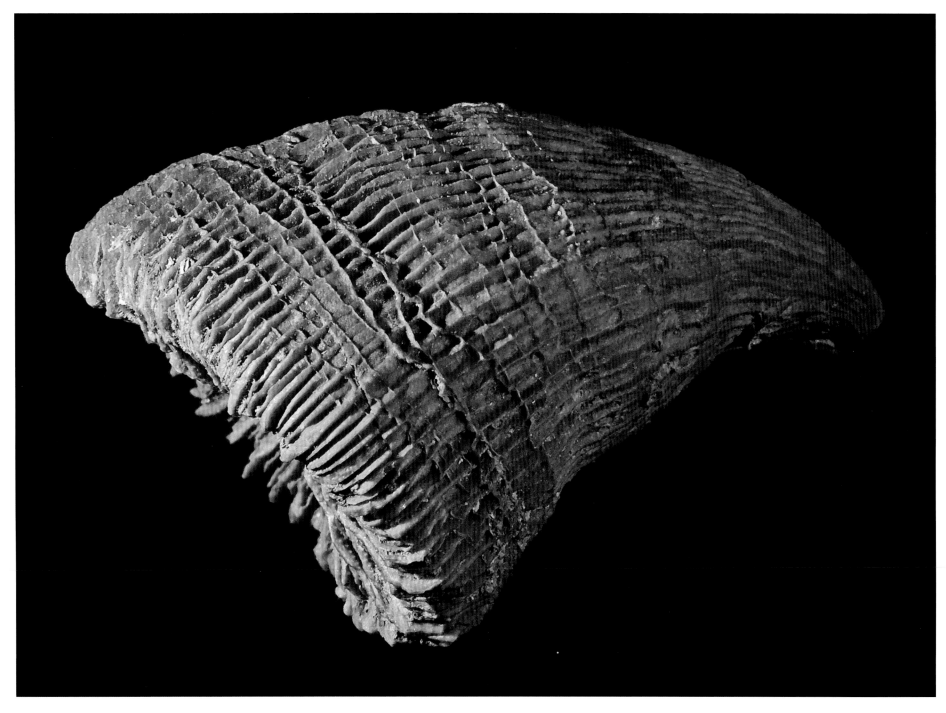

Placosmilia
Oberkreide, etwa 84 Ma
Montsech, Spanien
Vergrößerung: etwa 4 x
Glossar: Korallen / Scleractinia

Placosmilia
Late Cretaceous, approx. 84 Ma
Montsech, Spain
Enlargement: approx. 4 x
Glossary: corals / Scleractinia

Cyclolites
Oberkreide, etwa 84 Ma
Montsech, Spanien
Vergrößerung: etwa 3 x
Glossar: Korallen / Scleractinia

Cyclolites
Late Cretaceous, approx. 84 Ma
Montsech, Spain
Enlargement: approx. 3 x
Glossary: corals / Scleractinia

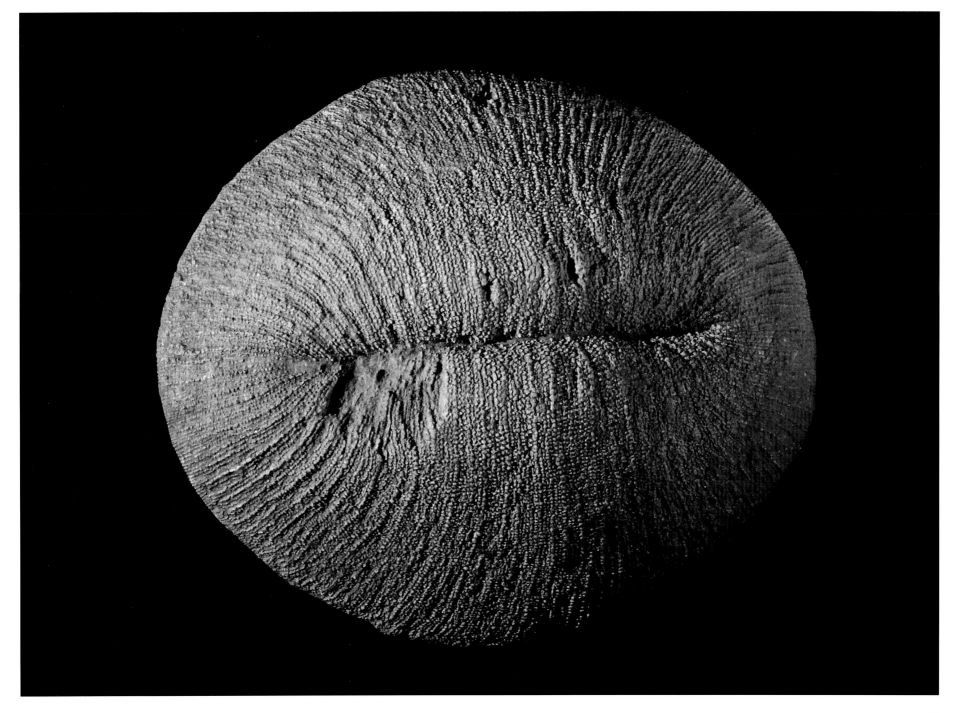

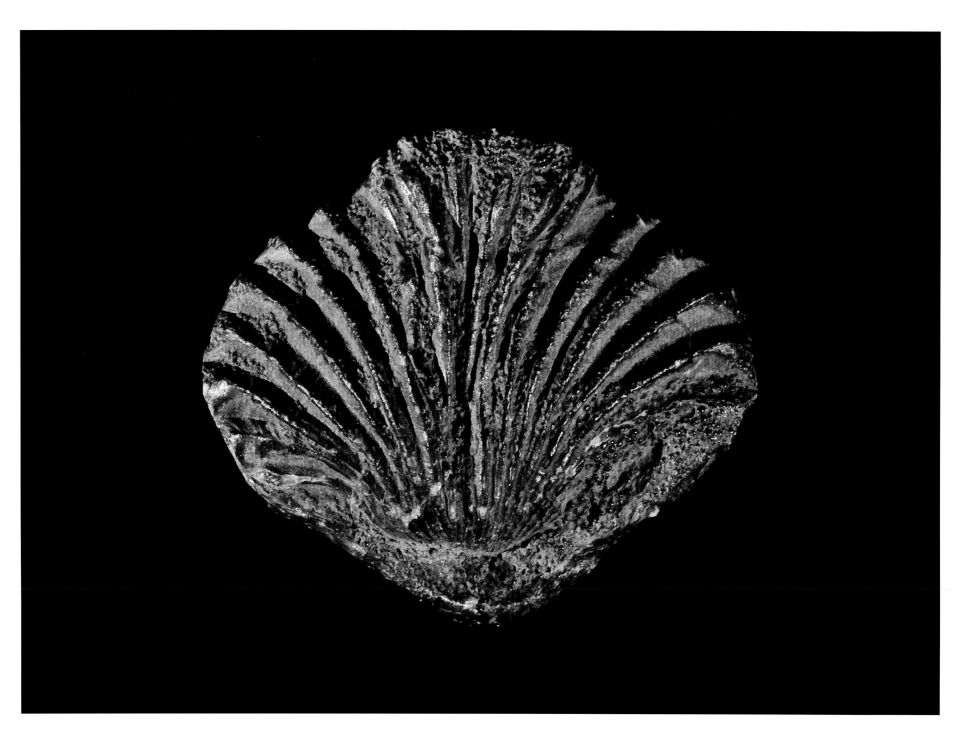

Rhynchonella
Unterkreide, etwa 135 Ma
Grube Marie, Steinloh, Deutschland
Vergrößerung: etwa 4 x
Glossar: Armfüßer

Rhynchonella
Early Cretaceous, approx. 135 Ma
Marie Mine, Steinloh, Germany
Enlargement: approx. 4 x
Glossary: brachiopods

Cyrtospirifer
Oberdevon, etwa 370 Ma
Barvaux, Belgien
Vergrößerung: etwa 3 x
Glossar: Armfüßer

Cyrtospirifer
Late Devonian, approx. 370 Ma
Barvaux, Belgium
Enlargement: approx. 3 x
Glossary: brachiopods

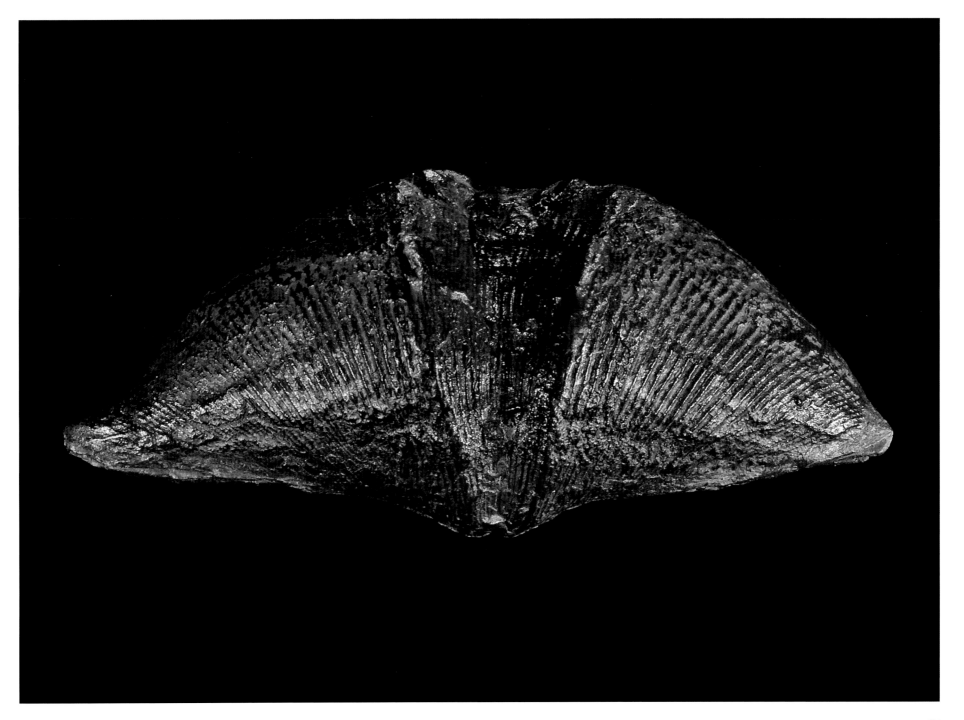

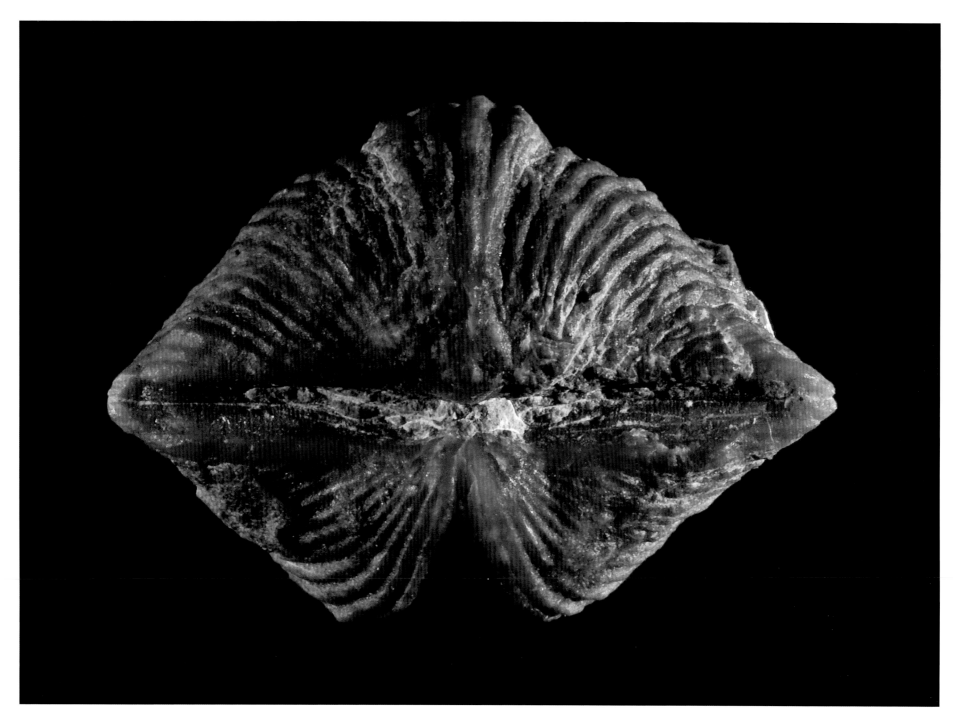

Platystrophia
Oberordovizium, etwa 450 Ma
Richmond, Indiana, USA
Vergrößerung: etwa 7 x
Glossar: Armfüßer

Platystrophia
Late Ordovician, approx. 450 Ma
Richmond, Indiana, USA
Enlargement: approx. 7 x
Glossary: brachiopods

Pliomera
Ordovizium, etwa 465 Ma
St. Petersburg, Rußland
Vergrößerung: etwa 4,5 x
Glossar: Gliedertiere / Trilobiten

Pliomera
Ordovician, approx. 465 Ma
St. Petersburg, Russia
Enlargement: approx. 4.5 x
Glossary: arthropods / trilobites

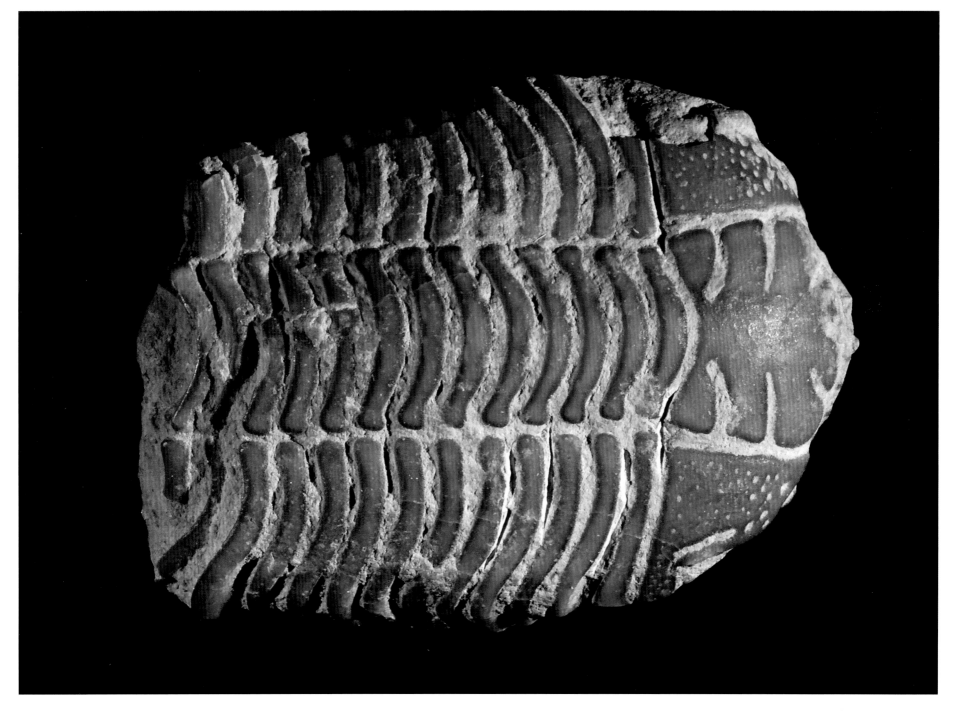

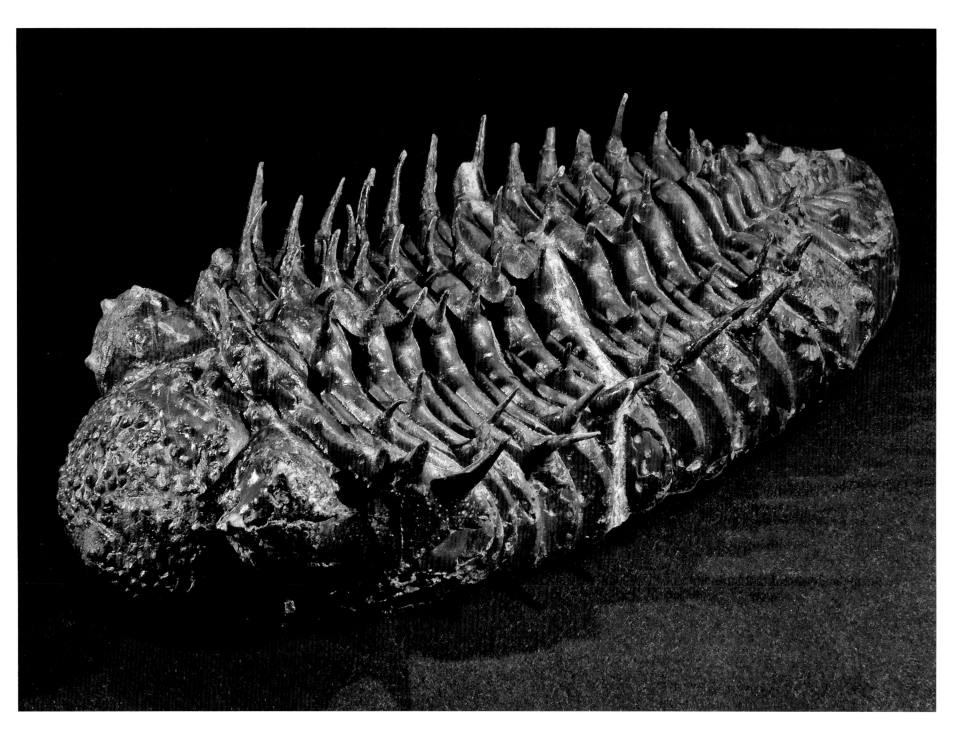

Drotops armatus
Mitteldevon, etwa 385 Ma
Aluif, Maidor, Marokko
Vergrößerung: etwa 3 x
Glossar: Gliedertiere / Trilobiten

Drotops armatus
Middle Devonian, approx. 385 Ma
Aluif, Maidor, Morocco
Enlargement: approx. 3 x
Glossary: arthropods / trilobites

Phacops rana, Abguß
Devon, etwa 380 Ma
Ohio, USA
Vergrößerung: etwa 5 x
Glossar: Gliedertiere / Trilobiten

Phacops rana, mould
Devonian, approx. 380 Ma
Ohio, USA
Enlargement: approx. 5 x
Glossary: arthropods / trilobites

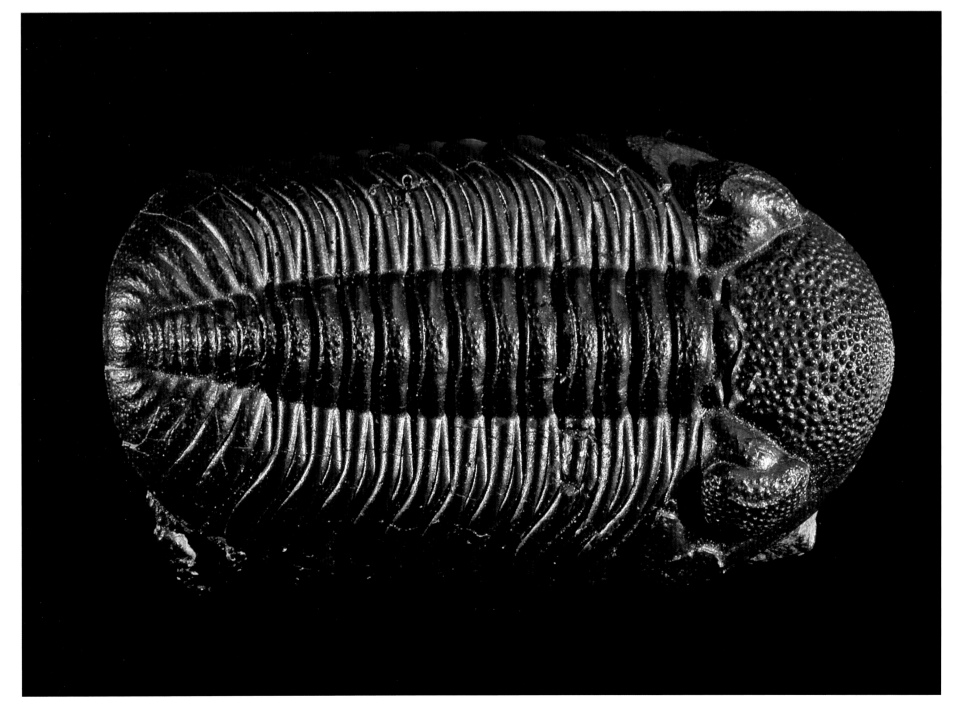

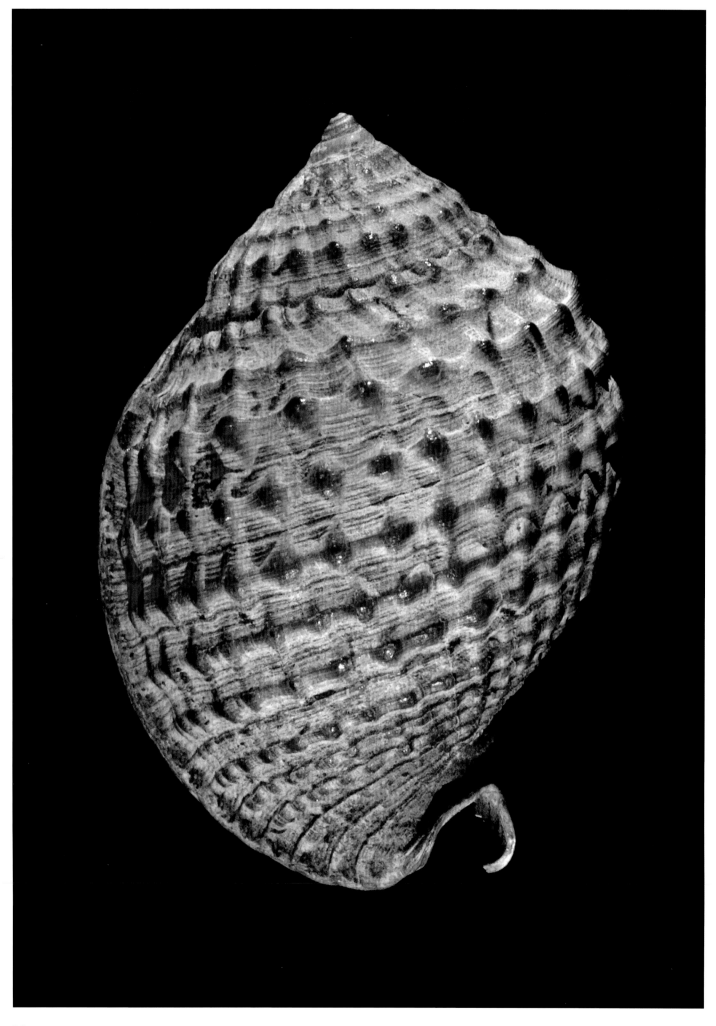

Semicassis
Unteroligozän, etwa 30 Ma
Berlin-Hermsdorf, Deutschland
Vergrößerung: etwa 4 x
Glossar: Weichtiere / Schnecken

Myophorella
Oberjura, etwa 153 Ma
St. Cruz, Portugal
Vergrößerung: etwa 3 x
Glossar: Weichtiere / Muscheln

Semicassis
Early Oligocene, approx. 30 Ma
Berlin-Hermsdorf, Germany
Enlargement: approx. 4 x
Glossary: molluscs / gastropods

Myophorella
Late Jurassic, approx. 153 Ma
St. Cruz, Portugal
Enlargement: approx. 3 x
Glossary: molluscs / bivalves

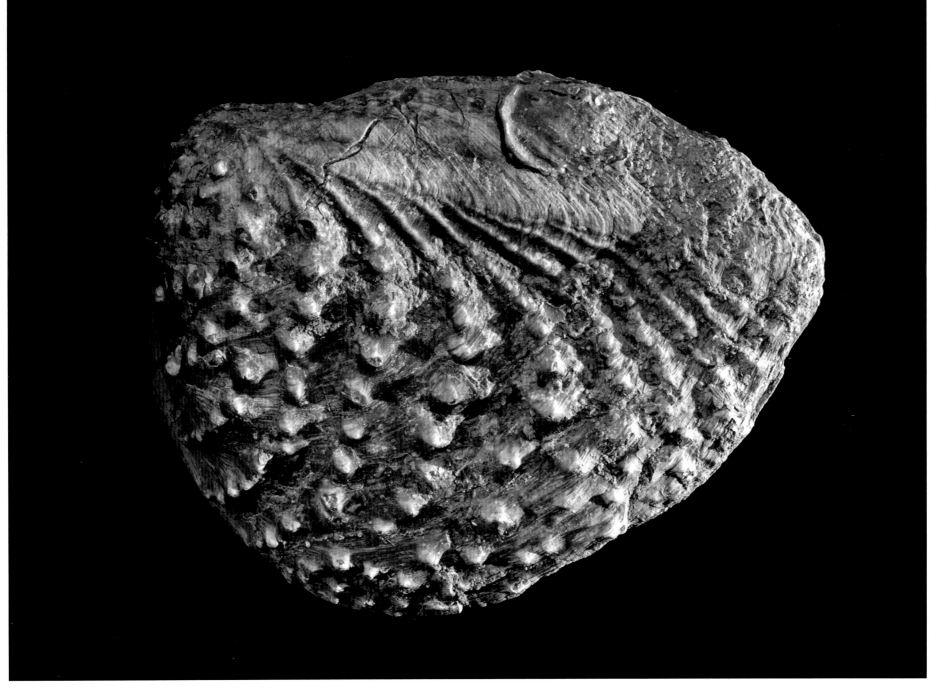

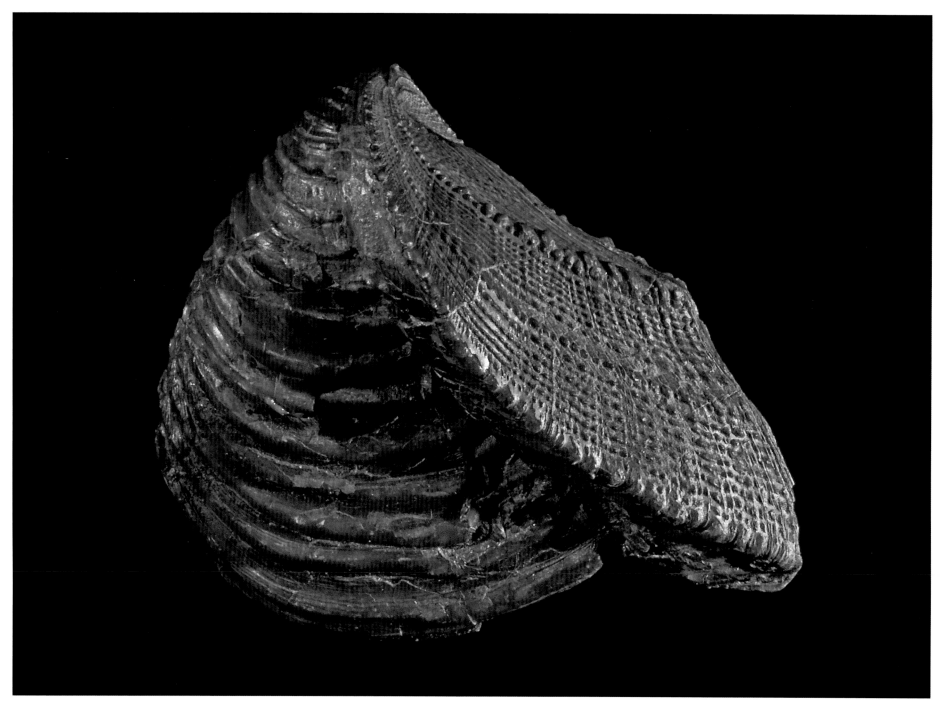

Trigonia
Mitteljura, etwa 170 Ma
Bethel, Bielefeld, Deutschland
Vergrößerung: etwa 3x
Glossar: Weichtiere / Muscheln

Trigonia
Middle Jurassic, approx. 170 Ma
Bethel, Bielefeld, Germany
Enlargement: approx. 3x
Glossary: molluscs / bivalves

Congeria
Pliozän, etwa 3 Ma
Baden, Österreich
Vergrößerung: etwa 4,2x
Glossar: Weichtiere / Muscheln

Congeria
Pliocene, approx. 3 Ma
Baden, Austria
Enlargement: approx. 4.2x
Glossary: molluscs / bivalves

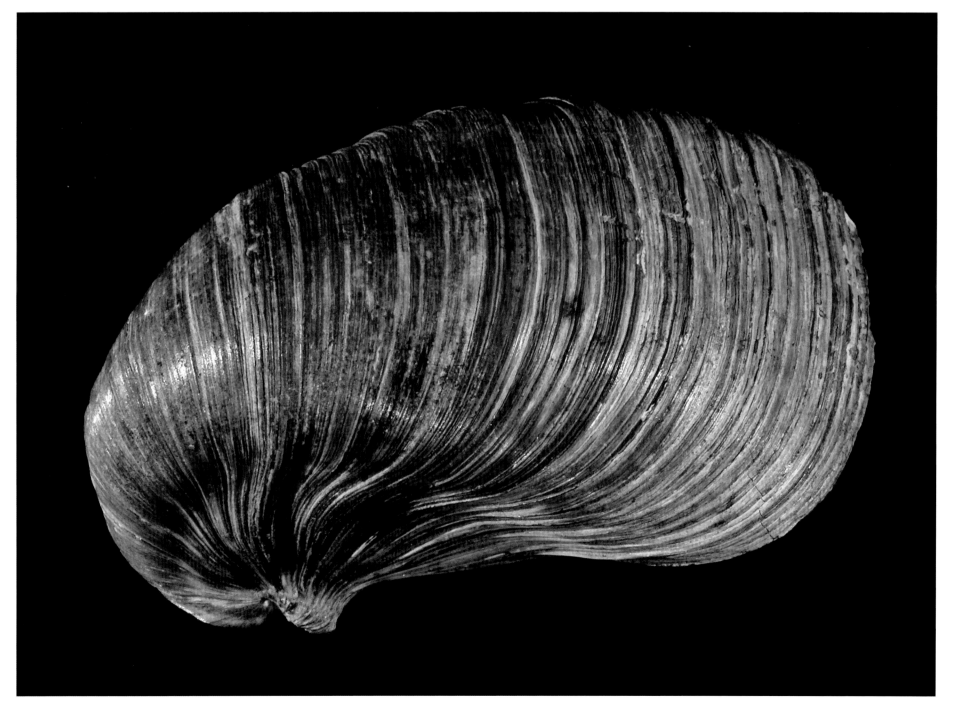

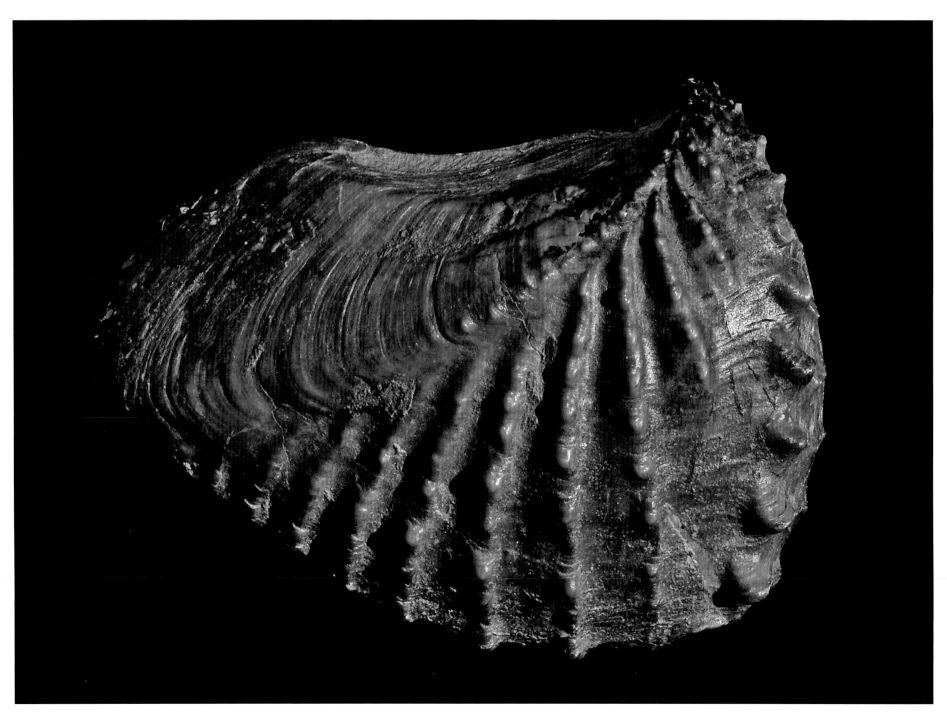

Scaphotrigonia
Mitteljura, etwa 178 Ma
Grünbach, Aalen, Deutschland
Vergrößerung: etwa 3,3 x
Glossar: Weichtiere / Muscheln

Scaphotrigonia
Middle Jurassic, approx. 178 Ma
Grünbach, Aalen, Germany
Enlargement: approx. 3,3 x
Glossary: molluscs / bivalves

Gryphaea
Unterjura, etwa 195 Ma
Gebhardshagen, Deutschland
Vergrößerung: etwa 4 x
Glossar: Weichtiere / Muscheln

Gryphaea
Early Jurassic, approx. 195 Ma
Gebhardshagen, Germany
Enlargement: approx. 4 x
Glossary: molluscs / bivalves

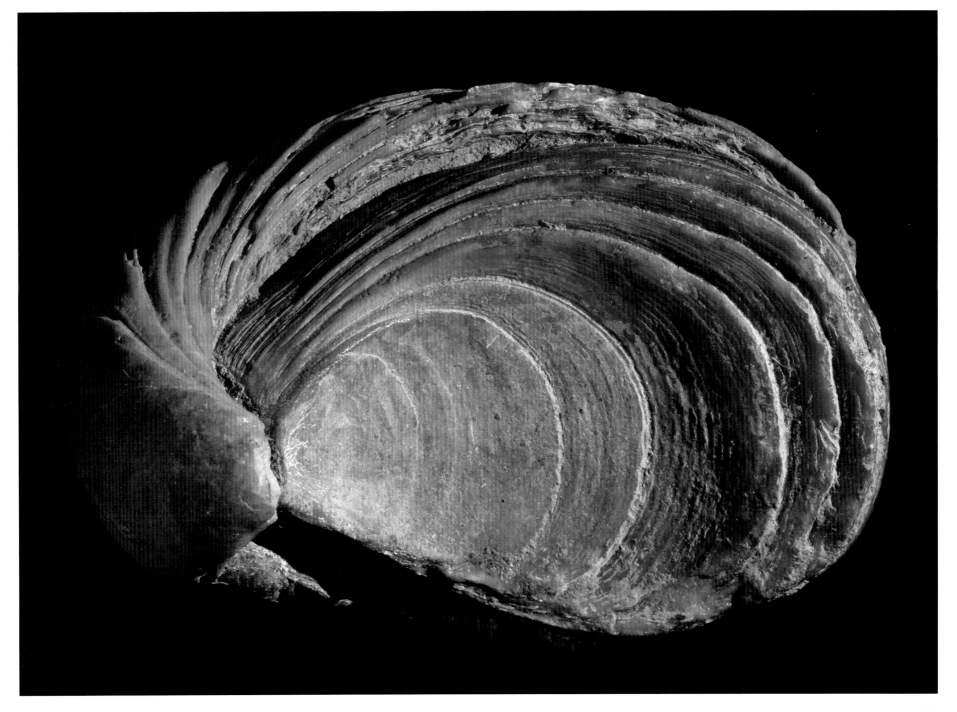

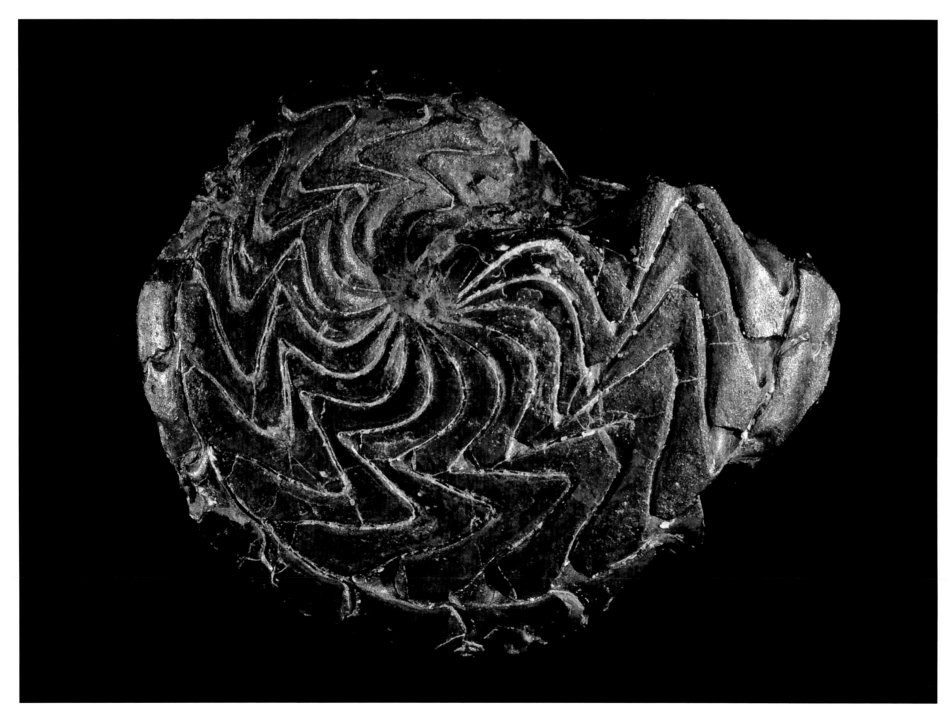

Discoclymenia
Oberdevon, etwa 360 Ma
Fezzou, Marokko
Vergrößerung: etwa 5,6 x
Glossar: Weichtiere / Ammoniten

Discoclymenia
Late Devonian, approx. 360 Ma
Fezzou, Morocco
Enlargement: approx. 5.6 x
Glossary: molluscs / ammonoids

Clypeus
Mitteljura, etwa 173 Ma
Ferques, Boulonnaise, Frankreich
Vergrößerung: etwa 3 x
Glossar: Stachelhäuter / Seeigel

Clypeus
Middle Jurassic, approx. 173 Ma
Ferques, Boulonnaise, France
Enlargement: approx. 3 x
Glossary: echinoderms / sea urchins

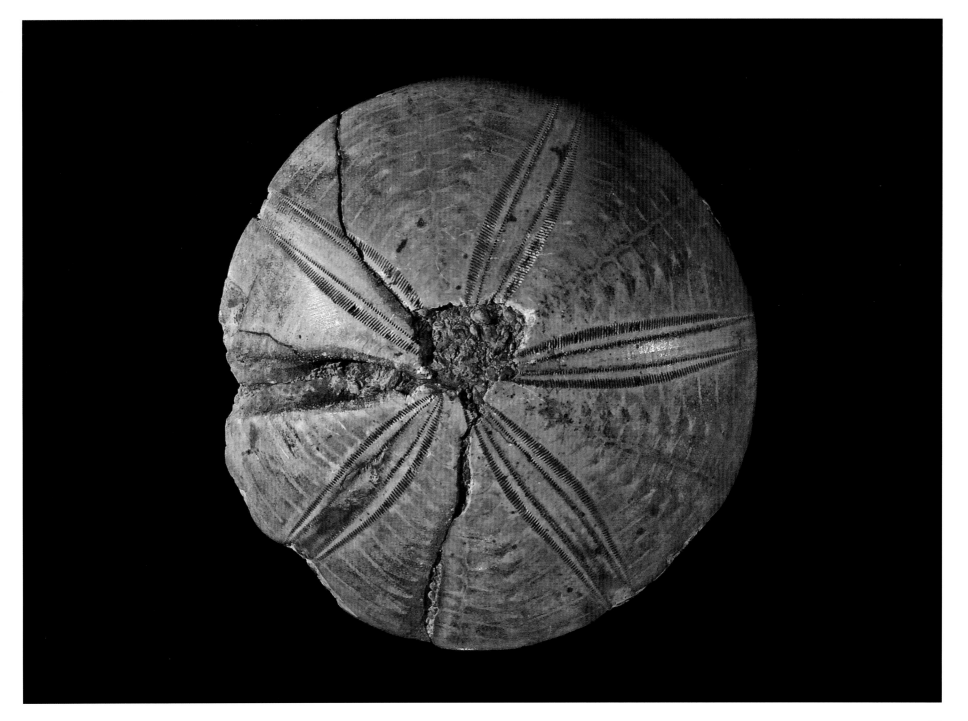

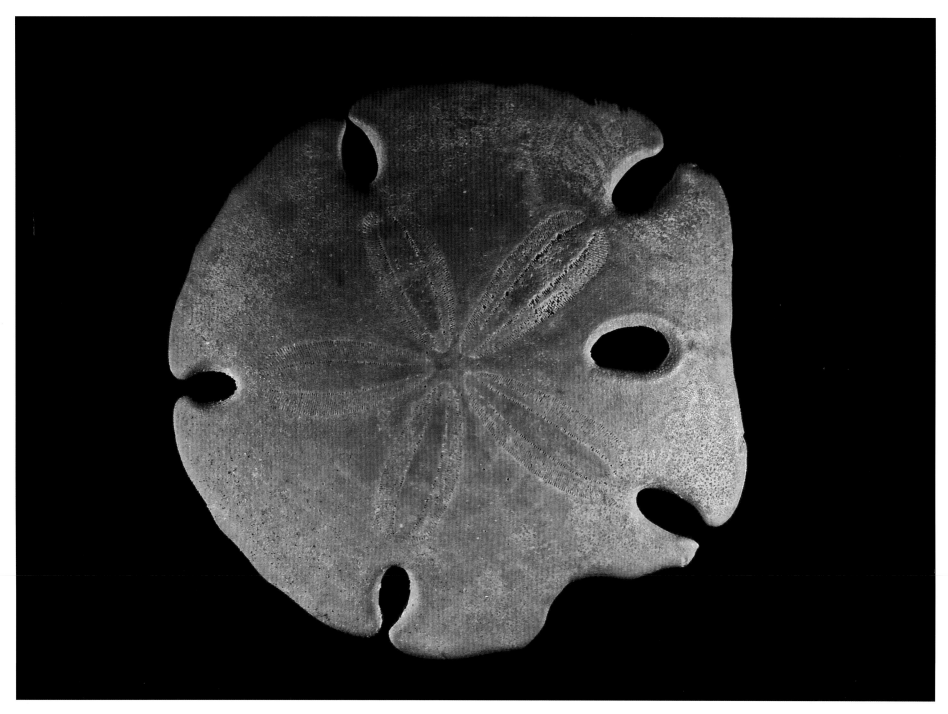

Encope
Pleistozän, etwa 1,5 Ma
Baja California, Mexiko
Vergrößerung: etwa 2 x
Glossar: Stachelhäuter / Seeigel

Encope
Pleistocene, approx. 1.5 Ma
Baja California, Mexico
Enlargement: approx. 2 x
Glossary: echinoderms / sea urchins

Rhipidocrinus, Kelchbasis
Devon, etwa 380 Ma
Gerolstein, Deutschland
Vergrößerung: etwa 4,5 x
Glossar: Stachelhäuter / Seelilien

Rhipidocrinus, basal crown
Devonian, approx. 380 Ma
Gerolstein, Germany
Enlargement: approx. 4.5 x
Glossary: echinoderms / crinoids

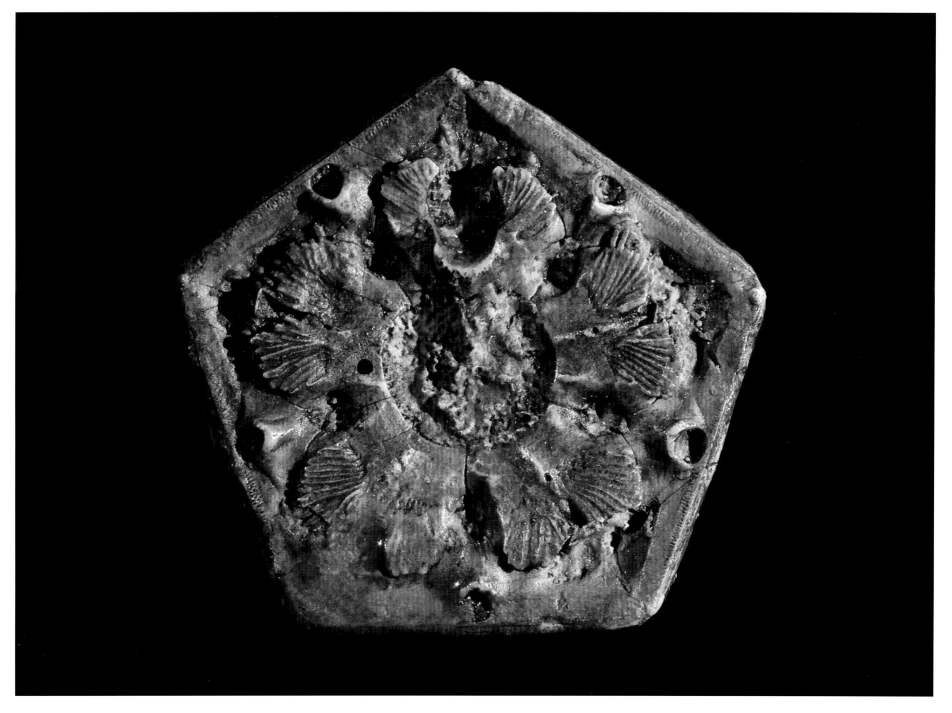

Acrosalenia
Oberjura, etwa 150 Ma
Saal, Kelheim, Deutschland
Vergrößerung: etwa 14 x
Glossar: Stachelhäuter / Seeigel

Macrocrinus
Unterkarbon, etwa 340 Ma
Montgomery County, Indiana, USA
Vergrößerung: etwa 10 x
Glossar: Stachelhäuter / Seelilien

Acrosalenia
Late Jurassic, approx. 150 Ma
Saal, Kelheim, Germany
Enlargement: approx. 14 x
Glossary: echinoderms / sea urchins

Macrocrinus
Early Carboniferous, approx. 340 Ma
Montgomery County, Indiana, USA
Enlargement: approx. 10 x
Glossary: echinoderms / crinoids

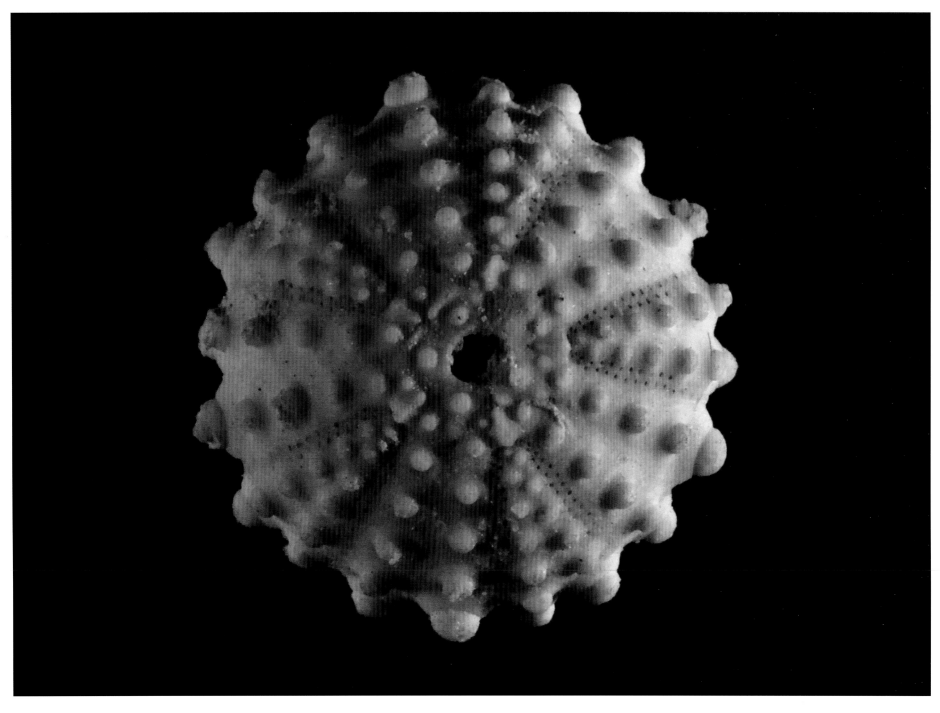

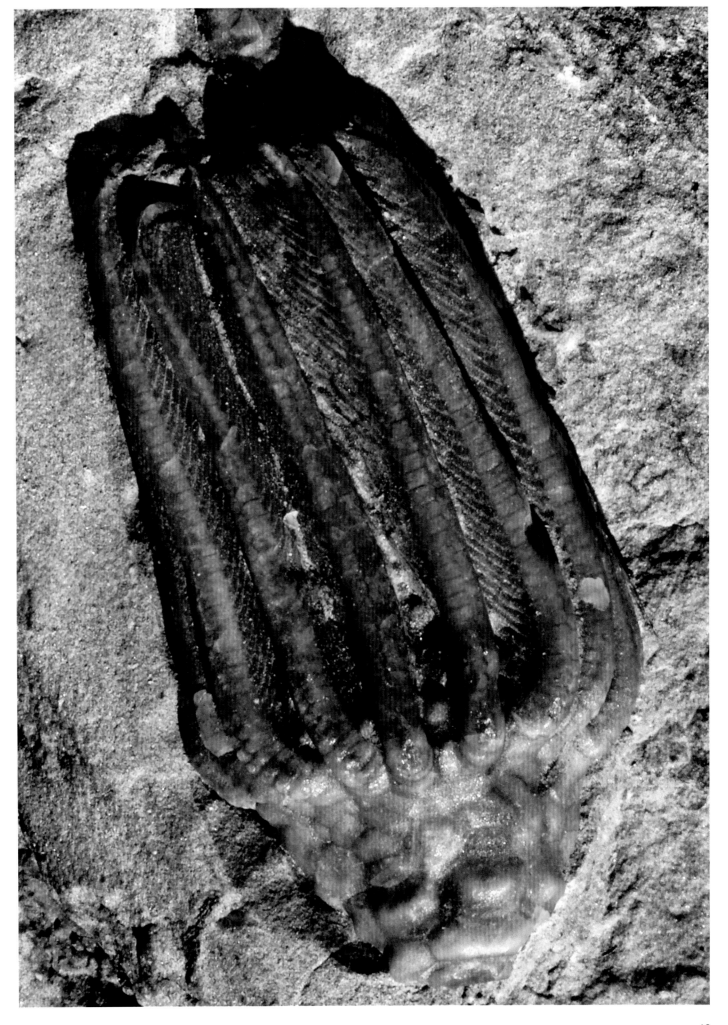

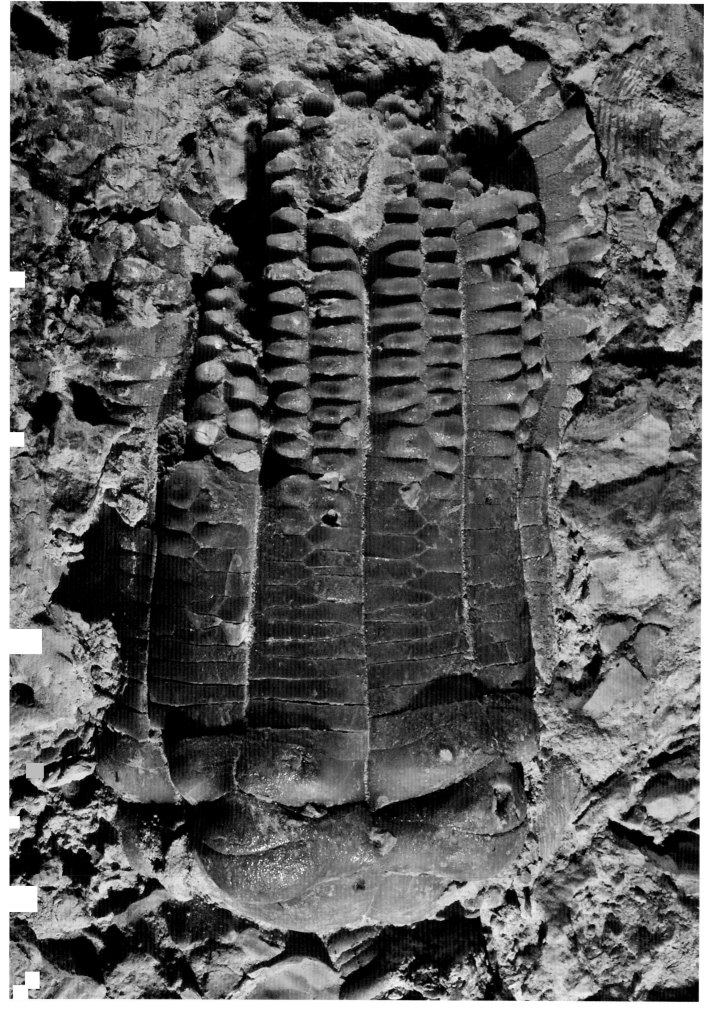

Encrinus, Krone
Mitteltrias, etwa 233 Ma
Erkerode, Deutschland
Vergrößerung: etwa 5 x
Glossar: Stachelhäuter / Seelilien

Encrinus, crown
Middle Triassic, approx. 233 Ma
Erkerode, Germany
Enlargement: approx. 5 x
Glossary: echinoderms / crinoids

Edriophus
Mittelordovizium, etwa 465 Ma
Bobcaygeon Form., Ontario, Kanada
Vergrößerung: etwa 5 x
Glossar: Stachelhäuter / Edrioasteroideen

Edriophus
Middle Ordovician, approx. 465 Ma
Bobcaygeon Form., Ontario, Canada
Enlargement: approx. 5 x
Glossary: echinoderms / edrioasteroids

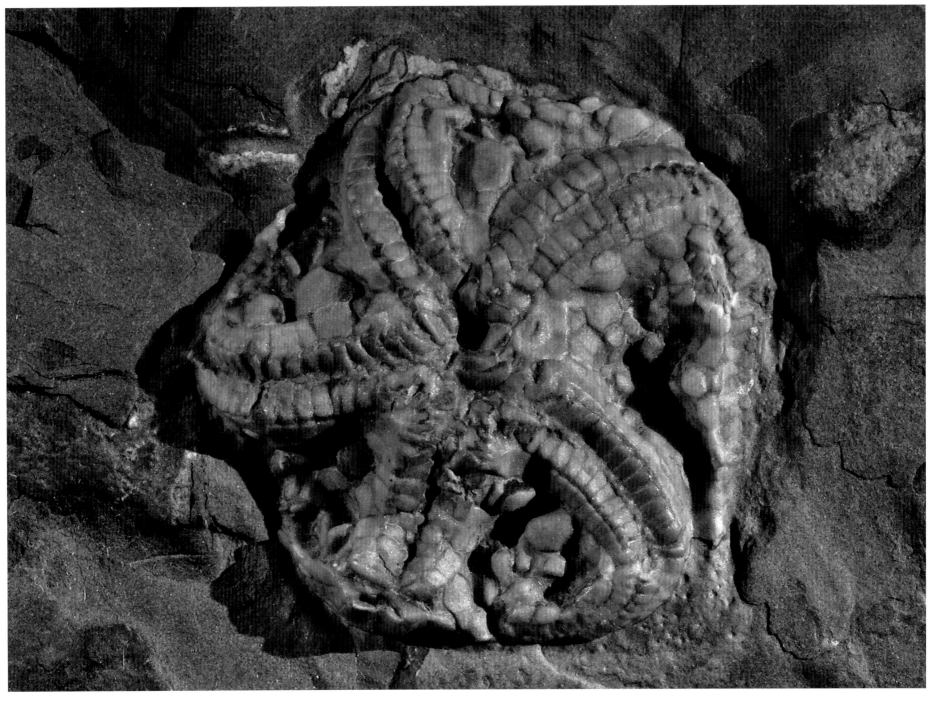

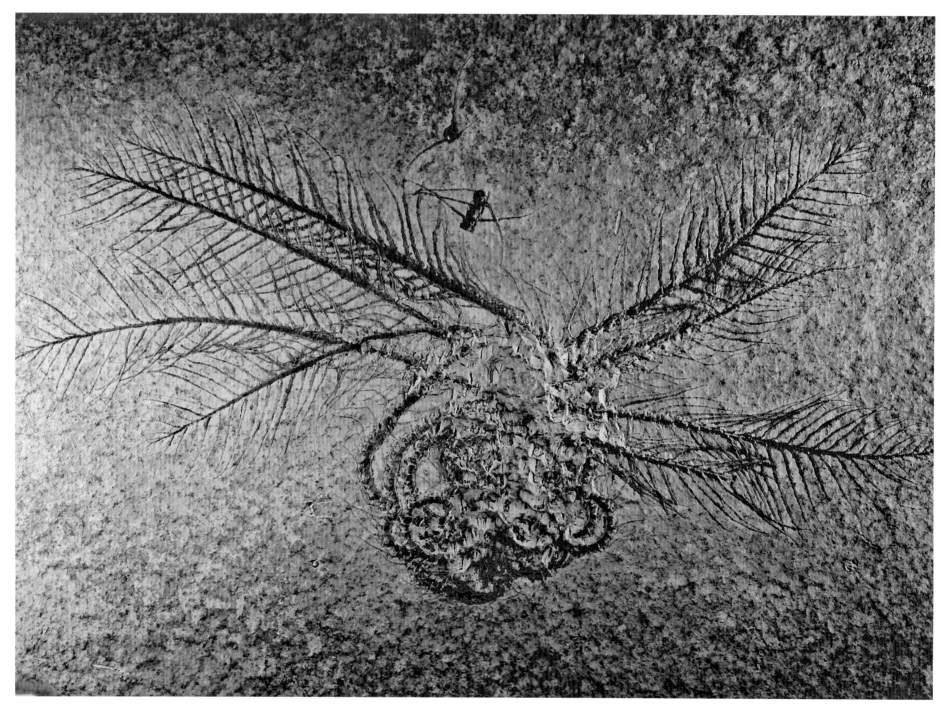

Comatula
Oberjura, etwa 152 Ma
Solnhofen, Deutschland
Vergrößerung: etwa 2 x
Glossar: Stachelhäuter / Seelilien

Comatula
Late Jurassic, approx. 152 Ma
Solnhofen, Germany
Enlargement: approx. 2 x
Glossary: echinoderms / crinoids

Saccocoma
Oberjura, ca. 145 Ma
Eichstätt, Bayern
Vergrößerung: etwa 7,5 x
Glossar: Stachelhäuter / Seelilien

Saccocoma
Late Jurassic, approx. 145 Ma
Eichstätt, Bavaria
Enlargement: approx. 7.5 x
Glossary: echinoderms / crinoids

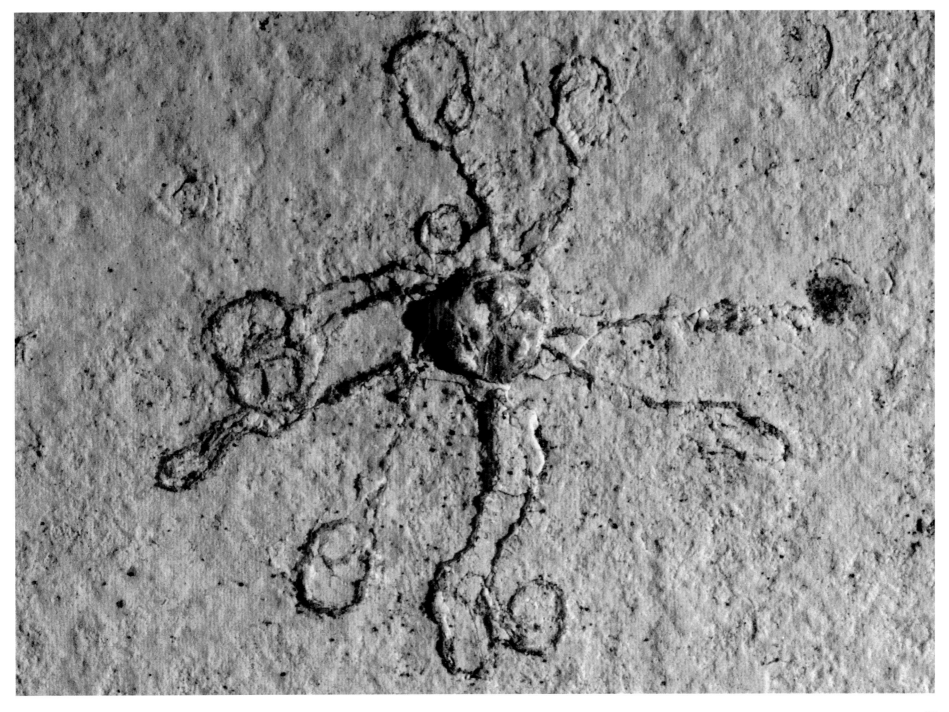

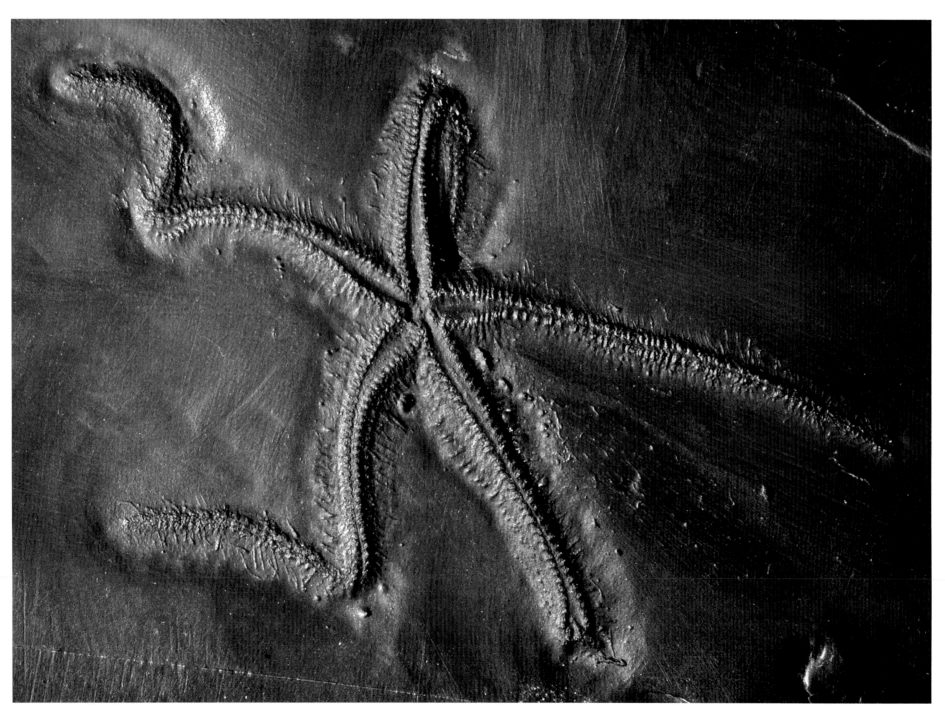

Urasterella
Unterdevon, etwa 400 Ma
Bundenbach, Deutschland
Vergrößerung: etwa 2,5 x
Glossar: Stachelhäuter / Seesterne

Urasterella
Early Devonian, approx. 400 Ma
Bundenbach, Germany
Enlargement: approx. 2.5 x
Glossary: echinoderms / asteroids

Bactrocrinus
Unterdevon, etwa 400 Ma
Bundenbach, Deutschland
Vergrößerung: etwa 3 x
Glossar: Stachelhäuter / Seelilien

Bactrocrinus
Early Devonian, approx. 400 Ma
Bundenbach, Germany
Enlargement: approx. 3 x
Glossary: echinoderms / crinoids

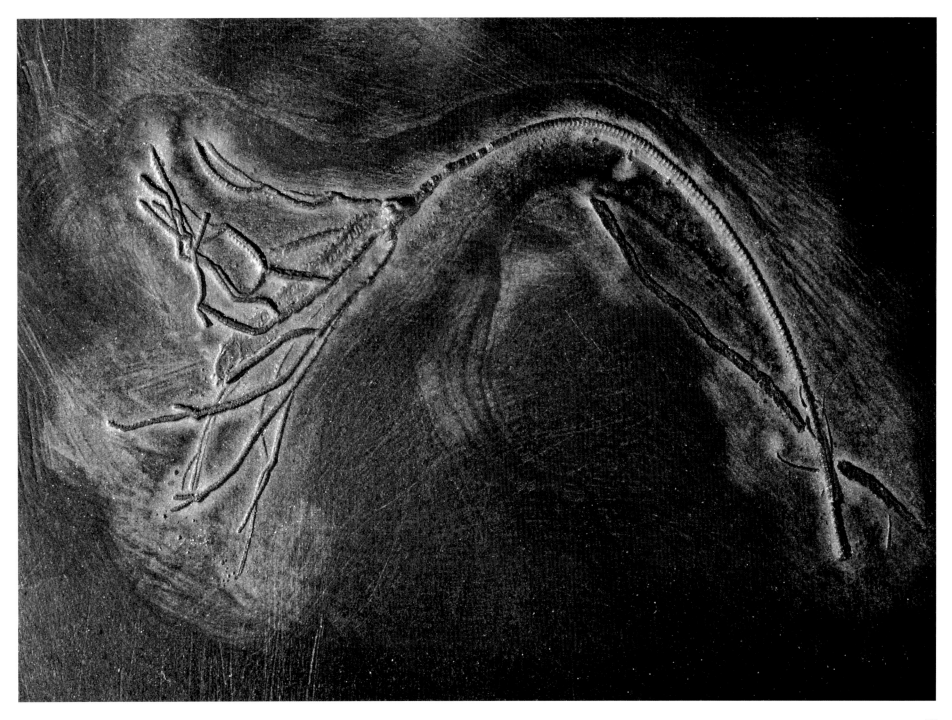

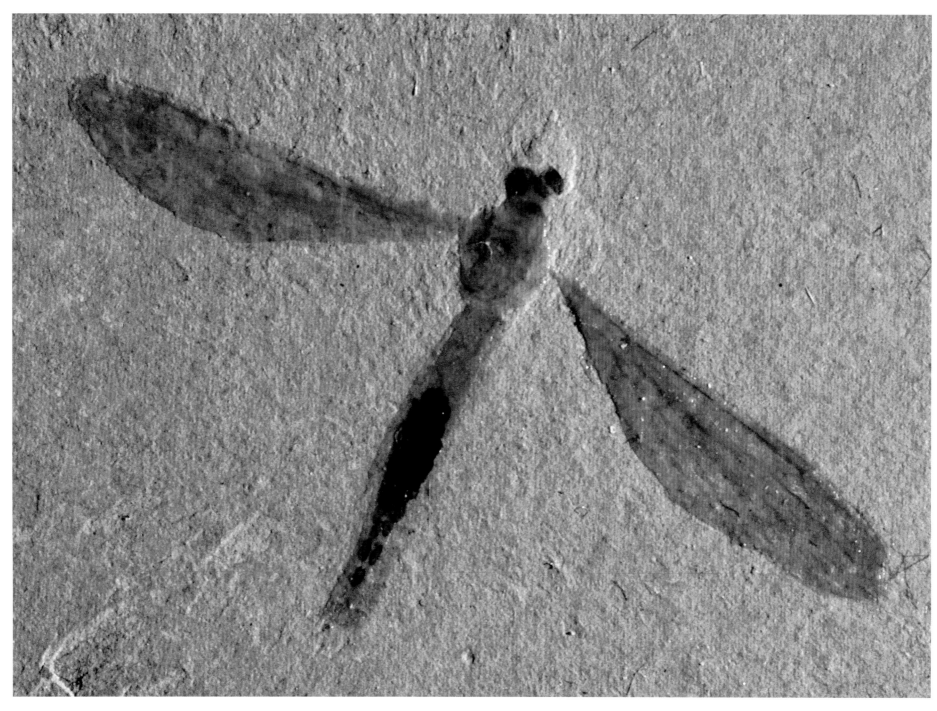

Tipula
Eozän, etwa 45 Ma
Rio Blanco County, Colorado, USA
Vergrößerung: etwa 9x
Glossar: Gliedertiere / Insekten

Tipula
Eocene, approx. 45 Ma
Rio Blanco County, Colorado, USA
Enlargement: approx. 9x
Glossary: arthropods / insects

Libelle, Cordulagomphus
Unterkreide, etwa 125 Ma
Santana Formation, Santana, Brasilien
Vergrößerung: etwa 5x
Glossar: Gliedertiere / Insekten

Dragonfly, Gordulagomphus
Early Cretaceous, approx. 125 Ma
Santana Formation, Santana, Brazil
Enlargement: approx. 5x
Glossary: arthropods / insects

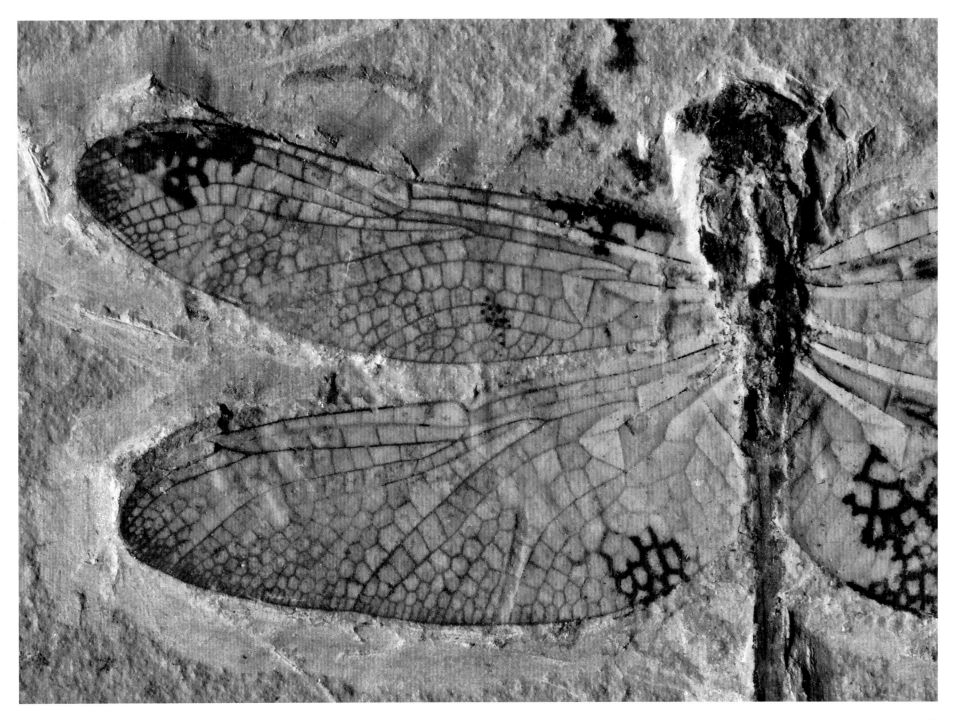

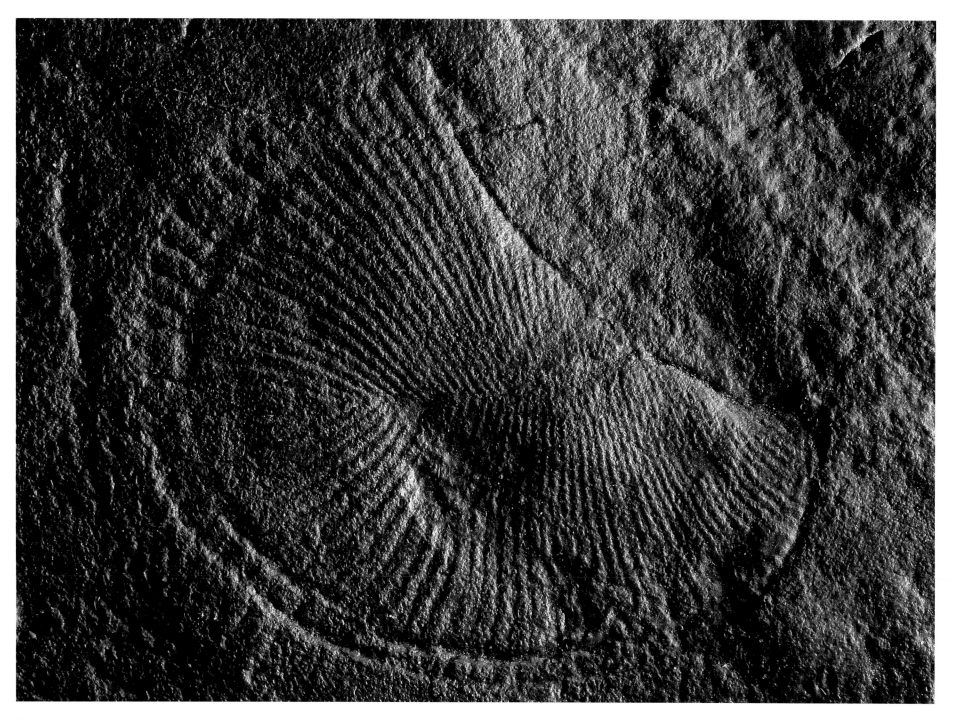

Dickinsonia, Abguß
Oberproterozoikum (Ediacara-Formation), etwa 560 Ma
Flinders Range, Süd Australien
Vergrößerung: etwa 3 x
Glossar: Vendobionta

Dickinsonia, mould
Late Protozoic (Ediacara formation), approx. 560 Ma
Flinders Range, South Australia
Enlargement: approx. 3 x
Glossary: Vendobionta

Pyritisierte Zaphrentis
Unterdevon, etwa 400 Ma
Bundenbach, Deutschland
Vergrößerung: etwa 11 x
Glossar: Korallen / Rugosa

Pyritized Zaphrentis
Early Devonian, approx. 400 Ma
Bundenbach, Germany
Enlargement: approx. 11 x
Glossary: corals / Rugosa

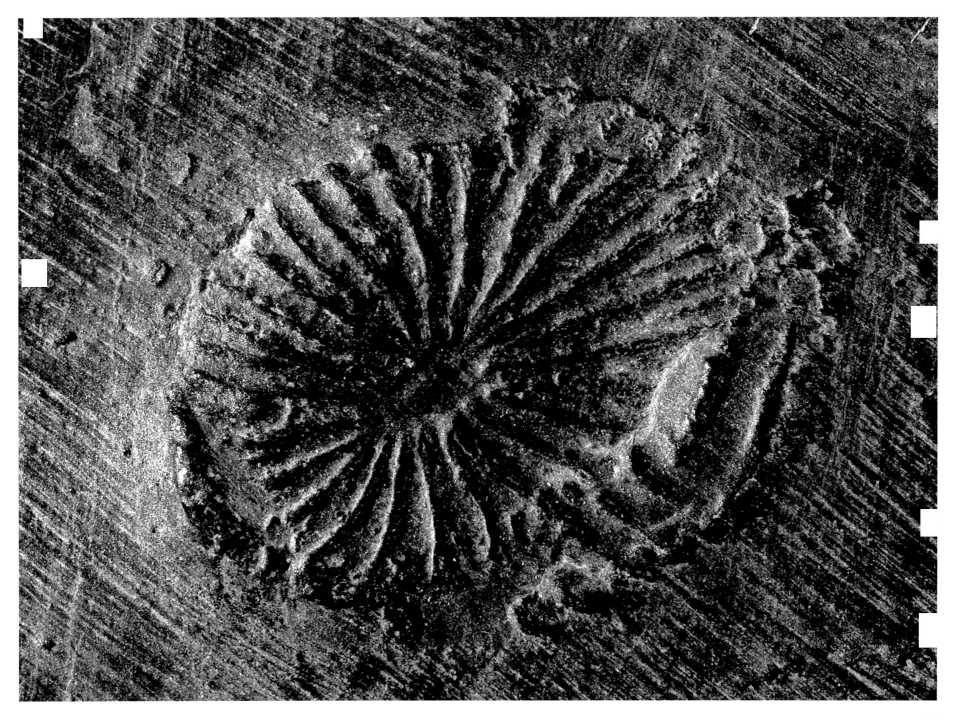

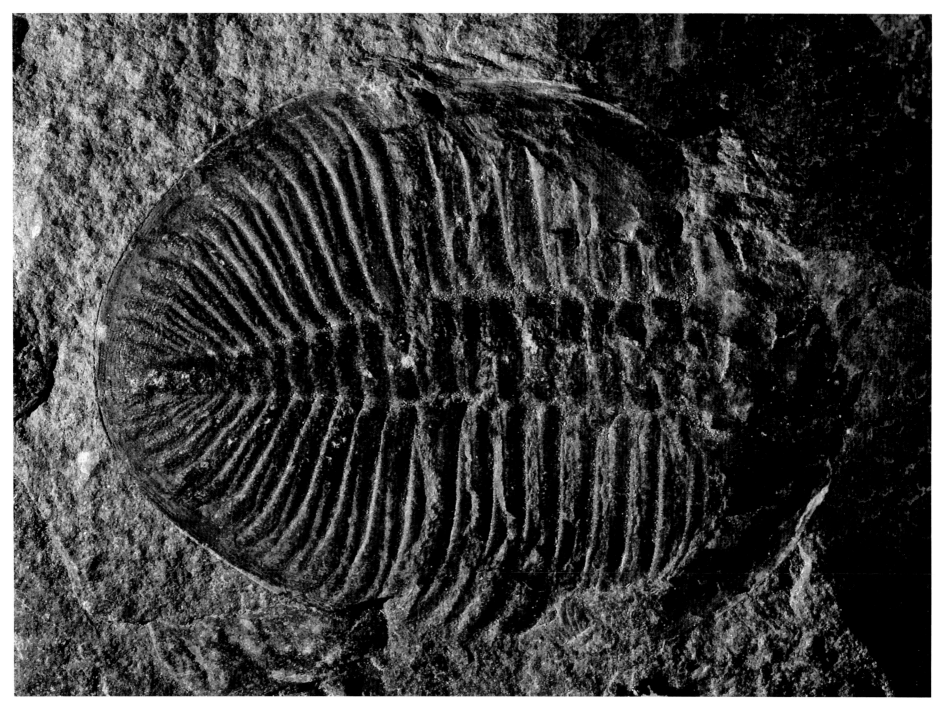

Ogygiocarella
Mittelordovizium, etwa 460 Ma
Wales, England
Vergrößerung: etwa 5 x
Glossar: Gliedertiere / Trilobiten

Ogygiocarella
Middle Ordovician, approx. 460 Ma
Wales, England
Enlargement: approx. 5 x
Glossary: arthropods / trilobites

Orthogarantiana
Mitteljura, etwa 173 Ma
Kinding, Deutschland
Vergrößerung: etwa 4 x
Glossar: Weichtiere / Ammoniten

Orthogarantiana
Middle Jurassic, approx. 173 Ma
Kinding, Germany
Enlargement: approx. 4 x
Glossary: molluscs / ammonoids

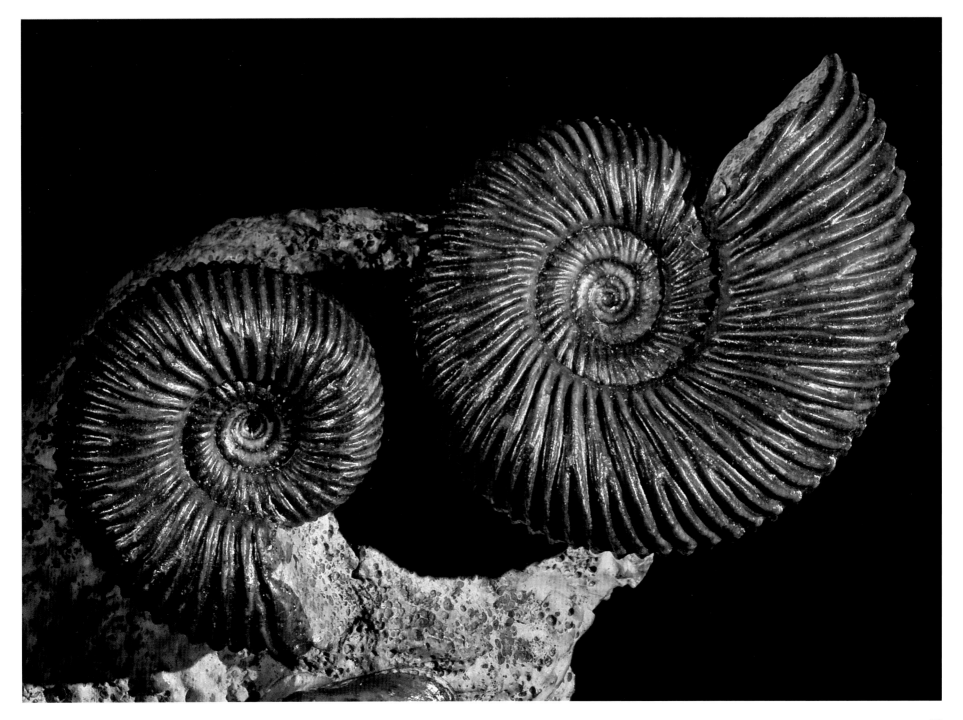

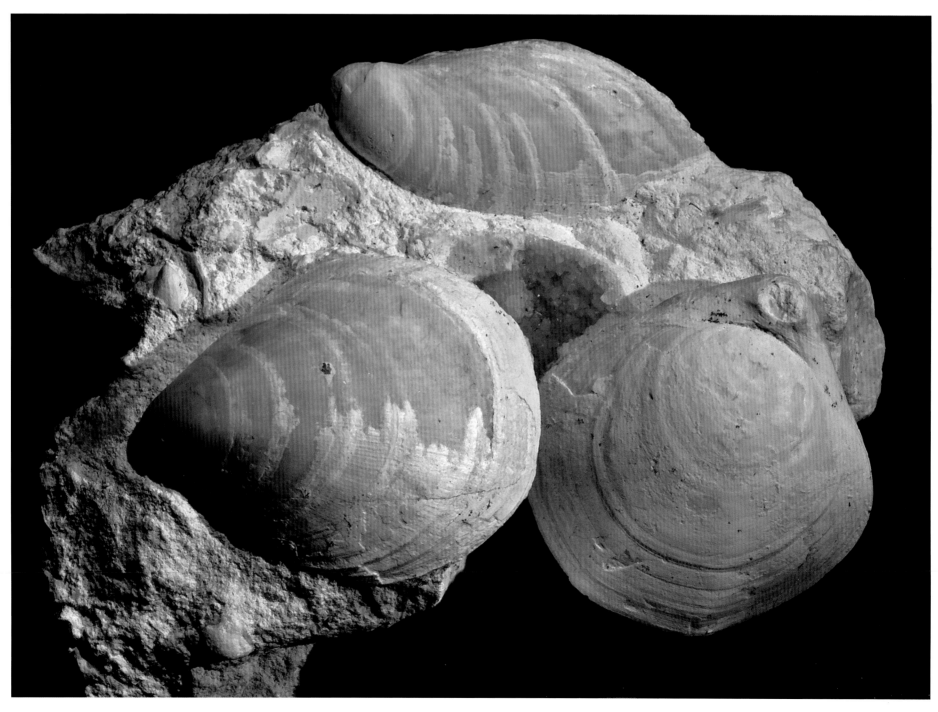

Juralina
Oberjura, etwa 148 Ma
Kelheim, Deutschland
Vergrößerung: etwa 3,3x
Glossar: Armfüßer

Juralina
Late Jurassic, approx. 148 Ma
Kelheim, Germany
Enlargement: approx. 3.3x
Glossary: brachiopods

Seepocken: *Balanus*
Miozän, etwa 15 Ma
West Kreta, Griechenland
Vergrößerung: etwa 8x
Glossar: Gliedertiere / Krebse

Balanus
Miocene, approx. 15 Ma
Western Crete, Greece
Enlargement: approx. 8x
Glossary: arthropods / crustaceans

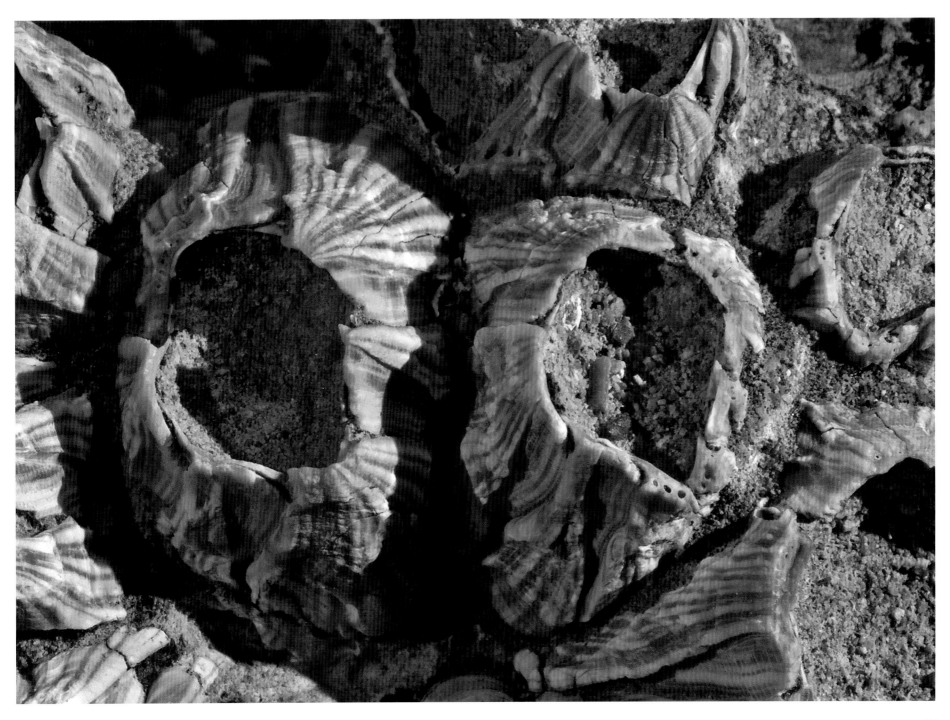

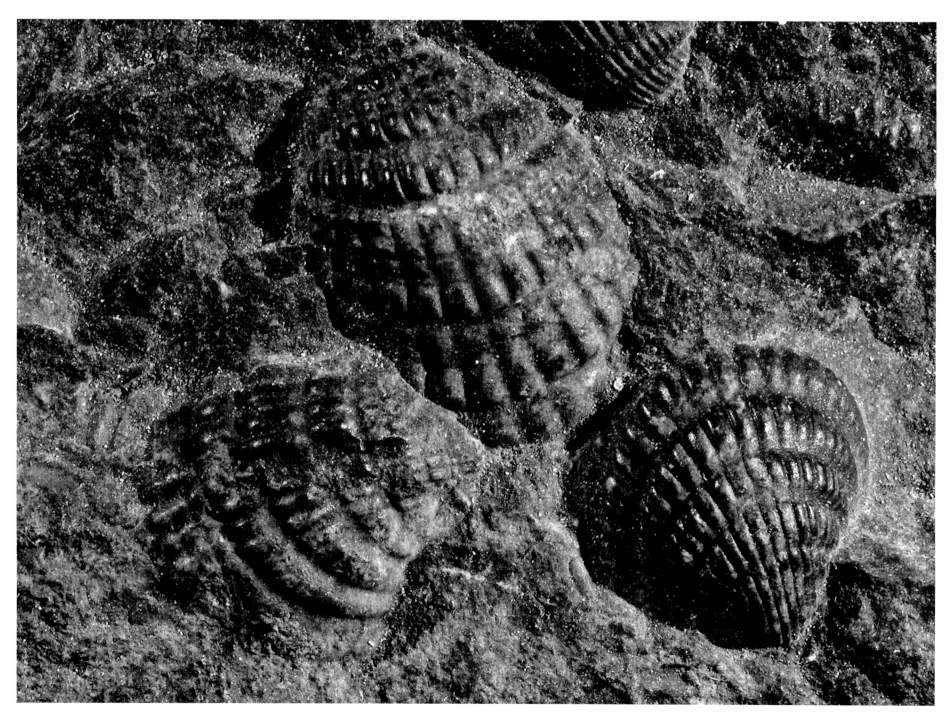

Cardiola
Obersilur, etwa 420 Ma
Lochkov, Tschechien
Vergrößerung: etwa 8,5 x
Glossar: Weichtiere / Muscheln

Cardiola
Late Silurian, approx. 420 Ma
Lochkov, Czech Republic
Enlargement: approx. 8.5 x
Glossary: molluscs / bivalves

Daonella
Obertrias, etwa 230 Ma
Seiseralm, Österreich
Vergrößerung: etwa 5,4 x
Glossar: Weichtiere / Muscheln

Daonella
Late Triassic, approx. 230 Ma
Seiseralm, Austria
Enlargement: approx. 5.4 x
Glossary: molluscs / bivalves

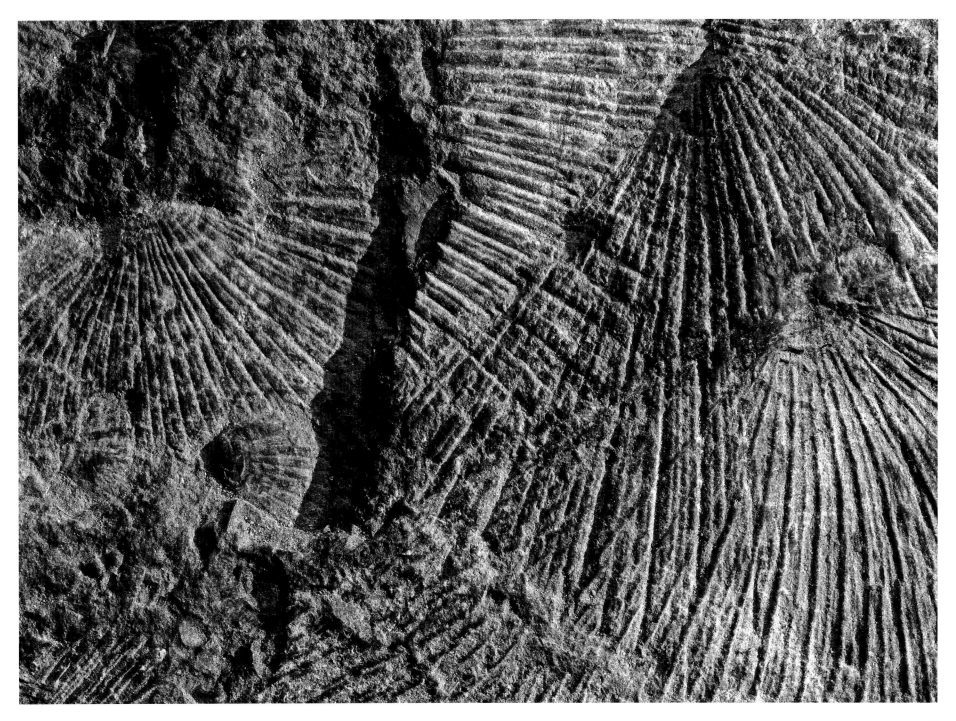

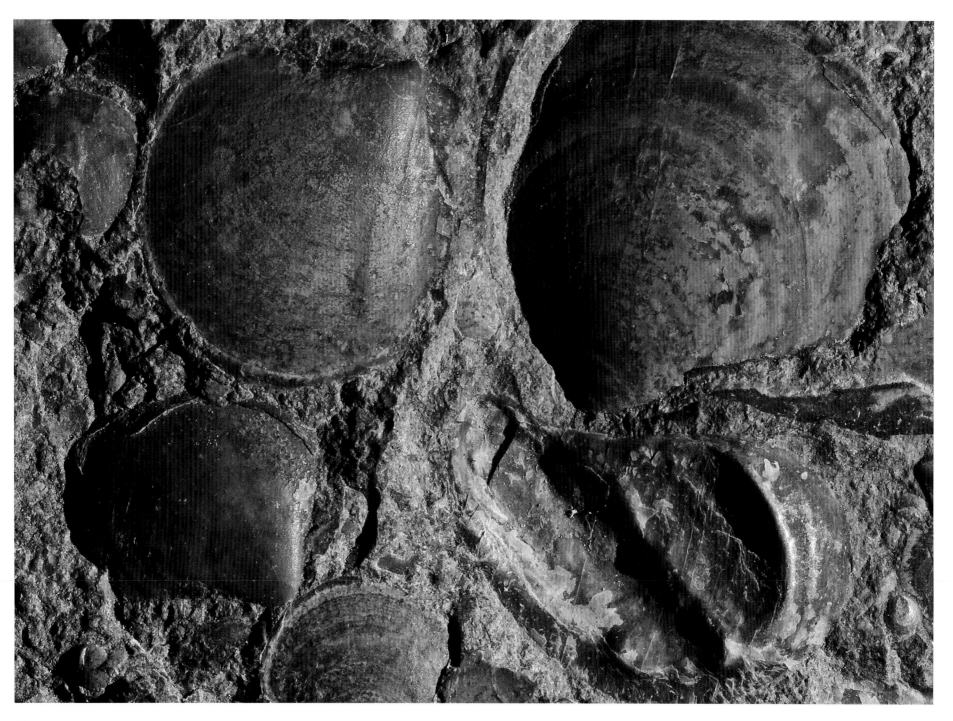

Camptonectes
Unterjura, etwa 203 Ma
Bebenhausen, Deutschland
Vergrößerung: etwa 4 x
Glossar: Weichtiere / Muscheln

Geocoma
Mitteljura, etwa 170 Ma
La Voulte sur Rhône, Frankreich
Vergrößerung: etwa 9 x
Glossar: Stachelhäuter / Schlangensterne

Camptonectes
Early Jurassic, approx. 203 Ma
Bebenhausen, Germany
Enlargement: approx. 4 x
Glossary: molluscs / bivalves

Geocoma
Mid-Jurassic, approx. 170 Ma
La Voulte sur Rhône, France
Enlargement: approx. 9 x
Glossary: echinoderms / ophiuroids

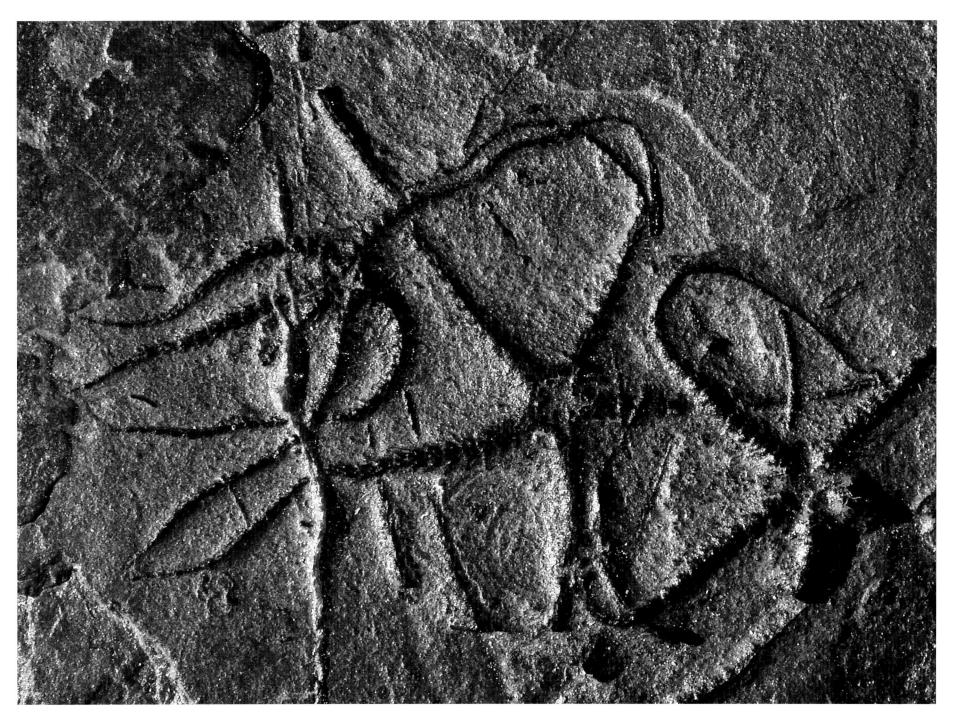

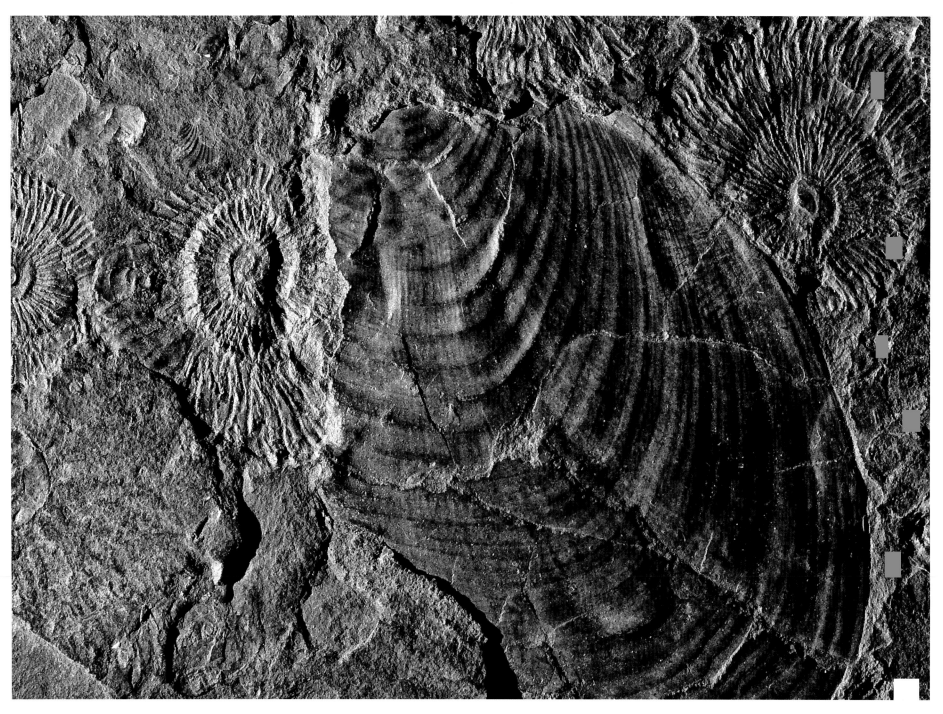

Inoceramus, Dactylioceras
Unterjura, etwa 187 Ma
Bad Boll, Deutschland
Vergrößerung: etwa 4,5 x
Glossar: Weichtiere / Muscheln und Ammoniten

Inoceramus, Dactylioceras
Early Jurassic, approx. 187 Ma
Bad Boll, Germany
Enlargement: approx. 4.5 x
Glossary: molluscs / bivalves and ammonites

Orbitolina
Oberkreide, etwa 95 Ma
Playa del Niños, Spanien
Vergrößerung: etwa 10,5 x
Glossar: Foraminiferen

Orbitolina
Late Cretaceous, approx. 95 Ma
Playa del Niños, Spain
Enlargement: approx. 10.5 x
Glossary: foraminifers

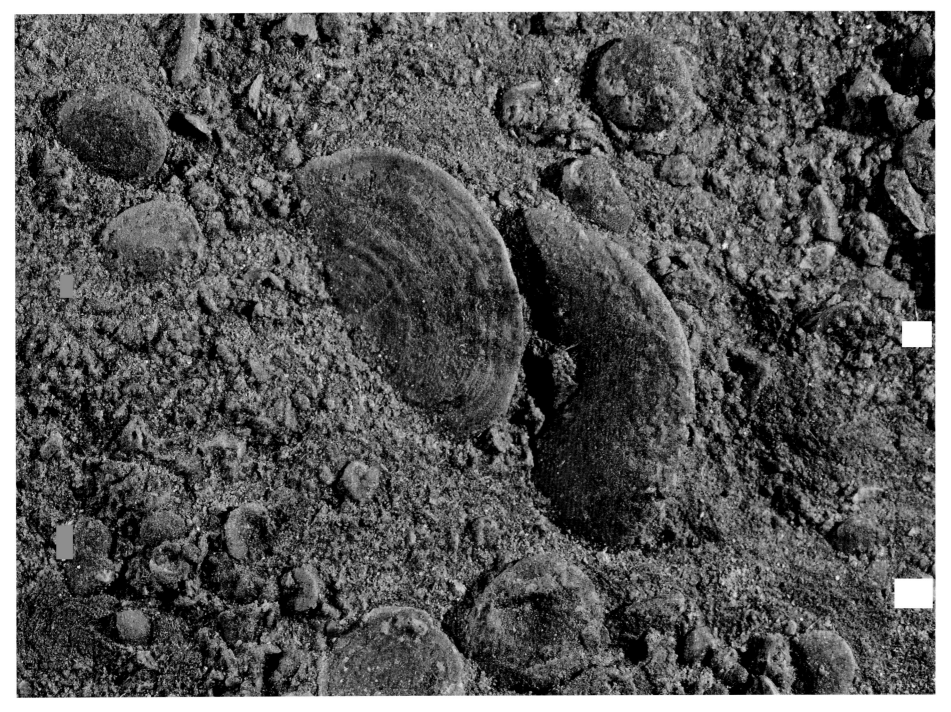

Parafusulina japonica
Unterperm, etwa 270 Ma
Kinshozan Akasaka, Japan
Vergrößerung: etwa 10x
Glossar: Foraminiferen

Parafusulina japonica
Early Permian, approx. 270 Ma
Kinshozan Akasaka, Japan
Enlargement: approx. 10x
Glossary: foraminifers

Chancelloria
Mittelkambrium, etwa 512 Ma
Millard County, Utah, USA
Vergrößerung: etwa 4,5x
Glossar: Chancellorien

Chancelloria
Middle Cambrian, approx. 512 Ma
Millard County, Utah, USA
Enlargement: approx. 4.5x
Glossary: chancellorians

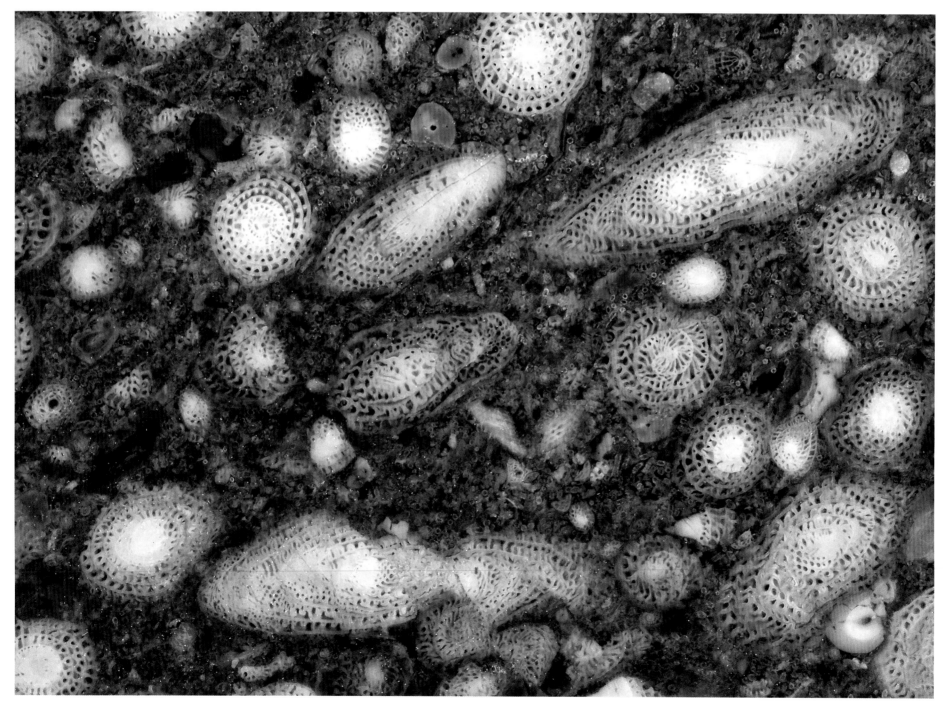

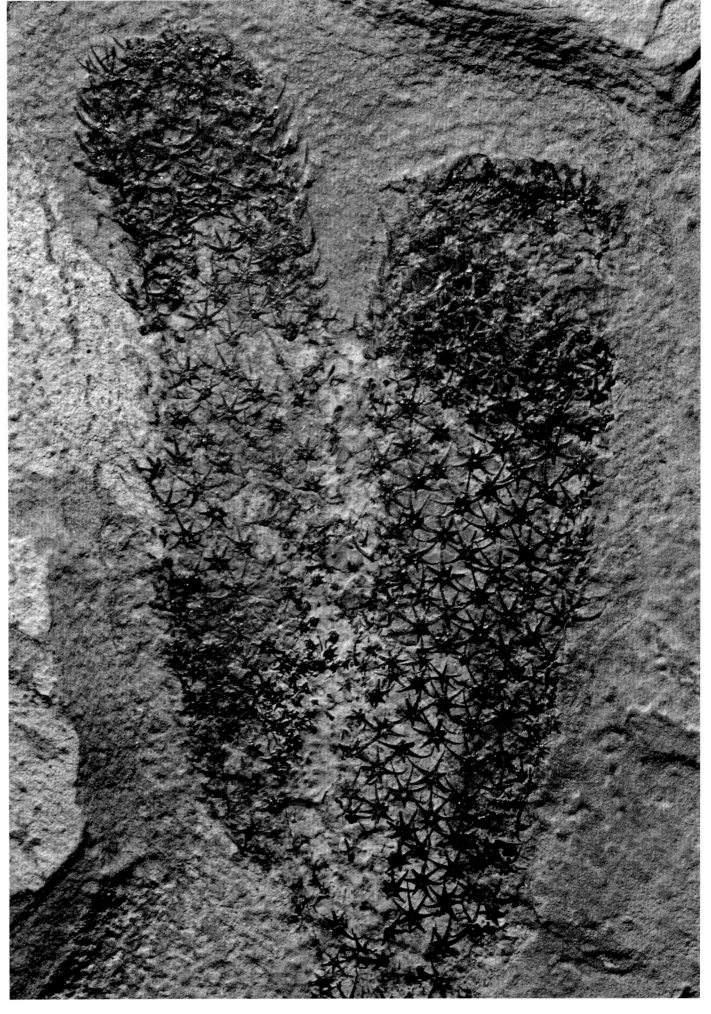

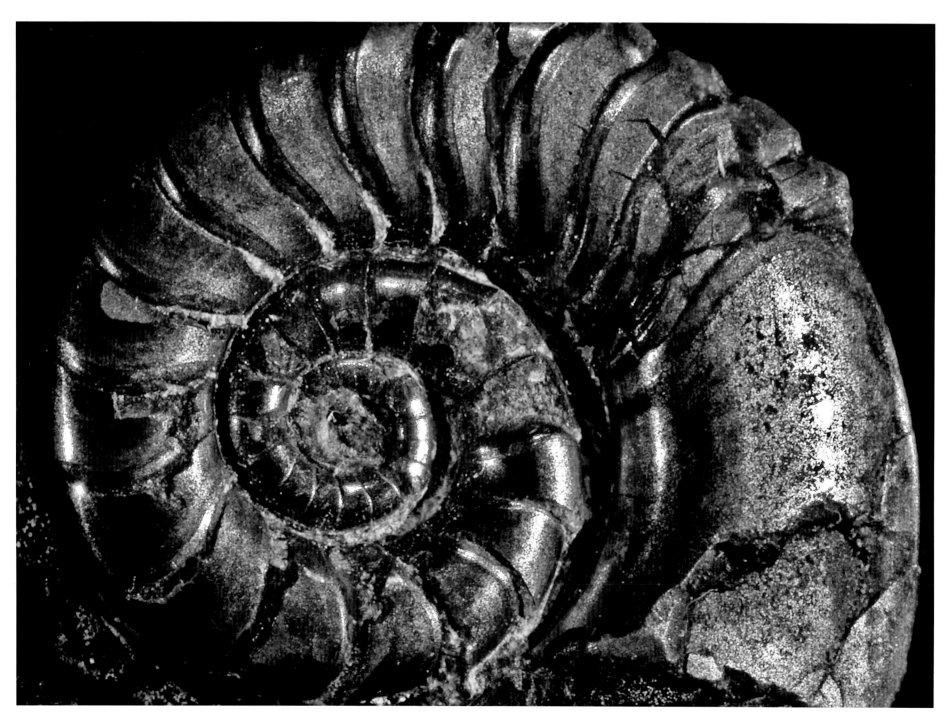

Gyroceratites
Mitteldevon, etwa 385 Ma
Wissenbach, Nassau, Deutschland
Vergrößerung: etwa 13 x
Glossar: Weichtiere / Ammoniten

Gyroceratites
Middle Devonian, approx. 385 Ma
Wissenbach, Nassau, Germany
Enlargement: approx. 13 x
Glossary: molluscs / ammonoids

Cardioceras
Oberjura, etwa 156 Ma
Anaba River, Sibirien, Rußland
Vergrößerung: etwa 10 x
Glossar: Weichtiere / Ammoniten

Cardioceras
Late Jurassic, approx. 156 Ma
Anaba River, Siberia, Russia
Enlargement: approx. 10 x
Glossary: molluscs / ammonoids

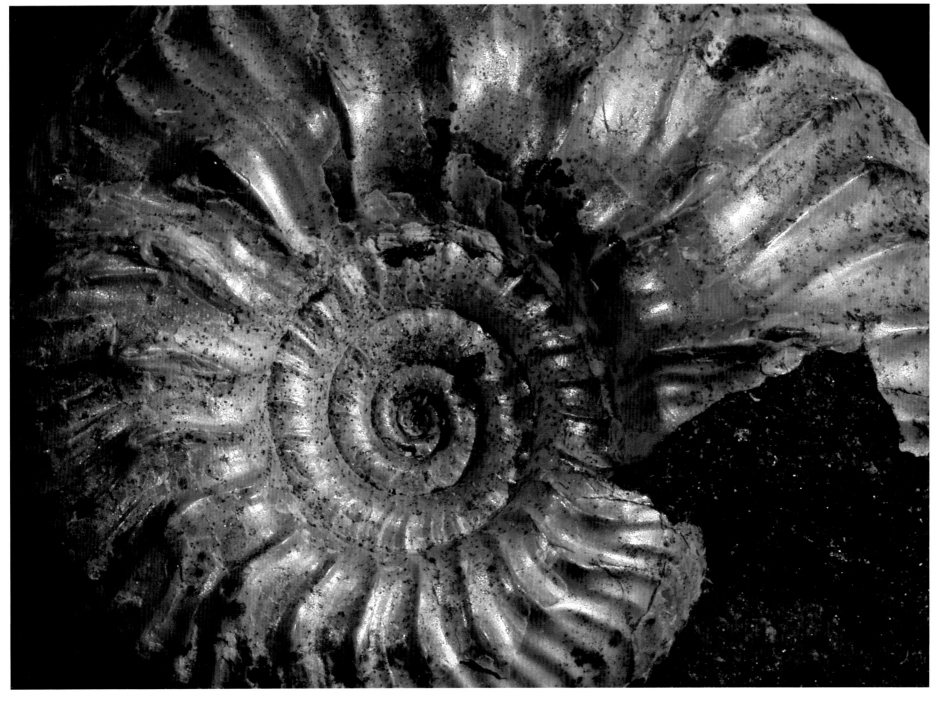

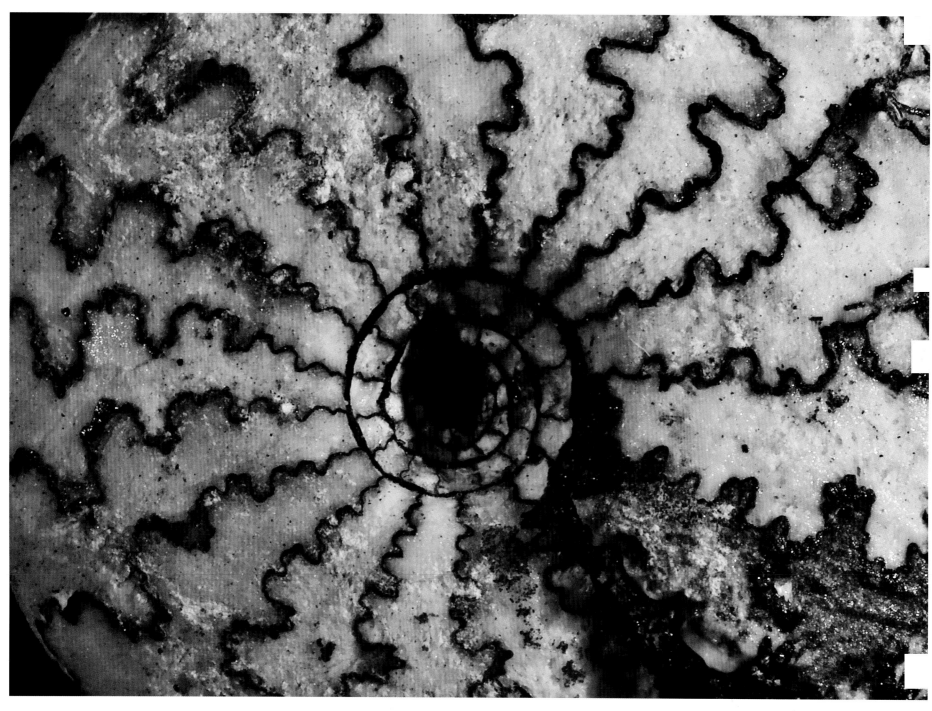

Craspedites
Oberjura, etwa 147 Ma
Makarjew, Rußland
Vergrößerung: etwa 12 x
Glossar: Weichtiere / Ammoniten

Craspedites
Late Jurassic, approx. 147 Ma
Makarjew, Russia
Enlargement: approx. 12 x
Glossary: molluscs / ammonoids

Cymatoceras, Medianschnitt mit Sipho
Unterkreide, etwa 110 Ma
Mahajanga, Madagaskar
Vergrößerung: etwa 3,5 x
Glossar: Weichtiere, Nautiliden

Cymatoceras, median section with siphuncle
Early Cretaceous, approx. 110 Ma
Mahajanga, Madagascar
Enlargement: approx. 3.5 x
Glossary: molluscs / nautilids

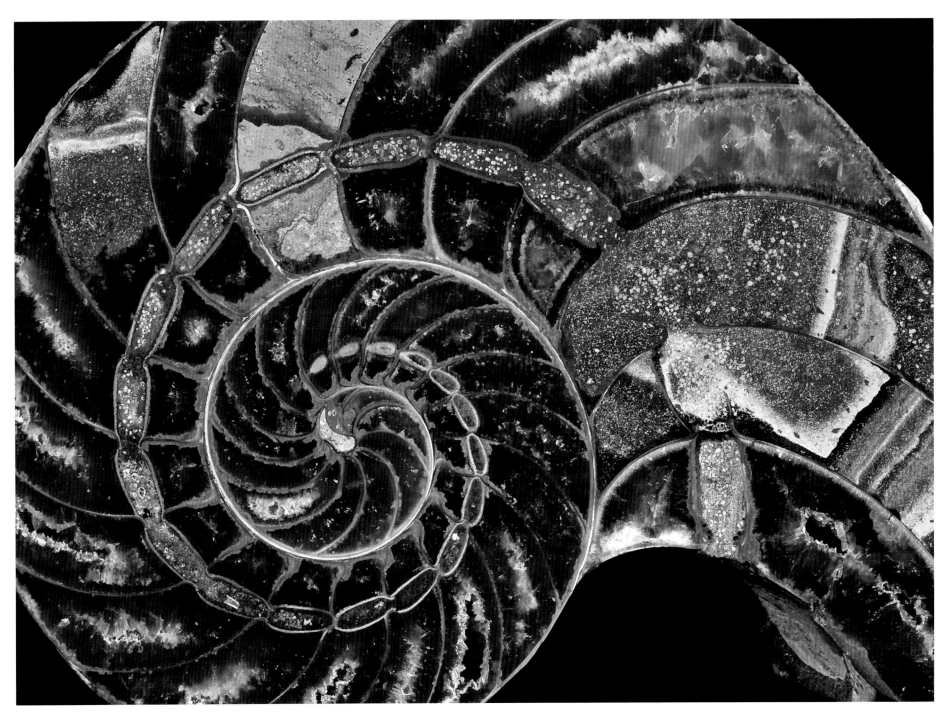

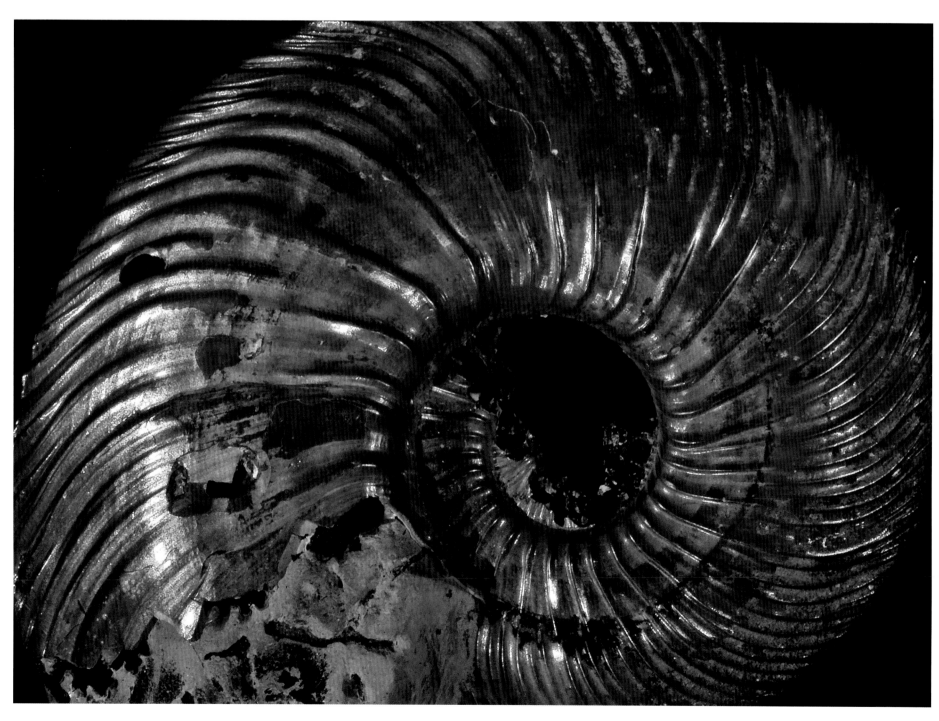

Quenstedtoceras
Mitteljura, etwa 162 Ma
Saratov, Wolga, Rußland
Vergrößerung: etwa 6 x
Glossar: Weichtiere / Ammoniten

Quenstedtoceras
Middle Jurassic, approx. 162 Ma
Saratov, Volga, Russia
Enlargement: approx. 6 x
Glossary: molluscs / ammonoids

Douvilleiceras
Unterkreide, etwa 110 Ma
Mahajanga, Madagaskar
Vergrößerung: etwa 3,3 x
Glossar: Weichtiere / Ammoniten

Douvilleiceras
Early Cretaceous, approx. 110 Ma
Mahajanga, Madagascar
Enlargement: approx. 3.3 x
Glossary: molluscs / ammonoids

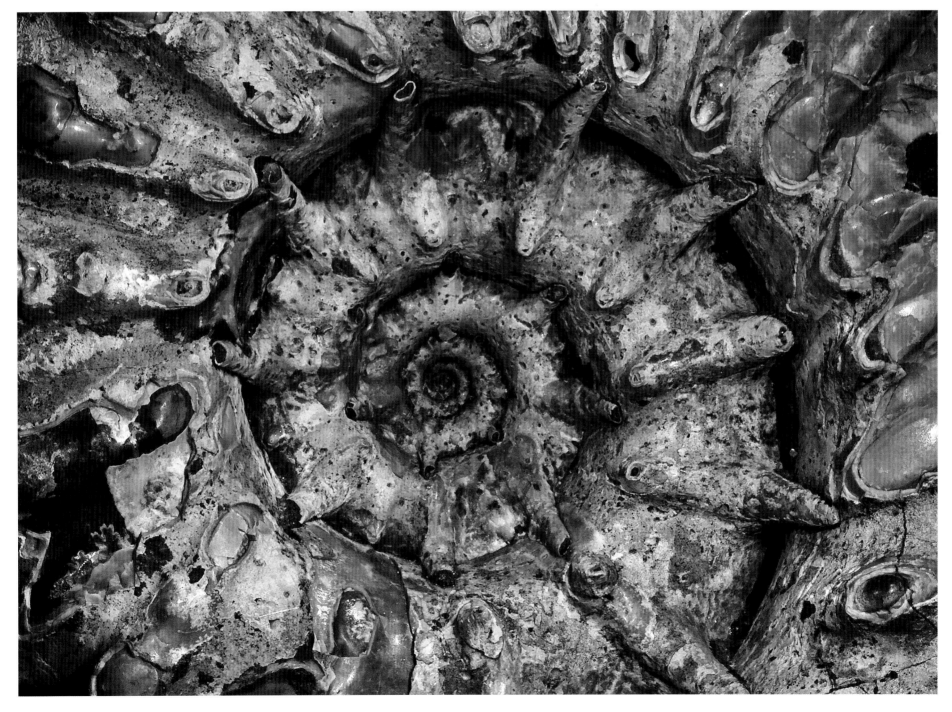

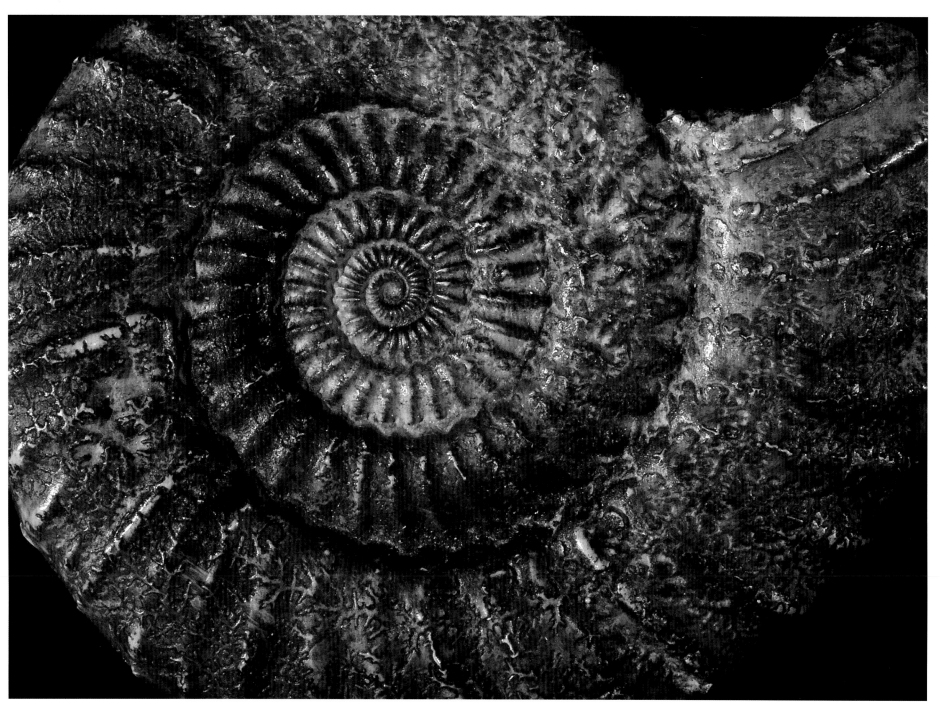

Uptonia jamesoni, Abguß
Unterjura, etwa 190 Ma
Sao Pedro de Muel, Portugal
Vergrößerung: etwa 4x
Glossar: Weichtiere / Ammoniten

Uptonia jamesoni, mould
Early Jurassic, approx. 190 Ma
Sao Pedro de Muel, Portugal
Enlargement: approx. 4x
Glossary: molluscs / ammonoids

Dactylioceras
Unterjura, etwa 185 Ma
Holzmaden, Deutschland
Vergrößerung: etwa 3x
Glossar: Weichtiere / Ammoniten

Dactylioceras
Early Jurassic, approx. 185 Ma
Holzmaden, Germany
Enlargement: approx. 3x
Glossary: molluscs / ammonoids

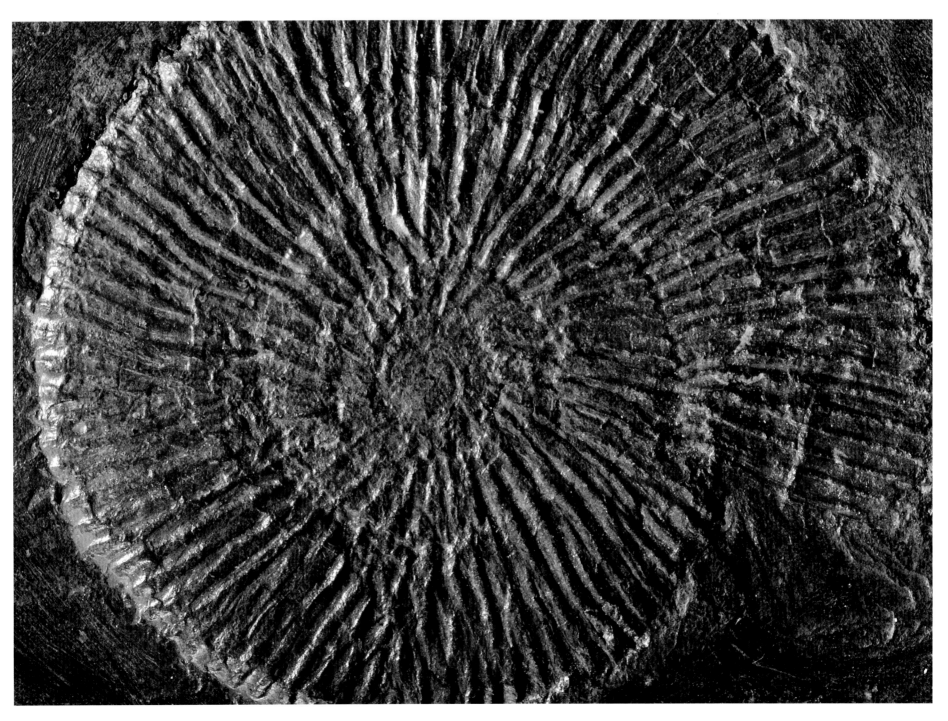

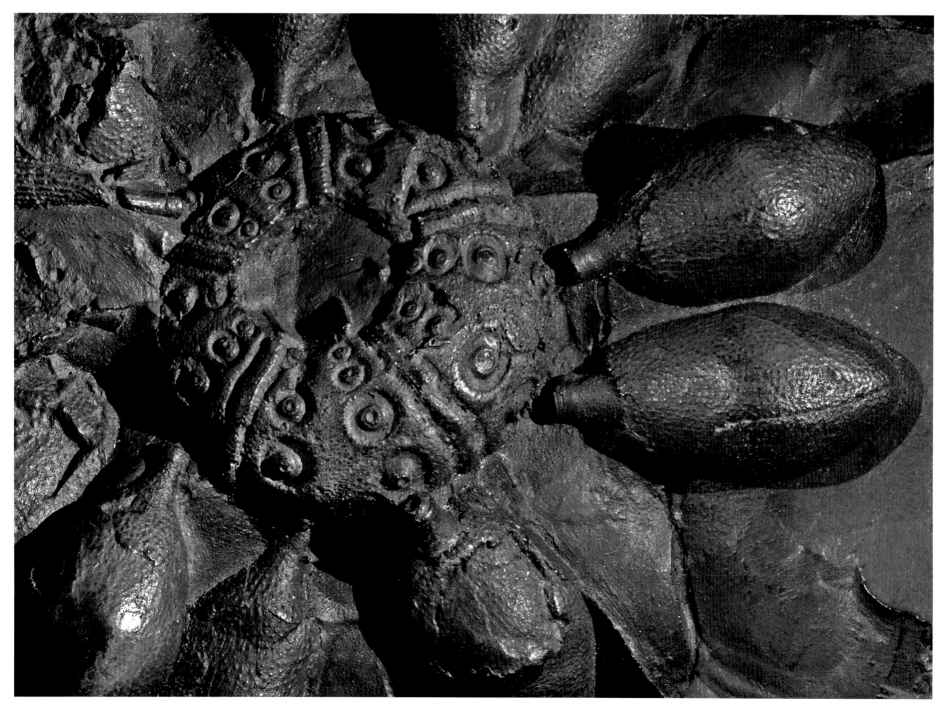

Tylocidaris, Abguß
Oberkreide, etwa 85 Ma
Dänemark
Vergrößerung: etwa 3x
Glossar: Stachelhäuter / Seeigel

Tylocidaris, mould
Late Cretaceous, approx. 85 Ma
Denmark
Enlargement: approx. 3x
Glossary: echinoderms / sea urchins

Hemicidaris
Jura, etwa 175 Ma
Noviou-Porcien, Frankreich
Vergrößerung: etwa 10x
Glossar: Stachelhäuter / Seeigel

Hemicidaris
Jurassic, approx. 175 Ma
Noviou-Porcien, France
Enlargement: approx. 10x
Glossary: echinoderms / sea urchins

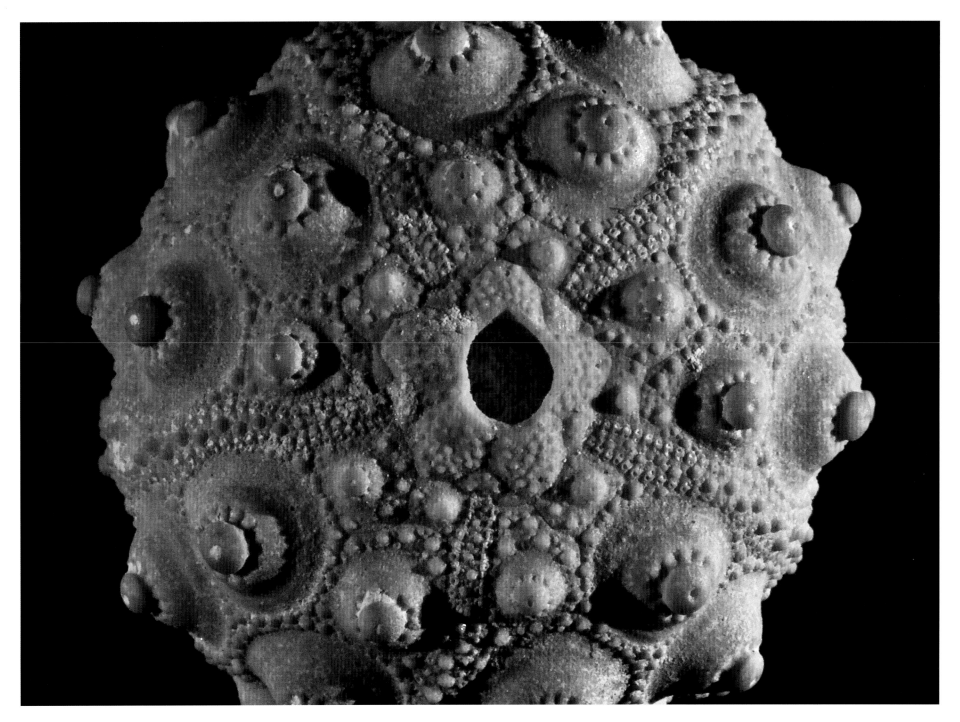

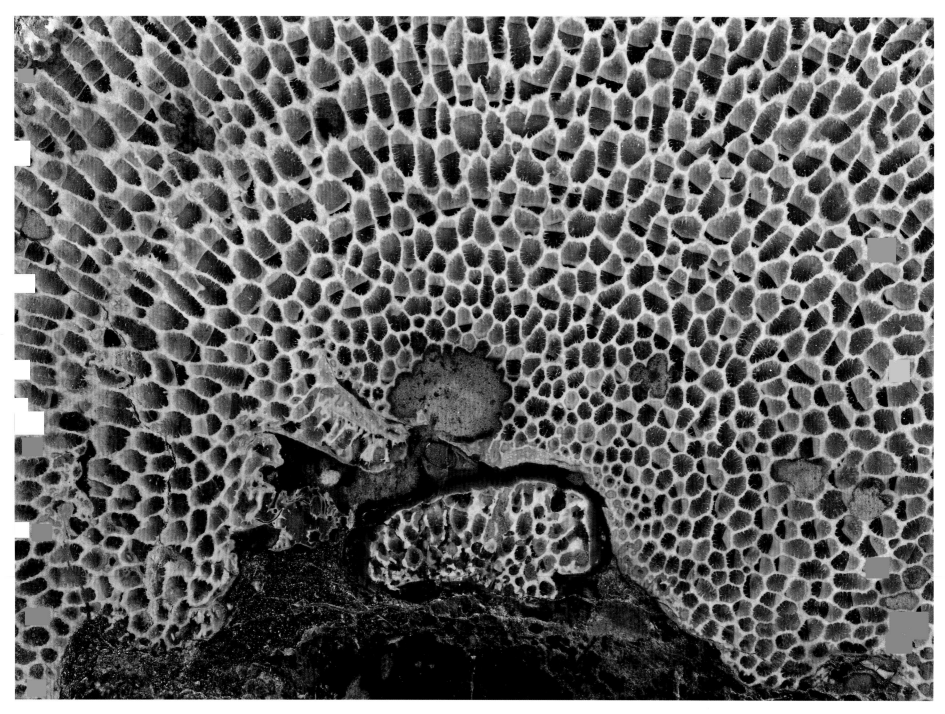

Acanthochaetetes
Unterkreide, etwa 105 Ma
Albeniz, Spanien
Vergrößerung: etwa 9 x
Glossar: Schwämme

Acanthochaetetes
Early Cretaceous, approx. 105 Ma
Albeniz, Spain
Enlargement: approx. 9 x
Glossary: sponges

Chonophyllum
Obersilur, etwa 420 Ma
Visby, Gotland, Schweden
Vergrößerung: etwa 3,7 x
Glossar: Korallen / Rugosa

Chonophyllum
Late Silurian, approx. 420 Ma
Visby, Gotland, Sweden
Enlargement: approx. 3.7 x
Glossary: corals / Rugosa

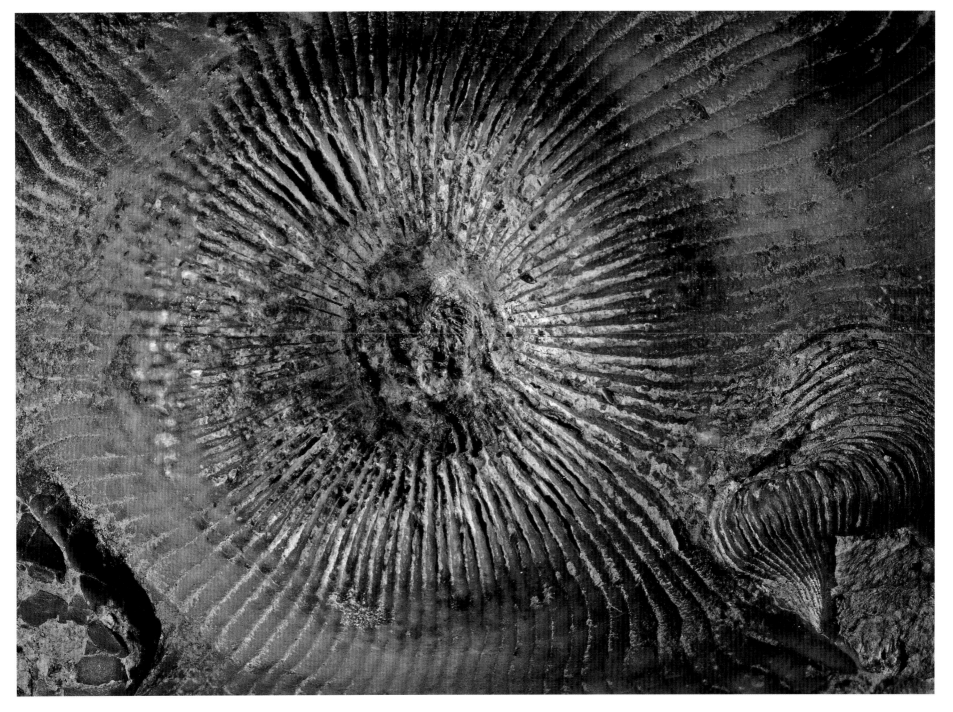

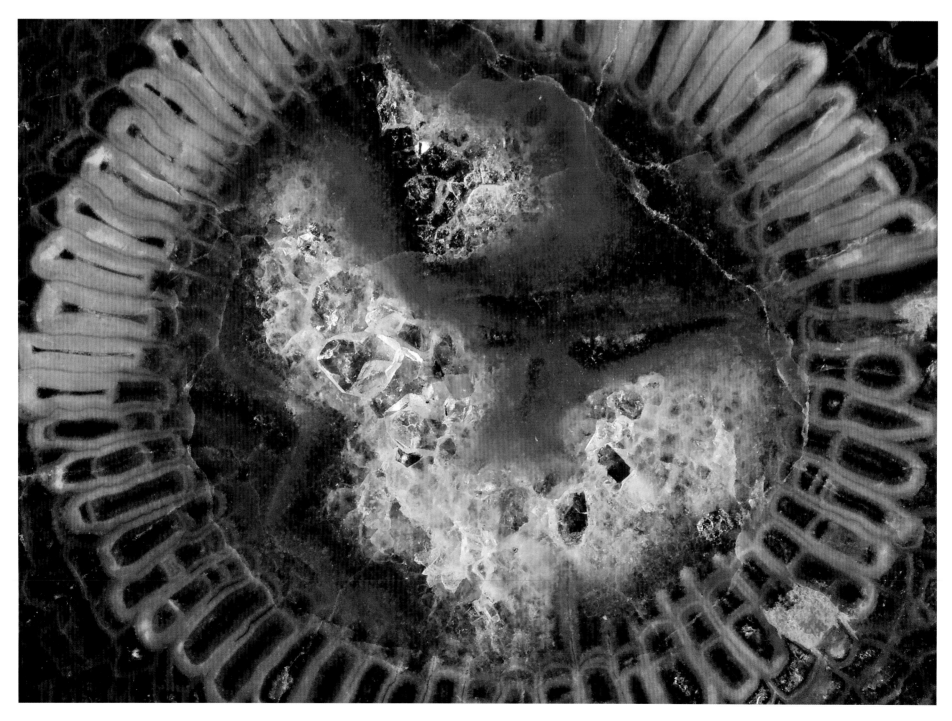

Schnitt durch eine rugose Koralle
Oberkarbon, etwa 300 Ma
Rabanal, Spanien
Vergrößerung: etwa 10 x
Glossar: Korallen / Rugosa

Section through a rugosan coral
Late Carboniferous, approx. 300 Ma
Rabanal, Spain
Enlargement: approx. 10 x
Glossary: corals / Rugosa

Semicassis
Unteroligozän, etwa 30 Ma
Berlin-Hermsdorf, Deutschland
Vergrößerung: etwa 12 x
Glossar: Weichtiere / Schnecken

Semicassis
Early Oligocene, approx. 30 Ma
Berlin-Hermsdorf, Germany
Enlargement: approx. 12 x
Glossary: molluscs / gastropods

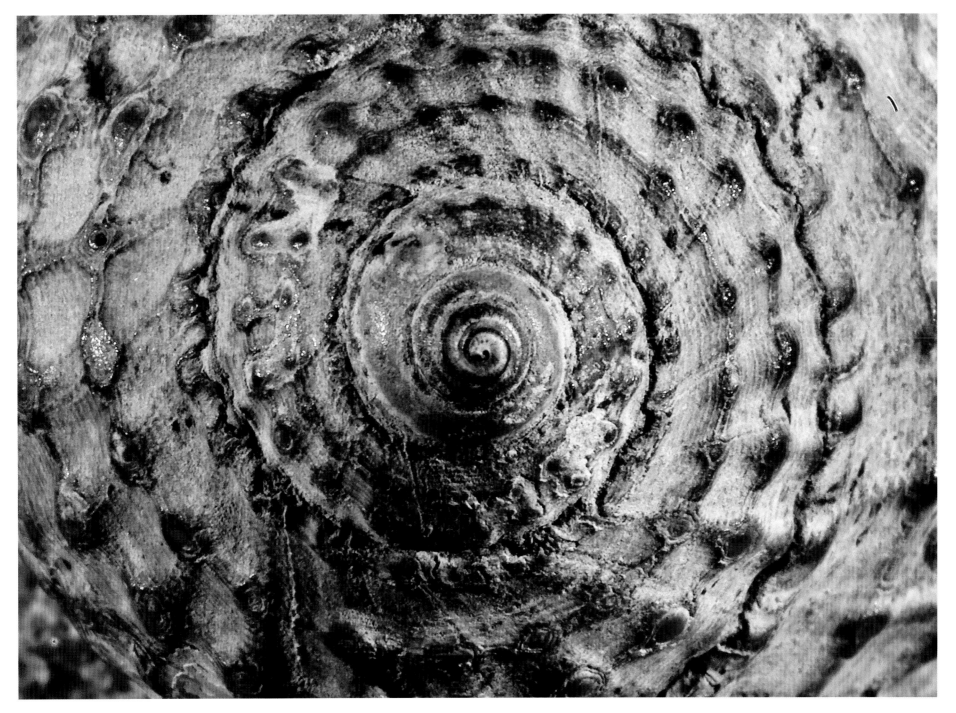

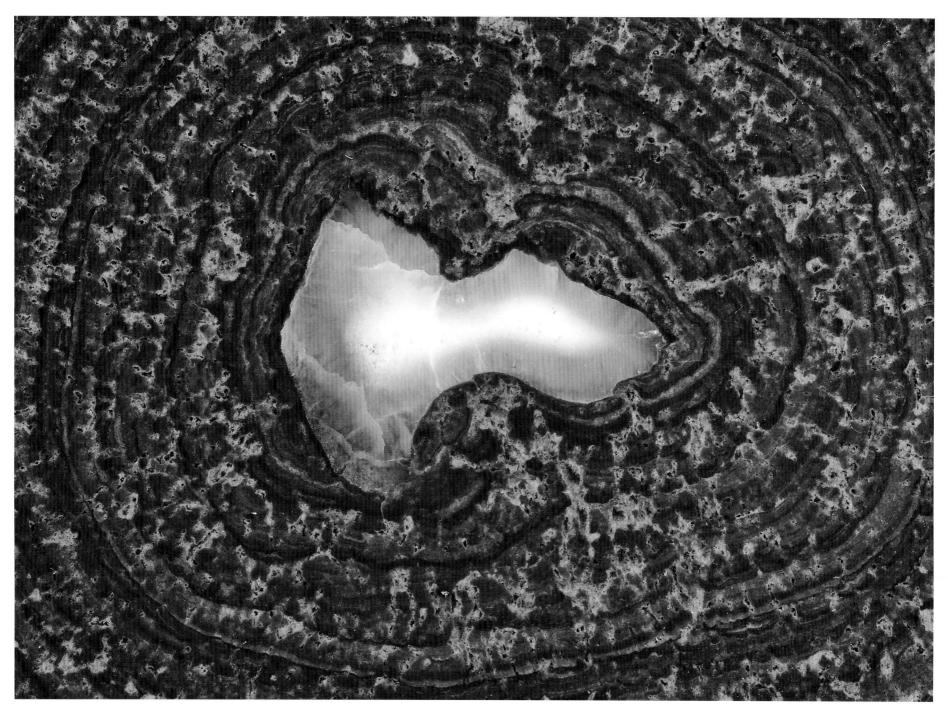

Süßwasser-Onkoid
Oberkreide, ca. 70 Ma
Val Cebre, Spanien
Vergrößerung: etwa 6,5 x
Glossar: Cyanobakterien / Onkoide

Bacterial pisoid
Late Cretaceous, approx. 70 Ma
Val Cebre, Spain
Enlargement: approx. 6.5 x
Glossary: blue-green algae / oncoids

Lopha
Mitteljura, etwa 173 Ma
Ringsheim, Deutschland
Vergrößerung: etwa 6,5 x
Glossar: Weichtiere / Muscheln

Lopha
Middle Jurassic, approx. 173 Ma
Ringsheim, Germany
Enlargement: approx. 6.5 x
Glossary: molluscs / bivalves

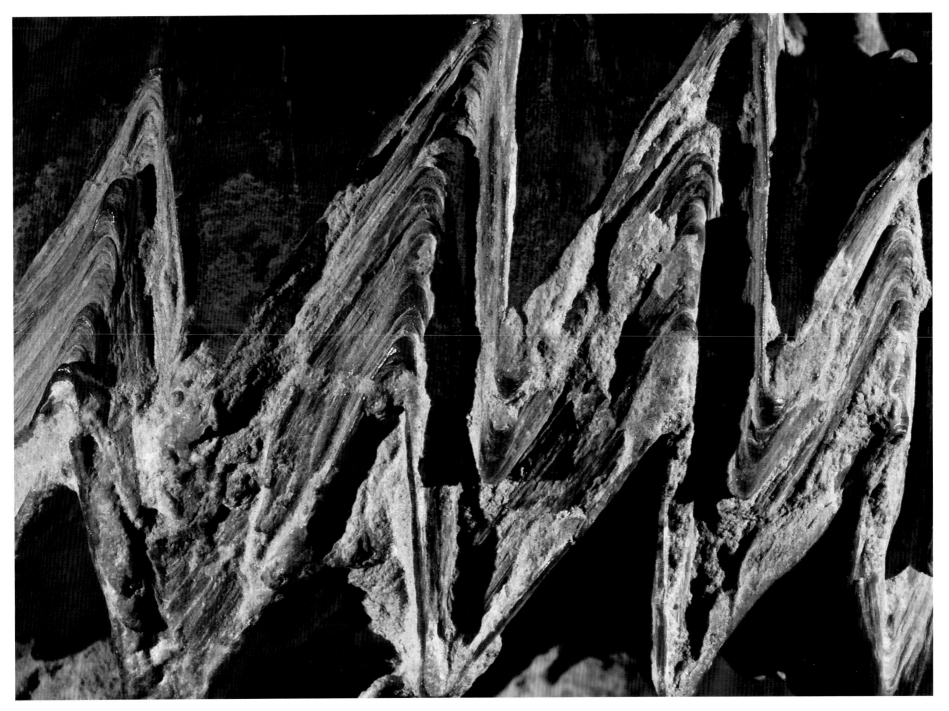

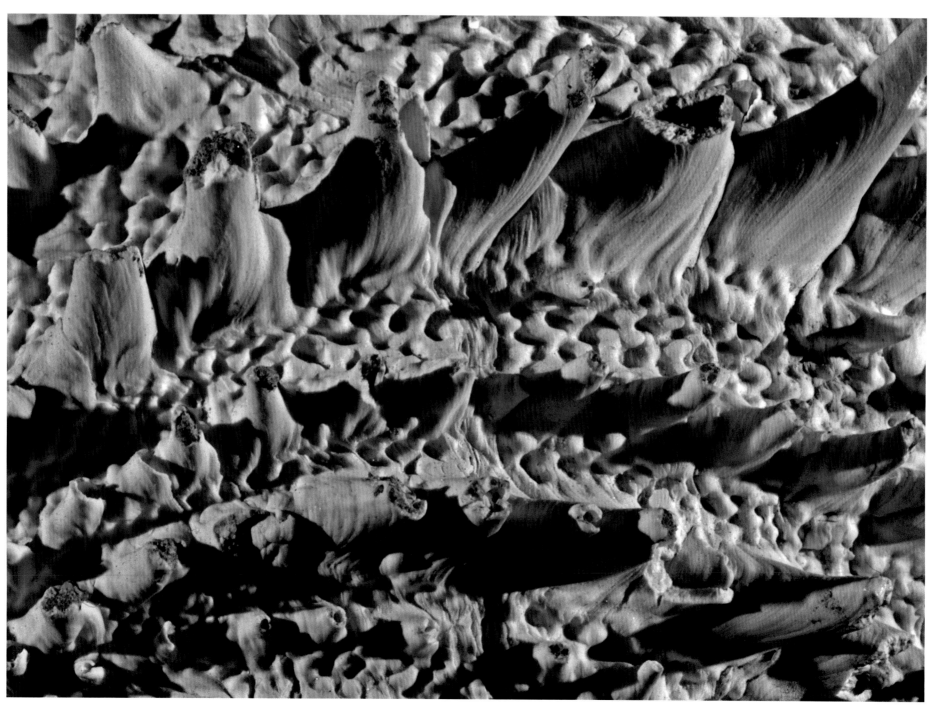

Arcinella
Pleistozän, etwa 1 Ma
Sarasota, Florida, USA
Vergrößerung: etwa 8,5 x
Glossar: Weichtiere / Muscheln

Arcinella
Pleistocene, approx. 1 Ma
Sarasota, Florida, USA
Enlargement: approx. 8.5 x
Glossary: molluscs / bivalves

Oberfläche von *Myophorella*
Oberjura, etwa 153 Ma
St. Cruz, Portugal
Vergrößerung: etwa 9 x
Glossar: Weichtiere / Muscheln

Surface structure of *Myophorella*
Late Jurassic, approx. 153 Ma
St. Cruz, Portugal
Enlargement: approx. 9 x
Glossary: molluscs / bivalves

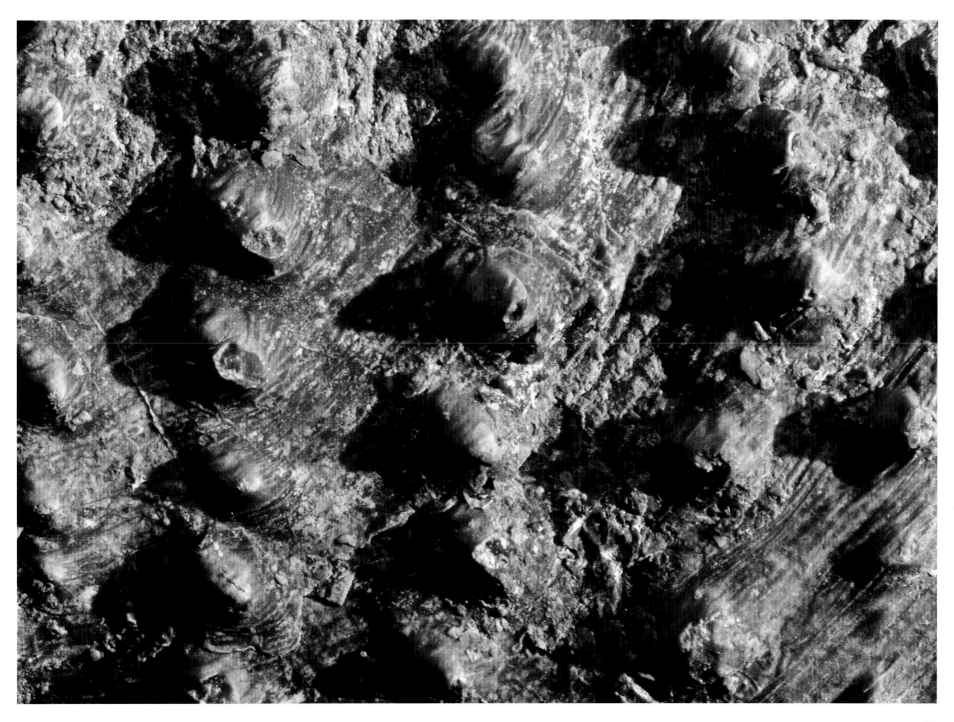

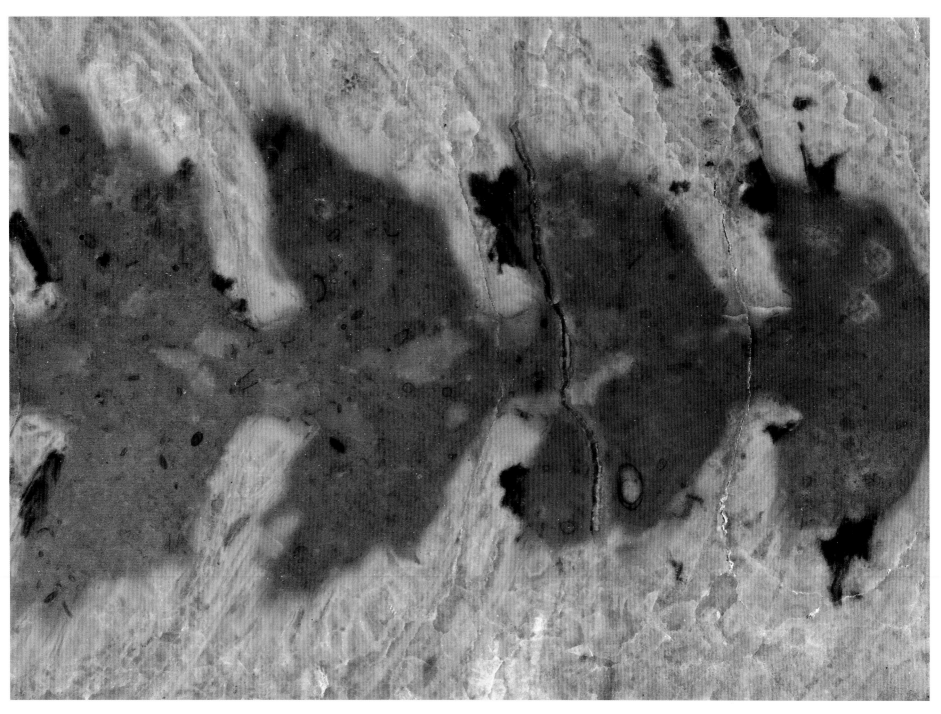

Schnitt durch die Siphonalstruktur eines Orthoceriden
Mitteldevon, etwa 380 Ma
Erfoud, Marokko
Vergrößerung: etwa 10x
Glossar: Weichtiere / Nautiliden

Section through the siphuncle of an orthocerid cephalopod
Middle Devonian, approx. 380 Ma
Erfoud, Morocco
Enlargement: approx. 10x
Glossary: molluscs / nautilids

Schnitt durch einen *Orthoceras*
Mitteldevon, etwa 380 Ma
Erfoud, Marokko
Vergrößerung: etwa 10x
Glossar: Weichtiere / Nautiliden

Section through an *Orthoceras*
Middle Devonian, approx. 380 Ma
Erfoud, Morocco
Enlargement: approx. 10x
Glossary: molluscs / nautilids

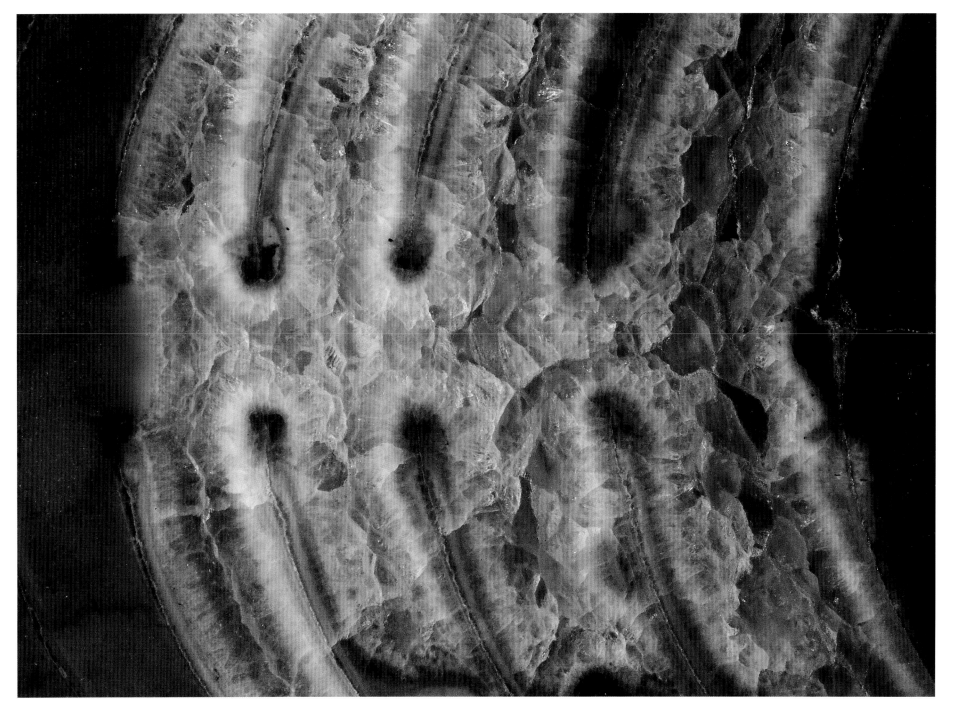

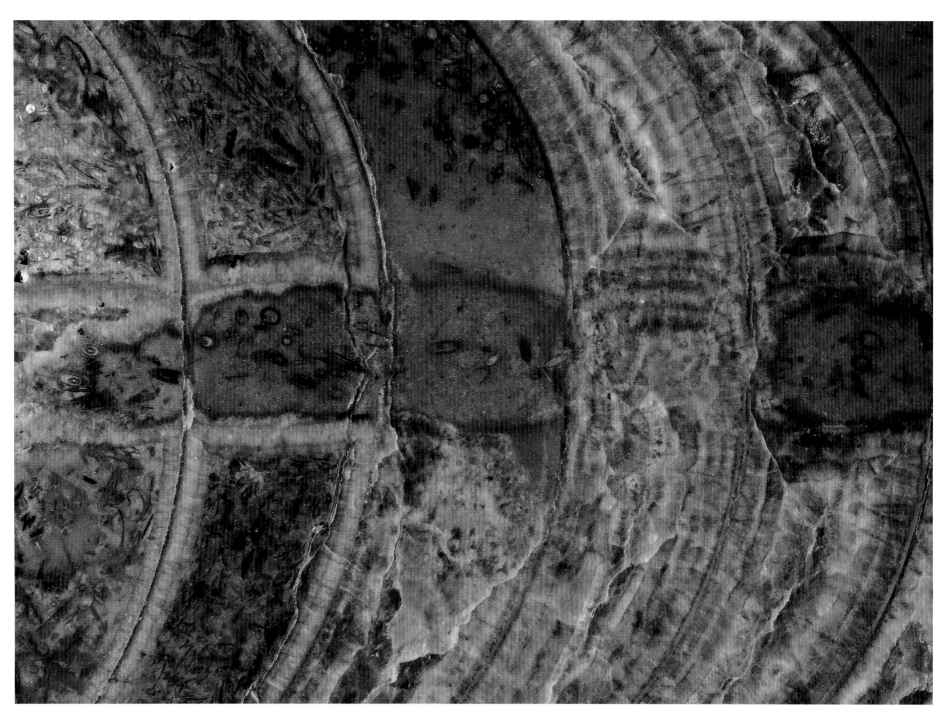

Schnitt durch den Sipho eines Orthoceriden
Mitteldevon, etwa 380 Ma
Erfoud, Marokko
Vergrößerung: etwa 10 x
Glossar: Weichtiere / Nautiliden

Longitudinal section through the siphuncle of an
orthocerid cephalopod
Middle Devonian, approx. 380 Ma
Erfoud, Morocco
Enlargement: approx. 10 x
Glossary: molluscs / nautilids

Schnitt durch den Sipho eines Actionoceriden
Mitteldevon, etwa 380 Ma
Erfoud, Marokko
Vergrößerung: etwa 6,6 x
Glossar: Weichtiere / Nautiliden

Longitudinal section through the siphuncle of an
actinocerid cephalopod
Middle Devonian, approx. 380 Ma
Erfoud, Morocco
Enlargement: approx. 6.6 x
Glossary: molluscs / nautilids

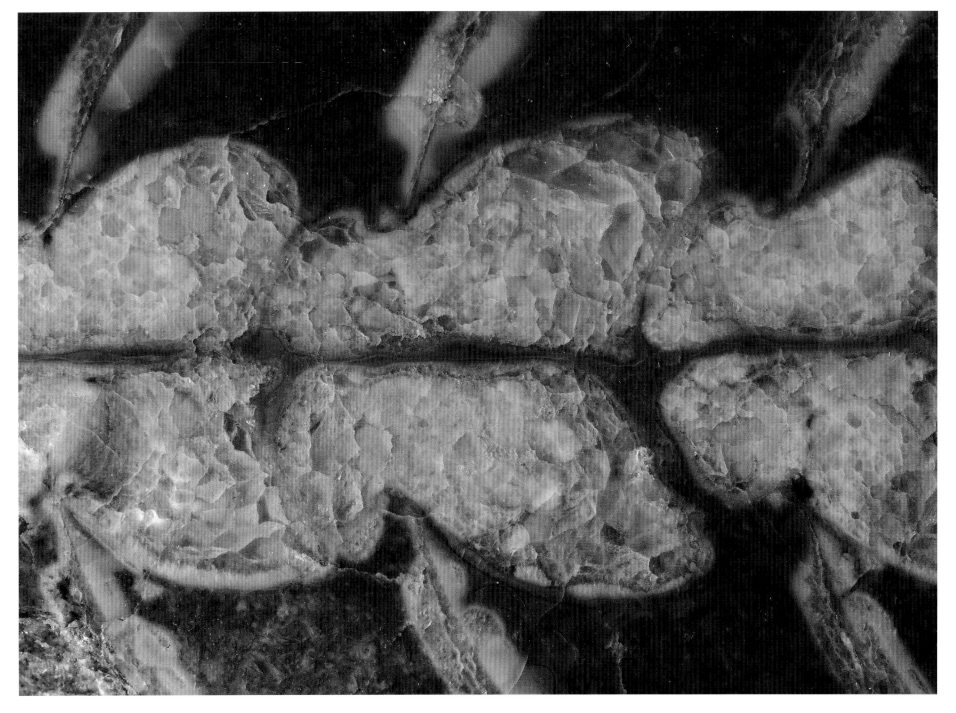

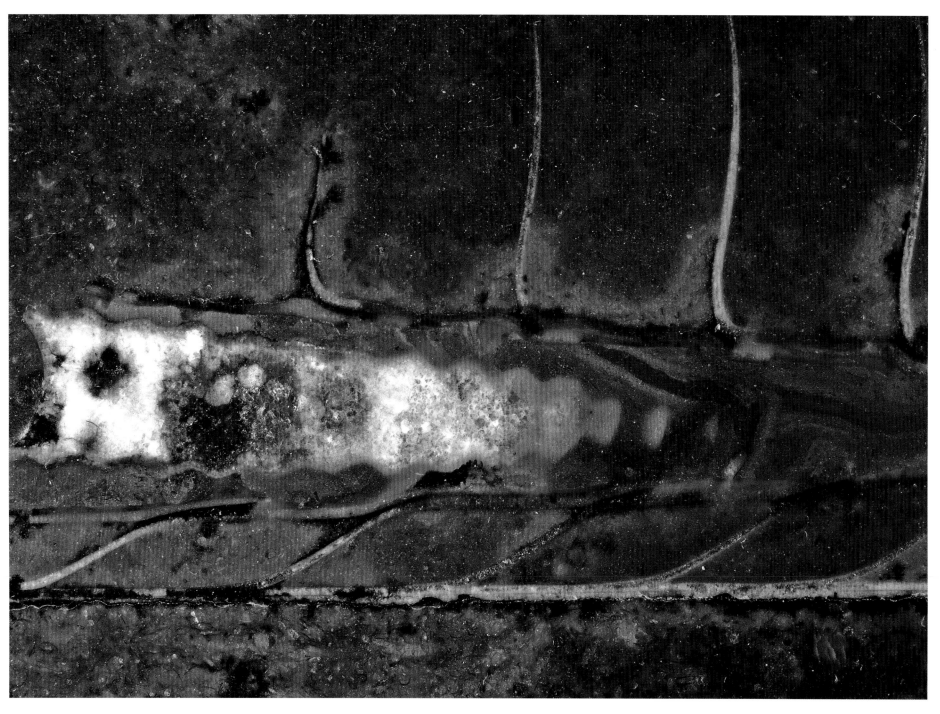

Schnitt durch den Sipho eines *Endoceras*
Unterordovizium, etwa 470 Ma
Hällekis, Kinnekulle, Schweden
Vergrößerung: etwa 6x
Glossar: Weichtiere / Nautiliden

Section through the siphuncle of an *Endoceras*
Early Ordovician, approx. 470 Ma
Hällekis, Kinnekulle, Sweden
Enlargement: approx. 6x
Glossary: molluscs / nautilids

Medianschnitt durch einen *Hildoceras*
Unterjura, etwa 190 Ma
Millau, Causses, Frankreich
Vergrößerung: etwa 9x
Glossar: Weichtiere / Ammoniten

Median section through an *Hildoceras*
Early Jurassic, approx. 190 Ma
Millau, Causses, France
Enlargement: approx. 9x
Glossary: molluscs / ammonoids

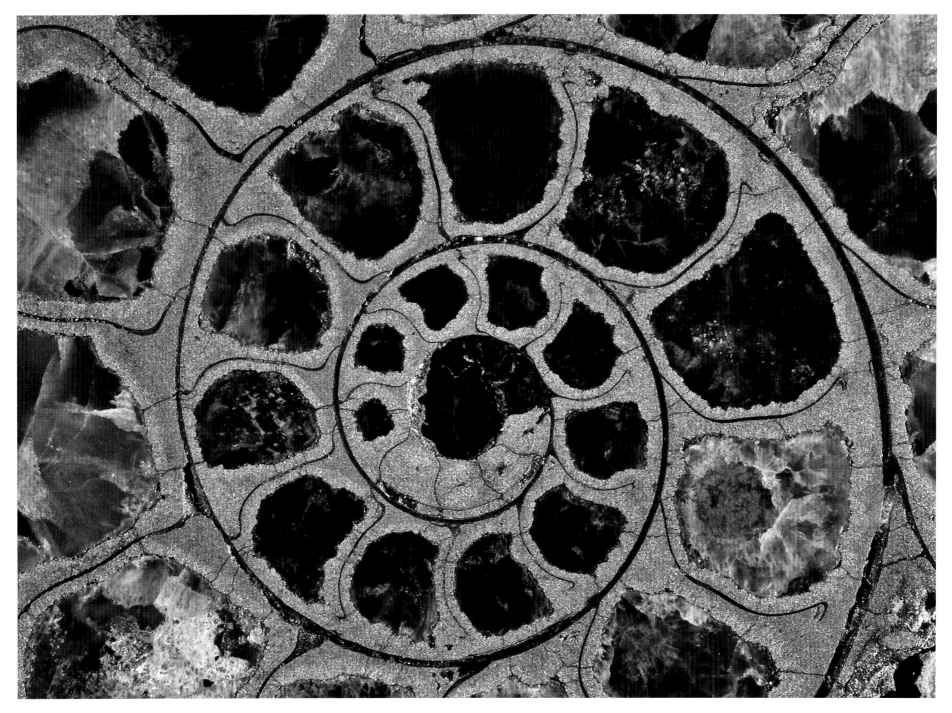

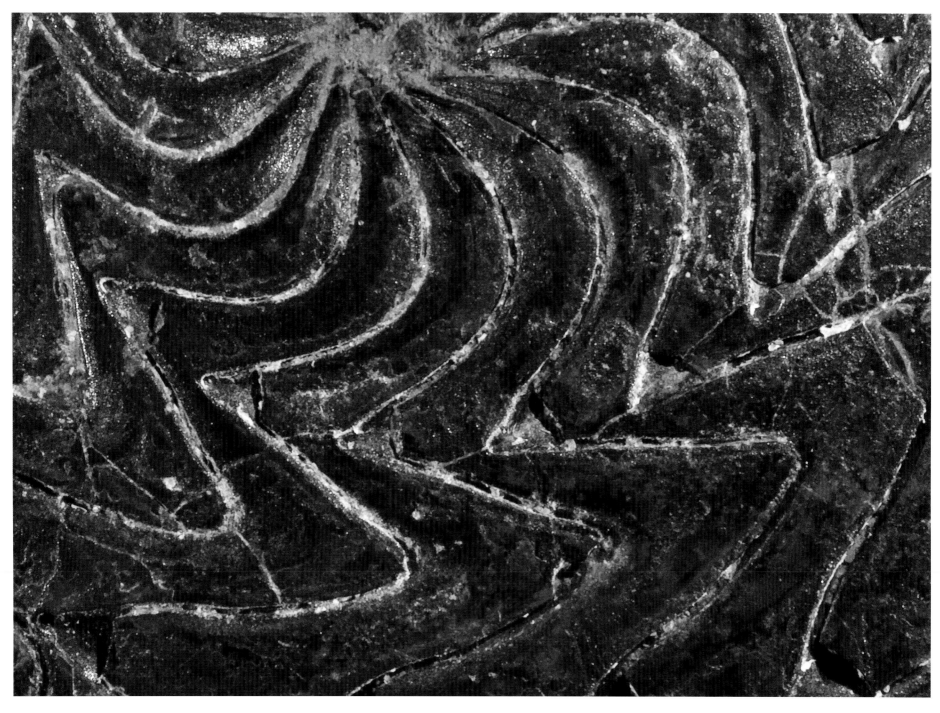

Goniatitische Lobenlinie von *Discoclymenia*
Oberdevon, etwa 360 Ma
Fezzou, Marokko
Vergrößerung: etwa 14 x
Glossar: Weichtiere / Ammoniten

Goniatitic suture of *Discoclymenia*
Late Devonian, approx. 360 Ma
Fezzou, Morocco
Enlargement: approx. 14 x
Glossary: molluscs / ammonoids

Vishnuites
Untertrias, etwa 242 Ma
Kap Stosch, Ost-Grönland
Vergrößerung: etwa 14 x
Glossar: Weichtiere / Ammoniten

Vishnuites
Early Triassic, approx. 242 Ma
Cape Stosch, East Greenland
Enlargement: approx. 14 x
Glossary: molluscs / ammonoids

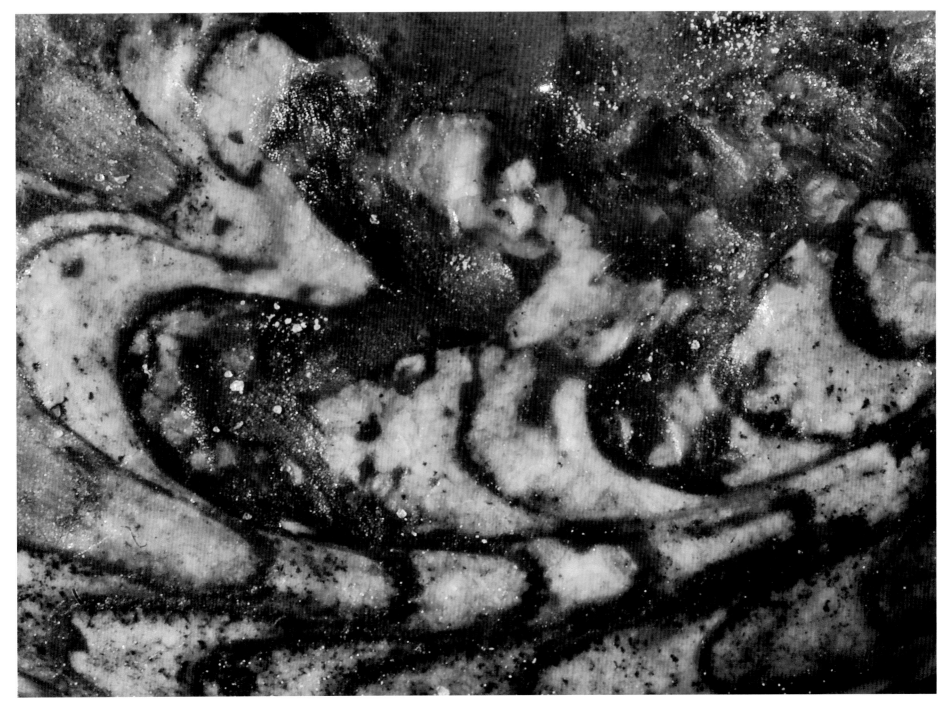

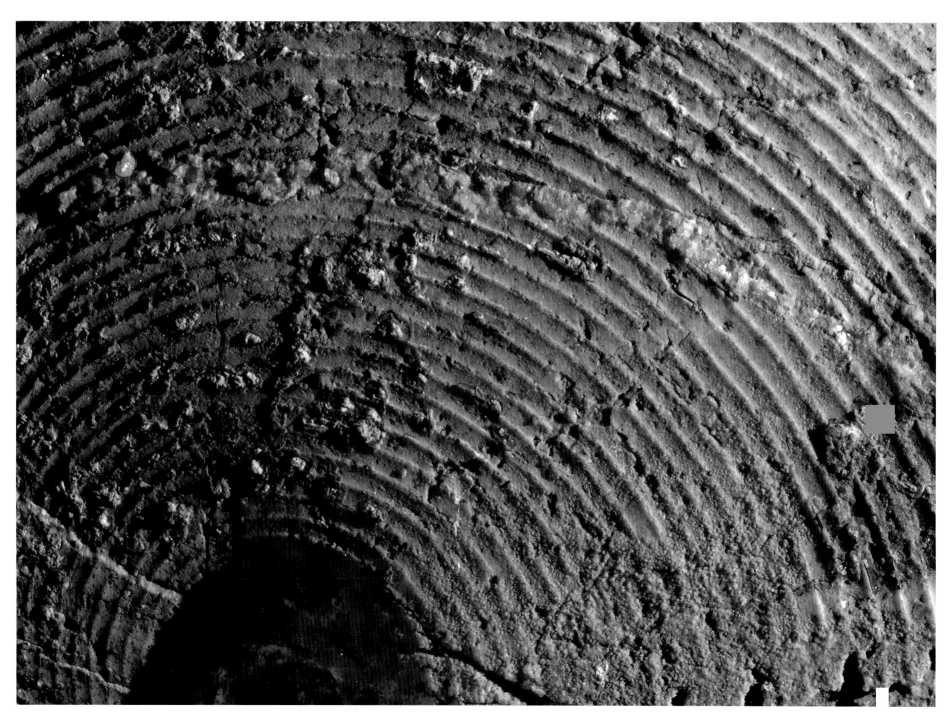

Spiralstreifen eines *Cladiscites*
Obertrias, etwa 225 Ma
Röthelstein, Österreich
Vergrößerung: etwa 6,5 x
Glossar: Weichtiere / Ammoniten

Spiral sculpture of *Cladiscites*
Late Triassic, approx. 225 Ma
Röthelstein, Austria
Enlargement: approx. 6,5 x
Glossary: molluscs / ammonoids

Schnitt durch ein *Megateuthis*-Rostrum
Mitteljura, etwa 170 Ma
Eningen, Deutschland
Vergrößerung: etwa 12 x
Glossar: Weichtiere / Belemniten

Section through a *Megatheuthis* rostrum
Middle Jurassic, approx. 170 Ma
Eningen, Germany
Enlargement: approx. 12 x
Glossary: molluscs / belemnites

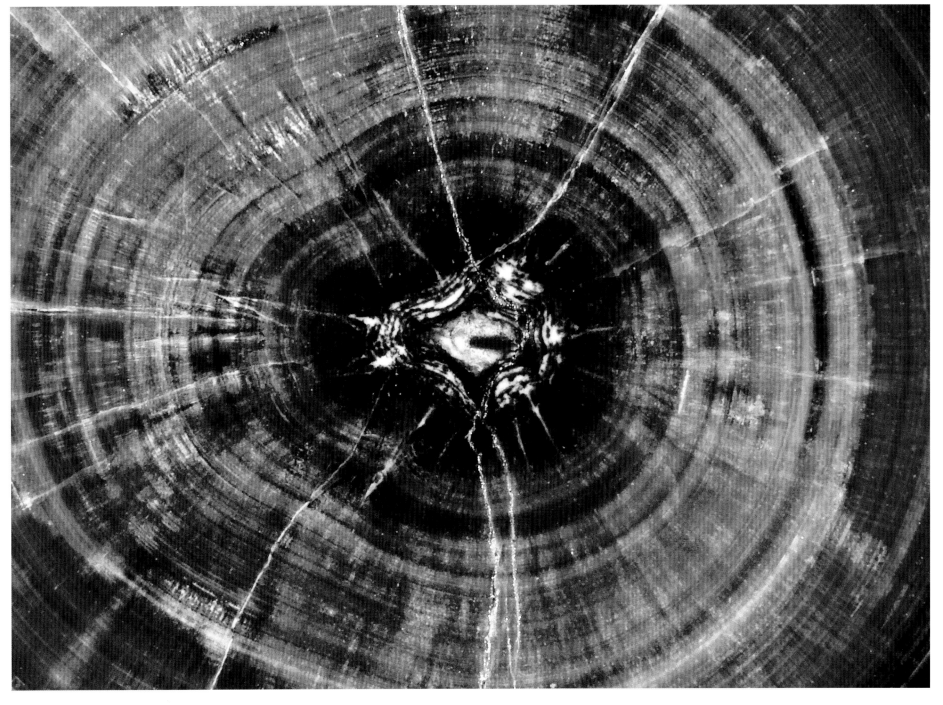

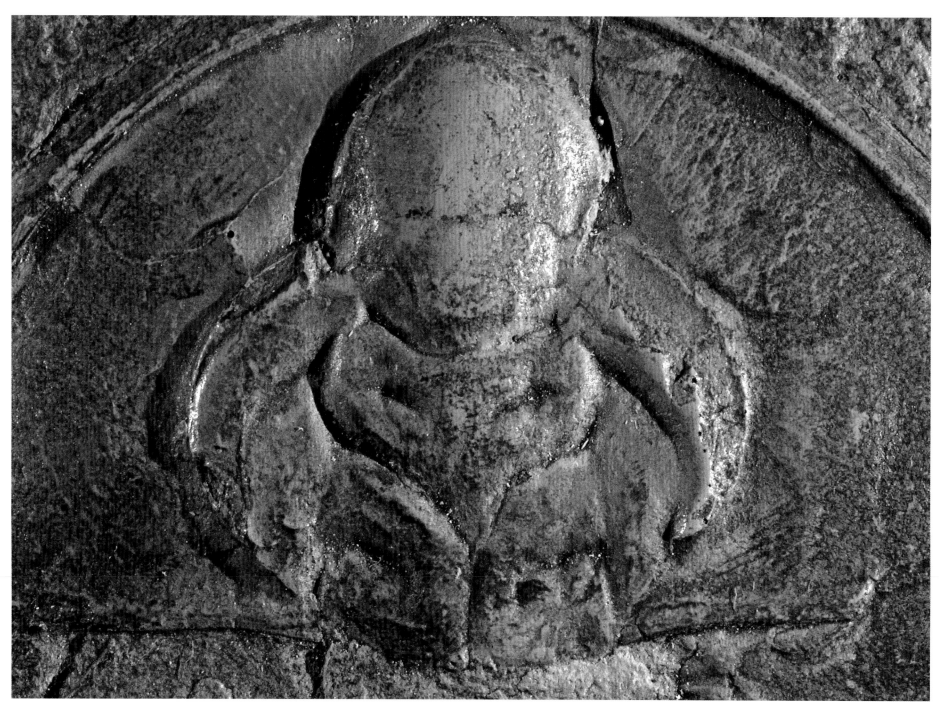

Olenellus-Cephalon
Unterkambrium, etwa 530 Ma
Death Valley, USA
Vergrößerung: etwa 8 x
Glossar: Gliedertiere / Trilobiten

Olenellus cephalon
Early Cambrian, approx. 530 Ma
Death Valley, USA
Enlargement: approx. 8 x
Glossary: arthropods / trilobites

Schizaster
Miozän, etwa 15 Ma
Birzebugga, Malta
Vergrößerung: etwa 7,5 x
Glossar: Stachelhäuter / Seeigel

Schizaster
Miocene, approx. 15 Ma
Birzebugga, Malta
Enlargement: approx. 7.5 x
Glossary: echinoderms / sea urchins

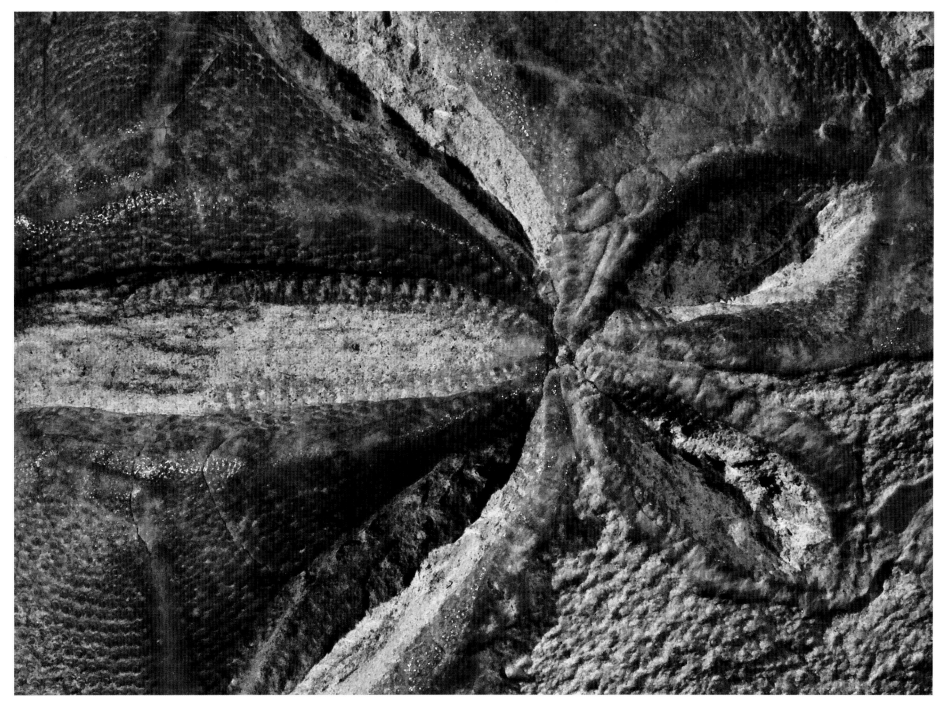

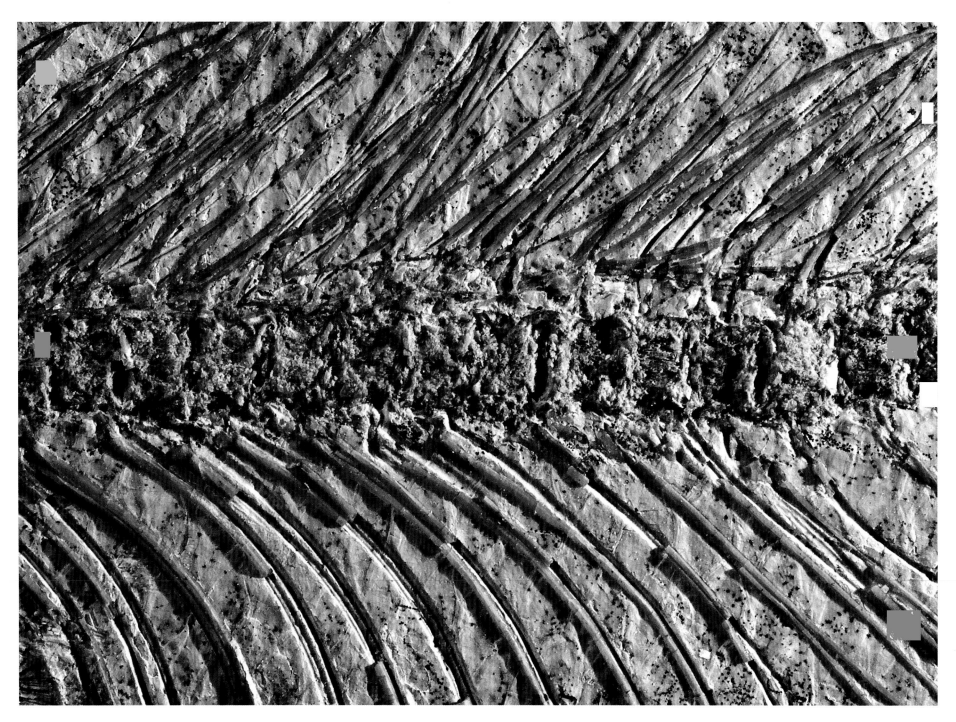

Wirbelsäulenstück des Knochenganoid-Fisches
Caturus
Oberjura, etwa 145 Ma
Daiting, Deutschland
Vergrößerung: etwa 5 x
Glossar: Wirbeltiere / Fische

Segment of the vertebral column of the holostean fish
Caturus
Late Jurassic, approx. 145 Ma
Daiting, Germany
Enlargement: approx. 5 x
Glossary: vertebrates / fishes

Eomesodon, Wirbelsäulenausschnitt
Oberjura, etwa 145 Ma
Daiting, Altmühlalb, Deutschland
Vergrößerung: etwa 5 x
Glossar: Wirbeltiere / Fische

Eomesodon, segment of the vertebrate column
Late Jurassic, approx. 145 Ma
Daiting, Germany
Enlargement: approx. 5 x
Glossary: vertebrates / fishes

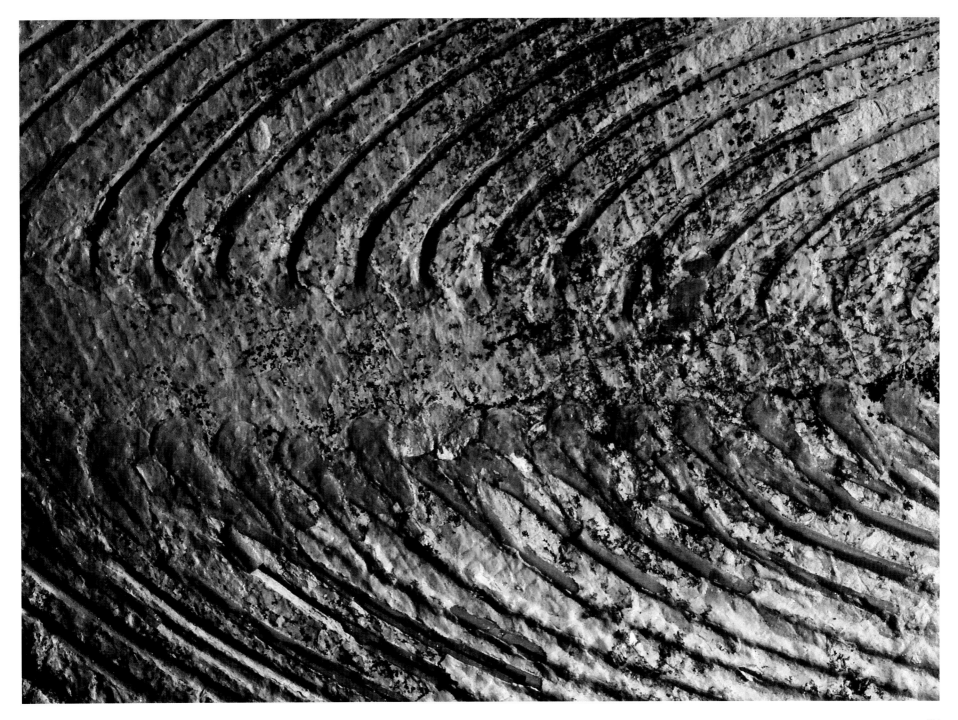

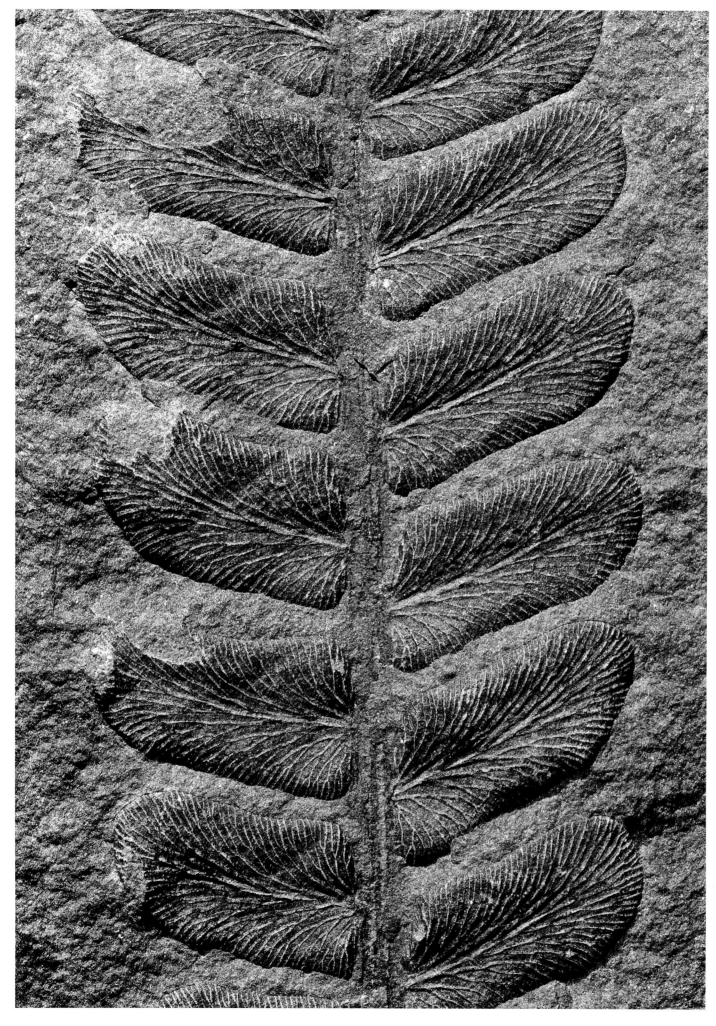

Pecopteris
Karbon, etwa 311 Ma
Mason Creek, Illinois, USA
Vergrößerung: etwa 5,8 x
Glossar: Gefäßpflanzen / Farnartige

Pecopteris
Carboniferous, approx. 311 Ma
Mason Creek, Illinois, USA
Enlargement: approx. 5.8 x
Glossary: fern-like pteridophytes

Pecopteris
Oberkarbon, etwa 300 Ma
Guchenbach, Deutschland
Vergrößerung: etwa 7,6 x
Glossar: Gefäßpflanzen / Farnartige

Pecopteris
Late Carboniferous, approx. 300 Ma
Guchenbach, Germany
Enlargement: approx. 7.6 x
Glossary: fern-like pteridophytes

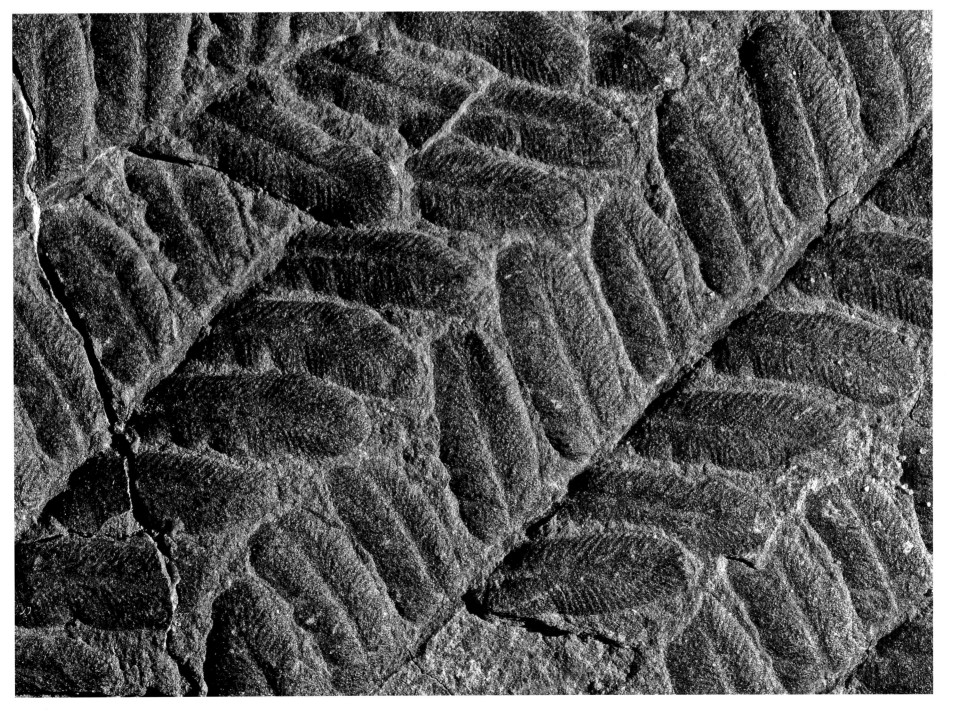

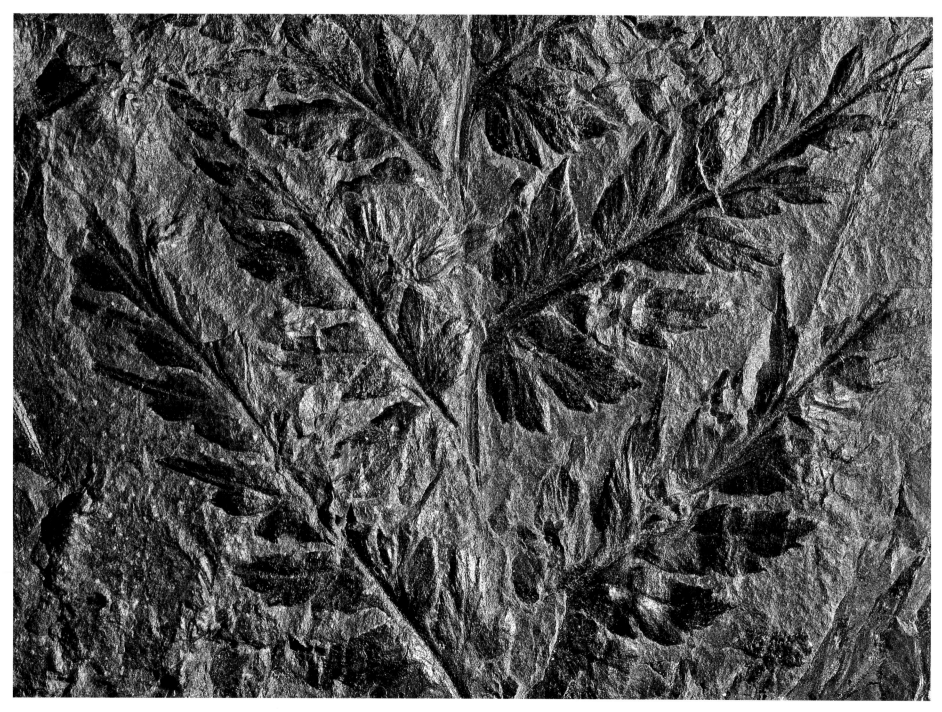

Mariopteris
Oberkarbon, etwa 300 Ma
Neunkirchen, Saarland, Deutschland
Vergrößerung: etwa 4,6x
Glossar: Gefäßpflanzen / Farnartige

Mariopteris
Late Carboniferous, approx. 300 Ma
Neunkirchen, Saarland, Germany
Enlargement: approx. 4.6x
Glossary: fern-like pteridophytes

Populus latior
Miozän, etwa 14 Ma
Öhningen, Deutschland
Vergrößerung: etwa 3,2x
Glossar: Gefäßpflanzen / Angiospermen

Populus latior
Miocene, approx. 14 Ma
Öhningen, Germany
Enlargement: approx. 3.2x
Glossary: pteridophytes / angiosperms

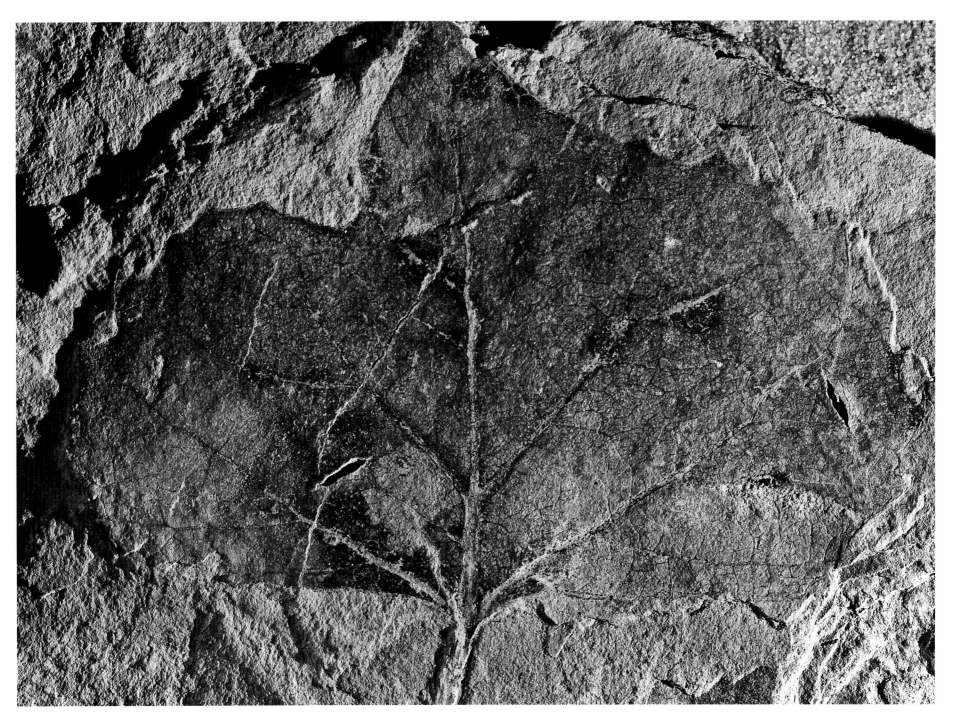

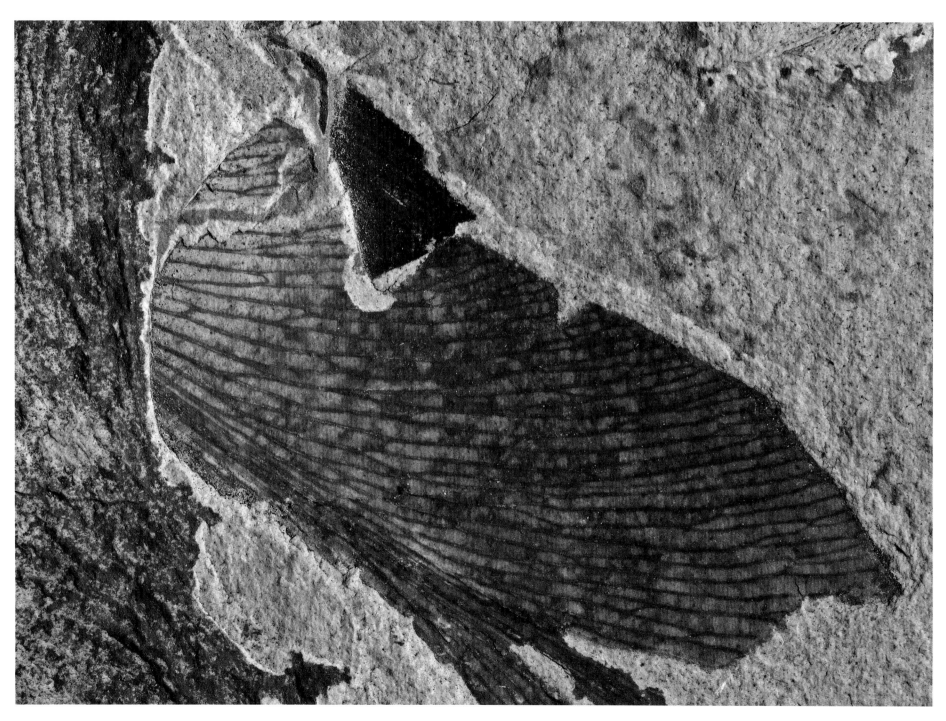

Glossopteris
Perm, etwa 270 Ma
Dunedoo, Australien
Vergrößerung: etwa 7,2 x
Glossar: Gefäßpflanzen / Farnartige

Glossopteris
Permian, approx. 270 Ma
Dunedoo, Australia
Enlargement: approx. 7.2 x
Glossary: fern-like pteridophytes

Farnartiger Nacktsamer *Thinnfeldia*
Trias / Jura Grenze, etwa 206 Ma
Unternschreez, Deutschland
Vergrößerung: etwa 6,3 x
Glossar: Gefäßpflanzen / Cycadeen

Fern-like *Thinnfeldia*
Triassic / Jurassic boundary, approx. 206 Ma
Unternschreez, Germany
Enlargement: approx. 6.3 x
Glossary: cycadean pteridophytes

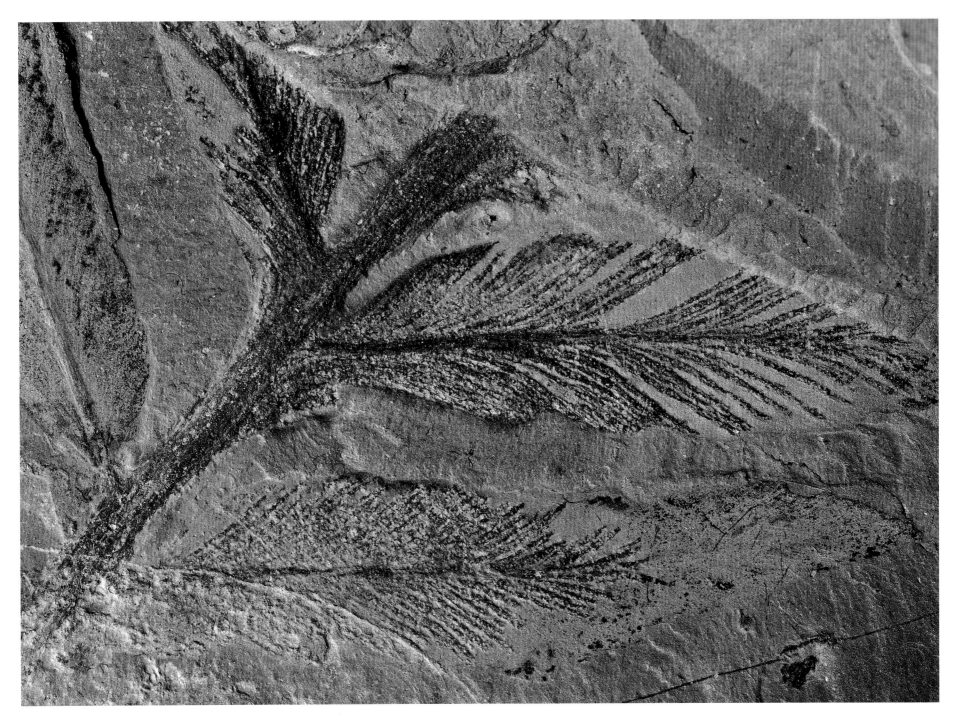

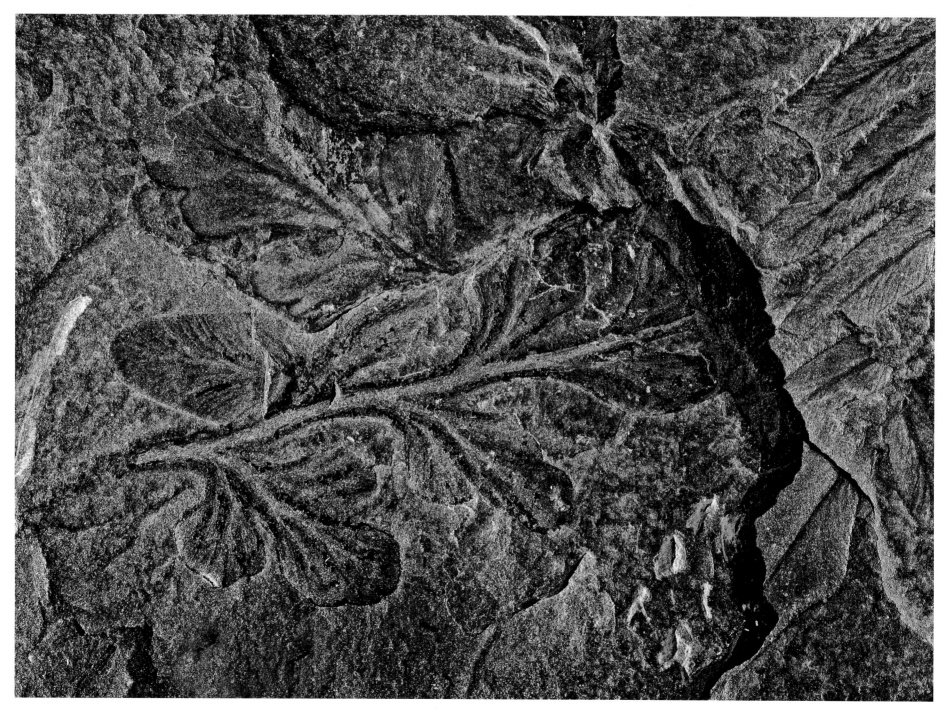

Sphenopteris obtusiloba
Oberkarbon, etwa 300 Ma
Saarbrücken, Deutschland
Vergrößerung: etwa 6,9 x
Glossar: Gefäßpflanzen / Farnartige

Sphenopteris obtusiloba
Late Carboniferous, approx. 300 Ma
Saarbrücken, Germany
Enlargement: approx. 6.9 x
Glossary: fern-like pteridophytes

Neuropteris
Oberkarbon, etwa 311 Ma
Saargebiet, Deutschland
Vergrößerung: etwa 5,5 x
Glossar: Gefäßpflanzen / Farnartige

Neuropteris
Late Carboniferous, approx. 311 Ma
Saar region, Germany
Enlargement: approx. 5.5 x
Glossary: fern-like pteridophytes

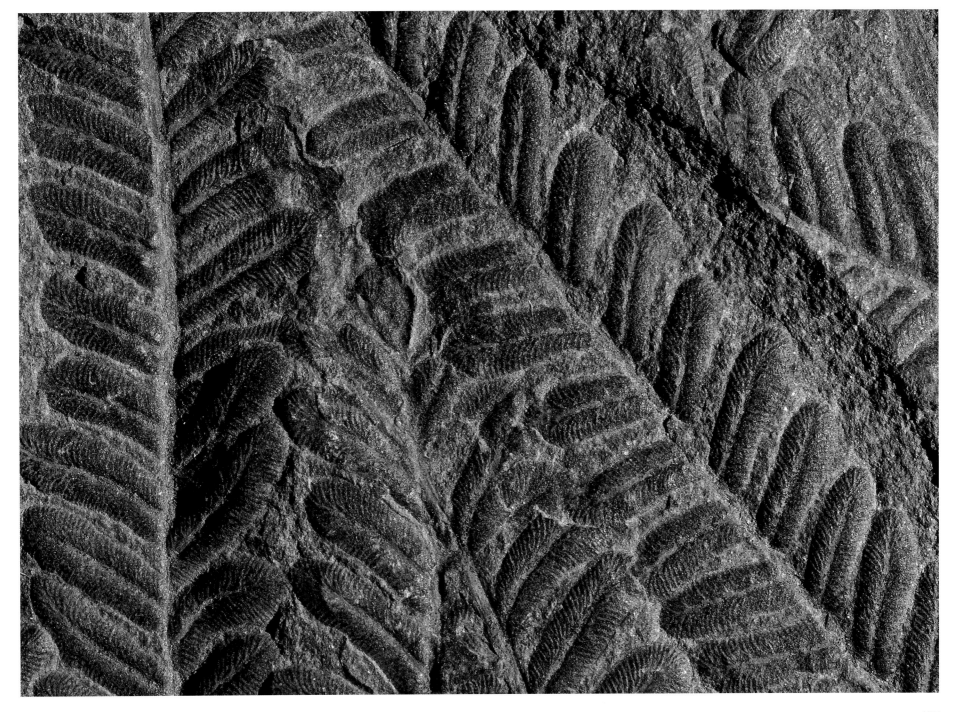

Acitheca
Oberkarbon, etwa 300 Ma
Graissesac, Frankreich
Vergrößerung: etwa 4,4 x
Glossar: Gefäßpflanzen / Farnartige

Acitheca
Late Carboniferous, approx. 300 Ma
Graissesac, France
Enlargement: approx. 4.4 x
Glossary: fern-like pteridophytes

Nilssonia
Trias / Jura-Grenze, etwa 206 Ma
Unternschreez, Deutschland
Vergrößerung: etwa 5,6 x
Glossar: Gefäßpflanzen / Cycadeen

Nilssonia
Triassic / Jurassic boundary, approx. 206 Ma
Unternschreez, Germany
Enlargement: approx. 5.6 x
Glossary: cycadean pteridophytes

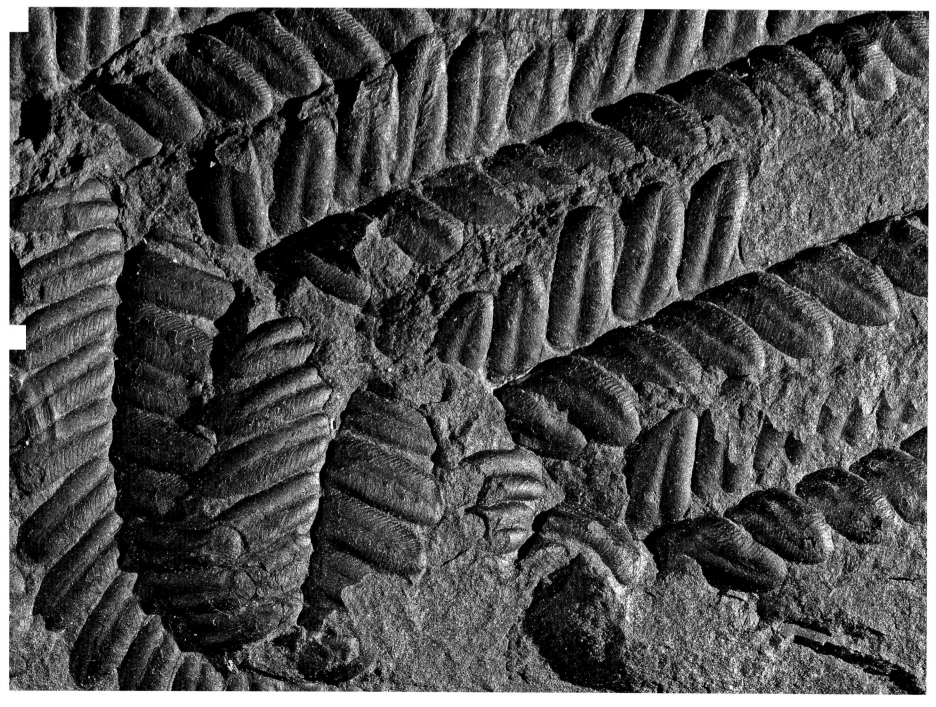

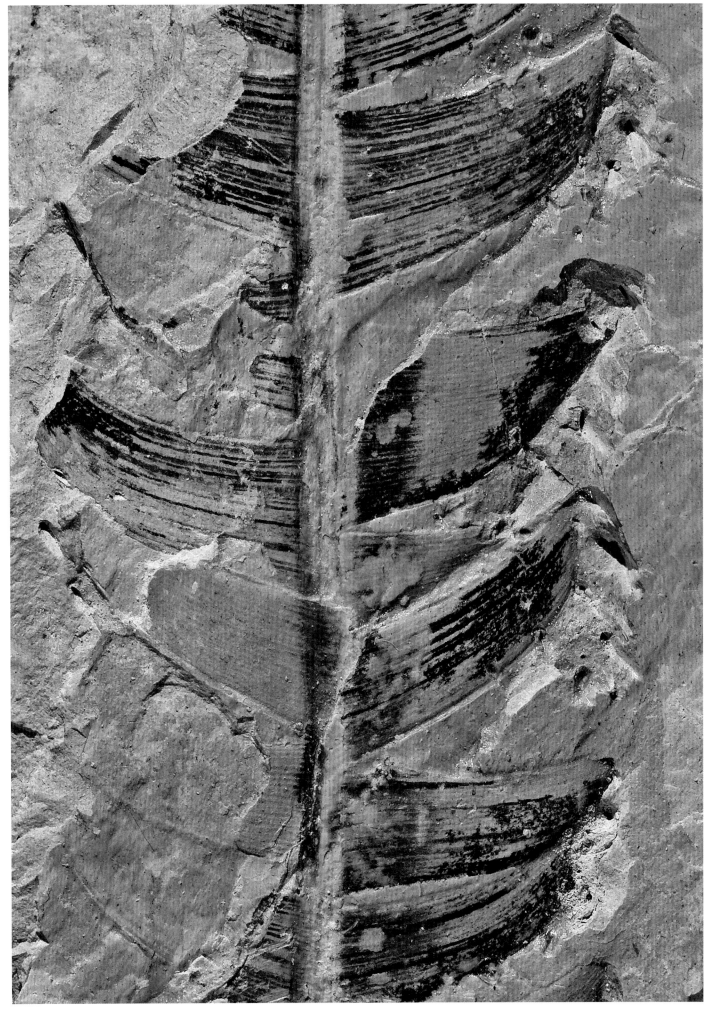

Schachtelhalm *Annularia*
Unter Perm, etwa 270 Ma
Sobernheim, Deutschland
Vergrößerung: etwa 5,7 x
Glossar: Gefäßpflanzen / Farnartige

Annularia horse tail
Early Permian, approx. 270 Ma
Sobernheim, Germany
Enlargement: approx. 5.7 x
Glossary: fern-like pteridophytes

Schuppenbaum *Lepidodendron*
Oberkarbon, etwa 300 Ma
Jaworzno, Polen
Vergrößerung: etwa 3,3 x
Glossar: Gefäßpflanzen / Farnartige

Lepidodendron
Late Carboniferous, approx. 300 Ma
Jaworzno, Poland
Enlargement: approx. 3.3 x
Glossary: fern-like pteridophytes

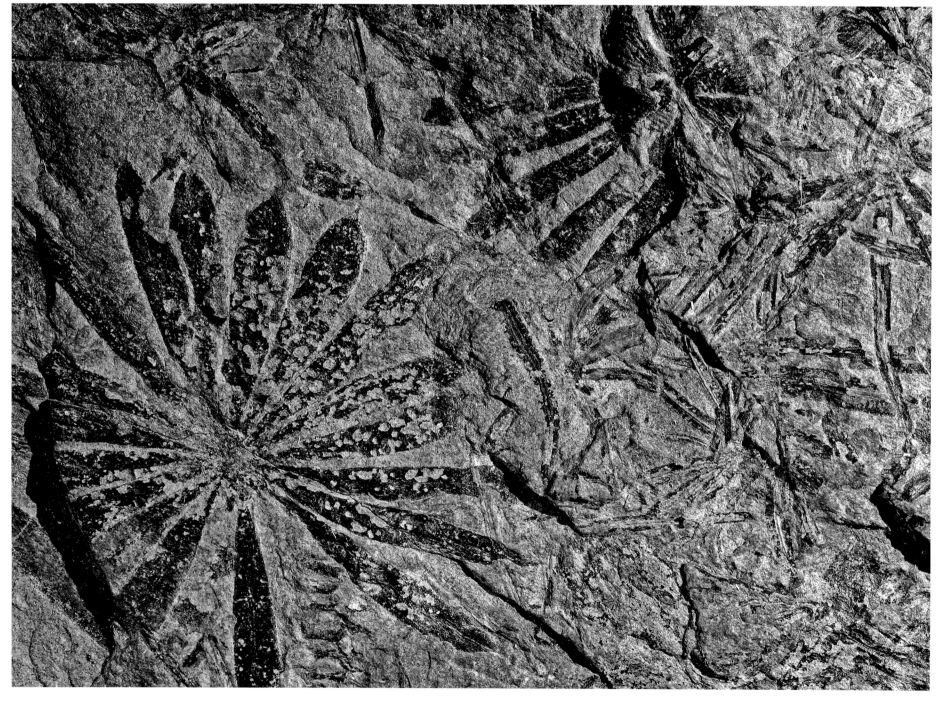

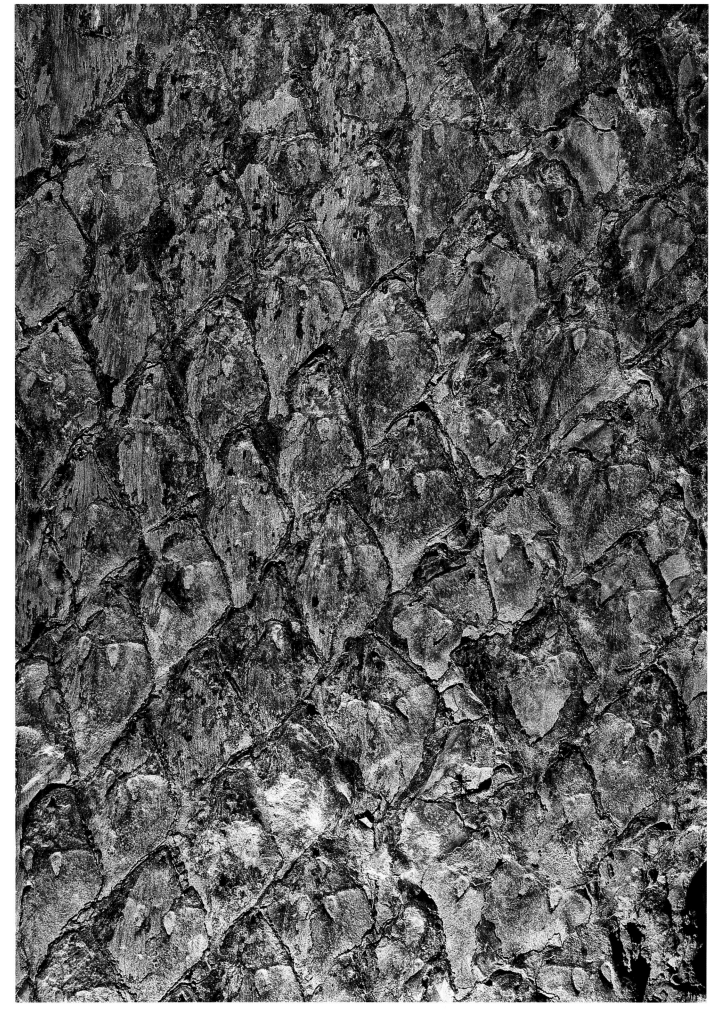

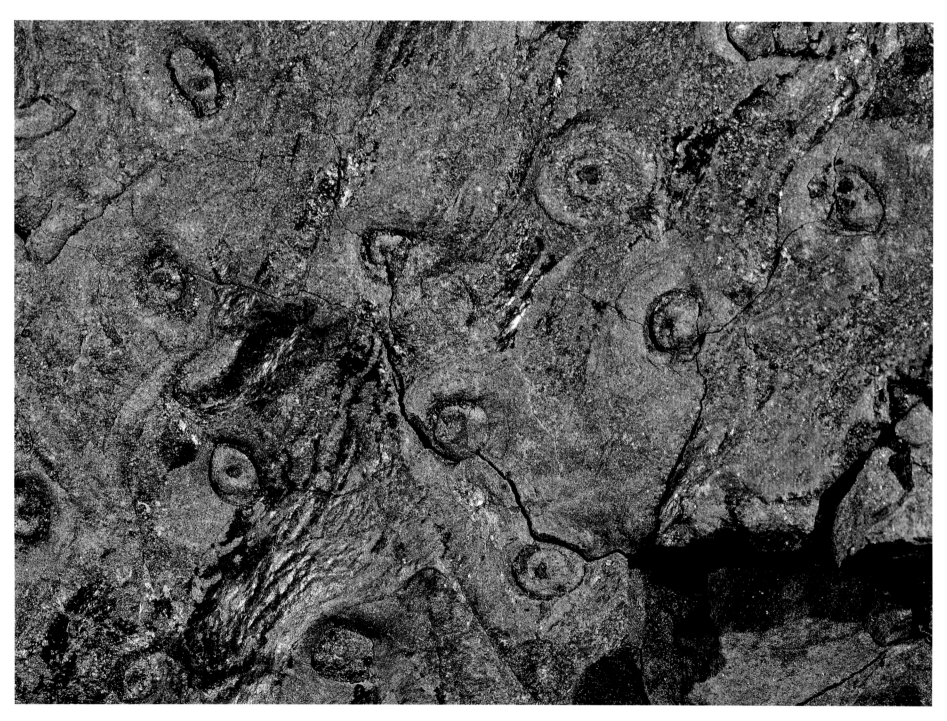

Bärlappbaum *Stigmaria*, Wurzelbereich
Oberkarbon, etwa 325 Ma
Douro, Portugal
Vergrößerung: etwa 3,7 x
Glossar: Gefäßpflanzen / Farnartige

Stigmaria, roots area
Late Carboniferous, approx. 325 Ma
Douro, Portugal
Enlargement: approx. 3.7 x
Glossary: fern-like pteridophytes

Sphenopteris
Oberkarbon, etwa 300 Ma
Saargebiet, Deutschland
Vergrößerung: etwa 3,7 x
Glossar: Gefäßpflanzen / Farnartige

Sphenopteris
Late Carboniferous, approx. 300 Ma
Saar region, Germany
Enlargement: approx. 3.7 x
Glossary: fern-like pteridophytes

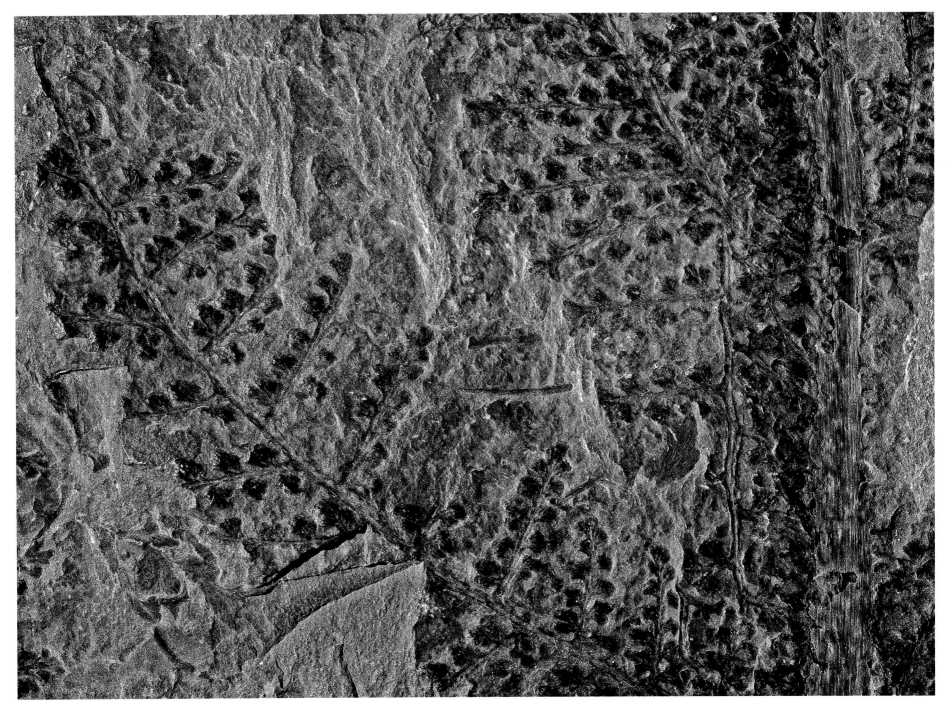

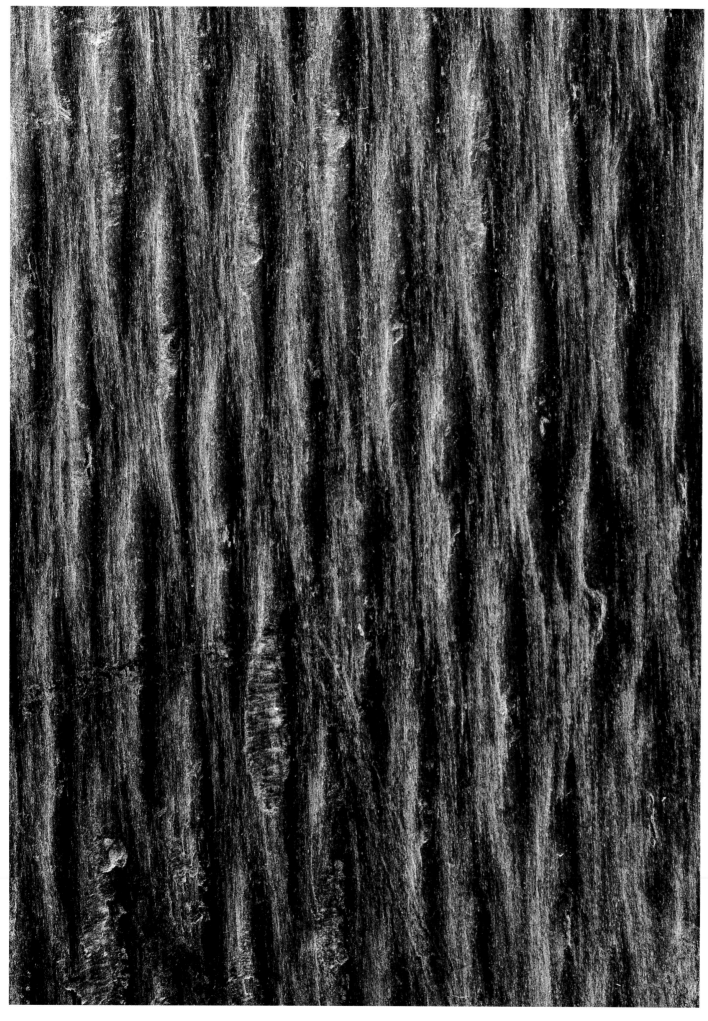

Schuppenbaum *Lepidodendron*,
Stamm
Oberkarbon, etwa 300 Ma
Jaworzno, Polen
Vergrößerung: etwa 5,4 x
Glossar: Gefäßpflanzen / Farnartige

Lepidodendron, stem
Late Carboniferous, approx. 300 Ma
Jaworzno, Poland
Enlargement: approx. 5.4 x
Glossary: fern-like pteridophytes

Schuppenbaum *Sigiiaria*, Blattnarben
Oberkarbon, etwa 300 Ma
Gladbeck, Deutschland
Vergrößerung: etwa 5,5x
Glossar: Gefäßpflanzen / Farnartige

Sigillaria, leaf scars
Late Carboniferous, approx. 300 Ma
Gladbeck, Germany
Enlargement: approx. 5.5x
Glossary: fern-like pteridophytes

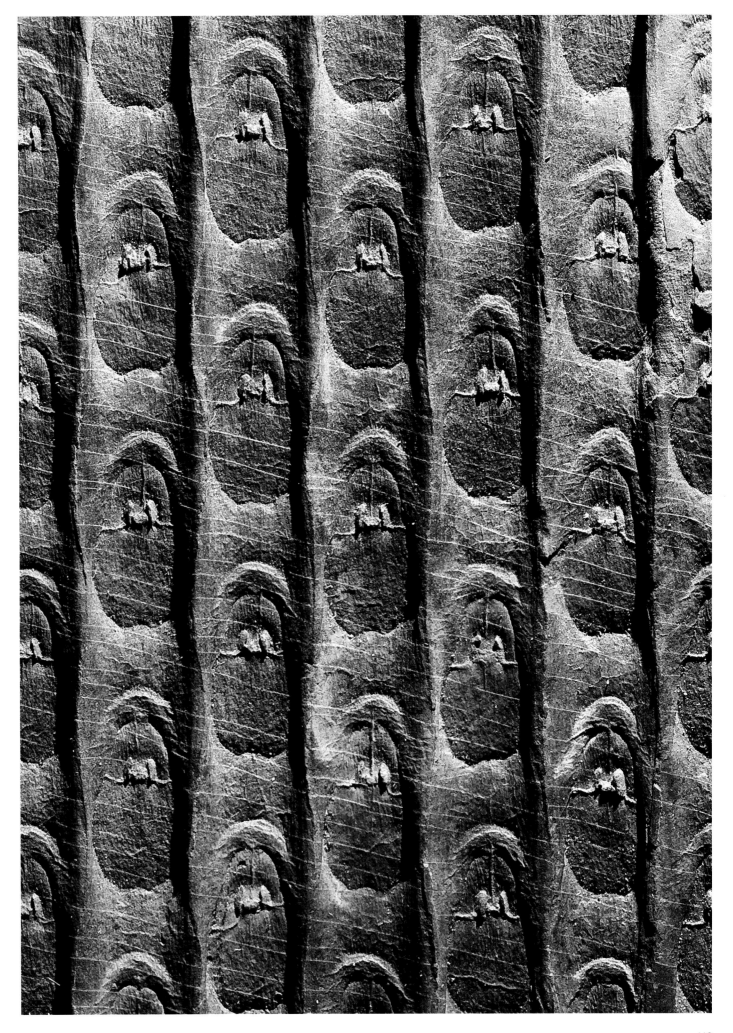

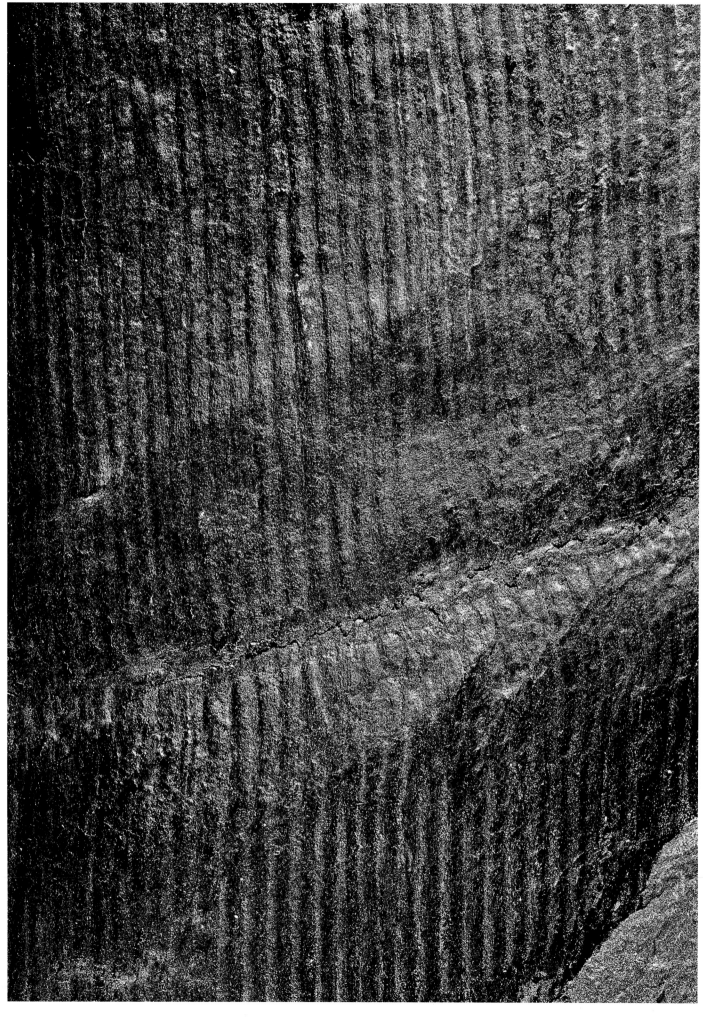

Schachtelhalm *Mesocalamites*
Oberkarbon, etwa 300 Ma
Graissesac, Frankreich
Vergrößerung: etwa 4 x
Glossar: Gefäßpflanzen / Farnartige

Mesocalamites
Late Carboniferous, approx. 300 Ma
Graissesac, France
Enlargement: approx. 4 x
Glossary: fern-like pteridophytes

Schuppenbaum *Lepidodendron*
Oberkarbon, etwa 325 Ma
Ibbenbüren, Deutschland
Vergrößerung: etwa 3x
Glossar: Gefäßpflanzen / Farnartige

Lepidodendron
Late Carboniferous, approx. 325 Ma
Ibbenbüren, Germany
Enlargement: approx. 3x
Glossary: fern-like pteridophytes

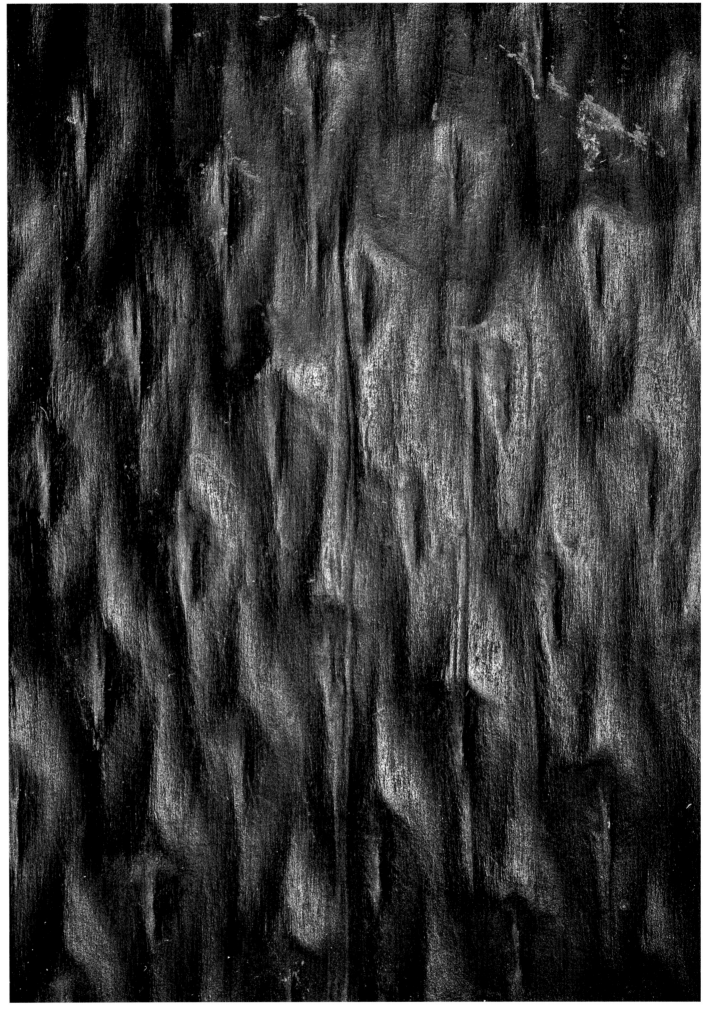

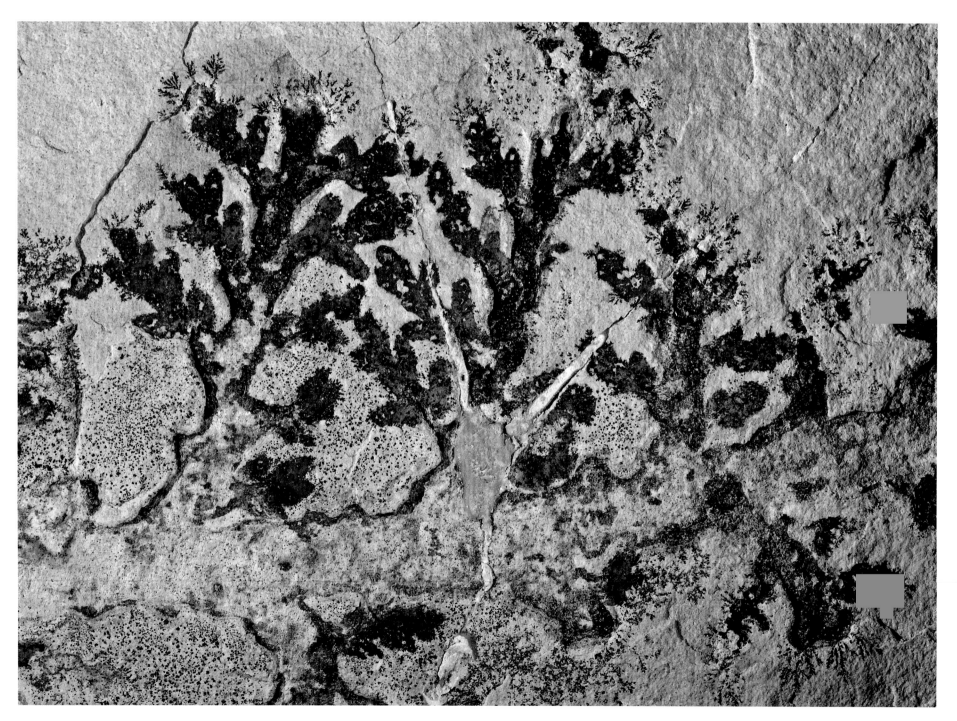

Brachyphyllum
Jura, etwa 175 Ma
Solnhofen, Deutschland
Vergrößerung: etwa 3x
Glossar: Gefäßpflanzen / Coniferen

Brachyphyllum
Jurassic, approx. 175 Ma
Solnhofen, Germany
Enlargement: approx. 3x
Glossary: pteridophytes / conifers

Zamites
Jura, etwa 175 Ma
New South Wales, Australien
Vergrößerung: etwa 3,6x
Glossar: Gefäßpflanzen / Cycadeen

Zamites
Jurassic, approx. 175 Ma
New South Wales, Australia
Enlargement: approx. 3.6x
Glossary: pteridophytes / cycadean

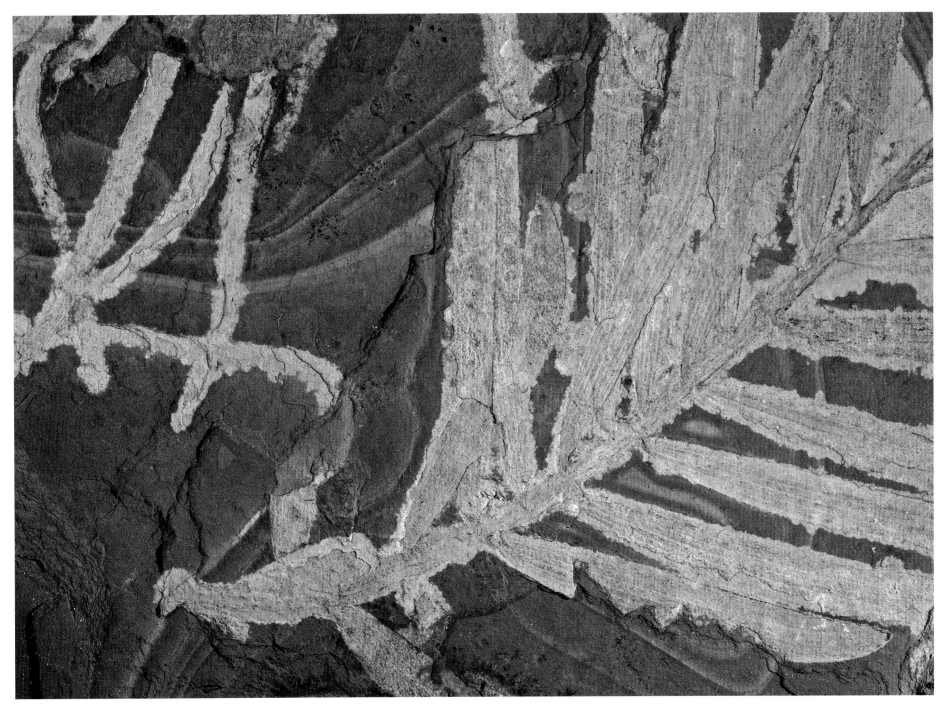

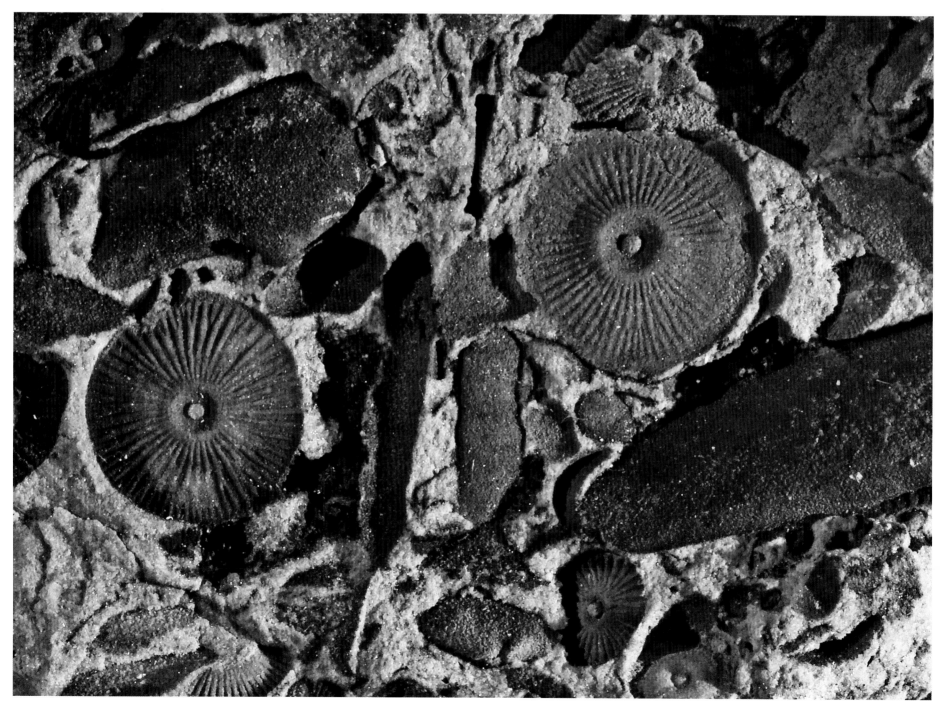

Rhipidocrinus, Stielglieder und *Pseudarca*
Unterdevon, etwa 400 Ma
Bocksberg, Deutschland
Vergrößerung: etwa 7 x
Glossar: Stachelhäuter / Seelilien; Weichtiere / Muscheln

Rhipidocrinus, columnalia and *Pseudarca*
Early Devonian, approx. 400 Ma
Bocksberg, Germany
Enlargement: approx. 7 x
Glossary: echinoderms / crinoids; molluscs / bivalves

Myophoria
Mitteltrias, etwa 235 Ma
Königslutter, Deutschland
Vergrößerung: etwa 4 x
Glossar: Weichtiere / Muscheln

Myophoria
Middle Triassic, approx. 235 Ma
Königslutter, Germany
Enlargement: approx. 4 x
Glossary: molluscs / bivalves

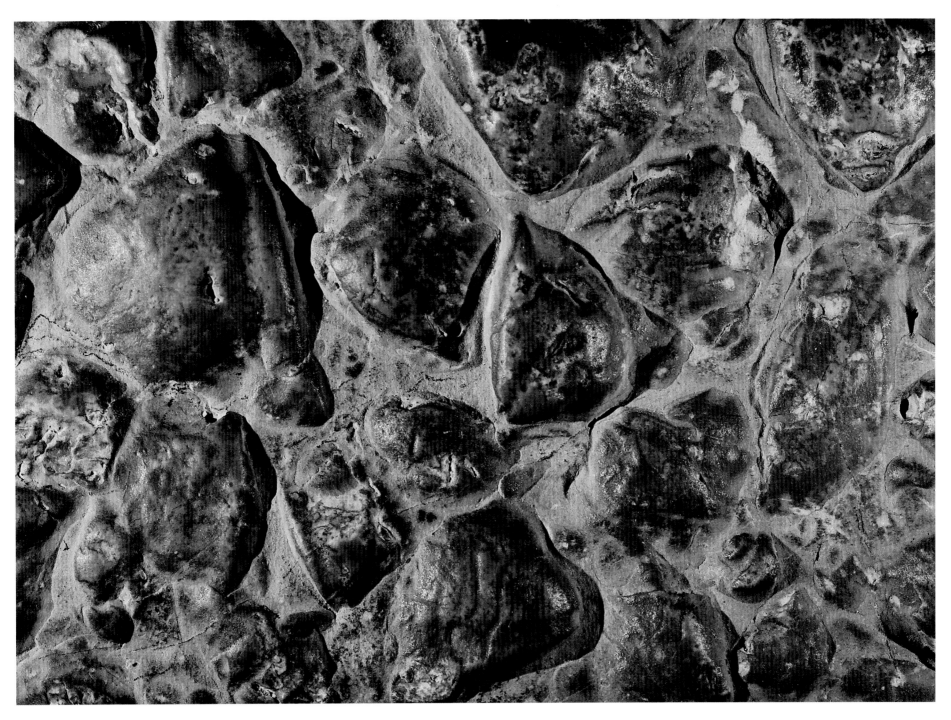

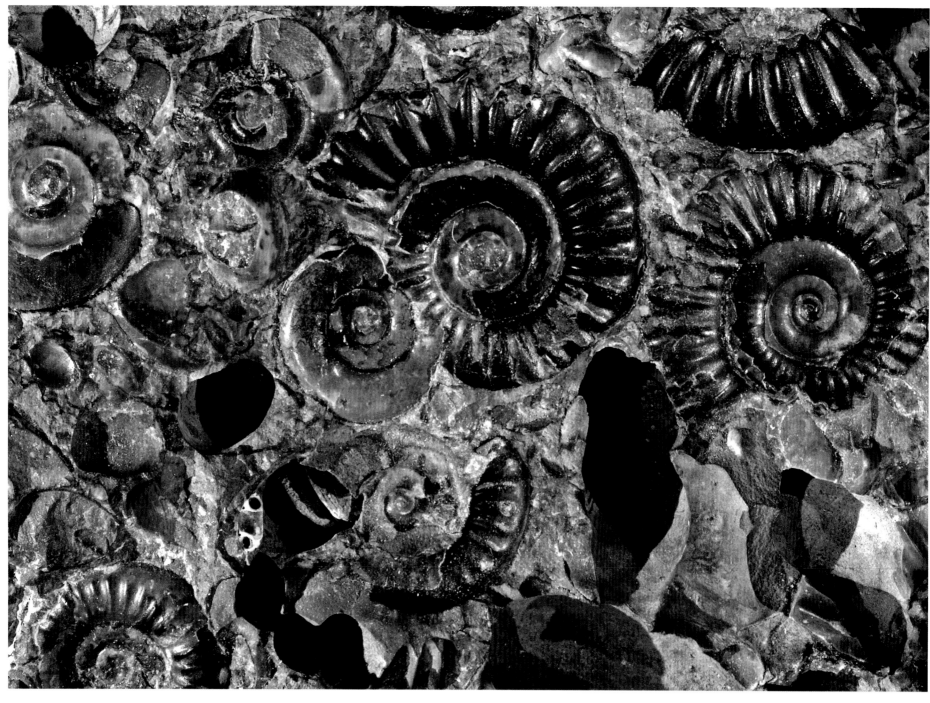

Arnicoceras
Unterjura, etwa 200 Ma
Robin Hood's Bay, England
Vergrößerung: etwa 4 x
Glossar: Weichtiere / Ammoniten

Arnicoceras
Early Jurassic, approx. 200 Ma
Robin Hood's Bay, England
Enlargement: approx. 4 x
Glossary: molluscs / ammonoids

Ellipsocephalus hoffi
Unterkambrium, 530 Ma
Jince, Tschechien
Vergrößerung: etwa 4,7 x
Glossar: Gliedertiere / Trilobiten

Ellipsocephalus hoffi
Early Cambrian, 530 Ma
Jince, Czech Republic
Enlargement: approx. 4.7 x
Glossary: arthropods / trilobites

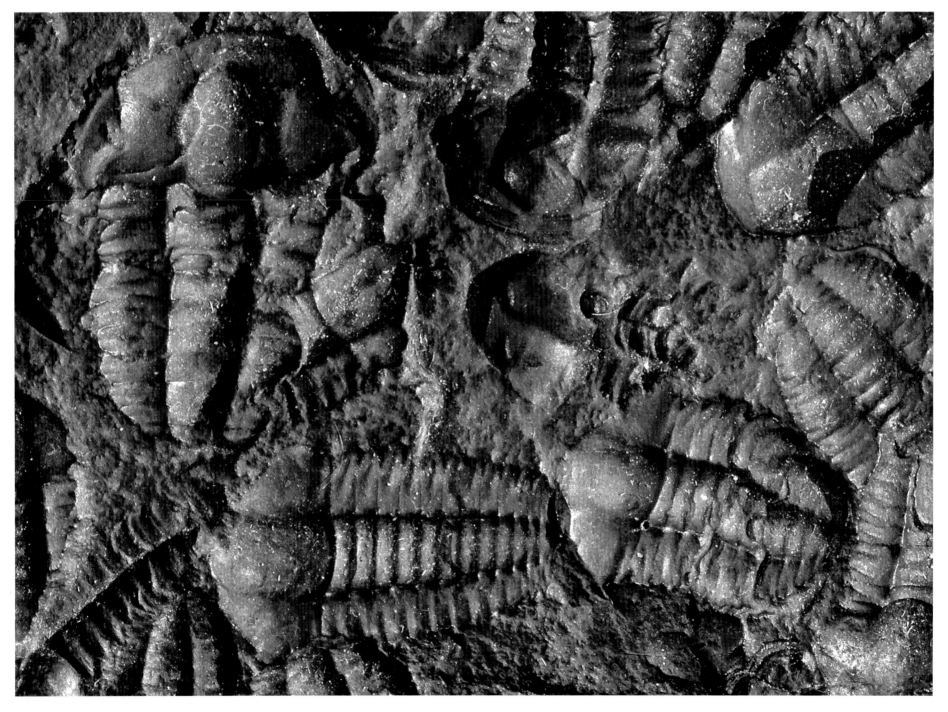

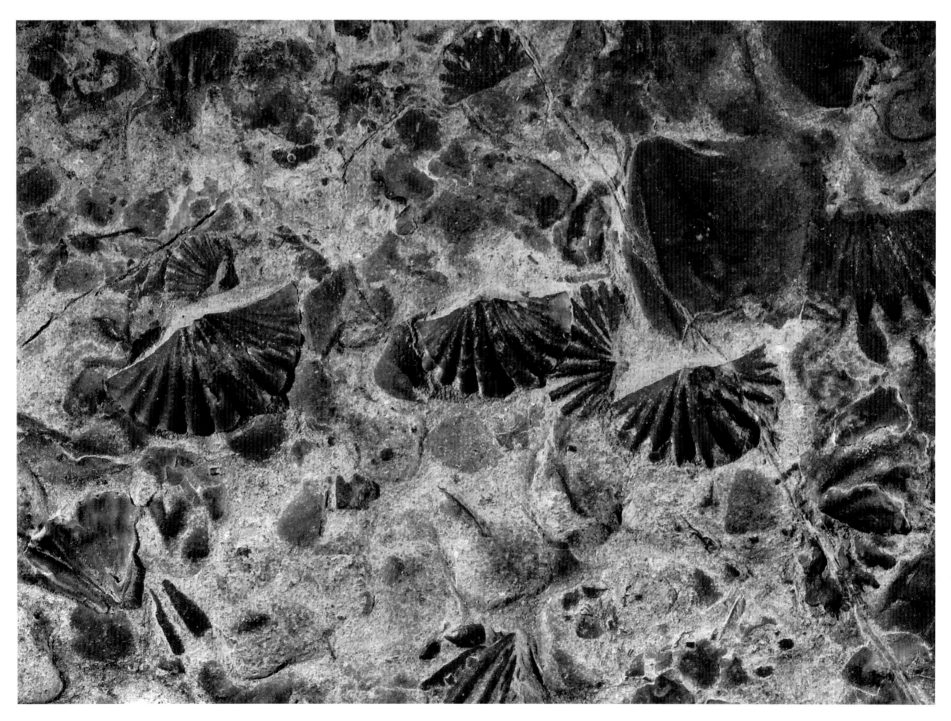

Spiriferina
Mitteltrias, etwa 238 Ma
Friedrichsgrube, Oberschlesien, Polen
Vergrößerung: etwa 4 x
Glossar: Armfüßer

Spiriferina
Middle Triassic, approx. 238 Ma
Friedrichsgrube, Upper Silesia, Poland
Enlargement: approx. 4 x
Glossary: brachiopods

Encrinus, Stielglieder, Trochiten
Mitteltrias, etwa 235 Ma
Schwäbisch Hall, Deutschland
Vergrößerung: etwa 3,5 x
Glossar: Stachelhäuter / Seelilien

Encrinus, columnalia
Middle Triassic, approx. 235 Ma
Schwäbisch Hall, Germany
Enlargement: approx. 3.5 x
Glossary: echinoderms / crinoids

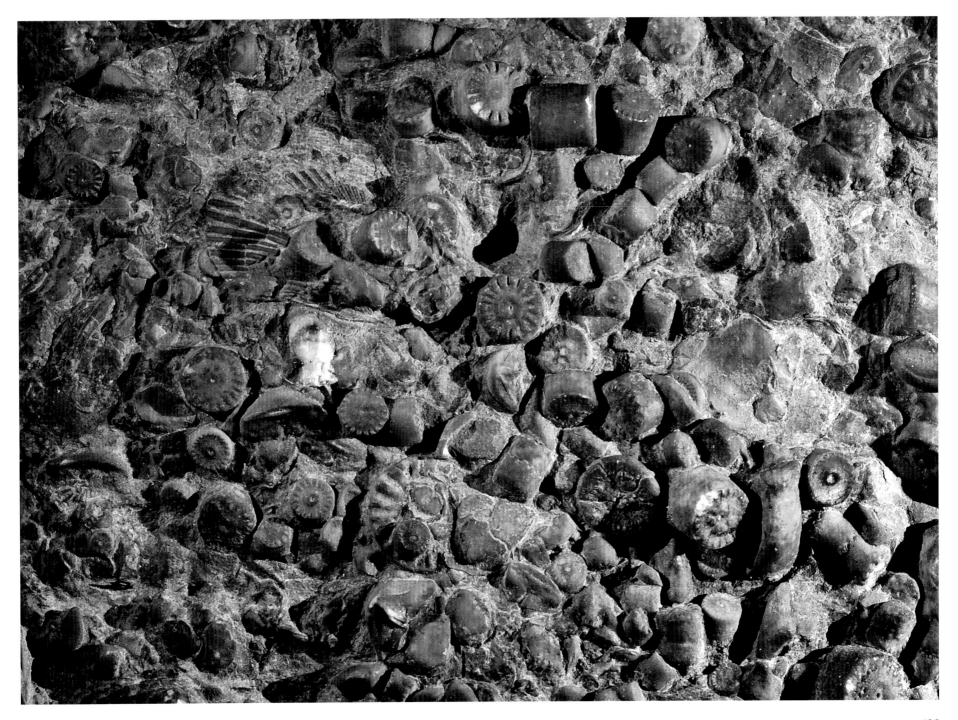

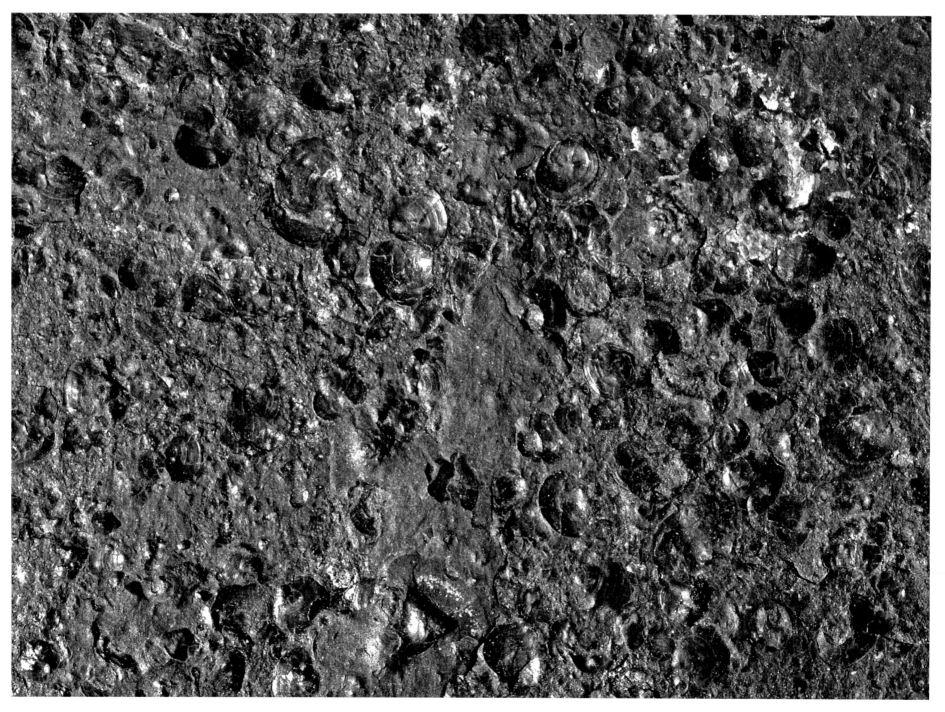

Obolus
Unterordovizium, etwa 487 Ma
Ottenby, Grönhögen, Schweden
Vergrößerung: etwa 3x
Glossar: Armfüßer

Obolus
Early Ordovician, approx. 487 Ma
Ottenby, Grönhögen, Sweden
Enlargement: approx. 3x
Glossary: brachiopods

Trochiten-Kalk (*Encrinus*-Stielglieder), Anschliff
Mitteltrias, etwa 233 Ma
Mainfranken, Deutschland
Vergrößerung: etwa 6,5x
Glossar: Stachelhäuter / Seelilien

Trochites Limestone (columnalia of *Encrinus*),
polished section
Middle Triassic, approx. 233 Ma
River Main, Franconia, Germany
Enlargement: approx. 6.5x
Glossary: echinoderms / crinoids

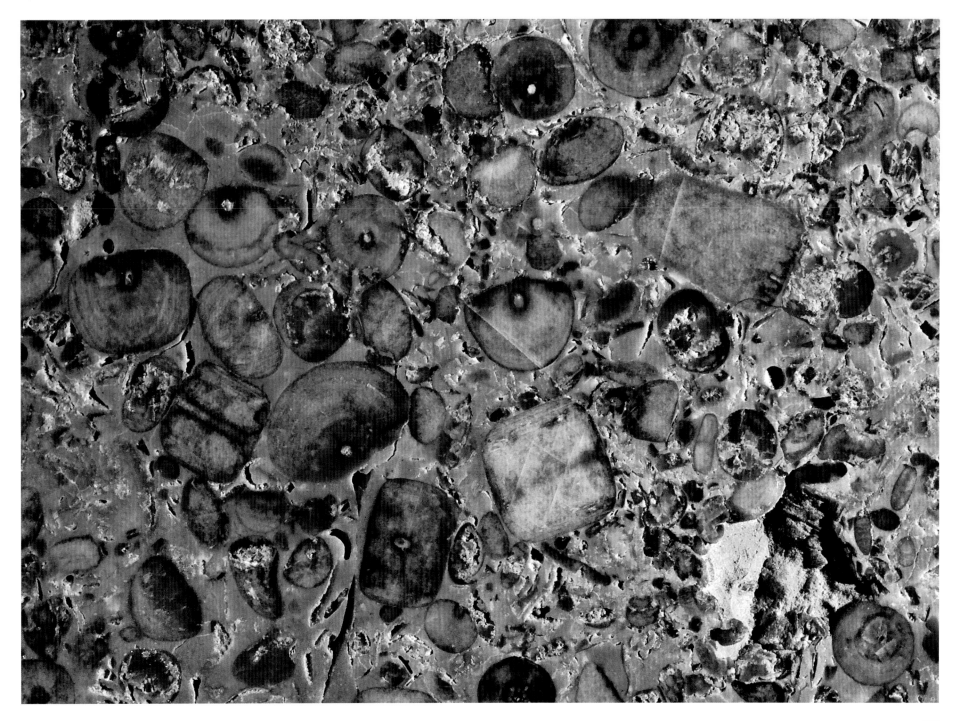

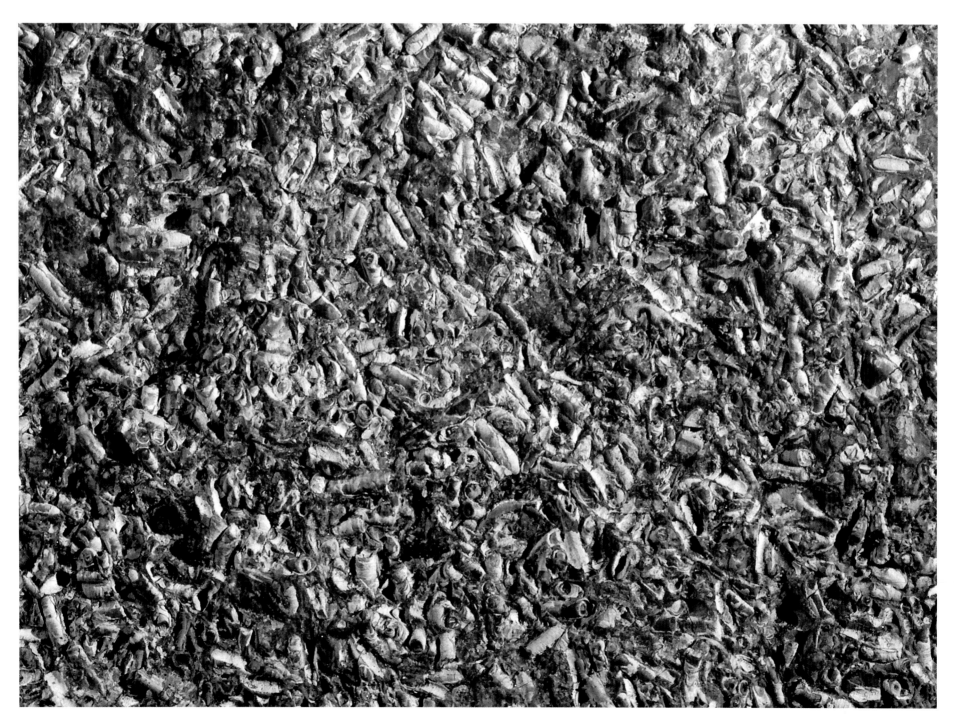

Serpula-Kalk
Oberjura, etwa 147 Ma
Thüste, Deutschland
Vergrößerung: etwa 7 x
Glossar: Ringelwürmer

Serpulid worm tubes
Late Jurassic, approx. 147 Ma
Thüste, Germany
Enlargement: approx. 7 x
Glossary: annelids

Parafusulina japonica
Unterperm, etwa 270 Ma
Kinshozan Akasaka, Japan
Vergrößerung: etwa 5 x
Glossar: Foraminiferen

Parafusulina japonica
Early Permian, approx. 270 Ma
Kinshozan Akasaka, Japan
Enlargement: approx. 5 x
Glossary: foraminifers

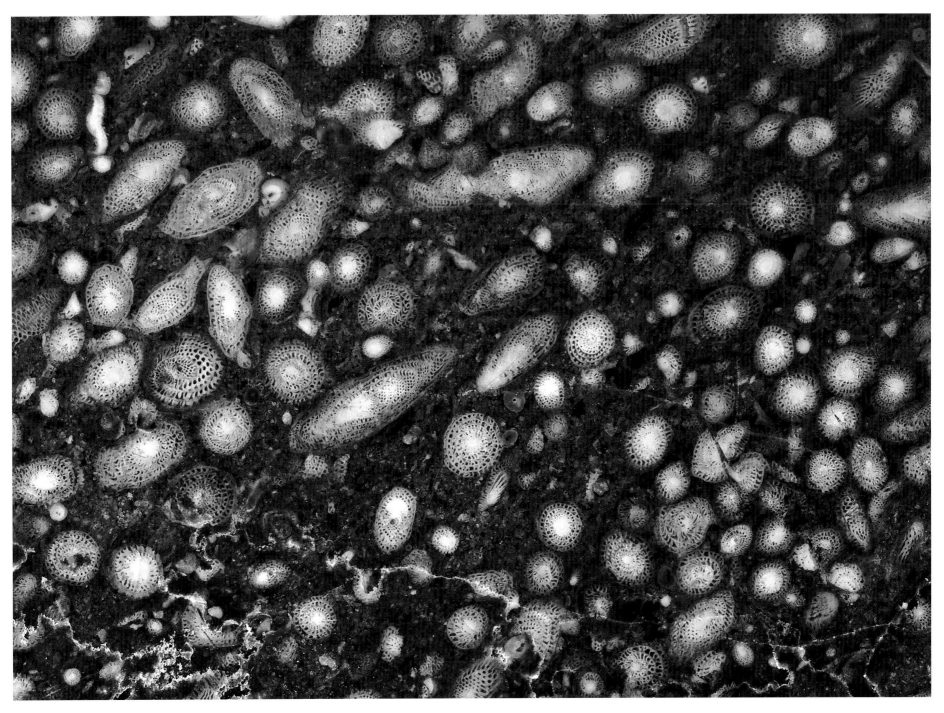

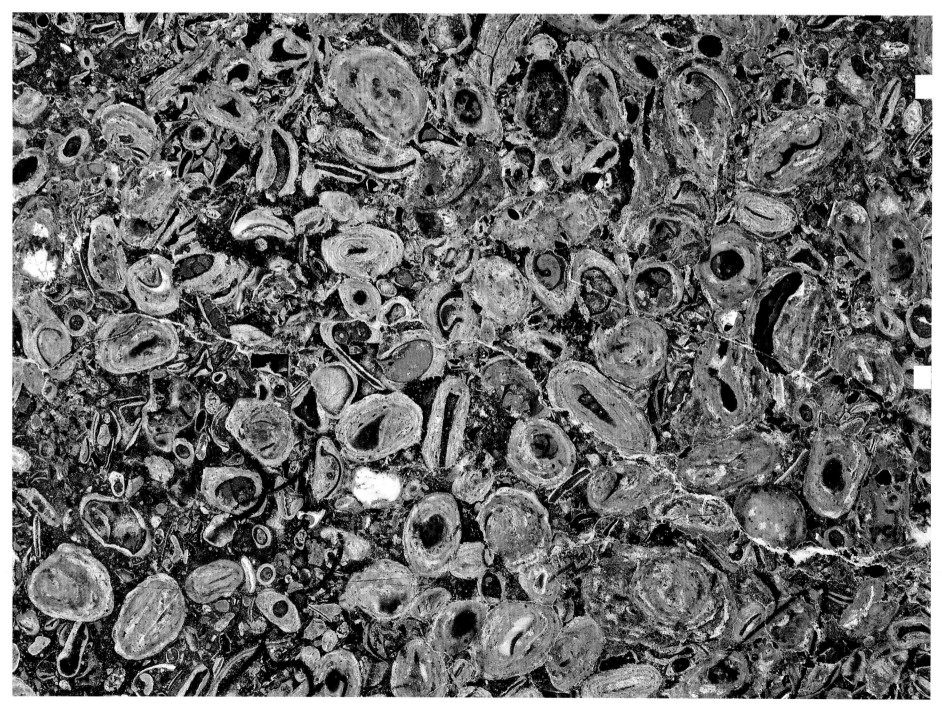

Oncoide
Oberjura, etwa 152 Ma
Teruel, Spanien
Vergrößerung: etwa 6 x
Glossar: Cyanobakterien

Oncoides
Late Jurassic, approx. 152 Ma
Teruel, Spain
Enlargement: approx. 6 x
Glossary: blue-green algae

Alveolina
Paläozän, etwa 60 Ma
Tremp, Spanien
Vergrößerung: etwa 9 x
Glossar: Foraminiferen

Alveolina
Palaeocene, approx. 60 Ma
Tremp, Spain
Enlargement: approx. 9 x
Glossary: foraminifers

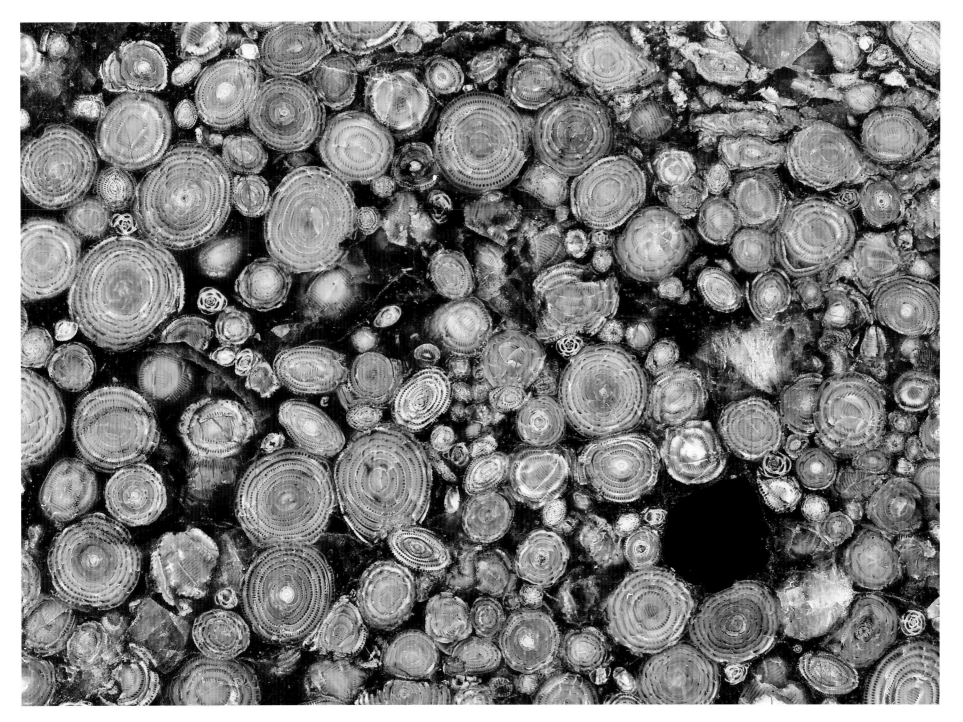

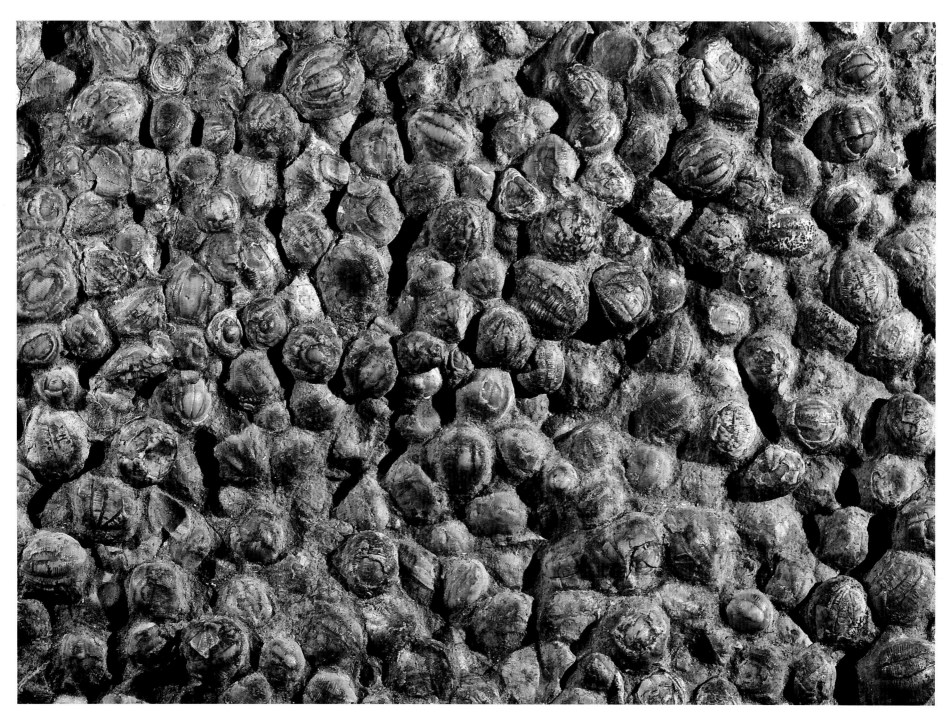

Fasciolites
Paläozän, etwa 60 Ma
Tremp, Spanien
Vergrößerung: etwa 6 x
Glossar: Foraminiferen

Fasciolites
Palaeocene, approx. 60 Ma
Tremp, Spain
Enlargement: approx. 6 x
Glossary: foraminifers

Gesteinsbildende Großforaminiferen: *Fasciolites lepidula*
Paläozän, etwa 60 Ma
Tremp, Spanien
Vergrößerung: etwa 12 x
Glossar: Foraminiferen

Rock-forming large foraminifers: *Fasciolites lepidula*
Palaeocene, approx. 60 Ma
Tremp, Spain
Enlargement: approx. 12 x
Glossary: oraminifers

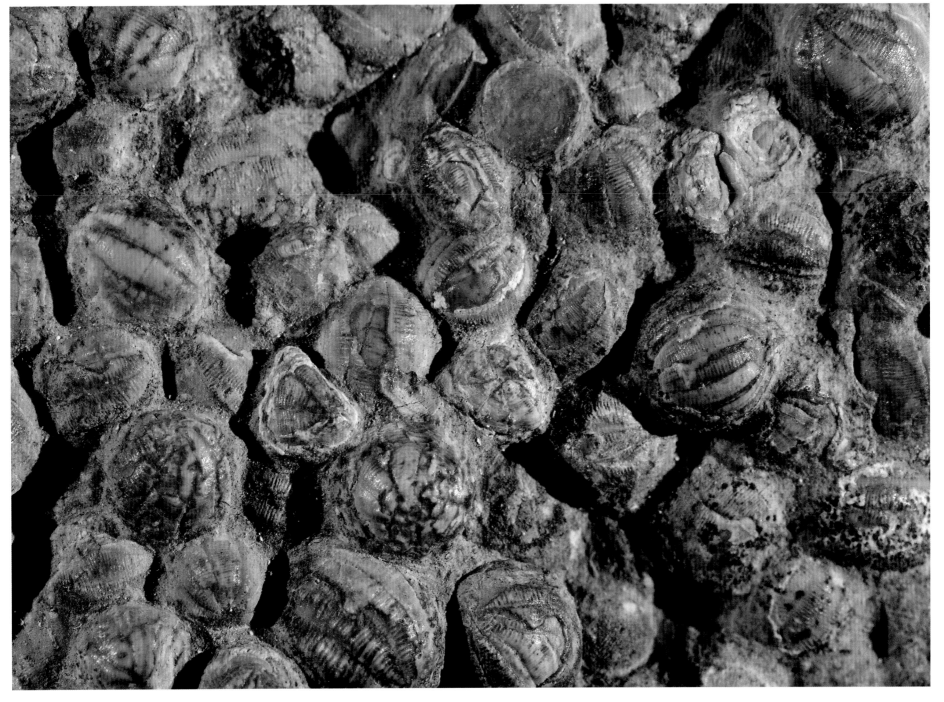

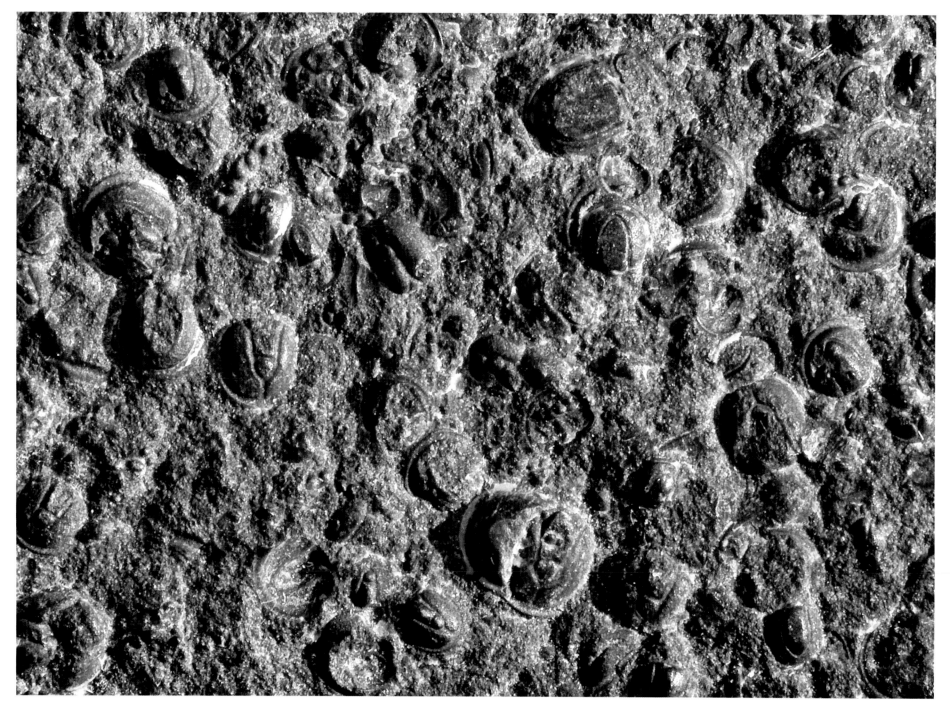

Agnostus pisiformis
Oberkambrium, etwa 500 Ma
Trolmen, Killekulle, Schweden
Vergrößerung: etwa 9 x
Glossar: Gliedertiere / Trilobiten

Agnostus pisiformis
Late Cambrian, approx. 500 Ma
Trolmen, Killekulle, Sweden
Enlargement: approx. 9 x
Glossary: arthropods / trilobites

Onkoide
Unterkreide, etwa 120 Ma
Galve, Spanien
Vergrößerung: etwa 7 x
Glossar: Cyanobakterien

Oncoid
Early Cretaceous, approx. 120 Ma
Galve, Spain
Enlargement: approx. 7 x
Glossary: blue-green algae

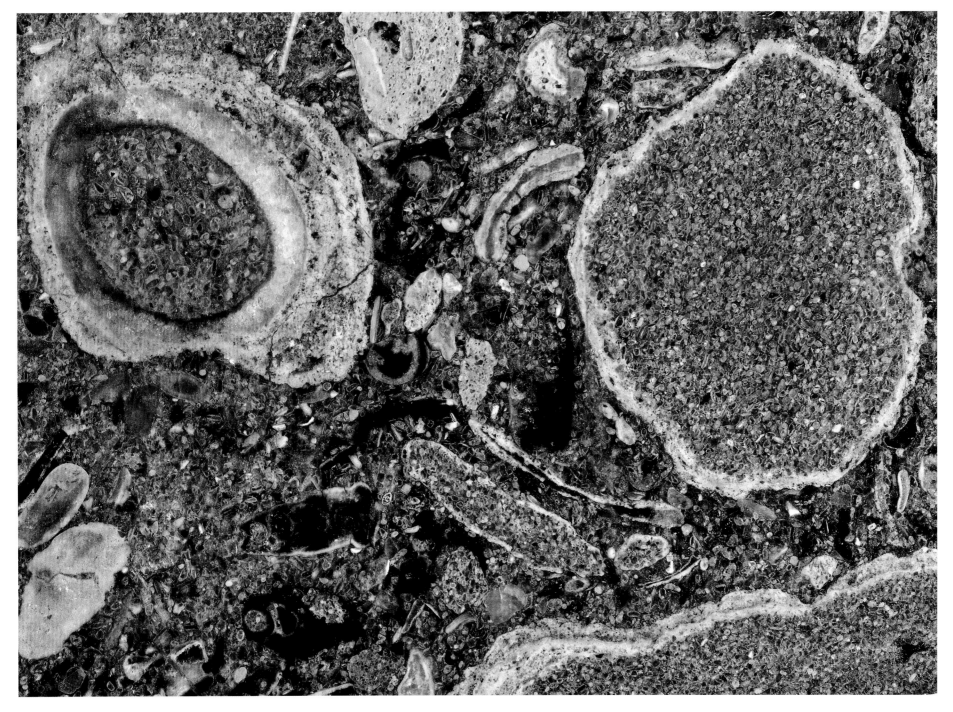

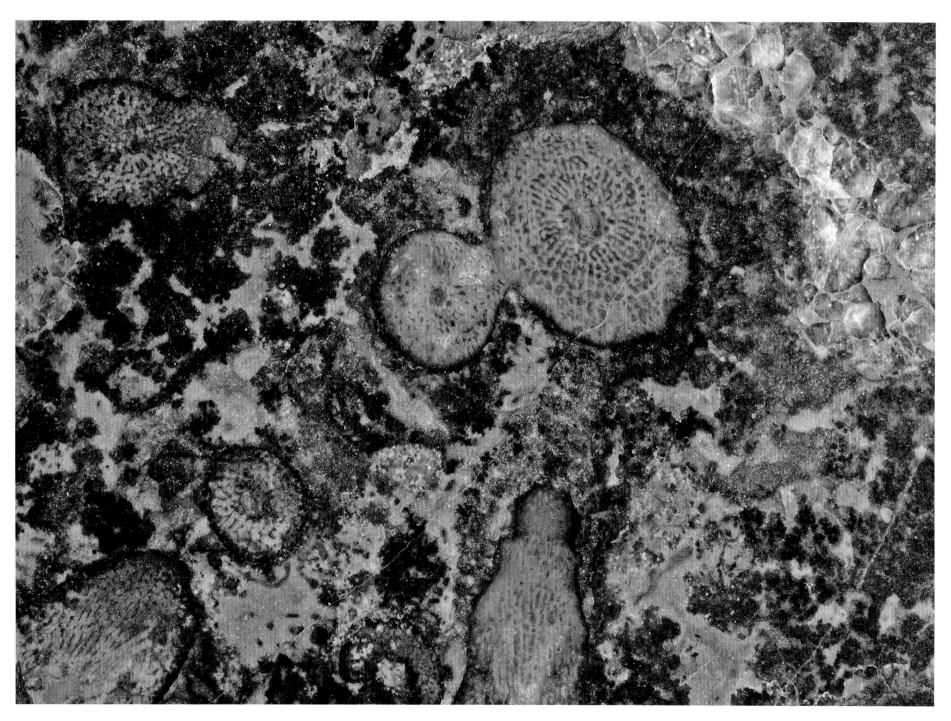

Archaeocyatha
Unterkambrium, etwa 520 Ma
Tazzemourte, Marokko
Vergrößerung: etwa 6 x
Glossar: Schwämme

Archaeocyatha
Early Cambrian, approx. 520 Ma
Tazzemourte, Marocco
Enlargement: approx. 6 x
Glossary: sponges

Thamnopora
Silur, etwa 428 Ma
Öland, Schweden
Vergrößerung: etwa 5,4 x
Glossar: Korallen / Tabulata

Thamnopora
Silurian, approx. 428 Ma
Öland, Sweden
Enlargement: approx. 5.4 x
Glossary: corals / Tabulata

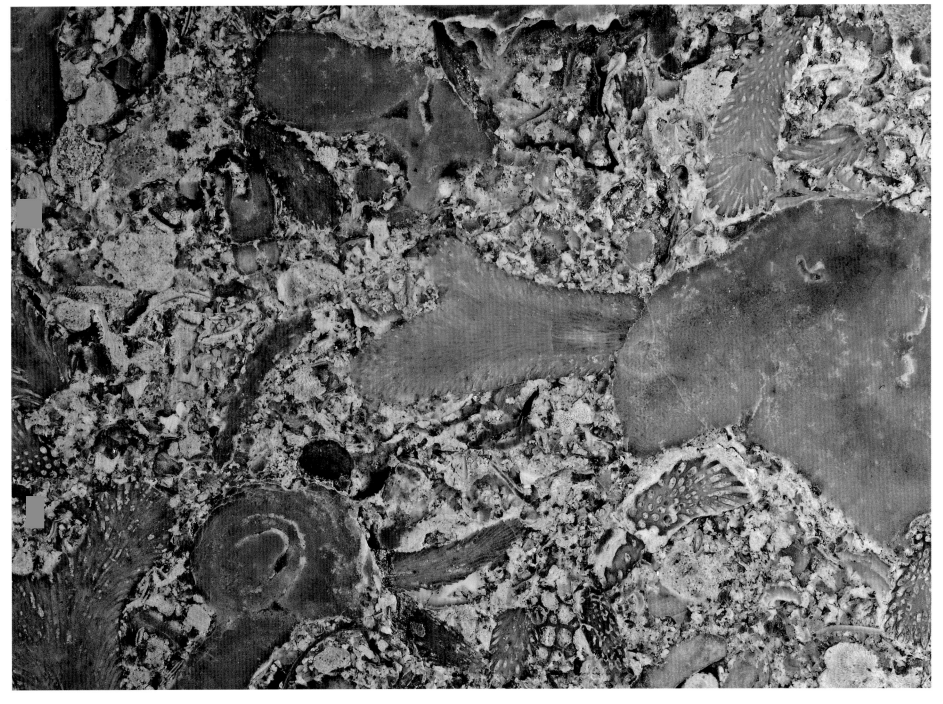

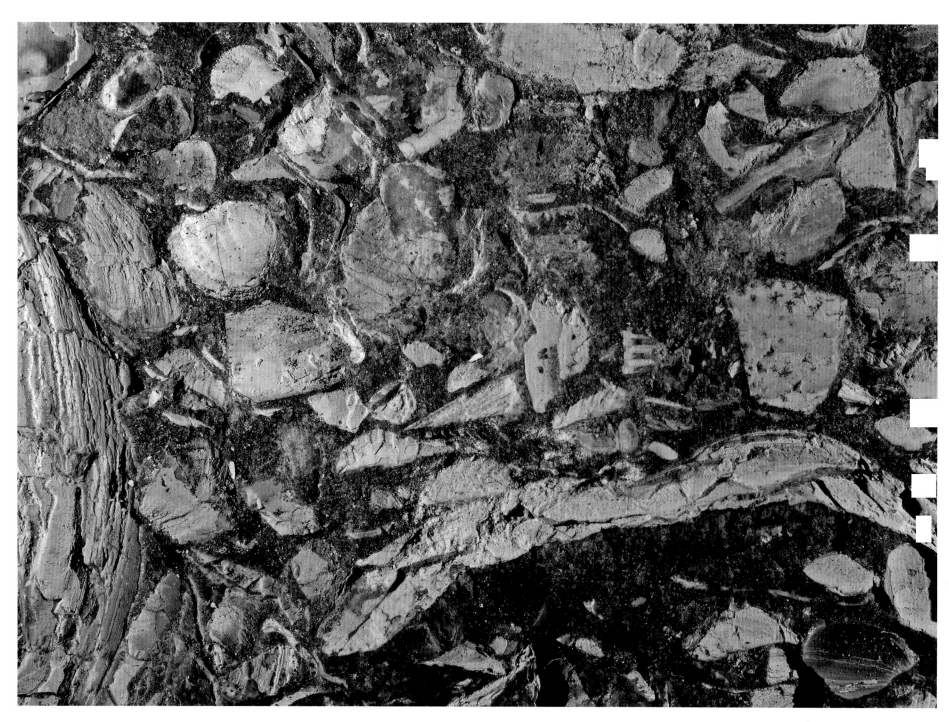

Muschelschill
Mio-Pliozän, etwa 5 Ma
Camacho, Rio de la Plata, Uruguay
Vergrößerung: etwa 6,6
Glossar: Weichtiere / Muscheln

Bivalve shell
Mio-Pliocene, approx. 5 Ma
Camacho, Rio de la Plata, Uruguay
Enlargement: approx. 6.6
Glossary: molluscs / bivalves

Kuckersit mit Bryozoen
Mittelordovizium, etwa 465 Ma
Kuckers, Estland
Vergrößerung: etwa 5 x
Glossar: Moostierchen

Kuckersite with bryozoans
Middle Ordovician, approx. 465 Ma
Kuckers, Estonia
Enlargement: approx. 5 x
Glossary: bryozoans

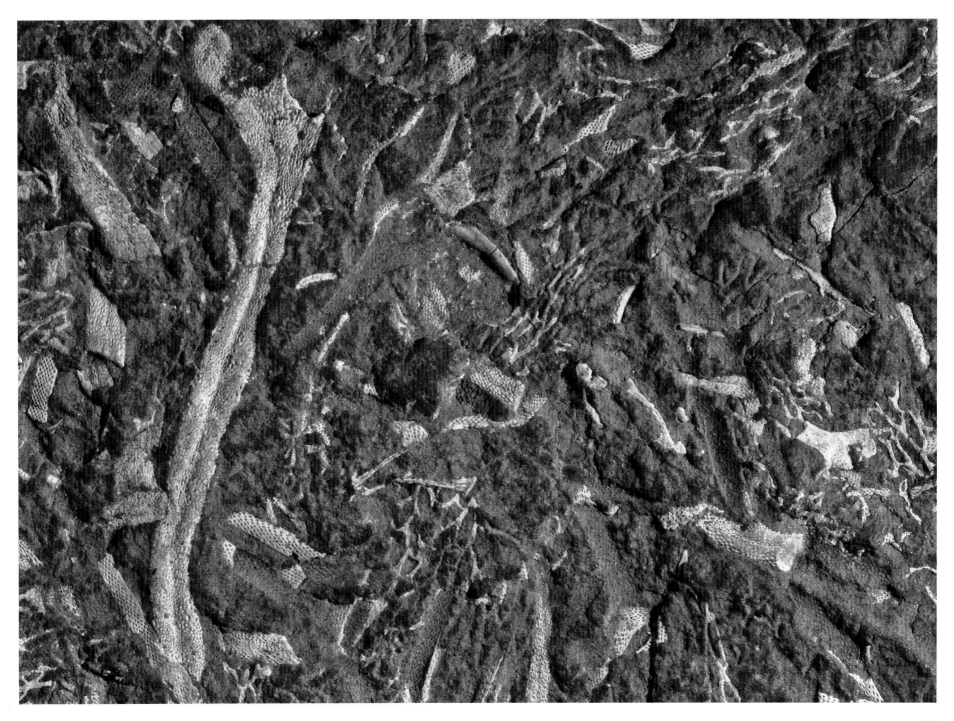

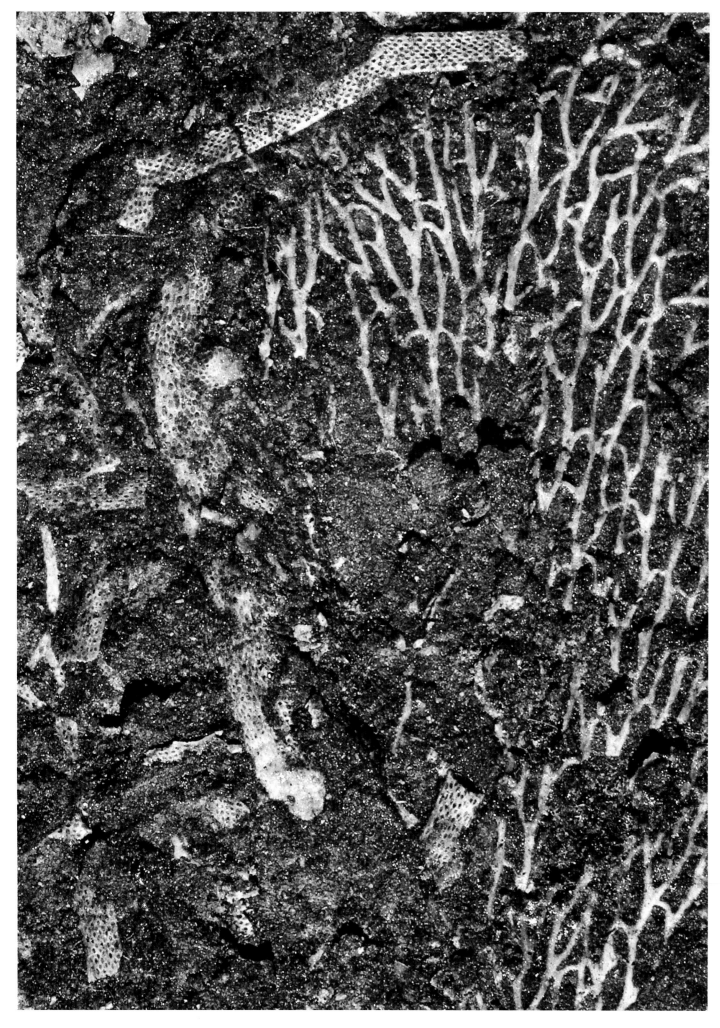

Kuckersit mit Bryozoen
Mittelordovizium, etwa 465 Ma
Kuckers, Estland
Vergrößerung: etwa 8,5 x
Glossar: Moostierchen

Kuckersite with bryozoans
Middle Ordovician, approx. 465 Ma
Kuckers, Estonia
Enlargement: approx. 8,5 x
Glossary: bryozoans

Muschelkalk-Anschliff mit *Coenothyris*
Mittlere Trias, etwa 235 Ma
Hohenloher Land, Deutschland
Vergrößerung: etwa 4 x
Glossar: Armfüßer

Polished section through a »Muschelkalk«
facies with *Coenothyris*
Middle Triassic, approx. 235 Ma
Hohenloher Land, Germany
Enlargement: approx. 4 x
Glossary: brachiopods

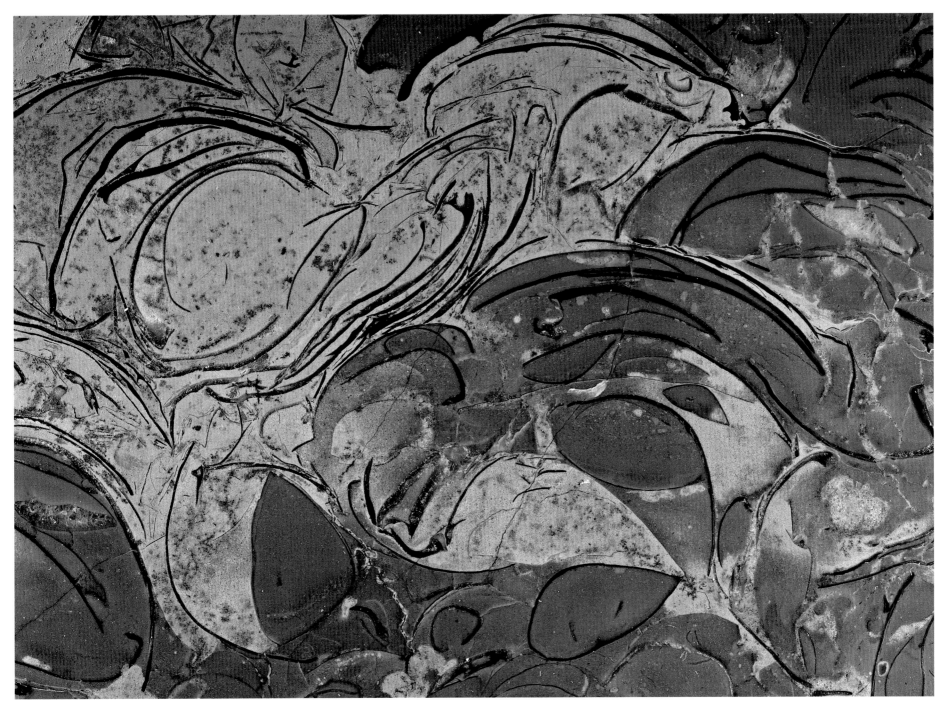

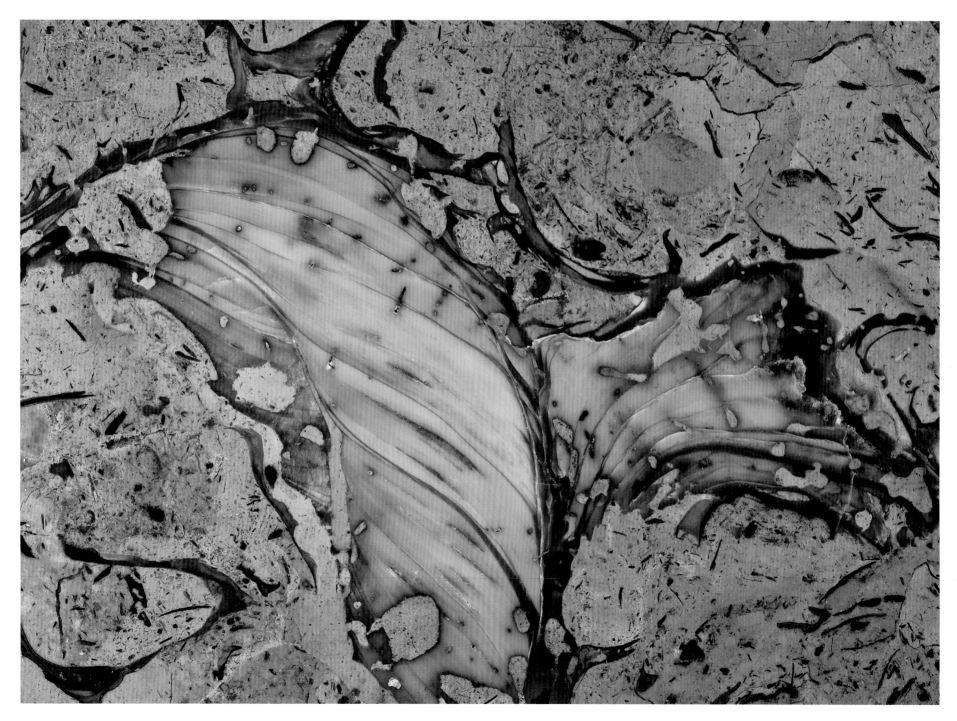

Bohrschwamm *Cliona*
Oberkreide, etwa 88 Ma
Sintra, Lissabon, Portugal
Vergrößerung: etwa 4,5 x
Glossar: Schwämme

Boring sponge *Cliona*
Late Cretaceous, approx. 88 Ma
Sintra, Lisbon, Portugal
Enlargement: approx. 4.5 x
Glossary: sponges

Coralliner Schwamm *Stromatopora*
Mitteldevon, etwa 380 Ma
Barrios de Gordon, Spanien
Vergrößerung: etwa 5,4 x
Glossar: Schwämme

Stromatoporoid coralline sponge
Middle Devonian, approx. 380 Ma
Barrios de Gordon, Spain
Enlargement: approx. 5.4 x
Glossary: sponges

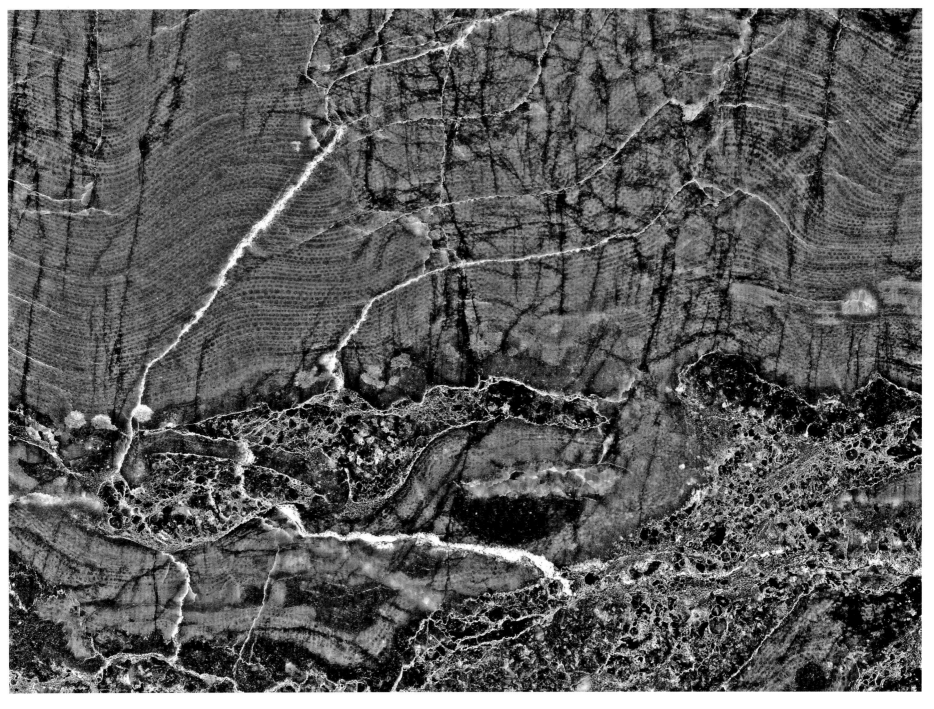

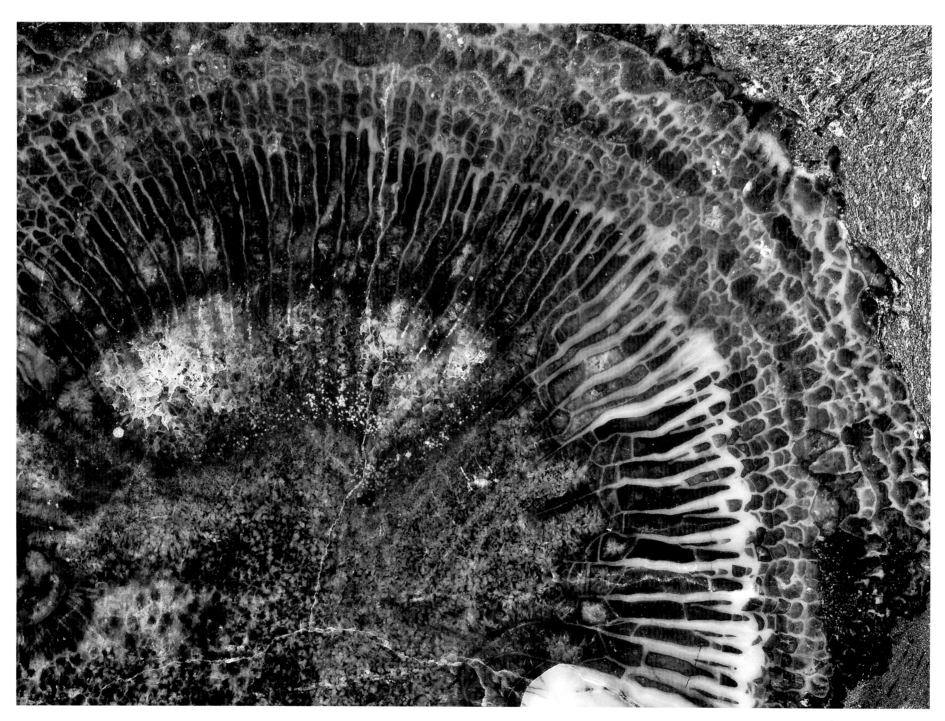

Schnitt durch eine rugose Koralle
Unterkarbon, etwa 340 Ma
Sablé sur Sarthe, Frankreich
Vergrößerung: etwa 7 x
Glossar: Korallen / Rugosa

Transversal section of a rugosan coral
Early Carboniferous, approx. 340 Ma
Sablé sur Sarthe, France
Enlargement: approx. 7 x
Glossary: corals / Rugosa

Acervularia
Silur, etwa 423 Ma
Gotland, Schweden
Vergrößerung: etwa 12 x
Glossar: Korallen / Rugosa

Acervularia
Silurian, approx. 423 Ma
Gotland, Sweden
Enlargement: approx. 12 x
Glossary: corals / Rugosa

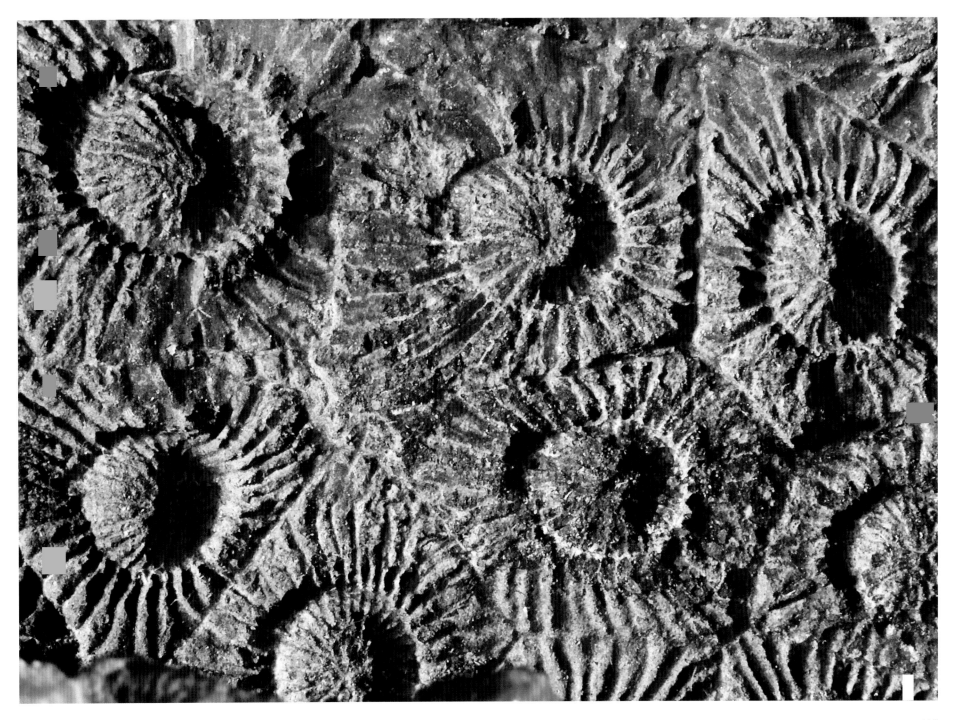

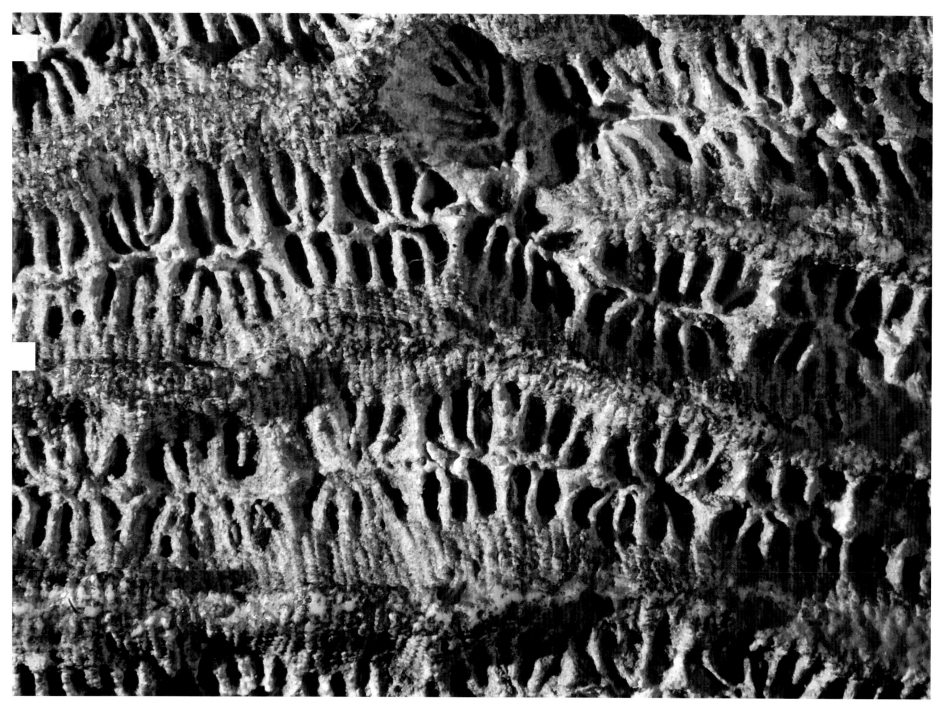

144

Latomeandra
Oberjura, etwa 150 Ma
Tübingen, Deutschland
Vergrößerung: etwa 13 x
Glossar: Korallen / Scleractinia

Latomeandra
Late Jurassic, approx. 150 Ma
Tübingen, Germany
Enlargement: approx. 13 x
Glossary: corals / Scleractinia

Halysites
Silur, etwa 425 Ma
Norddeutsches Glazialgeschiebe
Vergrößerung: etwa 7 x
Glossar: Korallen / Tabulata

Halysites
Silurian, approx. 425 Ma
Glacial drift, Northern Germany
Enlargement: approx. 7 x
Glossary: corals / Tabulata

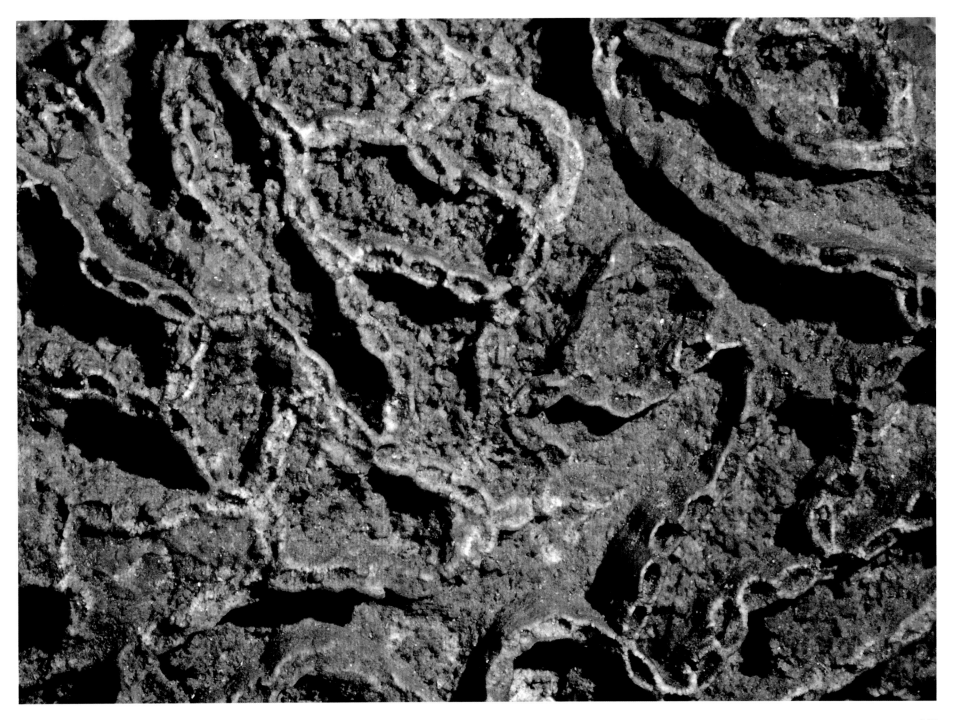

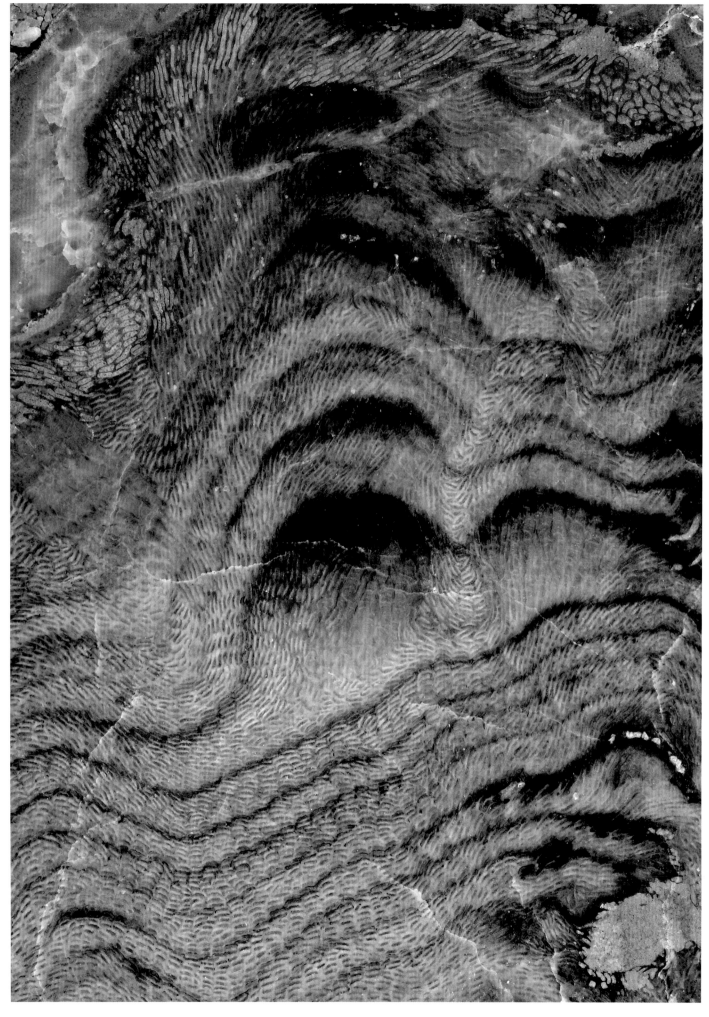

Alveolites
Mitteldevon, etwa 382 Ma
Geras de Gordon, Spanien
Vergrößerung: etwa 6x
Glossar: Korallen / Tabulata

Alveolites
Middle Devonian, approx. 382 Ma
Geras de Gordon, Spain
Enlargement: approx. 6x
Glossary: corals / Tabulata

Halysites
Obersilur, etwa 420 Ma
Gotland, Schweden
Vergrößerung: etwa 5x
Glossar: Korallen / Tabulata

Halysites
Late Silurian, approx. 420 Ma
Gotland, Sweden
Enlargement: approx. 5x
Glossary: corals / Tabulata

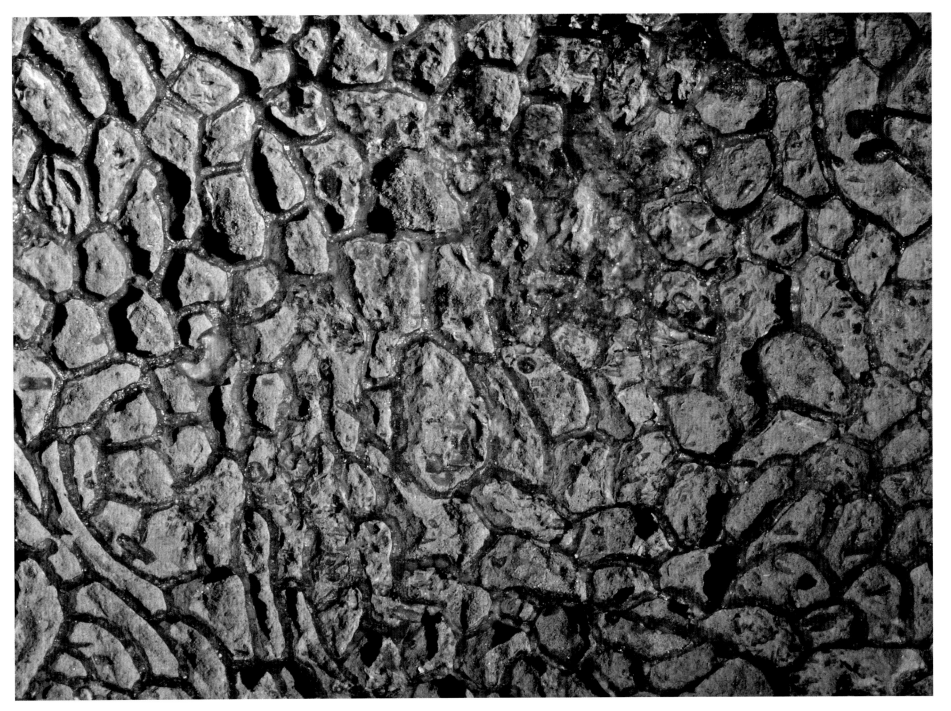

Stromatolith
Oberjura, ca. 147 Ma
Thüste, Deutschland
Vergrößerung: etwa 4,5 x
Glossar: Cyanobakterien

Stromatolite
Late Jurassic, approx. 147 Ma
Thüste, Germany
Enlargement: approx. 4.5 x
Glossary: blue-green algae

Stromatolith mit Trockenrissen
Oberproterozoikum, etwa 600 Ma
Omberg, Schweden
Vergrößerung: etwa 4 x
Glossar: Cyanobakterien

Stromatolite with desiccation cracks
Late Proterozoic, approx. 600 Ma
Omberg, Sweden
Enlargement: 4 x
Glossary: blue-green algae

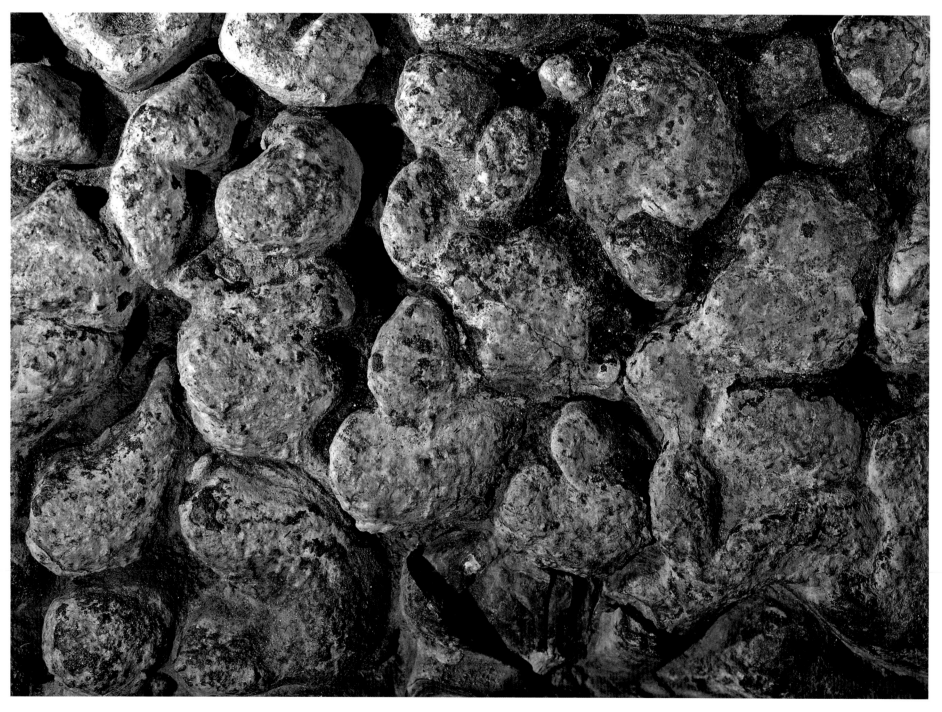

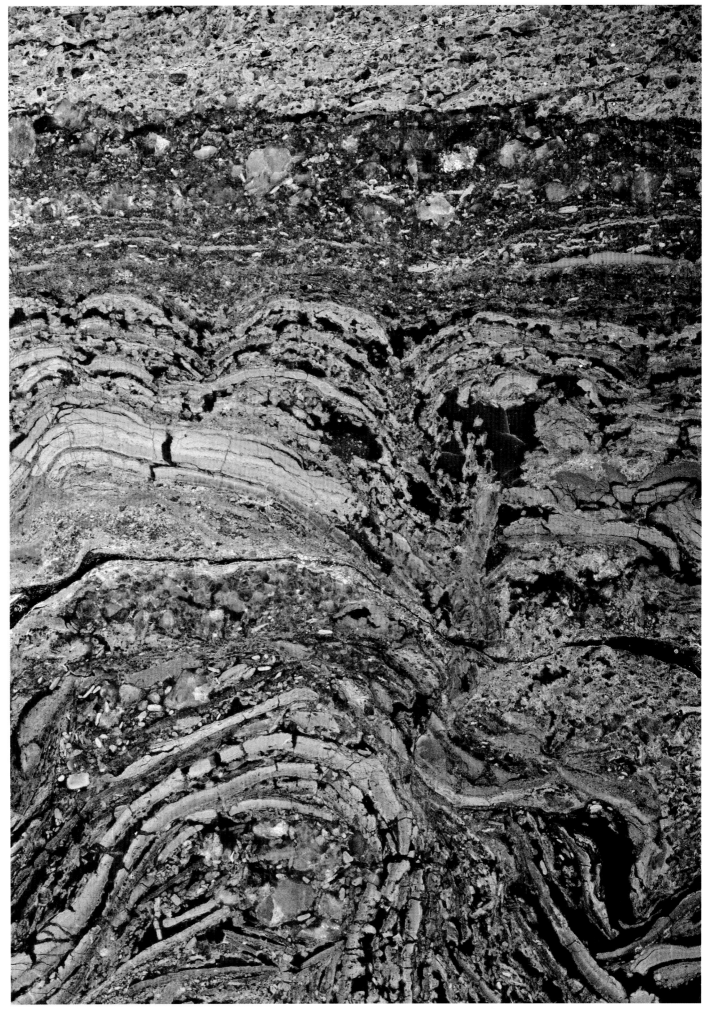

Onkoide
Unterkreide, etwa 125 Ma
Galve, Spanien
Vergrößerung: etwa 5,6x
Glossar: Cyanobakterien

Oncoid
Early Cretaceous, approx. 125 Ma
Galve, Spain
Enlargement: approx. 5.6x
Glossary: blue-green algae

Loferit
Obertrias, etwa 222 Ma
Nördliche Kalkalpen
Vergrößerung: etwa 6x
Glossar: Cyanobakterien

Loferite
Late Triassic, approx. 222 Ma
Northern Calcareous Alps
Enlargement: approx. 6x
Glossary: blue-green algae

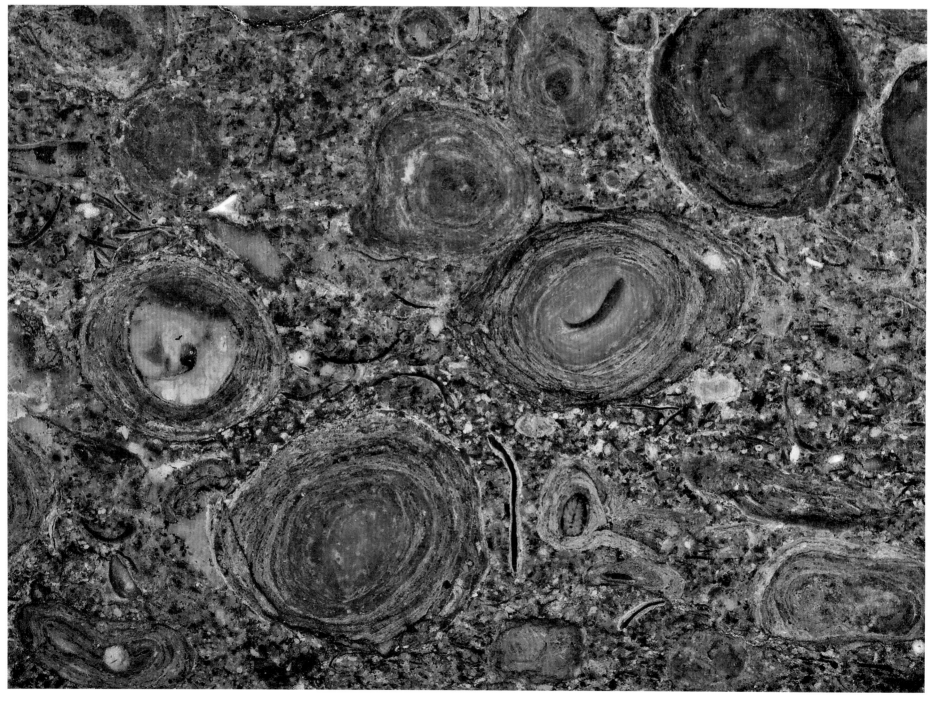

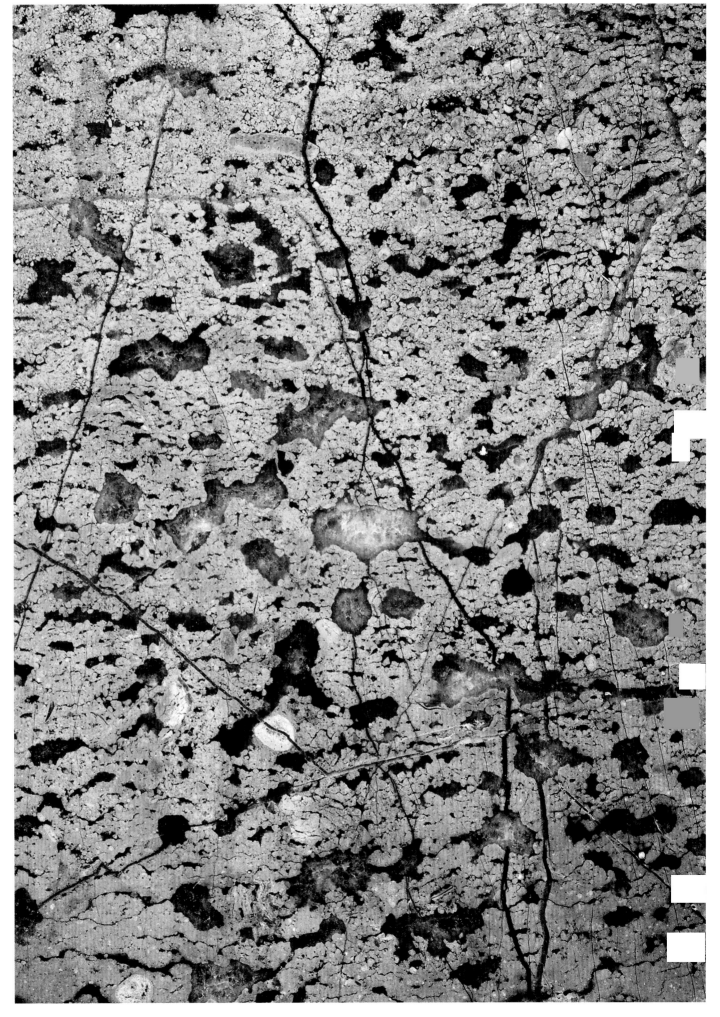

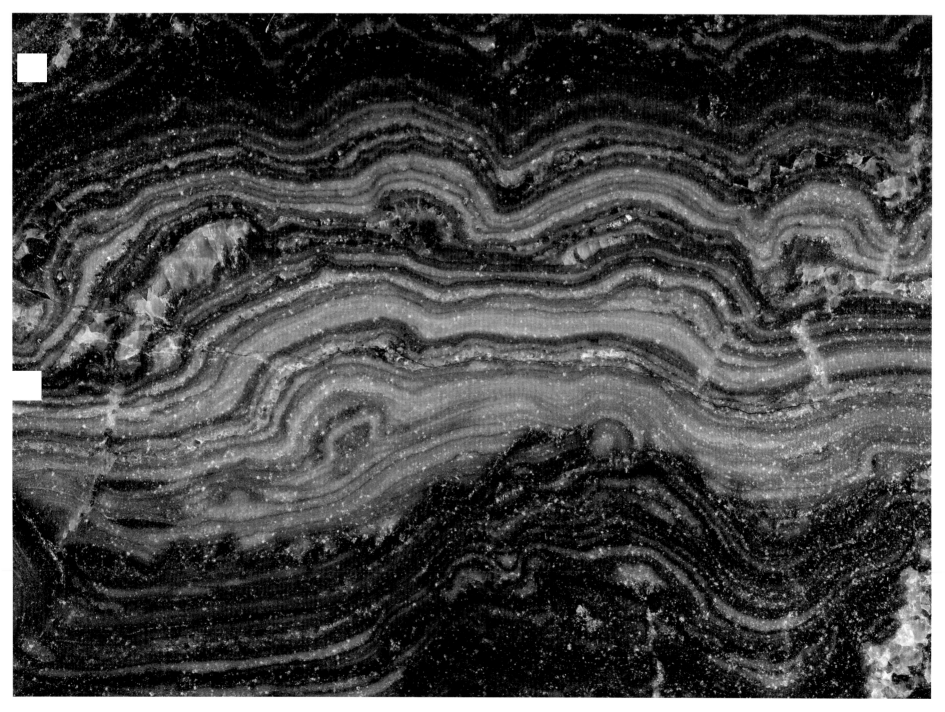

Stromatolith
Unterproterozoikum, etwa 1800 Ma
Kuruman, Süd-Afrika
Vergrößerung: etwa 4,7 x
Glossar: Cyanobakterien

Stromatolite
Early Proterozoic, approx. 1800 Ma
Kuruman, South Africa
Enlargement: approx. 4.7 x
Glossary: blue-green algae

Stromatolith, Säulenstruktur
Jungpräkambrium, etwa 650 Ma
Limfjord, Dänemark
Vergrößerung: etwa 3 x
Glossar: Cyanobakterien

Stromatolite, Columnar structure
Late Precambrian, approx. 650 Ma
Limfjord, Denmark
Enlargement: approx. 3 x
Glossary: blue-green algae

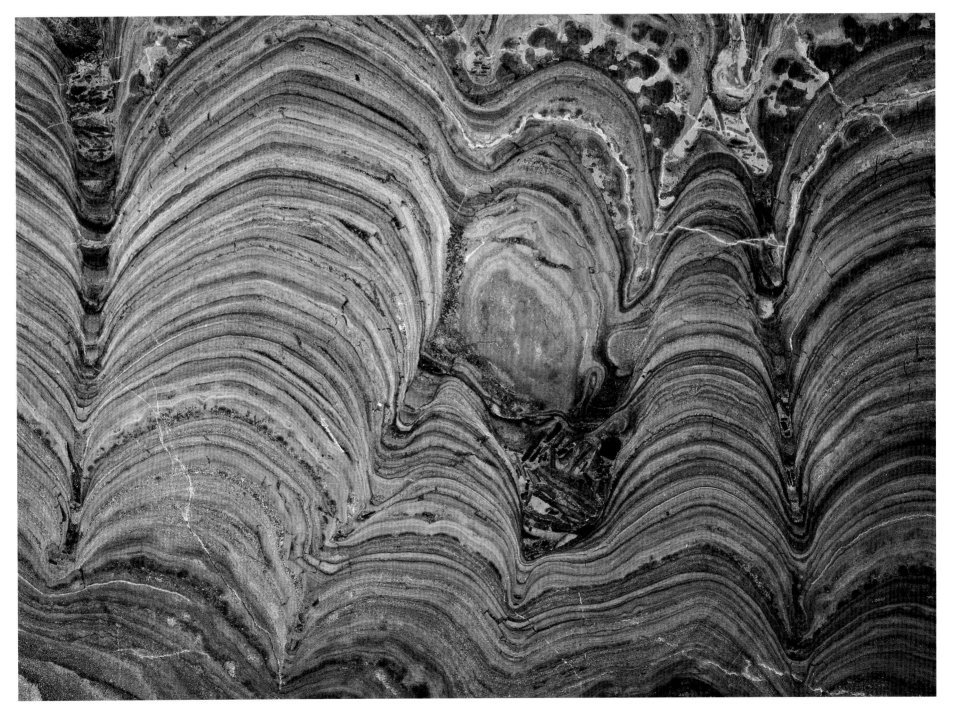

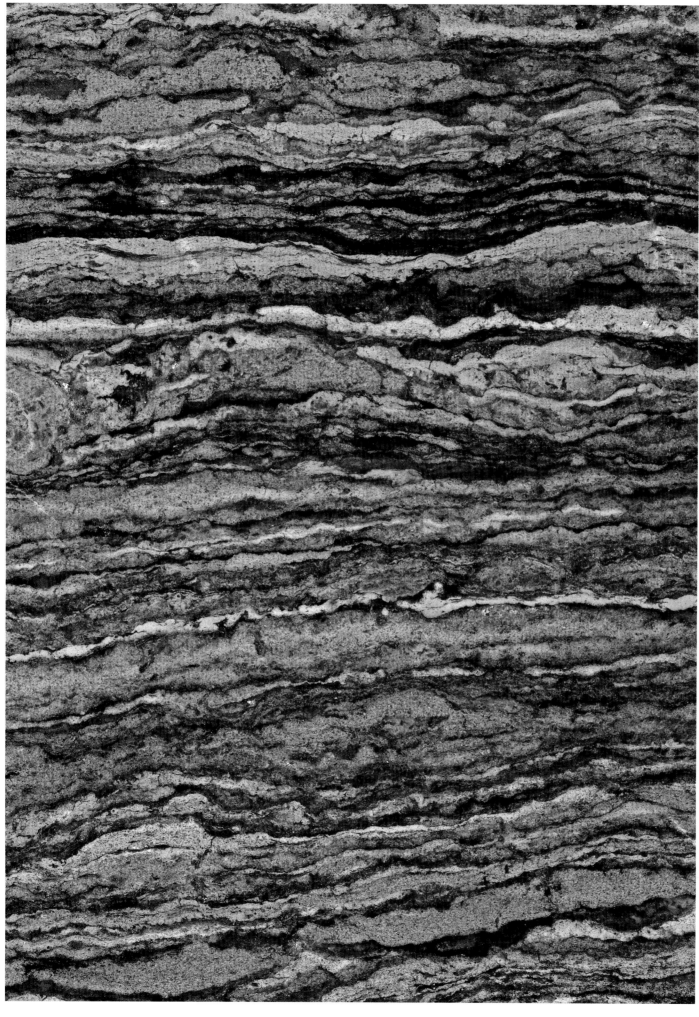

Laminarer *Stromatolith*
Obertrias, etwa 215 Ma
Gaussau, Salzburg, Österreich
Vergrößerung: etwa 5,4 x
Glossar: Cyanobakterien

Laminated *Stromatolite*
Late Triassic, approx. 215 Ma
Gaussau, Salzburg, Austria
Enlargement: approx. 5.4 x
Glossary: blue-green algae

Paranorites, ceratitische Lobenlinie
Untertrias, etwa 245 Ma
Salt Range, Indien
Vergrößerung: etwa 7,5 x
Glossar: Weichtiere / Ammoniten

Paranorites, ceratitic suture
Early Triassic, approx. 245 Ma
Salt Range, India
Enlargement: approx. 7.5 x
Glossary: molluscs / ammonoids

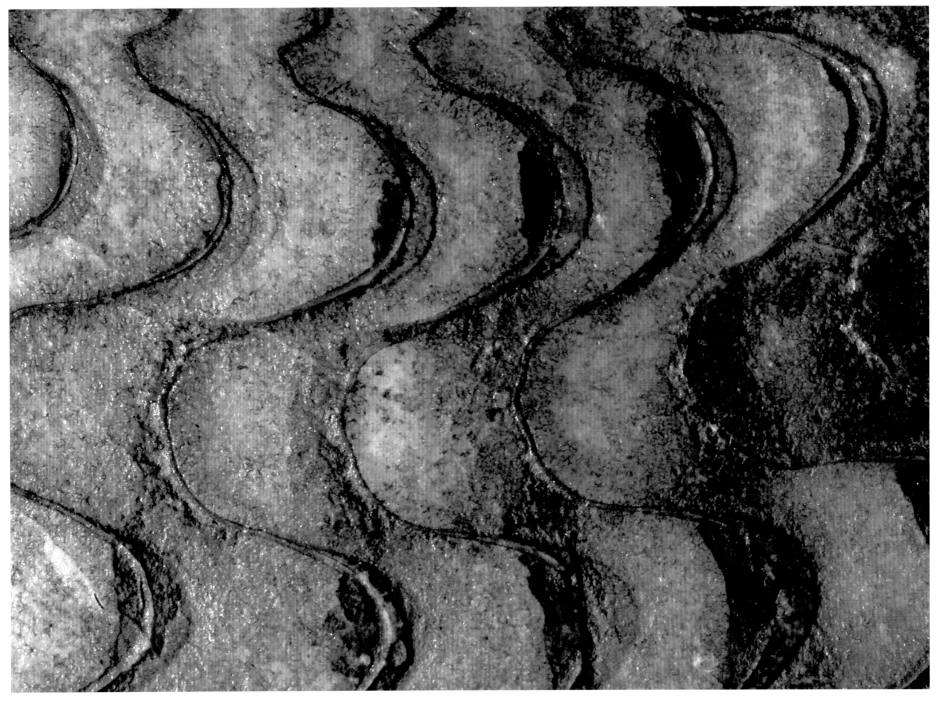

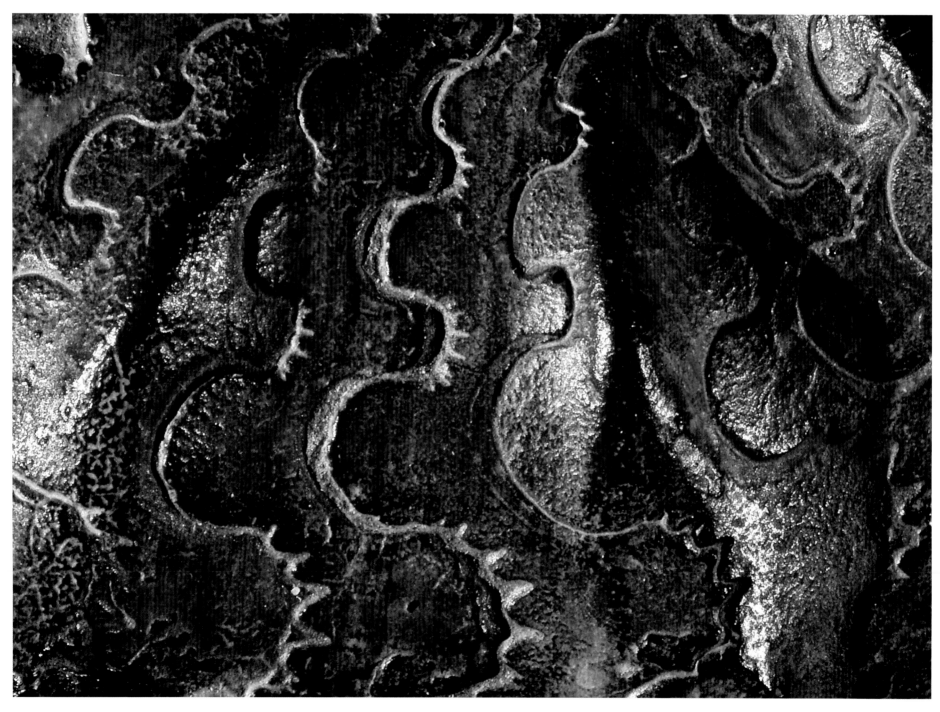

Ceratitische Lobenlinie
Mitteltrias, etwa 235 Ma
Hessen, Deutschland
Vergrößerung: etwa 9x
Glossar: Weichtiere / Ammoniten

Ceratitic suture
Middle Triassic, approx. 235 Ma
Hesse, Germany
Enlargement: approx. 9x
Glossary: molluscs / ammonoids

Ceratitische Lobenlinie
Mitteltrias, etwa 235 Ma
Thüringen, Deutschland
Vergrößerung: etwa 9x
Glossar: Weichtiere / Ammoniten

Ceratitic suture
Middle Triassic, approx. 235 Ma
Thuringia, Germany
Enlargement: approx. 9x
Glossary: molluscs / ammonoids

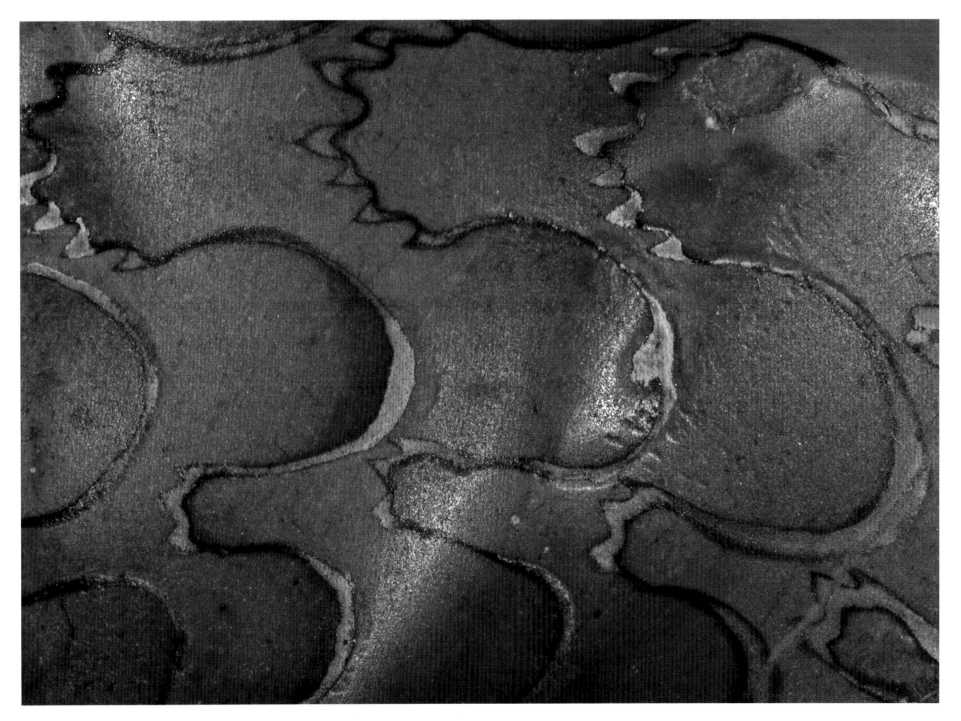

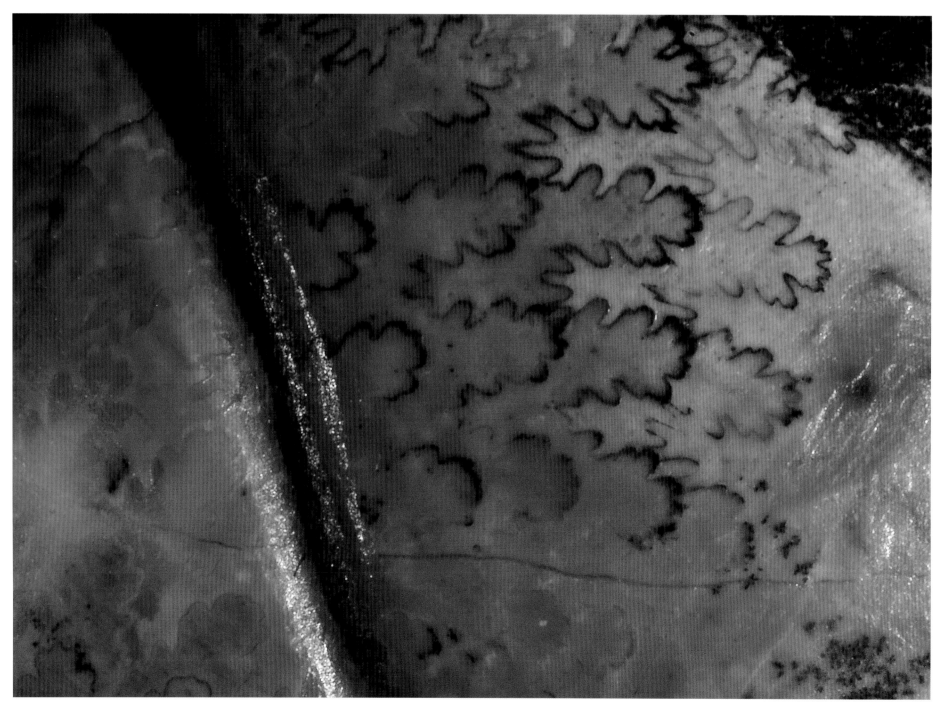

Arcestes, Lobenlinie
Obertrias, etwa 210 Ma
Feuerkogel, Österreich
Vergrößerung: etwa 13 x
Glossar: Weichtiere / Ammoniten

Arcestes, suture line
Late Triassic, approx. 210 Ma
Feuerkogel, Austria
Enlargement: approx. 13 x
Glossary: molluscs / ammonoids

Baculites, Lobenlinie
Oberkreide, etwa 75 Ma
Cheyenne River, Süd Dakota, USA
Vergrößerung: etwa 10 x
Glossar: Weichtiere / Ammoniten

Baculites, suture line
Late Cretaceous, approx. 75 Ma
Cheyenne River, South Dakota, USA
Enlargement: approx. 10 x
Glossary: molluscs / ammonoids

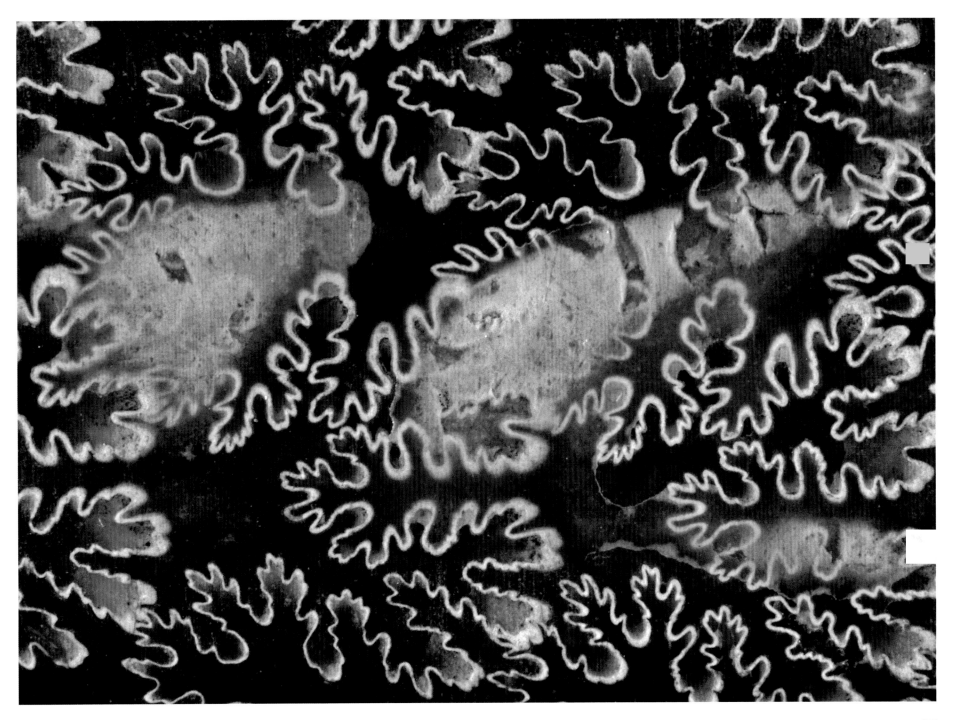

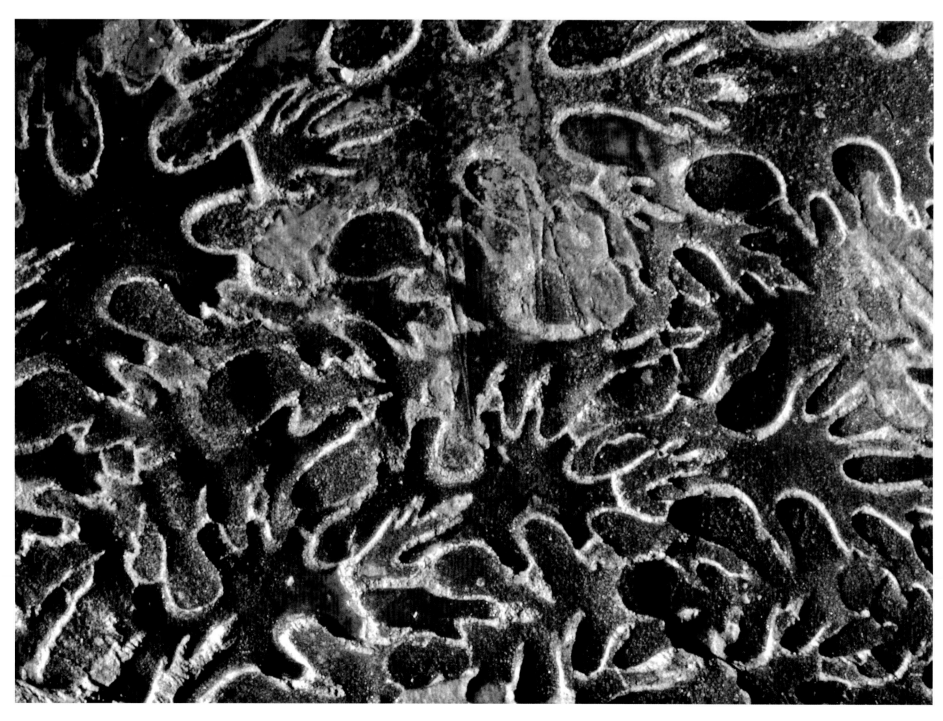

Phylloceras, Lobenlinie
Unterjura, etwa 190 Ma
Sao Pedro de Muel, Portugal
Vergrößerung: etwa 13 x
Glossar: Weichtiere / Ammoniten

Phylloceras, suture line
Early Jurassic, approx. 190 Ma
Sao Pedro de Muel, Portugal
Enlargement: approx. 13 x
Glossary: molluscs / ammonoids

Cardioceras, verkieselt
Oberjura, etwa 156 Ma
Neuvizy, Frankreich
Vergrößerung: etwa 12 x
Glossar: Weichtiere / Ammoniten

Cardioceras, silicified
Late Jurassic, approx. 156 Ma
Neuvizy, France
Enlargement: approx. 12 x
Glossary: molluscs / ammonoids

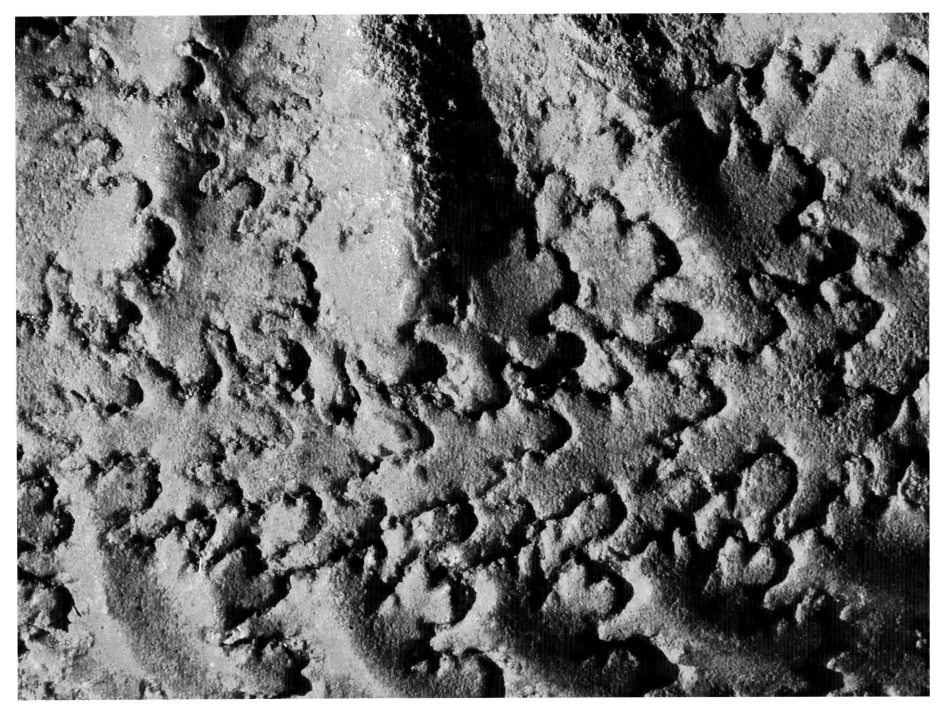

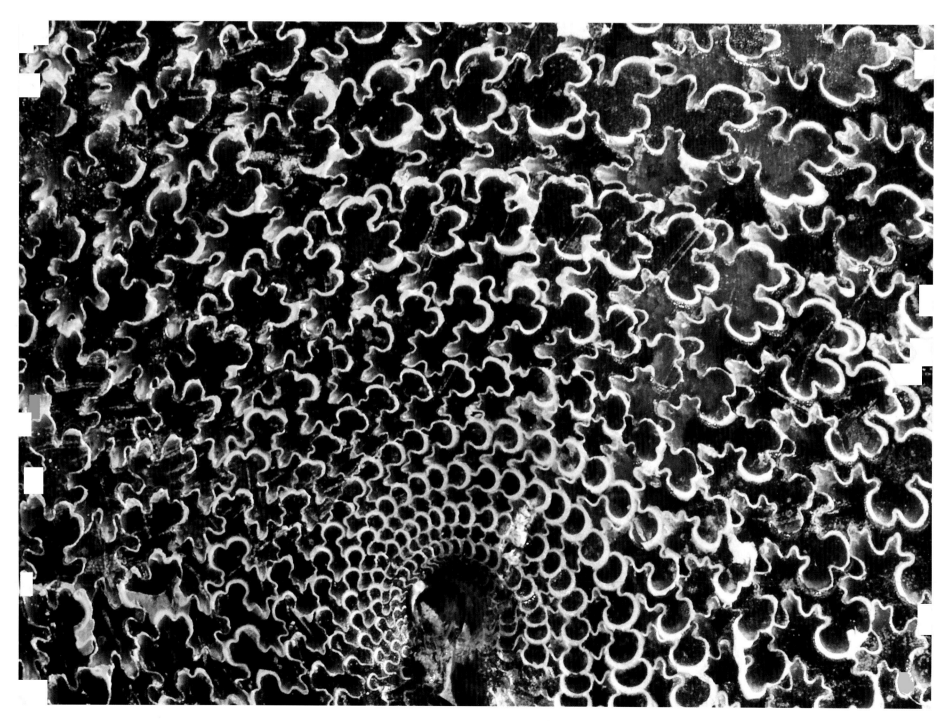

Sphenodiscus, Lobenlinie
Oberkreide, etwa 70 Ma
Fox Hills, South Dakota, USA
Vergrößerung: etwa 12 x
Glossar: Weichtiere / Ammoniten

Sphenodiscus, suture line
Late Cretaceous, approx. 70 Ma
Fox Hills, South Dakota, USA
Enlargement: approx. 12 x
Glossary: molluscs / ammonoids

Lytoceras, Lobenlinie, von Relikten der Anwachslinien
überlagert
Unterjura, etwa 185 Ma
Blumberg, Deutschland
Vergrößerung: etwa 10 x
Glossar: Weichtiere / Ammoniten

Lytoceras, suture line, overprinted by relicts of growth
lines
Early Jurassic, approx. 185 Ma
Blumberg, Germany
Enlargement: approx. 10 x
Glossary: molluscs / ammonoids

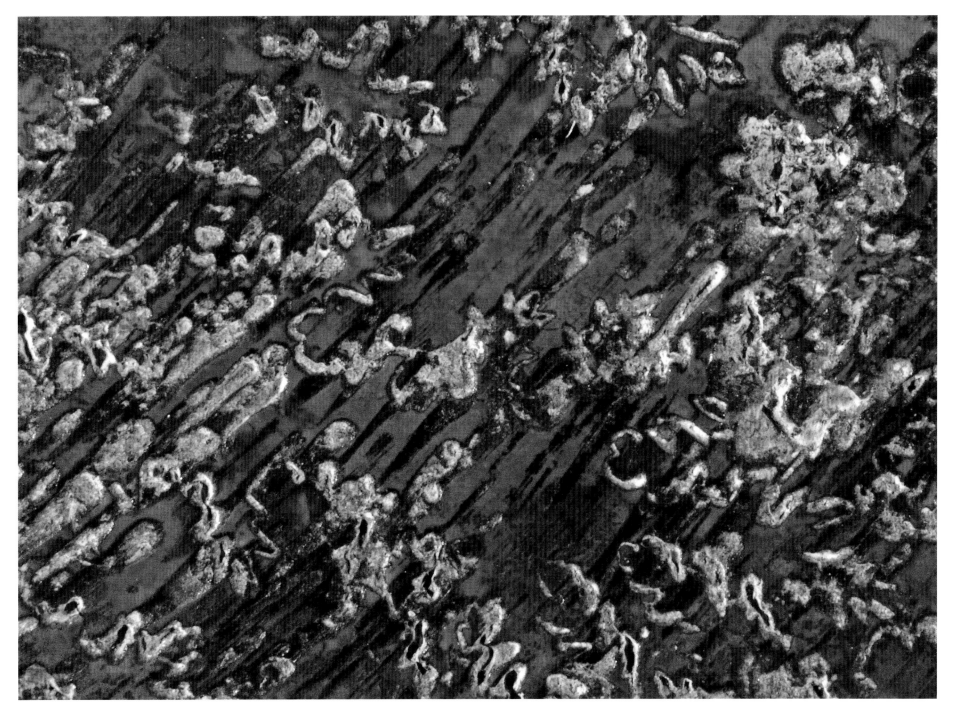

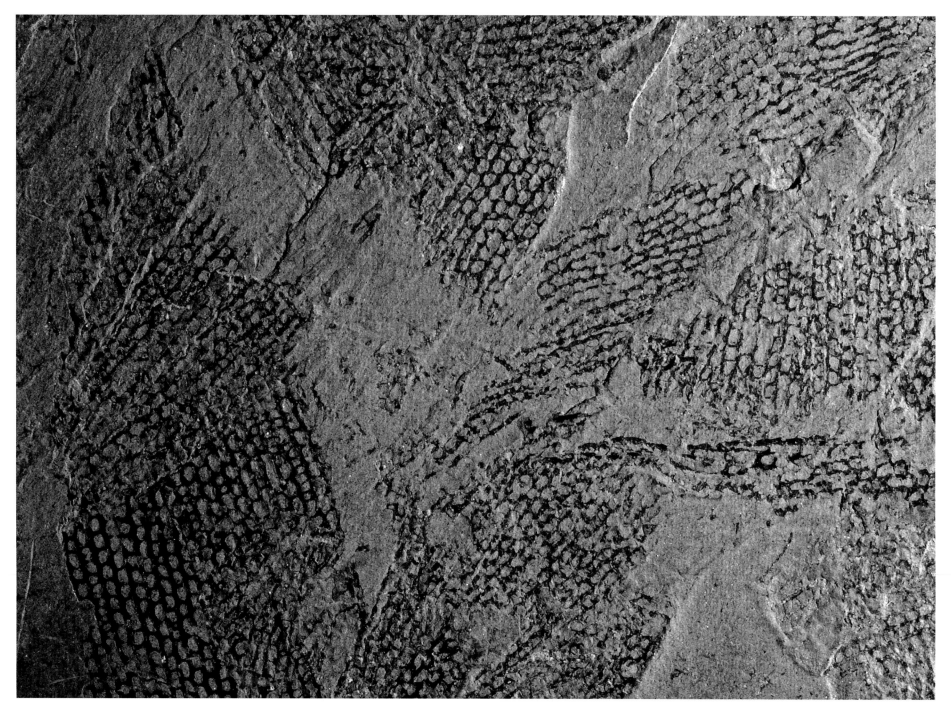

Rhabdinopora (Dictyonema)
Unterordovizium, etwa 487 Ma
Bornholm, Schweden
Vergrößerung: etwa 3,5 x
Glossar: Graptolithen / Dendroidea

Rhabdinopora (Dictyonema)
Early Ordovician, approx. 487 Ma
Bornholm, Sweden
Enlargement: approx. 3.5 x
Glossary: graptolites / Dendroidea

Monograptus
Obersilur, etwa 420 Ma
Berlin
Vergrößerung: etwa 9 x
Glossar: Graptolithen / Graptolithina

Monograptus
Late Silurian, approx. 420 Ma
Berlin
Enlargement: approx. 9 x
Glossary: graptolites / Graptolithina

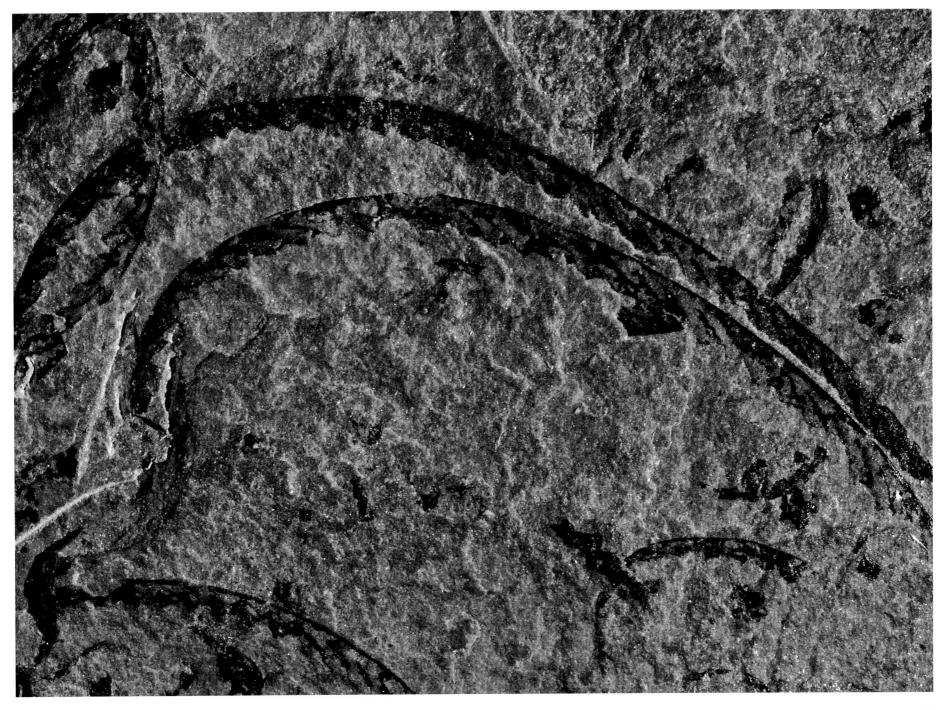

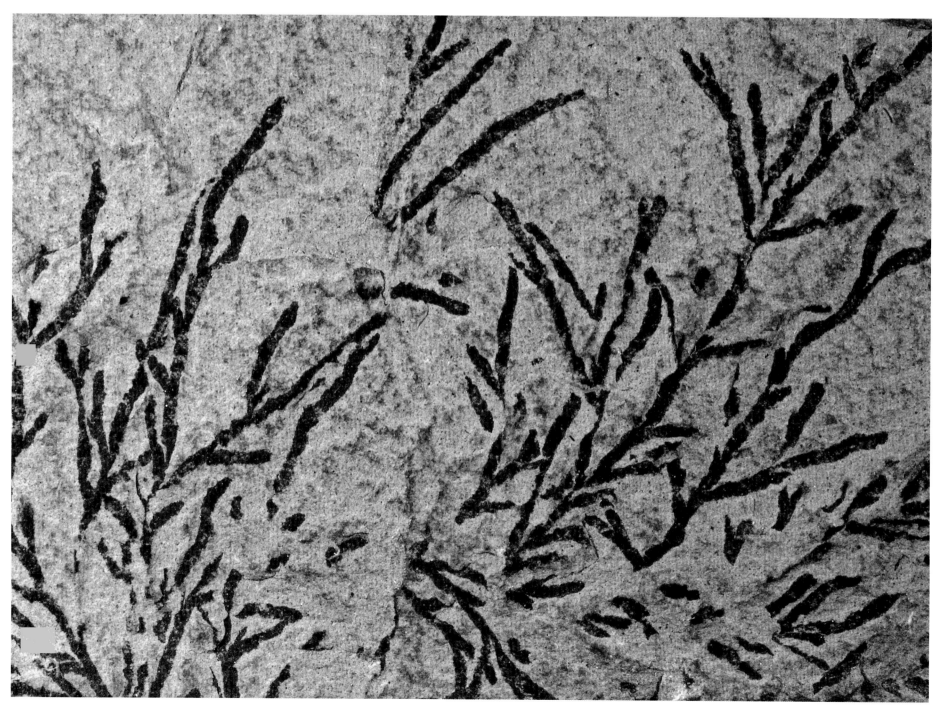

Chondrites
Oberkreide, etwa 99 Ma
Fischen, Deutschland
Vergrößerung: etwa 6x
Glossar: Spurenfossilien

Chondrites
Upper Cretaceous, approx. 99 Ma
Fischen, Germany
Enlargement: approx. 6x
Glossary: trace fossils

Chancelloria
Mittelkambrium, etwa 512 Ma
Millard County, Utah, USA
Vergrößerung: etwa 13x
Glossar: Chancellorien

Chancelloria
Middle Cambrian, approx. 512 Ma
Millard County, Utah, USA
Enlargement: approx. 13x
Glossary: chancellorids

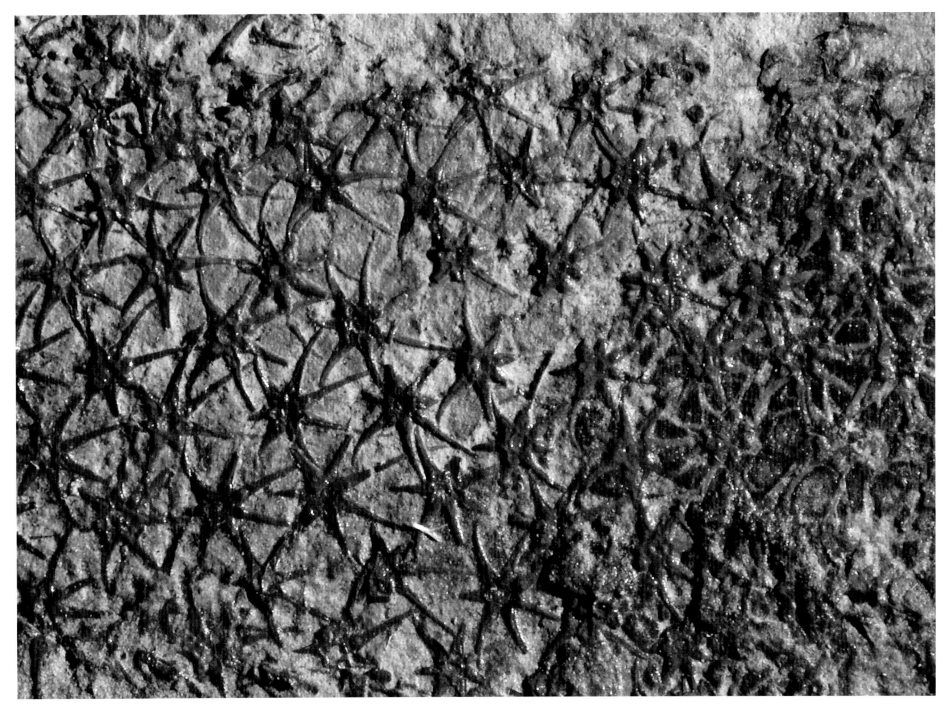

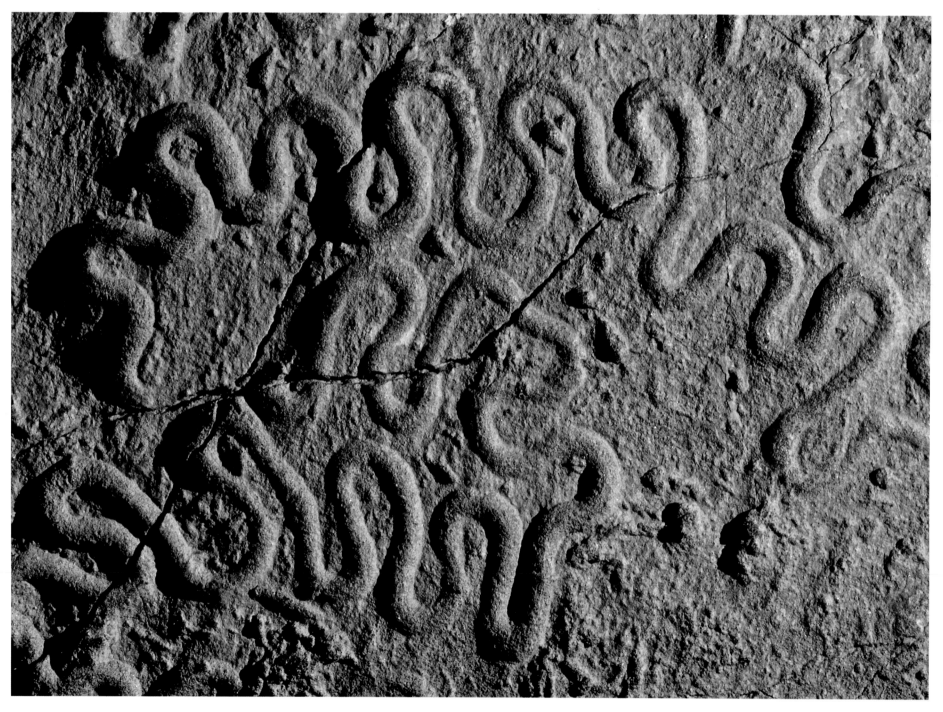

Cosmorhape
Eozän, etwa 45 Ma
Nordapennin, Italien
Vergrößerung: etwa 3x
Glossar: Spurenfossilien

Cosmorhape
Eocene, approx. 45 Ma
Northern Apennines, Italy
Enlargement: approx. 3x
Glossary: trace fossils

Scaphotrigonia
Mitteljura, etwa 178 Ma
Grünbach, Deutschland
Vergrößerung: etwa 14x
Glossar: Weichtiere / Muscheln

Scaphotrigonia
Middle Jurassic, approx. 178 Ma
Grünbach, Germany
Enlargement: approx. 14x
Glossary: molluscs / bivalves

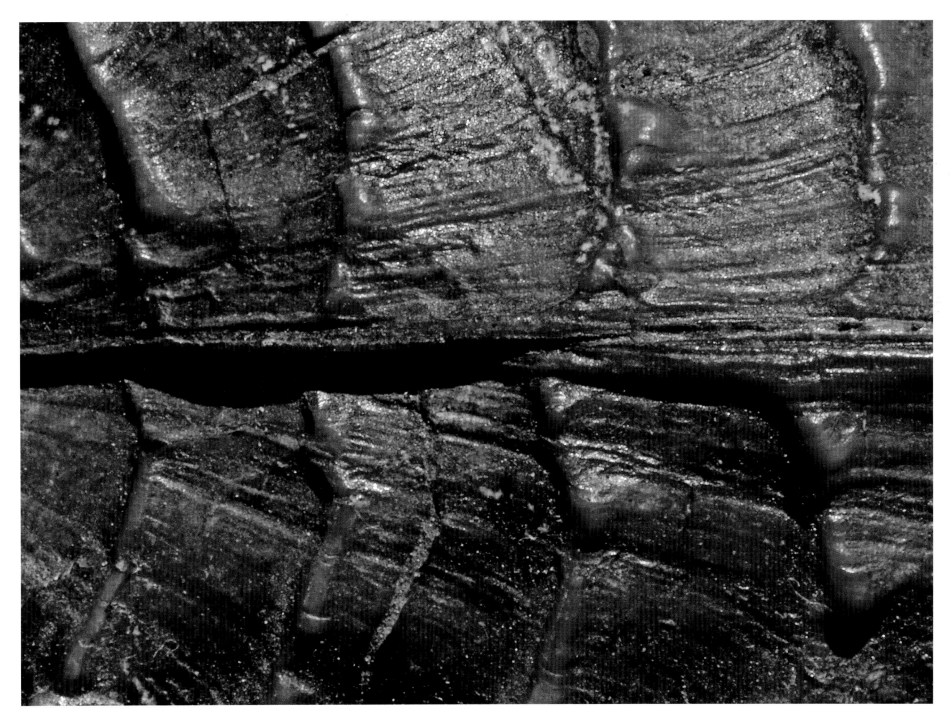

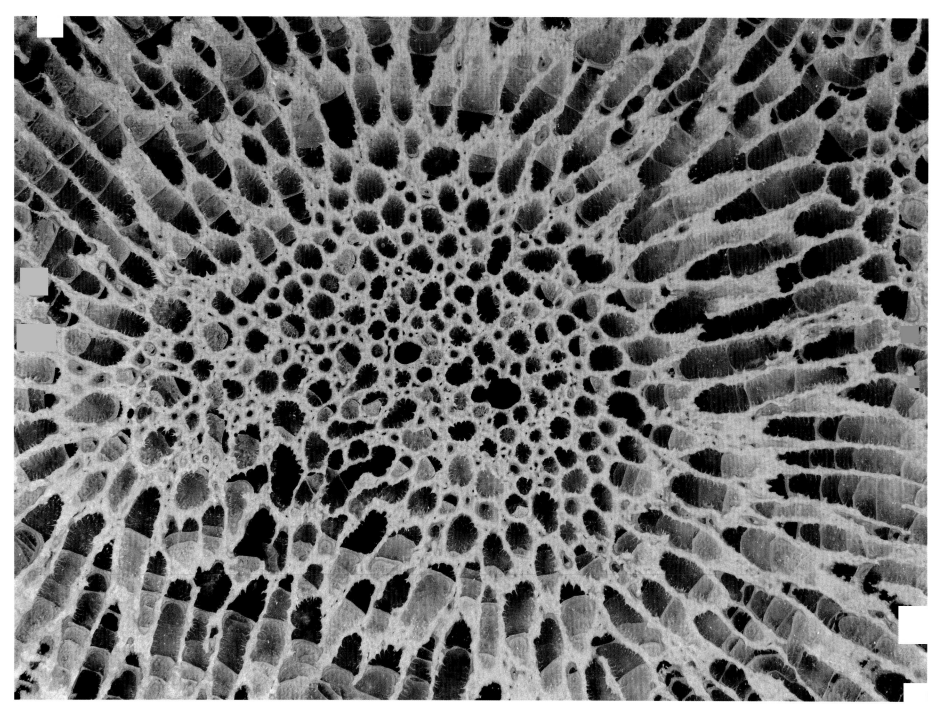

Acanthochaetetes, kalkiges Basalskelett
Unterkreide, etwa 105 Ma
Albeniz, Spanien
Vergrößerung: etwa 12 x
Glossar: Schwämme

Acanthochaetetes, calcareous basal skeleton
Early Cretaceous, approx. 105 Ma
Albeniz, Spain
Enlargement: approx. 12 x
Glossary: sponges

Actaeonella
Oberkreide, etwa 92 Ma
Gosau, Österreich
Vergrößerung: etwa 4 x
Glossar: Weichtiere / Schnecken

Actaeonella
Late Cretaceous, approx. 92 Ma
Gosau, Austria
Enlargement: approx. 4 x
Glossary: molluscs / gastropods

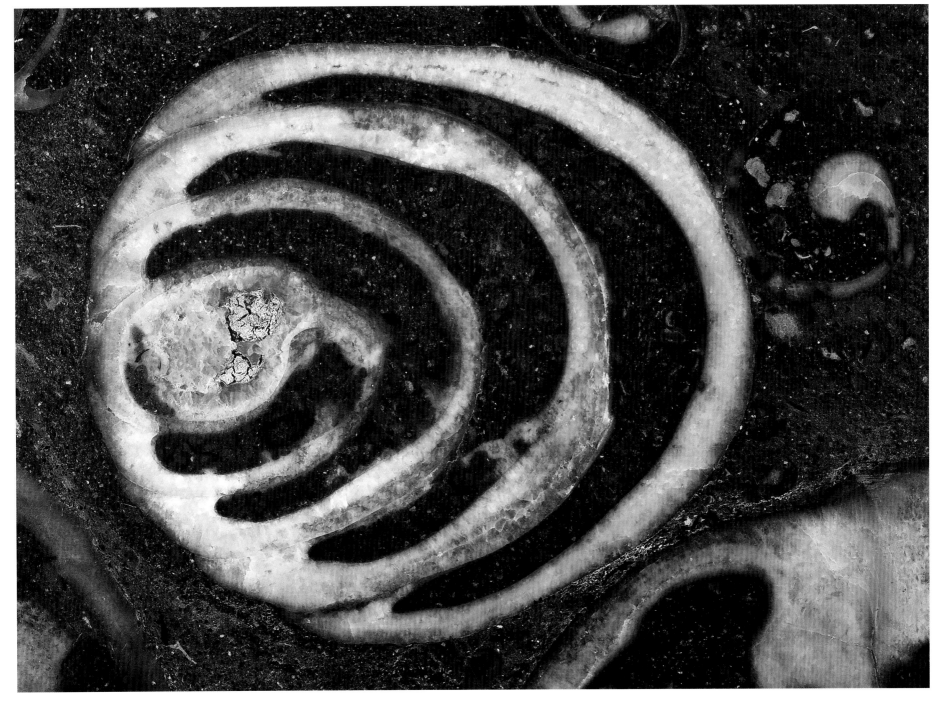

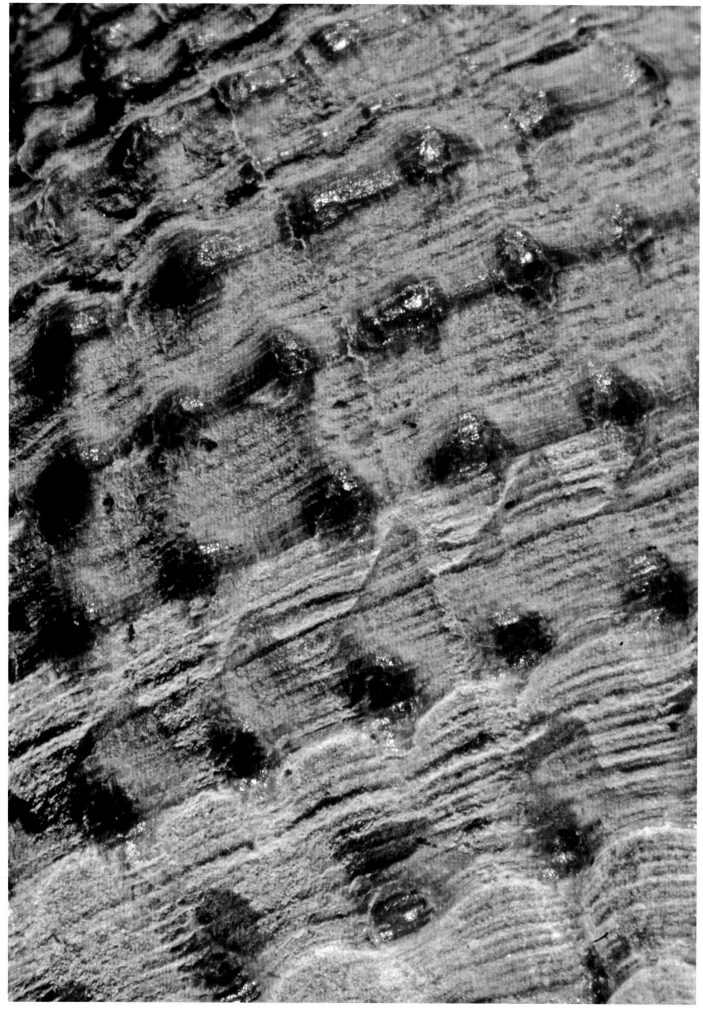

Semicassis, Oberflächenstruktur
Unteroligozän, etwa 30 Ma
Berlin-Hermsdorf, Deutschland
Vergrößerung: etwa 14 x
Glossar: Weichtiere / Schnecken

Semicassis, surface structure
Early Oligocene, approx. 30 Ma
Berlin-Hermsdorf, Germany
Enlargement: approx. 14 x
Glossary: molluscs / gastropods

Trigonia
Mitteljura, etwa 170 Ma
Bethel, Bielefeld, Deutschland
Vergrößerung: etwa 12 x
Glossar: Weichtiere / Muscheln

Trigonia
Middle Jurassic, approx. 170 Ma
Bethel, Bielefeld, Germany
Enlargement: approx. 12 x
Glossary: molluscs / bivalves

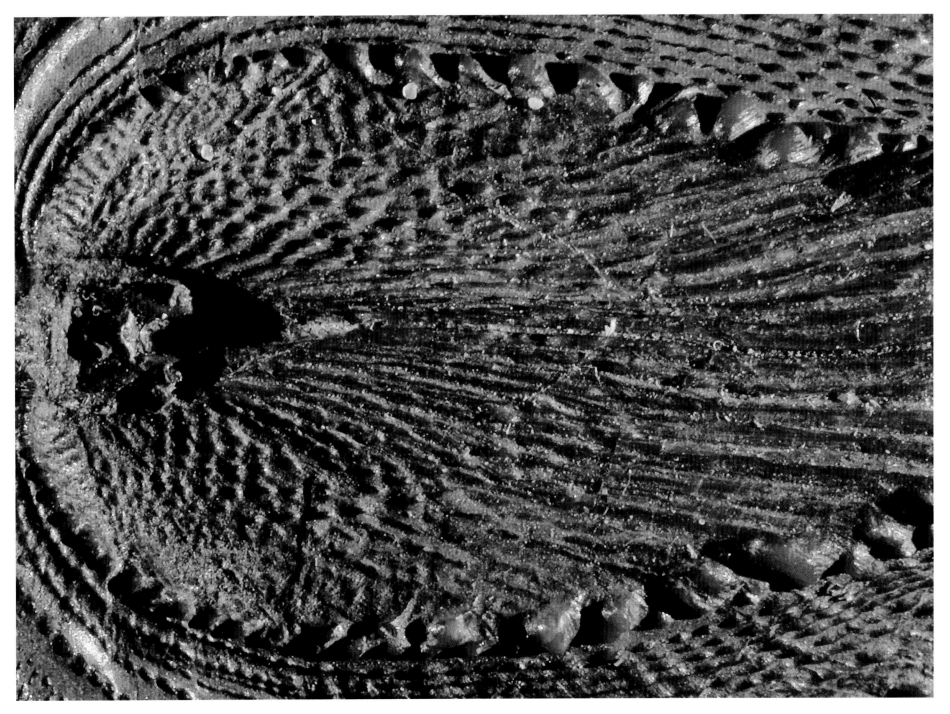

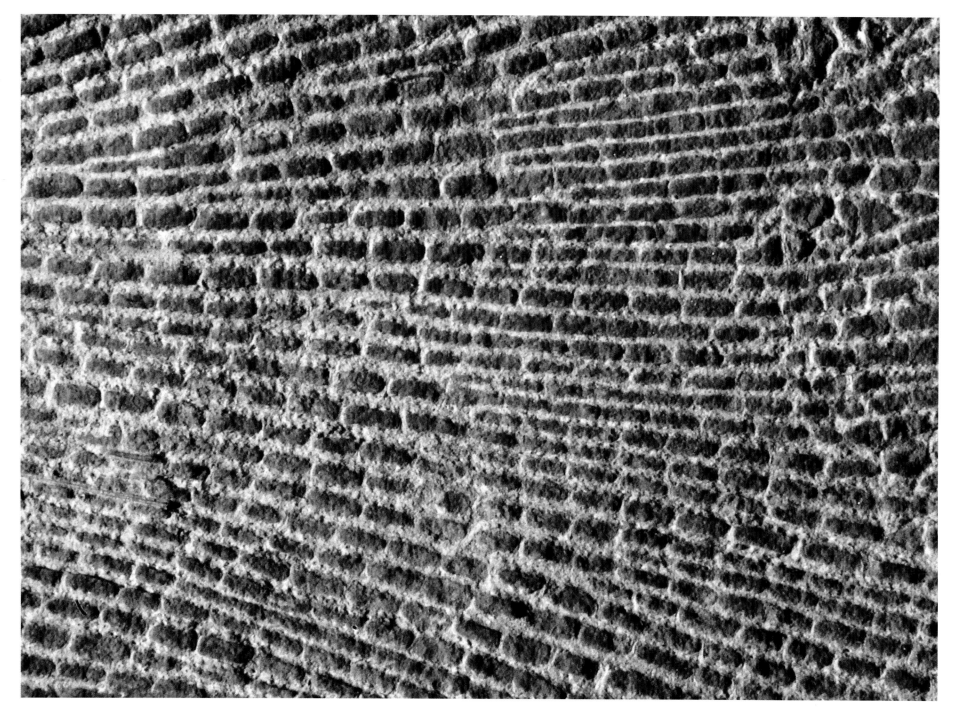

Fenestella
Unterkarbon, etwa 350 Ma
Modave (Huy), Belgien
Vergrößerung: etwa 12 x
Glossar: Moostierchen

Fenestella
Early Carboniferous, approx. 350 Ma
Modave (Huy), Belgium
Enlargement: approx. 12 x
Glossary: bryozoans

Orthotetes
Mitteldevon, etwa 380 Ma
St. Johann, Eifel, Deutschland
Vergrößerung: etwa 11 x
Glossar: Armfüßer

Orthotetes
Middle Devonian, approx. 380 Ma
St. Johann, Eifel, Germany
Enlargement: approx. 11 x
Glossary: brachiopods

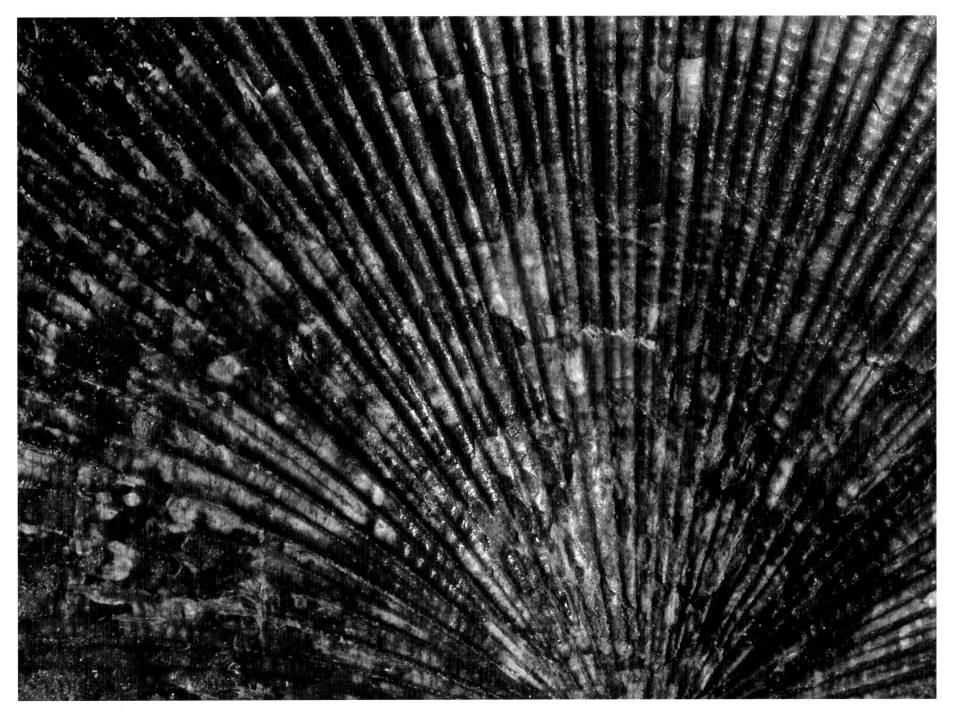

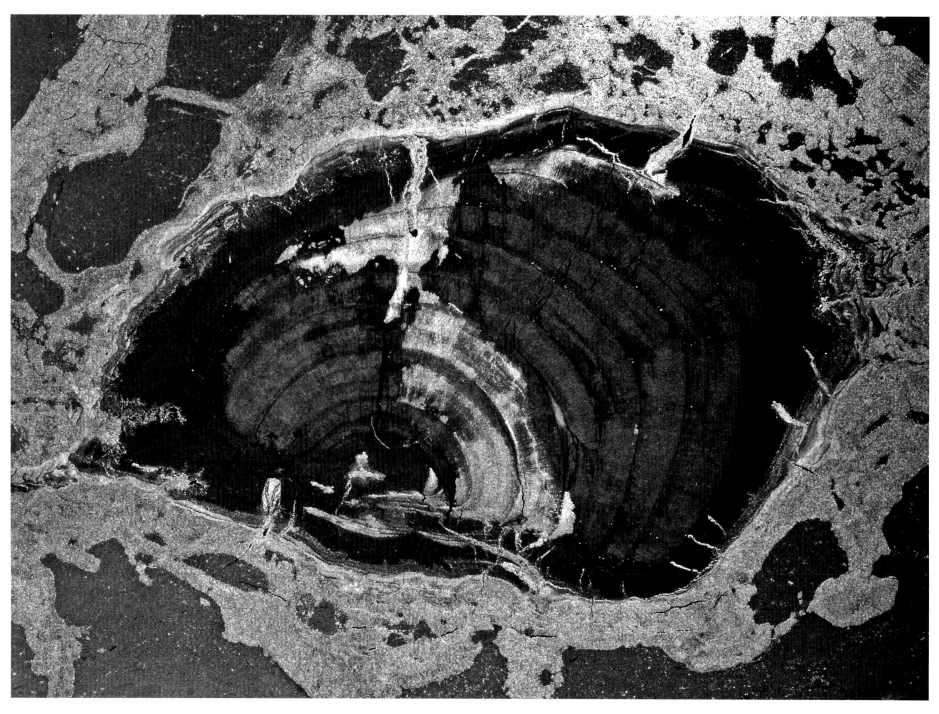

Holz, pyritisiert
Unterjura, etwa 193 Ma
Buttenheim, Deutschland
Vergrößerung: etwa 4 x
Glossar: Gefäßpflanzen, Coniferen

Wood, pyritized
Early Jurassic, approx. 193 Ma
Buttenheim, Germany
Enlargement: approx. 4 x
Glossary: conifers

Drotops armatus
Mitteldevon, etwa 385 Ma
Aluif, Maidor, Marokko
Vergrößerung: etwa 7 x
Glossar: Gliedertiere / Trilobiten

Drotops armatus
Middle Devonian, approx. 385 Ma
Aluif, Maidor, Morocco
Enlargement: approx. 7 x
Glossary: arthropods / trilobites

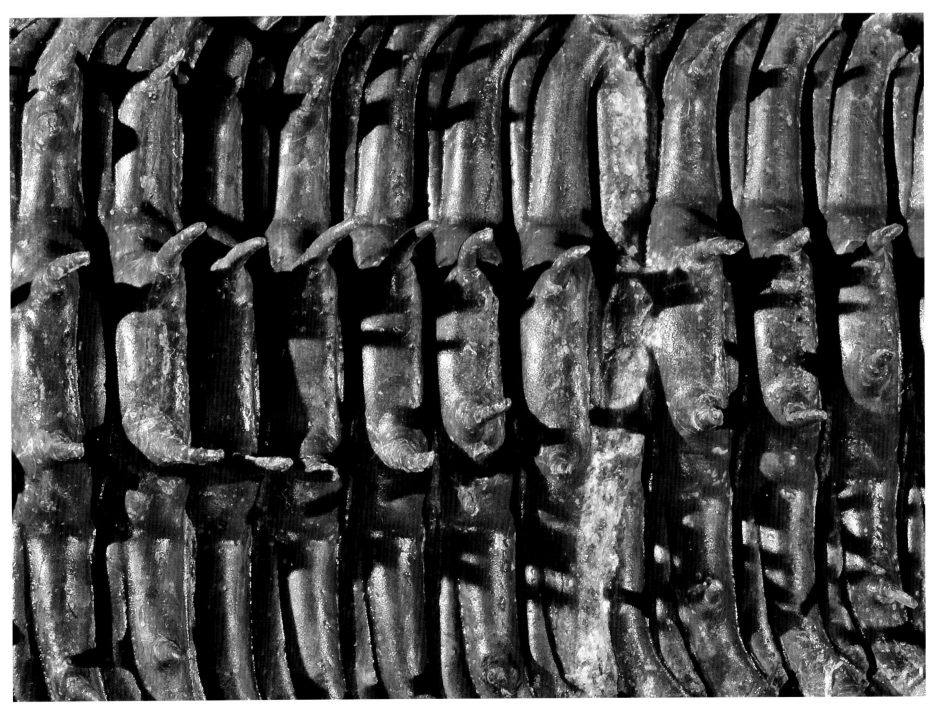

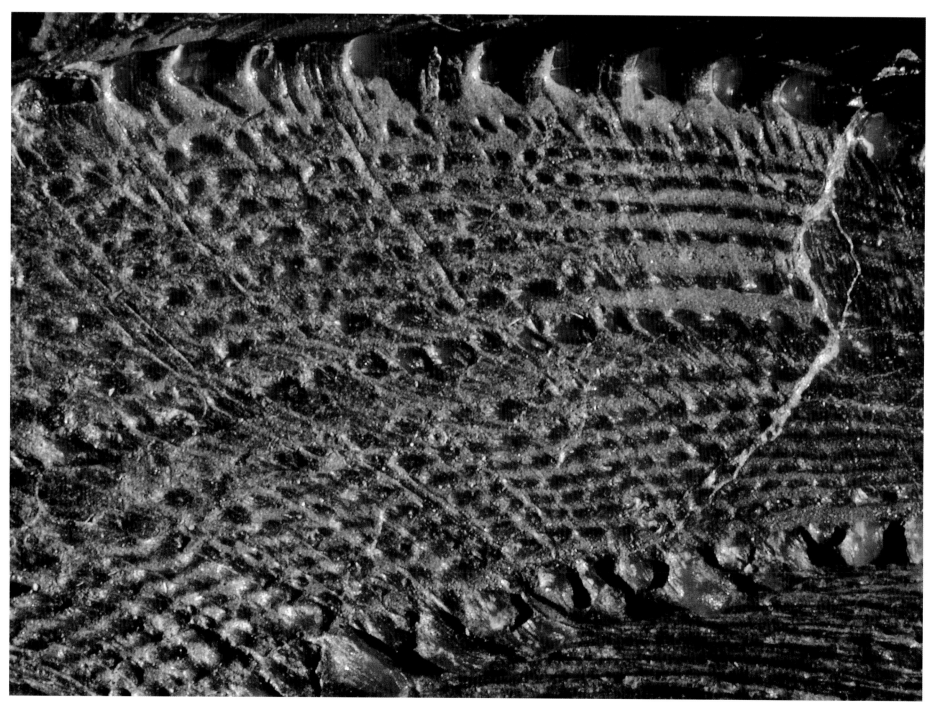

Trigonia
Mitteljura, etwa 170 Ma
Bethel, Bielefeld, Deutschland
Vergrößerung: etwa 11 x
Glossar: Weichtiere / Muscheln

Trigonia
Middle Jurassic, approx. 170 Ma
Bethel, Bielefeld, Germany
Enlargement: approx. 11 x
Glossary: molluscs / bivalves

Harpoceras, Sichelrippen
Unterjura, etwa 190 Ma
Whitby, England
Vergrößerung: etwa 5,7 x
Glossar: Weichtiere / Ammoniten

Harpoceras, falcate ribs
Early Jurassic, approx. 190 Ma
Whitby, England
Enlargement: approx. 5.7 x
Glossary: molluscs / ammonoids

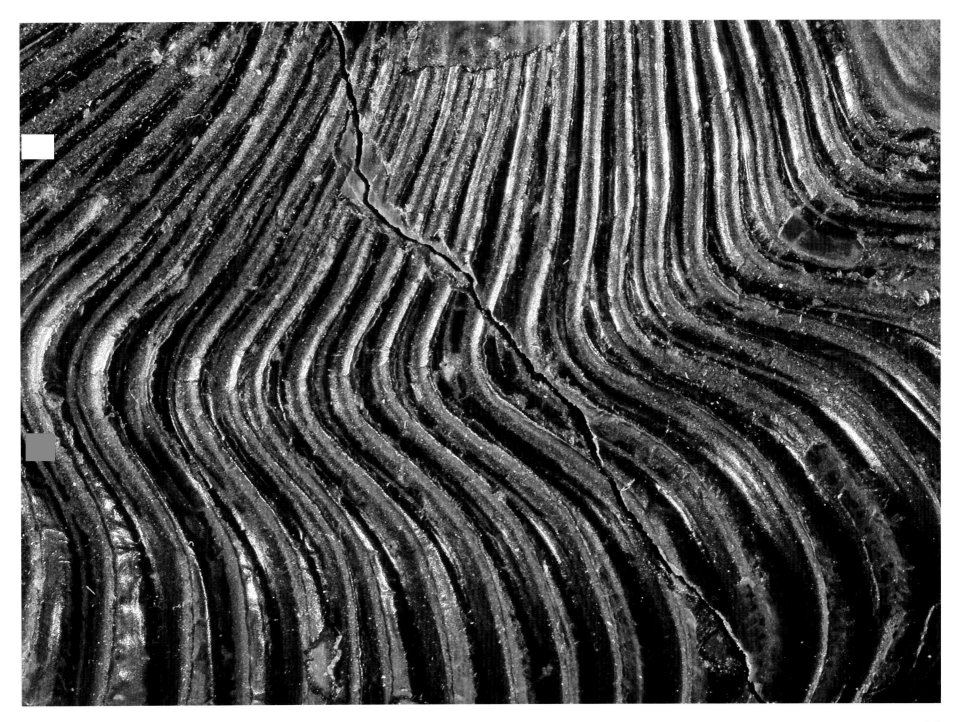

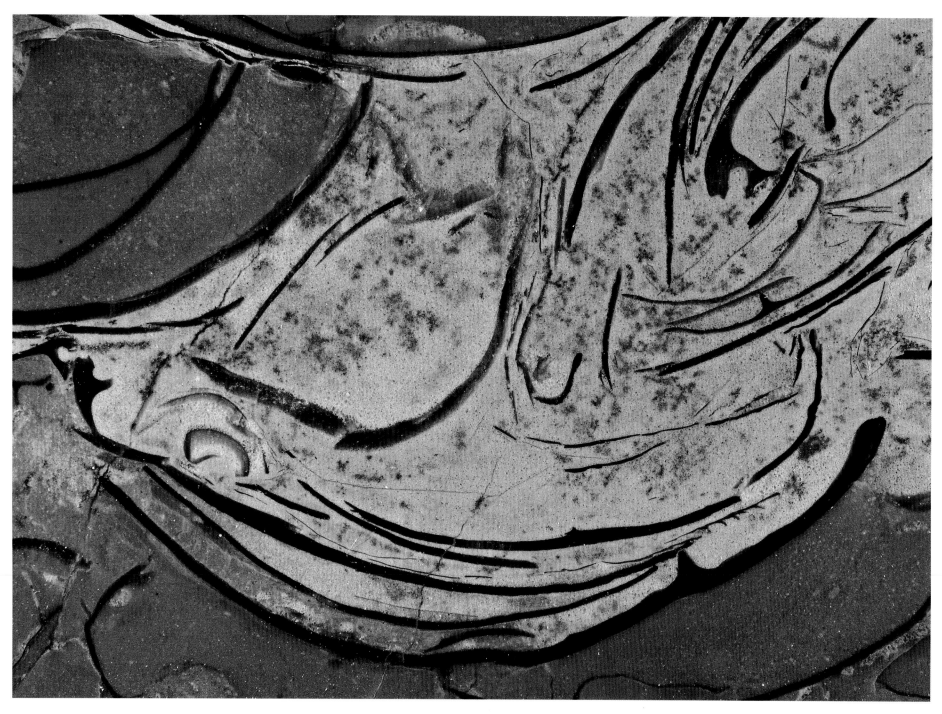

Muschelkalk-Anschliff mit *Coenothyris*
Mittlere Trias, etwa 235 Ma
Hohenloher Land, Deutschland
Vergrößerung: etwa 9 x
Glossar: Armfüßer

Polished section through a »Muschelkalk«
facies with *Coenothyris*
Middle Triassic, approx. 235 Ma
Hohenloher Land, Germany
Enlargement: approx. 9 x
Glossary: brachiopods

Sediment-gefüllte Bohrlöcher von *Cliona*,
in Muschelschale
Oberkreide, etwa 88 Ma
Sintra, Lissabon, Portugal
Vergrößerung: etwa 5 x
Glossar: Schwämme

Borings of *Cliona* in a bivalve shell
infilled with sediment
Late Cretaceous, approx. 88 Ma
Sintra, Lisbon, Portugal
Enlargement: approx. 5 x
Glossary: sponges

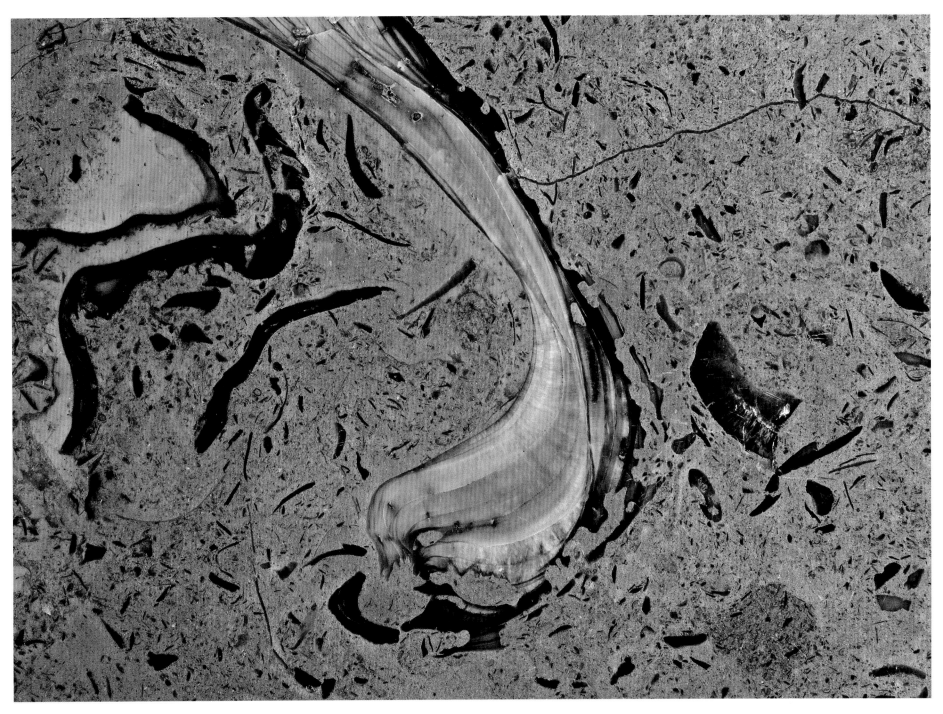

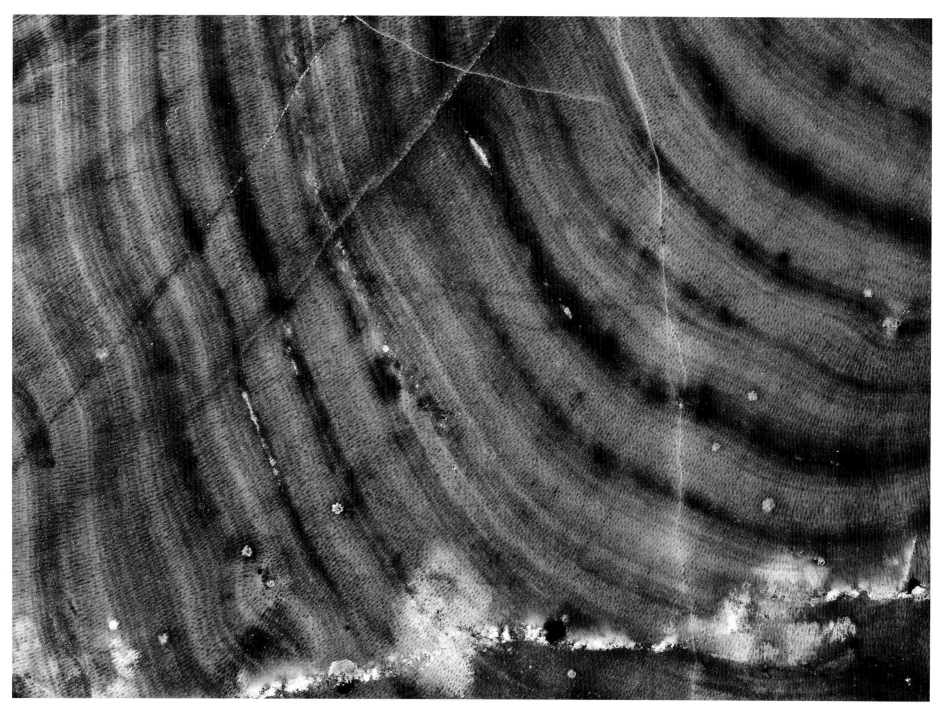

Chaetetopsis, kalkiges Basalskelett
Oberjura, etwa 152 Ma
Villar del Campo, Spanien
Vergrößerung: etwa 6x
Glossar: Schwämme

Chaetetopsis, calcareous basal skeleton
Late Jurassic, approx. 152 Ma
Villar del Campo, Spain
Enlargement: approx. 6x
Glossary: sponges

Coralliner Schwamm *Stylothalamia*
Oberkreide, etwa 95 Ma
Liencres, Spanien
Vergrößerung: etwa 5,8x
Glossar: Schwämme

Coralline sponge *Stylothalamia*
Late Cretaceous, approx. 95 Ma
Liencres, Spain
Enlargement: approx. 5.8x
Glossary: sponges

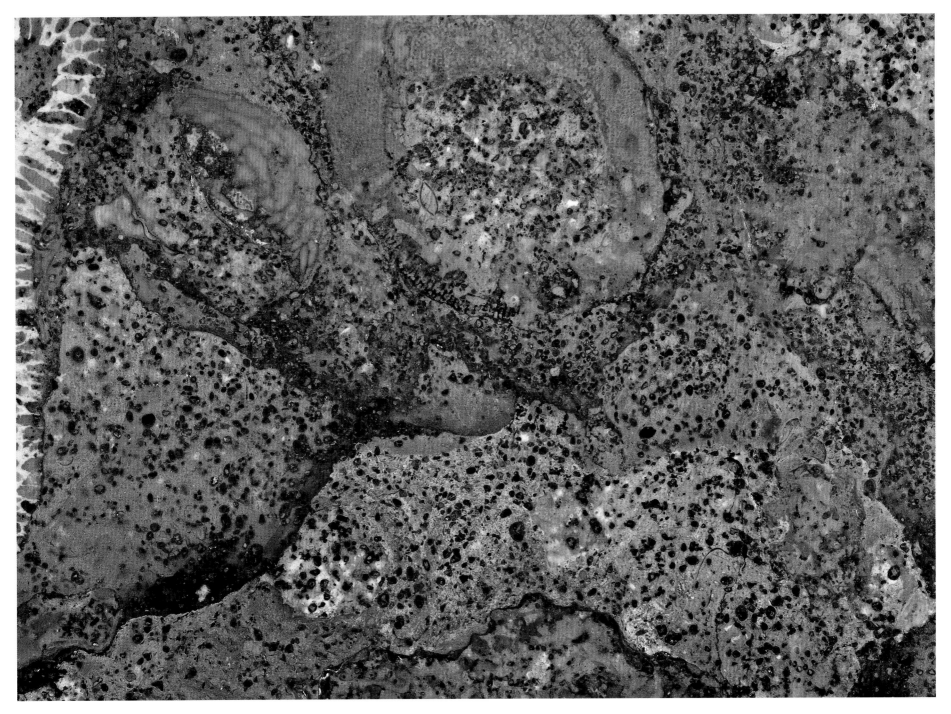

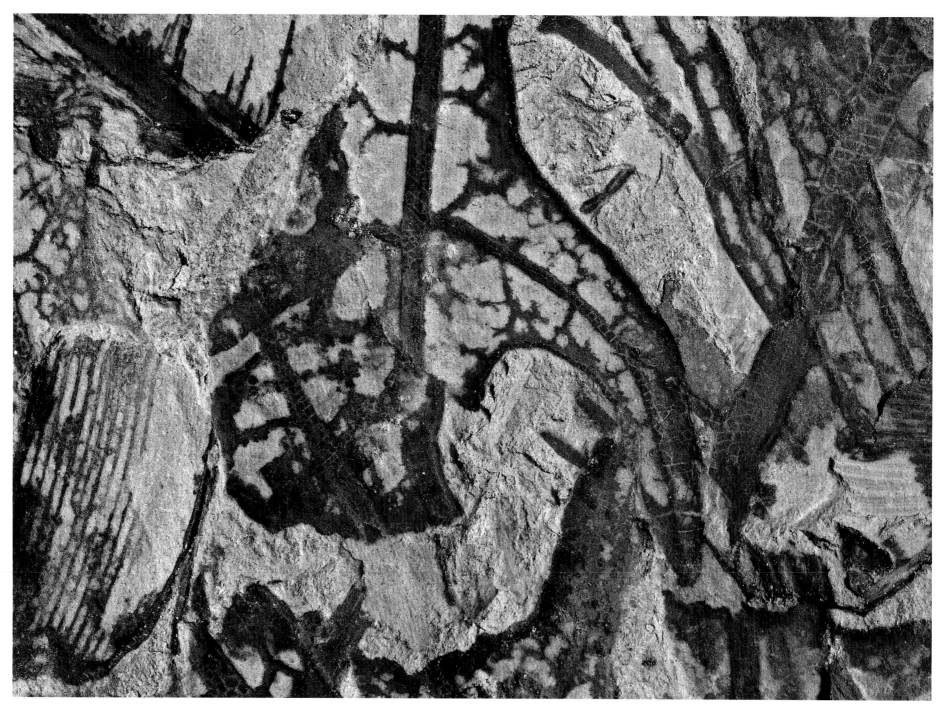

Nilssonia
Trias / Jura-Grenze, etwa 206 Ma
Unternschreez, Deutschland
Vergrößerung: etwa 5,6 x
Glossar: Gefäßpflanzen / Cycadeen

Nilssonia
Triassic / Jurassic boundary, approx. 206 Ma
Unternschreez, Germany
Enlargement: approx. 5.6 x
Glossary: pteridophytes / cycadean

Verkieselter Baumstamm: *Dadoxylon*
Unterperm, etwa 270 Ma
Chemnitz-Hilbersdorf, Deutschland
Vergrößerung: etwa 8,5 x
Glossar: Gefäßpflanzen / Coniferen

Silicified wood: *Dadoxylon*
Early Permian, approx. 270 Ma
Chemnitz-Hilbersdorf, Germany
Enlargement: approx. 8.5 x
Glossary: pteridophytes / conifers

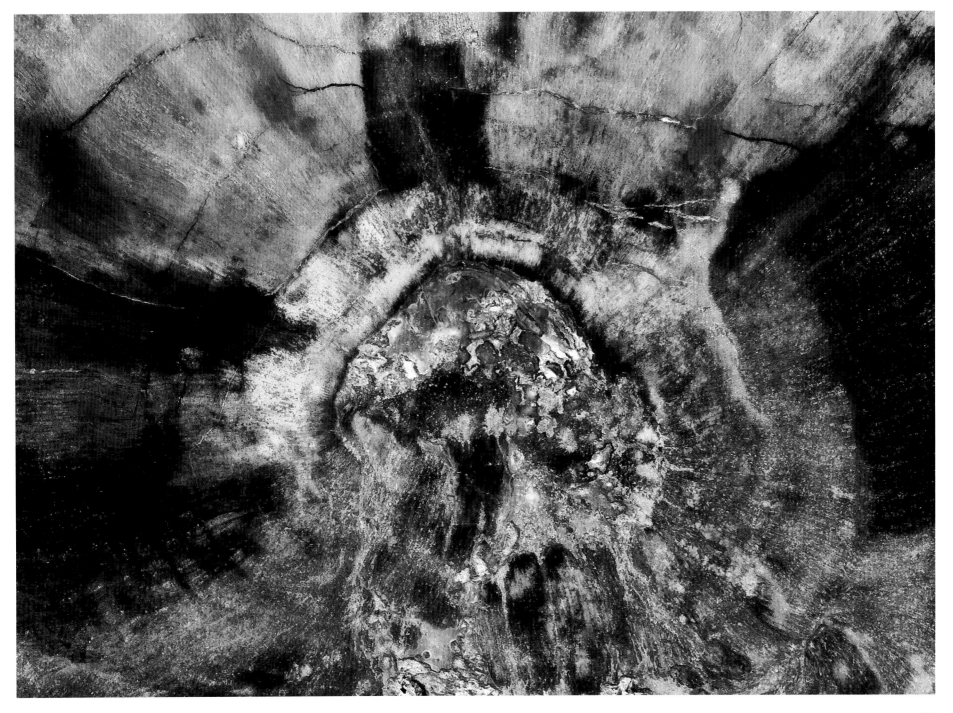

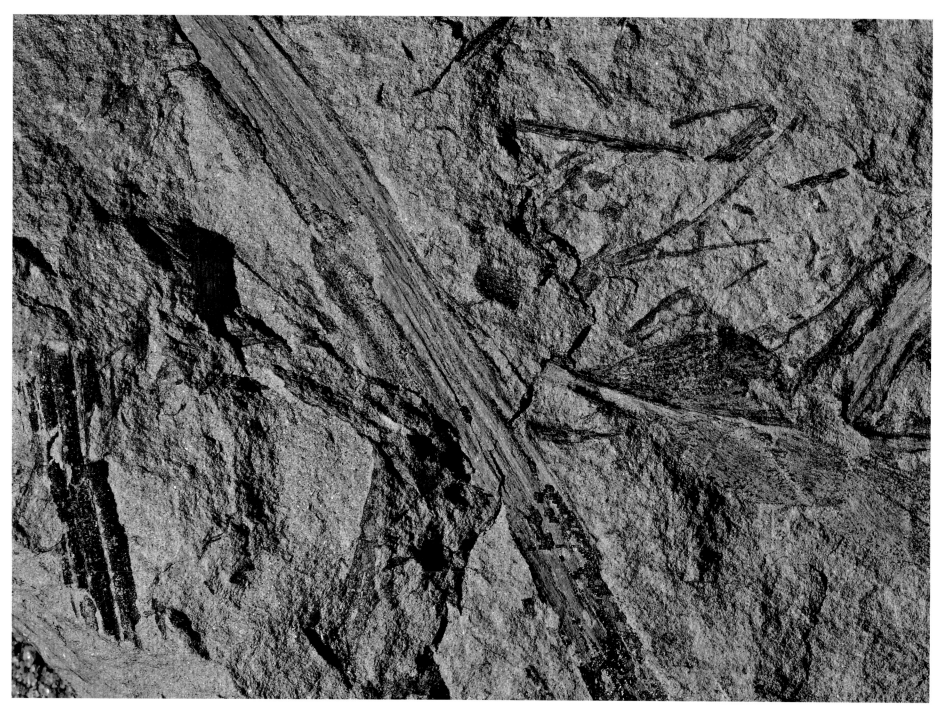

Archaeopteris
Oberdevon, etwa 364 Ma
Scaumenac Bay, Kanada
Vergrößerung: etwa 4 x
Glossar: Gefäßpflanzen / Farnartige

Archaeopteris
Late Devonian, approx. 364 Ma
Scaumenac Bay, Canada
Enlargement: approx. 4 x
Glossary: fern-like pteridophytes

Fucoides
Unterjura, etwa 188 Ma
Achdorf, Deutschland
Vergrößerung: etwa 3,5 x
Glossar: Spurenfossilien

Fucoides
Early Jurassic, approx. 188 Ma
Achdorf, Germany
Enlargement: approx. 3.5 x
Glossary: trace fossils

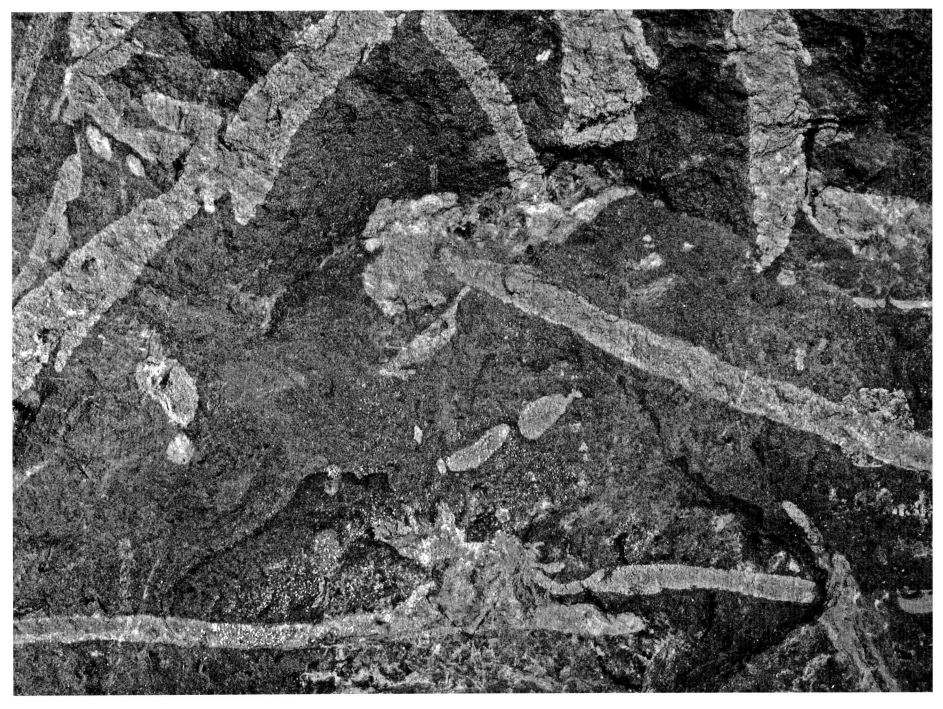

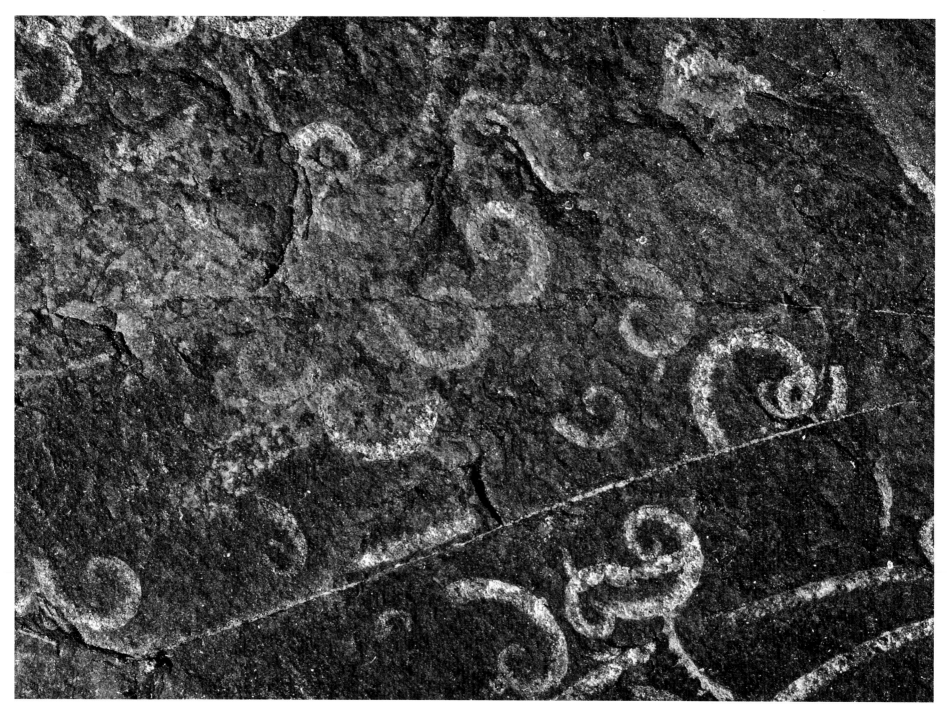

Monograptus
Mittelsilur, etwa 425 Ma
Simrishamn, Schweden
Vergrößerung: etwa 4,5 x
Glossar: Graptolithen / Graptolithina

Monograptus
Middle Silurian, approx. 425 Ma
Simrishamn, Sweden
Enlargement: approx. 4.5 x
Glossary: graptolites / Graptolithina

Anschliff eines Rudisten-Kalkes mit riffbildenden
Muscheln
Unterkreide, etwa 95 Ma
Alicante, Spanien
Vergrößerung: etwa 3 x
Glossar: Weichtiere / Muscheln

Polished section through a rudist limestone with
mollucs creating reefs
Early Cretaceous, approx. 95 Ma
Alicante, Spain
Enlargement: approx. 3 x
Glossary: molluscs / bivalves

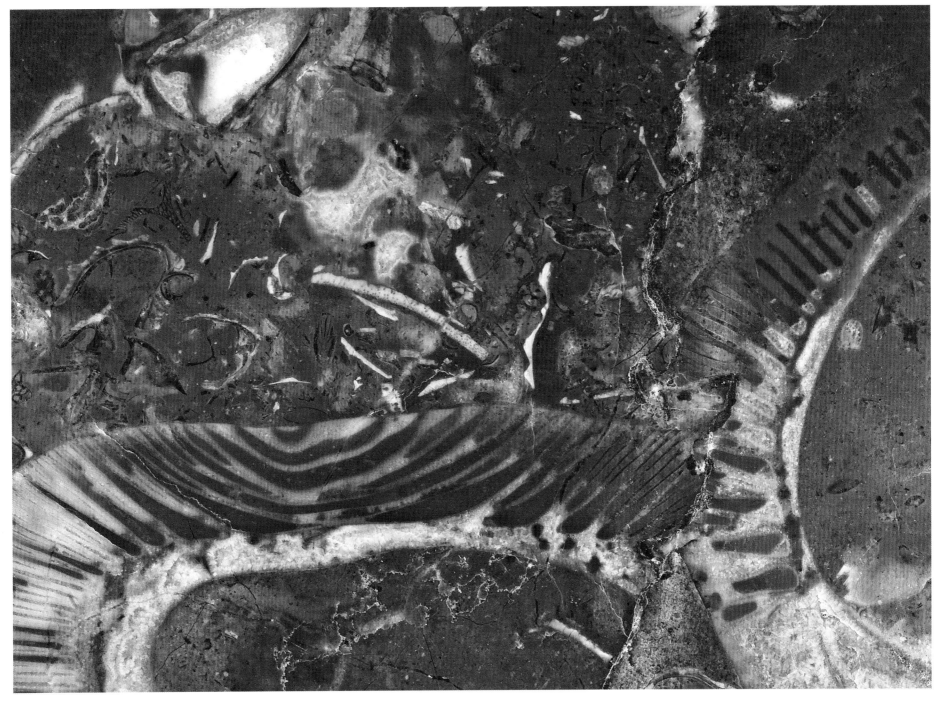

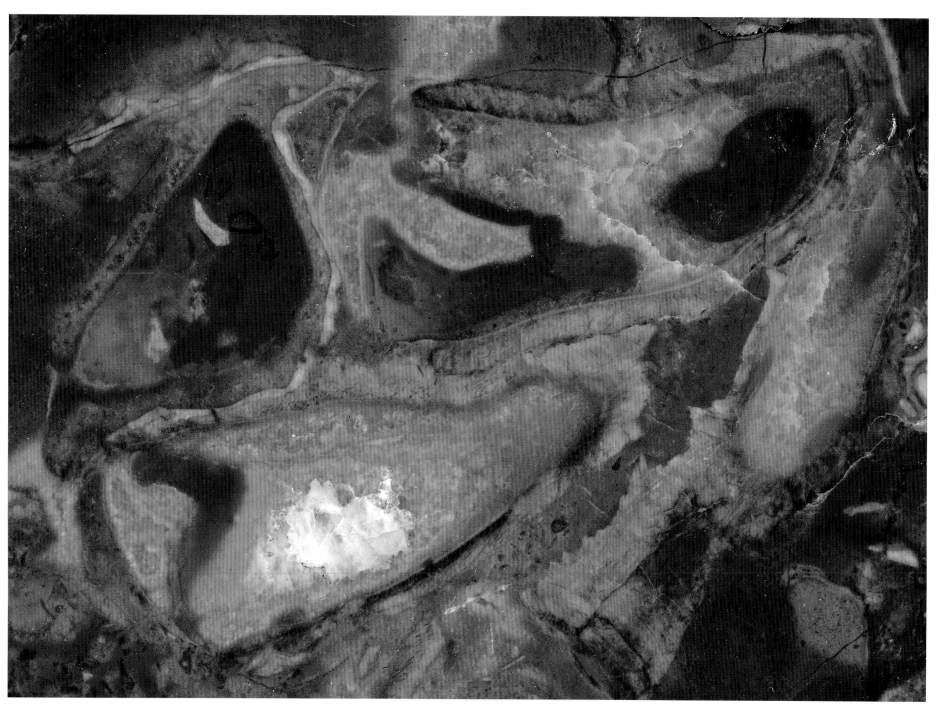

Riffbildende Rudisten
Unterkreide, etwa 95 Ma
Alicante, Spanien
Vergrößerung: etwa 7 x
Glossar: Weichtiere / Muscheln

Rudists creating reefs
Early Cretaceous, approx. 95 Ma
Alicante, Spain
Enlargement: approx. 7 x
Glossary: molluscs / bivalves

Congeria
Pliozän, etwa 3 Ma
Baden, Wiener Becken, Österreich
Vergrößerung: etwa 7 x
Glossar: Weichtiere / Muscheln

Congeria
Pliocene, approx. 3 Ma
Baden, Vienna basin, Austria
Enlargement: approx. 7 x
Glossary: molluscs / bivalves

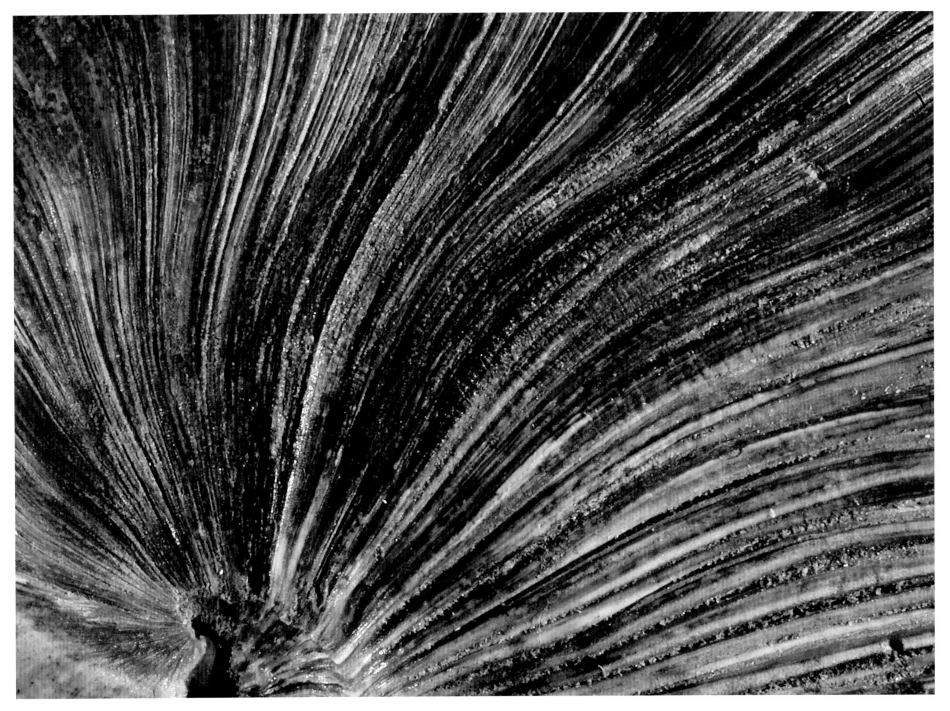

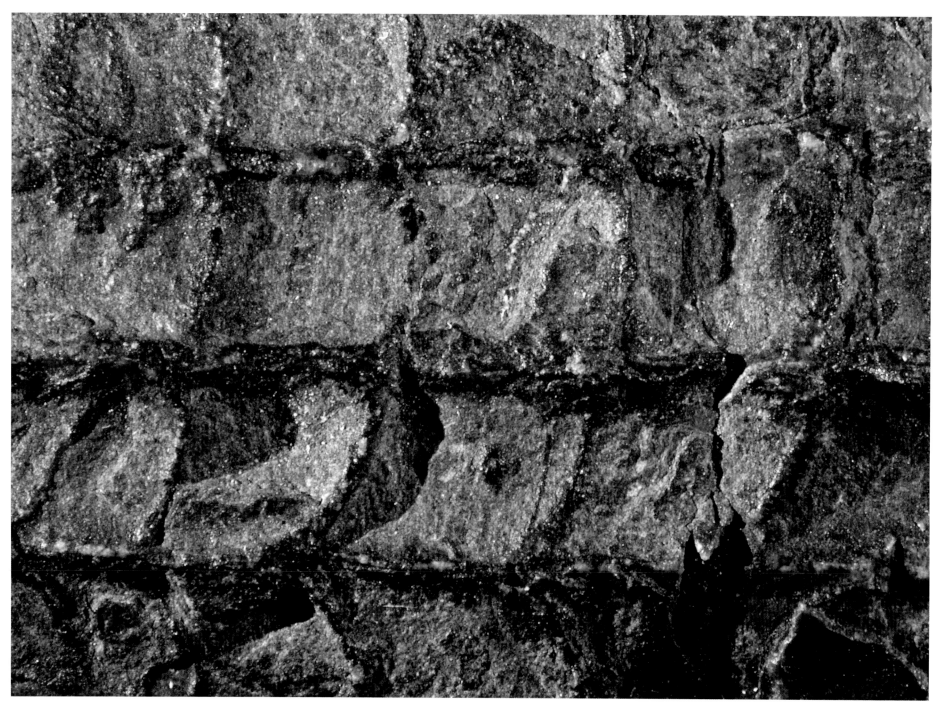

Oberflächenornament von *Corbuloceras*
Obersilur, etwa 420 Ma
Bureck, Tschechien
Vergrößerung: etwa 11 x
Glossar: Weichtiere / Nautiliden

Surface structure of *Corbuloceras*
Late Silurian, approx. 420 Ma
Bureck, Czech Republic
Enlargement: approx. 11 x
Glossary: molluscs / nautiloids

Baculites, Lobenlinie
Oberkreide, etwa 75 Ma
Cheyenne River, Süd Dakota, USA
Vergrößerung: etwa 14 x
Glossar: Weichtiere / Ammoniten

Baculites, suture line
Late Cretaceous, approx. 75 Ma
Cheyenne River, South Dakota, USA
Enlargement: approx. 14 x
Glossary: molluscs / ammonoids

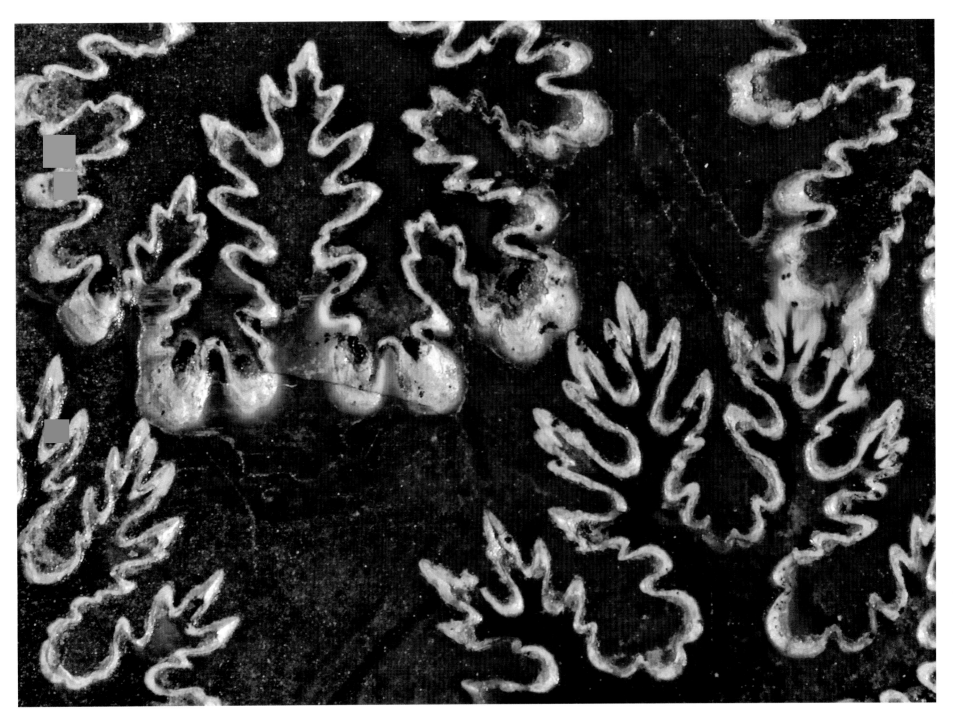

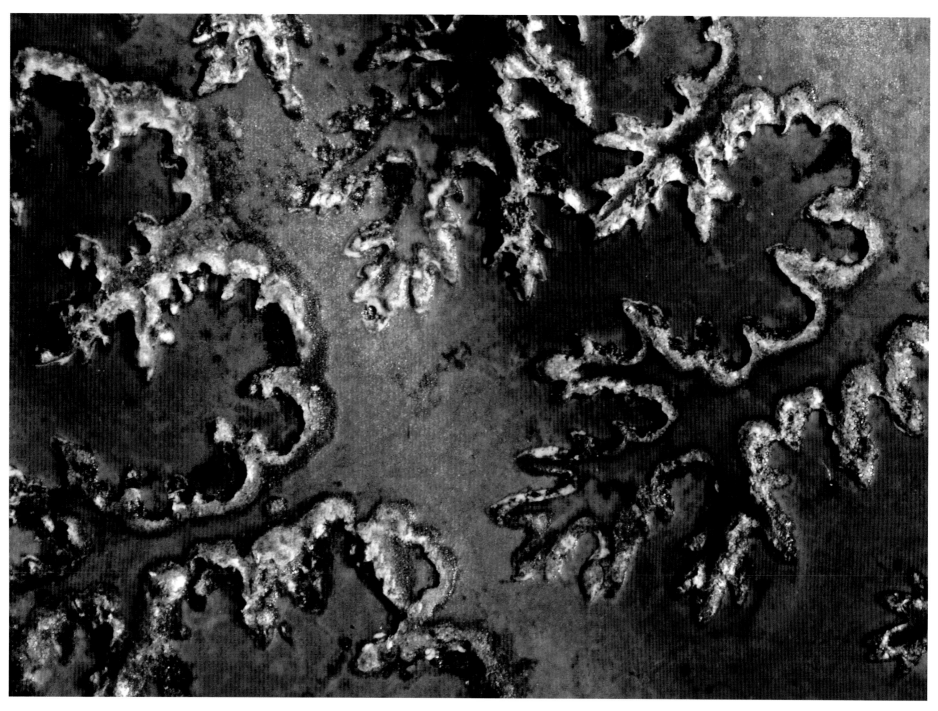

Lytoceras jurense, Lobenlinie
Unterjura, etwa 185 Ma
Blumberg, Deutschland
Vergrößerung: etwa 13x
Glossar: Weichtiere / Ammoniten

Lytoceras jurense, suture line
Early Jurassic, approx. 185 Ma
Blumberg, Germany
Enlargement: approx. 13x
Glossary: molluscs / ammonoids

Dictyophyllum
Trias / Jura Grenze, etwa 206 Ma
Unternschreez, Deutschland
Vergrößerung: etwa 5,4x
Glossar: Gefäßpflanzen / Farne

Dictyophyllum
Triassic / Jurassic boundary, approx. 206 Ma
Unternschreez, Germany
Enlargement: approx. 5.4x
Glossary: pteridophytes / ferns

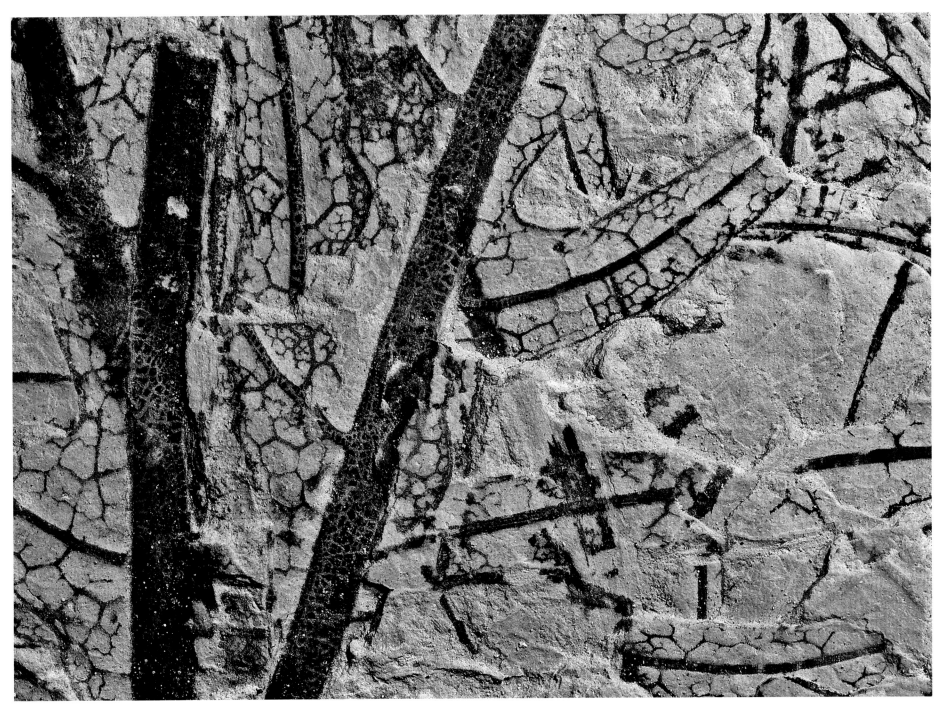

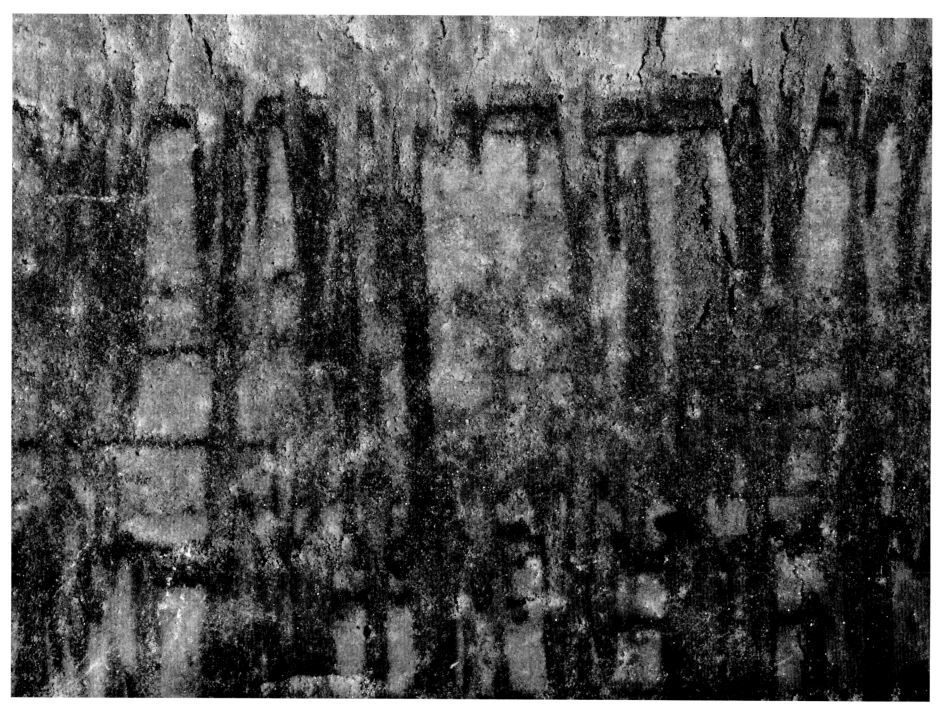

Scolithos Sandstein
Kambrium, etwa 510 Ma
Berlin, Deutschland, Geschiebe
Vergrößerung: etwa 4 x
Glossar: Spurenfossilien

Scolithos sandstone
Cambrian, approx. 510 Ma
Berlin, Germany, glacial drift
Enlargement: approx. 4 x
Glossary: trace fossils

Radiolarit
Mitteljura, etwa 175 Ma
Breittach, Allgäu, Deutschland
Vergrößerung: etwa 10 x
Glossar: Radiolarien

Radiolarite
Middle Jurassic, approx. 175 Ma
Breittach river, Allgäu, Germany
Enlargement: approx. 10 x
Glossary: radiolarians

Helmut Keupp
Glossar

Frühere Lebensformen können auf ganz unterschiedliche Weise in den Sedimentgesteinen fossil überliefert werden. Wir sprechen von sogenannten Körperfossilien, wenn konfigurierte Reste des ehemaligen Organismus selbst in ihrer Originalsubstanz oder, wie in den meisten Fällen, in chemisch veränderter Form als »Versteinerung« vorliegen, also Mumien, Knochen, Schalen, Blätter und ähnliches. Oft sind die Reste im Laufe der Zeit aufgelöst worden, dann zählen auch ihre unmittelbaren Abformungen durch das umgebende Gestein zu den Körperfossilien, Abdruck und Steinkern genannt. Bei den Chemofossilien sind Abbauprodukte der organischen Substanzen fein verteilt im Sediment enthalten, so Amino- und Fettsäuren oder Bitumina. Aber auch die Auswirkungen aktiver Lebensäußerungen auf das Sediment können, ohne daß das verursachende Lebewesen selbst fossil geworden ist, als Spurenfossilien wichtige Informationen über die Lebewesen und ihre Umweltbedingungen liefern.

Photoautotrophe Organismen

Es handelt sich hierbei um Lebewesen, die ihren Stoffwechsel auf der Basis der Photosynthese bewerkstelligen, das heißt, daß sie mit Hilfe von Farbkörperchen und der Nutzung des Sonnenlichts als Energieträger in der Lage sind, aus anorganischen Stoffen, aus Kohlendioxid und Wasser unter Freisetzen von elementarem Sauerstoff organische Substanzen aufzubauen, etwa Zucker und Stärke. Sie bilden als erstes Glied der Nahrungsketten die Voraussetzung für tierisches, für heterotrophes Leben.

Cyanobakterien, Blue-green Algae, sind heute im Meer, im Süßwasser oder auf dem Festland weit verbreitete, Matten bildende Bakterien ohne Zellkern. Sie können mit Hilfe von grünen und blauen Farbkörperchen, die unterhalb der Zellwand auf dem sogenannten Thylakoid angereichert sind, Photosynthese betreiben, vorwiegend mittels des niederenergetischen, nur wenige Meter in die Wassersäule vordringenden Rotlicht-Spektrums. Sie gelten als die »Erfinder« der Photosynthese. Ihre seit knapp 4 Milliarden Jahren zurückverfolgbare Aktivität ist zum einen durch den CO_2-Entzug für die Ablagerung der ersten Kalksteine in den Urozeanen verantwortlich, in Form der fein laminierten »**Stromatolithe**« und »**Loferite**«, das sind dichte Kalke mit laminiert angeordneten Hohlraumsystemen, zum anderen durch die permanente O_2-Produktion für die seit etwa 2 Milliarden Jahren wirksame Umstellung der Atmosphäre von der anoxischen zu einer oxischen. Werden in der Brandung rotierende Körper von Filmen mit Cyanobakterien überzogen, entstehen konzentrische laminierte Kalkkörper, die »**Onkoide**«.

Rotalgen sind Vertreter der sogenannten Eucaryonten, deren Zellverband aus hoch organisierten Zellen mit klar definierten Kompartimenten aufgebaut ist, zum Beispiel einem Zellkern. Aufgrund ihrer roten Farbkörperchen nutzen sie für die Photosynthese vorwiegend das hochenergetische blaue und violette Licht. Sie erreichen dadurch im Meer bei optimalen Lichtverhältnissen Eindringtiefen von mehr als 200 m. Manche Gruppen verkalken ihre Zellwände, so daß der wenig spezialisierte Zellverband, der Thallus, in seiner primären Struktur fossil überliefert werden kann.

Seit dem ausgehenden Ordovizium, vor etwa 450 Millionen Jahren, haben die Pflanzen das Festland erobert und dort Pionierarbeit für landlebende Tiere geleistet, die in der darauffolgenden Epoche der Erdgeschichte, dem Silur, nachfolgen.

Die Evolution der höheren Landpflanzen beginnt mit einfachen Gefäßpflanzen, die ihre Zellverbände zu echten Geweben differenzieren, besonders zu Leitgeweben oder Gefäßen. Die Gefäßpflanzen lassen sich von den Grünalgen ableiten, den Thallophyten, die keine entsprechende Differenzierung der Zelle besitzen. Grüne Pflanzen nutzen für ihre Photosynthese kurz- und langwelliges Licht. Von den drei Großgruppen der Landpflanzen: Moosartige oder Bryophyta, Farnartige oder Pteridophyta und Samenpflanzen oder Spermatophyta sind vor allem die beiden letzten Gruppen im Fossilreport häufig anzutreffen. Die Moose als an feuchte Standorte des Landlebens angepaßte »Thallophyten« führen eher ein Schattendasein.

Die **Farnartigen** sind Gefäßpflanzen mit einem speziellen Vermehrungsmodus, einem komplexen Generationswechsel mit Sporenbildung. Zu dieser Gruppe gehören erstens verschiedene Gruppen von **Farnen**, zum Beispiel Nacktfarne, eigentliche Farne und Samenfarne wie *Pecopteris, Sphenopteris, Neuropteris* und *Mariopteris*, zweitens die **Bärlappgewächse**, zum Beispiel *Lepidodendron* und *Sigillaria*, und drittens die **Schachtelhalme**, zum Beispiel *Annularia* und *Mesocalamites*. Diese drei Gruppen haben im Jungpaläozoikum erstmals große Bäume entwickelt und gemeinsam mit ersten Samenpflanzen, den Gymnospermen, großflächige Sumpfwälder entstehen lassen, die u. a. im Karbon Grundlage für die Steinkohlebildung waren.

Die Samenpflanzen gliedern sich in die Nacktsamer oder **Gymnospermen**, die Nadelhölzer oder **Coniferen** und die Blütenpflanzen oder **Angiospermen**. Die ursprünglicheren Gymnospermen haben so prominente Gruppen wie die **Cycadeen**-Verwandten *Glossopteris, Nilssonia, Thinnfeldia* und *Ginkgo* hervorgebracht. Die Coniferen prägten vor allem die Flora des ausgehenden Paläozoikums und des Erdmittelalters. Die Angiospermen entwickelten sich seit dem Beginn der Kreidezeit besonders formenreich. Vor allem die Entwicklung von Gräsern hat das Landschaftsbild der Erde und die Tierwelt grundlegend verändert. Es kam zu Steppenbildung und in ihrem Gefolge zu weidenden Herden.

Heterotrophe Organismen

Der tierische Organismus ist für seine Ernährung auf einen Stoffwechsel angewiesen, der bereits vorgefertigte organische Substanzen umsetzt. Durch den grundsätzlich eucaryontischen Zellbauplan sind alle Tiere für die Energieversorgung auf die Sauerstoffatmung angewiesen.

Foraminiferen sind Einzeller mit einer den Amöben ähnlichen Zweiteilung der Zelle in ein inneres dichtes und äußeres transparentes Plasma. Die meist nur Bruchteile eines Millimeters, jedoch im Extremfall bis 20 cm groß werdenden Zellen bauen ein aus einzelnen Kammern zusammengesetztes Gehäuse aus Kalk, verkittetem Feindetritus oder polymerem organischen Material, aus Tektin. Ein mehr oder weniger komplexes Porensystem in den Gehäusewänden und zwischen den Kammern sichert die Kommunikation zwischen den Kammern. Ihre artspezifische Formenvielfalt macht die Foraminiferen zu

klassischen Leitfossilien der Mikropaläontologie, die eine zuverlässige Altersbestimmung der sie einschließenden Sedimentgesteine ermöglichen.

Die filigran gebauten **Radiolarien** sind seit mehr als 500 Millionen Jahren ein wichtiger Bestandteil des heterotrophen Meeresplanktons. Ihre formenreichen Skelette bestehen aus Kieselsäure, aus Skelett-Opal und bauen radialstrahlige Gitterkugeln, Spumellarien, oder polar zentrierte, mützenförmige Körper, die sogenannten Nassellarien. Auf den Böden insbesondere tiefer Ozeane, auf denen wegen des hohen CO_2-Gehalts jeglicher Kalk aufgelöst wird, bilden sie den Hauptanteil oft bunter Kieselschiefer-Sedimente, der **Radiolarite**.

Schwämme oder Porifera stellen die ursprünglichste Organisationsstufe vielzelliger Tiere dar, sie besitzen weder echte Gewebe noch differenzierte Organe. Mit Hilfe ihrer inneren Kragengeißelzellen erzeugen sie einen Wasserstrom, der durch ein komplexes Porensystem der Schwammwand geleitet wird. Sie werden deshalb als Strudler bezeichnet. Die Schwämme bauen ein aus einzelnen Nadeln zusammengesetztes Sklerenskelett auf, das bei den ursprünglichen Formen aus Kieselsäure, SiO_2 nH_2O, besteht oder aus Spongin, bei den abgeleiteten Kalkschwämmen aus Kalk. Unabhängig von diesem primären Sklerenskelett können viele Schwämme mit Hilfe ihrer äußeren Zellschicht, dem Pinacoderm, ein zusätzliches, stets kalkiges Basalskelett bilden. Diese sekundären Basalskelette haben bei einzelnen Gruppen, bei den **Corallinen Schwämmen**, die Funktion des primären Stützskeletts übernommen, so die Archaeocyathinen, Stromatoporen und Chaetetiden. Die **Bohrschwämme**, etwa *Cliona*, verzichten auf die Bildung eines eigenen Basalskeletts und bohren in fremdes Kalksubstrat, um ihren Körper darin zu schützen.

Chancellorien sind eine auf das Kambrium beschränkte Gruppe von Strudlern unklarer systematischer Zuordnung. Aufgrund ihrer sternförmigen, in die lederartige Außenhaut eingelagerten Kalk-Skleren wurden sie ursprünglich in die Verwandtschaft der Schwämme gestellt. Die abweichende Morphologie der Skleren, sie sind aus hohlen Einzelelementen zusammengesetzt, und Unterschiede in der Struktur der Außenhaut führen zu einer Diskussion ihrer Zuordnung zu Polypen höher entwickelter Nesseltiere. Möglicherweise stehen sie sogar an der stammesgeschichtlichen Basis der »Deuterostomier«, zu denen unter anderem die Stachelhäuter und Wirbeltiere gehören.

Von den radiär-symmetrischen Lebewesen, den Radiata, haben vor allem die **Korallen** ein gutes Erhaltungspotential, da sie ihre Polypen bzw. Polypenkolonien durch ein kombiniertes Innen- und Außenskelett aus Kalk stützen. Die sackförmige Grundkonstruktion der Radiata besteht aus einem zentralen Gastralraum mit einer von Tentakeln umgebenen, kombinierten Mund- und Afteröffnung. Die dickwandigen **Rugosa**, die ihre radialen Septen zur Stütze ihrer Gastralraum-Einfaltungen in einer vierzähligen Symmetrie ausbauen, sind im Erdaltertum, im Paläozoikum, verbreitet und fungieren zusammen mit corallinen Schwämmen als wichtige Riffbildner. Sie sterben am Ende des Paläozoikums aus. Ihre Rolle wird durch die sich in der Trias neu etablierenden modernen, dünnwandigen Steinkorallen übernommen, die **Scleractinia**. Sie zeichnen sich durch eine konsequente sechszählige Radialsymmetrie aus. Die ebenfalls nur auf das Paläozoikum beschränkte Gruppe der **Tabulata** läßt ihre zwölfzählige Radialsymmetrie infolge der Reduktion von Kalksepten kaum mehr erkennen.

Bilateral gebaute Tiere, die **Bilateralia**, haben grundsätzlich zwei verschiedene Köperöffnungen, Mund und After, und ordnen ihren Körper entlang einer Längsachse so an, daß die Nahrung vom Mund aus sukzessive und gegenüber der Radiata-Konstruktion deutlich effektiver aufbereitet werden kann.

Ringelwürmer oder Annelida sind durch eine serielle Wiederholung gleichartiger Körperabschnitte gekennzeichnet. Die sogenannten Sedentaria, das sind festsitzende Anneliden mit strudelnder Ernährungsweise, bauen zum Teil feste, röhrenförmige Kalkgehäuse, *Serpula*.

Armfüßer oder Brachiopoda sind eine formenreiche Gruppe doppelklappiger Meeresstrudler, deren Blütezeit im Erdaltertum lag. Heute leben sie bevorzugt an einem häutigen Stiel befestigt oder mit der Schale unmittelbar aufgewachsen in verborgenen Habitaten, oft in größeren Wassertiefen oder abgeschirmten Felsnischen. Ihr zentrales Versorgungsorgan, der paarige Lophophor, ist zugleich Strudelapparat und Atmungsorgan, dient jedoch nicht der Fortbewegung, wie der auf einer ursprünglich falschen Annahme gründende Name vermuten läßt. Bei den ursprünglicheren Formen sind die beiden Schalenklappen, die durch ihren hohen organischen Materialanteil oft »hornig« erscheinen, nicht durch ein sich verzahnendes Scharnier verbunden. Die zum Strudeln notwendige Öffnung der Schalen erfolgt bei ihnen vielmehr durch ein komplexes System aus Öffner-, Schließ- und Stabilisierungsmuskeln, welche den Weichkörper so komprimieren, daß die Schalen auseinanderklaffen und damit eine sogenannte indirekte Öffnung bilden. Dagegen haben die moderneren, artikulaten Brachiopoden durch Rückverlagerung des Öffnermuskelansatzes vor das Scharnier eine direkte Schalenöffnung über Hebelzug entwickelt. Dabei verhindert ein durch Zähne und Zahngruben ineinander greifendes Schloß ein seitliches Ausbrechen der Schalen. Um die Zugkräfte effektiv wirksam werden zu lassen, ist bei den Articulata eine steife, kalkige Schale unabdingbar. Ihre Schalen werden gerne mit Muschelschalen verwechselt. Brachiopoden haben aber eine kleinere Dorsal- und größere Ventralschale, letztere ist häufig mit einem Stielloch versehen, so daß die Spiegelebene senkrecht durch die Mitte beider Schalen verläuft. Bei den Muscheln dagegen sind die beiden Klappen rechts-links orientiert, so daß die Spiegelebene in der Regel parallel zur Klappennaht verläuft und beide Schalenhälften spiegelsymmetrisch sind.

Moostierchen oder Bryozoa sind seit dem Ordovizium bekannte, stets kolonial lebende, teilweise nur Bruchteile eines Millimeters messende kleine Tiere, deren häufig verkalkte Kolonien teils aufrecht, bäumchenförmig wachsen, daher der deutsche Name »Moostierchen«, teils häufig aber nur flache Krusten bilden. Die Einzelindividuen, die Zooide, die in Röhren der Kolonie leben, kommunizieren über ein Kanalsystem miteinander, über das Stolon, und sind zur Erfüllung ganz unterschiedlicher Aufgaben ausgebildet, für Ernährung, Verteidigung oder Fortpflanzung, mit morphologisch oft ganz unterschiedlichen Formen. Das zentrale Organ der Bryozoen ist – wie bei den ihnen verwandten Brachiopoden – ein Lophophor, dessen Tentakeln ring- oder hufeisenförmig um die Mundöffnung angeordnet sind.

Gliedertiere oder Arthropoda leiten sich von ursprünglich ringelwurmähnlich segmentierten Vorfahren ab und haben durch die »Erfindung« von isoliert beweglichen Gliedmaßen eine ungeheuer erfolgreiche Konstruktion lanciert. Die Arthropoden wurden dadurch zu den erfolgreichsten Räubern des Erdaltertums, unter-

stützt durch eine ausgezeichnete Rundum-Sehfähigkeit mit Komplexaugen, mit Facettenaugen. Der Körper ist zu drei größeren Segmenten verschmolzen, Cephalon, Thorax und Pygidium. Als Widerlager für die Muskulatur der Gliedmaßen entwickelte sich ein fester Außenpanzer aus Chitin, teilweise durch Kalkeinlagerungen verstärkt. Da aber die polymerisierte Chitinhaut nicht wachstumsfähig ist, müssen sich Arthropoden, solange sie an Größe zunehmen, regelmäßig häuten. Die Gliedfüße waren ursprünglich als Spaltbeine mit einem als Kiemen fungierenden Seitenast konstruiert. Nach deren Spezialisierung besonders im Bereich des Cephalons können verschiedene Großgruppen unterschieden werden.

Die **Trilobiten**, deren Blütezeit im Altpaläozoikum lag, entsprechen fast ganz dem Grundmuster der Arthropoden: klare Dreigliederung des Körpers mit einem verkalkten Rückenpanzer, dem Tergit. Das Cephalon enthält neben einem Antennenpaar fünf Gliedmaßenpaare auf der Unterseite, die wie alle weiteren Gliedmaßen im Thorax und Pygidium überwiegend noch als »Laufbeine« konstruiert sind.

Die **Spinnentiere** oder Chelicerata haben die Antennen reduziert und den Körper zu zwei Segmenten verschmolzen, Prosoma und Opisthosoma. Charakteristisch ist im Kopfbereich die Umgestaltung der vorderen Gliedmaßen zu zangenartigen Cheliceren und einem Paar Tastfühlern, den Pedipalpen, sowie die Reduktion der Gliedmaßen im Opisthosoma auf vier Paar Laufbeine. Bereits im Paläozoikum haben sich erste Vertreter der Spinnen und Skorpione durch die Entwicklung einer Trachaeenatmung auf dem Festland etabliert.

Die große Gruppe der Mandibulata umfaßt vor allem die aquatisch lebenden Krebse, Crustacea, Diantennata, und die auf dem Festland extrem erfolgreichen Insekten. Ihre gemeinsamen Merkmale sind die Ausbildung eines komplexen Kauapparates aus Ober- und Unterkiefer, Mandibeln und Maxillen, die aus der Umwandlung von ursprünglich drei Gliedmaßenpaaren des Kopfbereichs erfolgte. Die Körpergliederung ist ursprünglich, dreigliederig, geblieben.

Die vielgestaltige und überwiegend im Wasser, aber auch auf dem Festland lebende Gruppe der **Krebse** oder Crustacea besitzt zwei Antennenpaare gemeinsam. Häufig sind die teilweise kräftig verkalkten Rückenpanzer von Kopf und Thorax zu einem Carapax verwachsen, allerdings nur äußerlich. Die modernen Zehnfuß-Krebse, die Malacostraca, haben an ihren fünf Paar Laufbeinen des Thorakalbereichs zum Teil kräftige Scheren entwickelt, während die Rankenfußkrebse mit dem Carapax am Untergrund festsitzen und ihre Laufbeine in lange Strudelwerkzeuge umgestaltet haben. Dies sind die Cirripedier, beispielsweise Seepocken oder **Balanus**.

Die Anpassung der **Insekten** an das Landleben geht mit der Entwicklung einer Trachaeenatmung zusammen, die unabhängig von der der Spinnen entwickelt wurde, sowie der Bildung von zwei Paar Flügeln, die aus dorsalen Fortsätzen thorakaler Körpersegmente entstanden. Die stammesgeschichtliche Entwicklung der Insekten wurde durch die enge Wechselbeziehung zur Entwicklung der Landpflanzen immer wieder gefördert, eine Co-Evolution. So konnte sich mit der Etablierung der Steinkohlewälder erstmals eine teilweise großwüchsige Vielfalt von Insekten entwickeln, etwa Libellen mit bis zu 70 cm Spannweite. Mit der Entwicklung der Blütenpflanzen und entsprechender Regenwälder entstand das unübersehbare Heer heute lebender Formen. Zwei Umstände beschränken fossile Insektenfunde vorwie-

gend auf sogenannte »Fossillagerstätten« mit besonders konservierenden Erhaltungsbedingungen, wie etwa anoxische, küstennah oder in terrestrischen Senken abgelagerte Schwarzschiefer, feinkörnige Plattenkalke oder Einschlüsse in Harzfallen im daraus entstehenden Bernstein. Der eine Umstand ist, daß es in den Chitinpanzern grundsätzlich keine Kalkeinlagerungen gibt. Der andere, daß der terrestrische Lebensraum nur selten über längere erdgeschichtliche Zeiten hinweg geeignete Möglichkeiten zur Fossilisation bietet.

Weichtiere oder Mollusca sind durch einen dreiteiligen Körper gekennzeichnet, den Kopf mit Reibzunge oder Radula, den Fuß und einen Eingeweidesack. Das alles wird von einem muskulösen Mantel umschlossen und besitzt keine inneren Stützelemente. Die meisten Mollusken bilden dafür eine Kalkschale aus, die primär als Außenskelett und Schutzorgan, als Gehäuse, dient. Die drei bedeutendsten Großgruppen dieser conchiferen oder Schalen tragenden Weichtiere haben sich im Kambrium durch ihre jeweilige Spezialisierung im Nahrungserwerb differenziert:

Die **Schnecken** oder Gastropoda haben sich als auf dem Boden kriechende Weidegänger spezialisiert. Die Kiemen lagen ursprünglich auf der dem Boden zugewandten Bauchseite des hinteren Körperabschnitts. Damit sie hinreichend mit Frischwasser versorgt werden konnten, wurde der Hinterleib unter seitlicher Drehung oder Torsion über den Kopf vor das dorsal gelegene Herz positioniert, damit entstanden die »Prosobranchier«. Diese Torsion führte zu einer asymmetrischen bzw. nur noch einseitigen Anlage der Kiemen und einer Spiralisierung des Körpers und des einteiligen Gehäuses. Einige Formen wurden im Verlauf der Evolution zu aktiven Schwimmern, oder sie ließen sich passiv im Wasser treiben, der planktonischen Lebensweise. Sie machten die Torsion wieder rückgängig, behielten die Asymmetrie der Kiemen jedoch weitgehend bei, sie werden »Opisthobranchier« genannt. Heute bewohnen die Schnecken als eine der artenreichsten Tierklassen nahezu alle aquatischen und terrestrischen Lebensräume.

Die **Muscheln** oder Bivalvia haben sich als erfolgreiche Nahrungsstrudler eingenischt und zunächst die sessile Lebensweise optimiert. Dazu gehört nicht nur der Ausbau der Kiemen als Strudel- und Filterapparat, sondern auch die Ausbildung einer zweiklappigen Schale, die während der aktiven Phase über eine Spannfeder, das Ligament, am gezähnelten Klappenscharnier, dem Schloß, geöffnet und in der Ruhezeit zum Schutz über ein Muskelsystem geschlossen wird.

Die **Kopffüßer** oder **Cephalopoda** sind als primäre Räuber die fortschrittlichste und intelligenteste Gruppe der Weichtiere. Neben extrem dotterreichen Eiern, die ein Larvenstadium außerhalb des Eies überflüssig machen, entwickelten sie vier herausragende Eigenschaften:

1. Der Fuß wurde in ursprünglich zehn Greif-Tentakel und einen röhrenförmigen Trichter umgebaut, mit dessen Hilfe sie das Atemwasser ruckartig aus der Kiemenhöhle ausstoßen und sich damit nach dem Rückstoßprinzip im Wasser fortbewegen können.

2. Es wurde ein konzentriertes Gehirn ausgebildet, das die Entwicklung intelligenter Jagd- und Tarnstrategien erlaubt.

3. Zusätzlich zur Radula entstand ein kräftiger Kieferapparat, er ähnelt einem Papageienschnabel.

4. Das einteilige Gehäuses wurde energiesparend als hydrostatischer Auftriebsapparat genutzt, der das Körpergewicht des Tieres im Wasser kompensiert. Dazu

wurden im hinteren Gehäuseabschnitt, im Phragmokon, in regelmäßigen Abständen Trennwände, Septen, eingezogen. Die einzelnen Kammern sind durch einen durchbluteten Hautschlauch, einen Sipho, untereinander und mit dem Weichkörper verbunden. Er sorgt für eine stickstoffreiche Gasfüllung, die dem Gehäuse den notwendigen Auftrieb verleiht und in den Kammern durch Abpumpen oder Fluten von Wasser die Tiefenlage austariert.

Die ursprünglicheren Vertreter der Kopffüßer, etwa *Nautilus,* haben sich das Außengehäuse bis heute erhalten, sie heißen Ectocochlia. Das Gros der modernen Tintenfische, der Coleoidea, verlagert das Gehäuse zunächst ins Innere des Körpers, zum Beispiel Belemniten, *Sepia oder Spirula.* Anschließend wird es im Zuge der Phylogenie weitgehend oder vollständig reduziert wie bei den Kalamaren oder Kraken. Die Coleoiden werden damit zu schnellen und gewandten Schwimmern.

Seit dem frühen Erdaltertum stellen Kopffüßer-Gehäuse eine der häufigsten und formenreichsten Fossilien in den Meeresablagerungen. Dabei unterscheiden wir bei den Ectocochlia zwischen den ursprünglichen Nautiliden und den abgeleiteten Ammoniten. Beide haben anfangs langgestreckte, konische Gehäuse und rollen diese dann unabhängig voneinander spiralig ein, um eine günstigere Schwimmposition ihres im letzten Teil des Gehäuses, der Wohnkammer, befindlichen Weichkörpers zu erzielen.

Bei den **Nautiliden** sind die Kammerscheidewände meist einfach, urglasförmig gewölbt, der Sipho ist kräftig und durchzieht die Kammern oft zentral. Sie haben mit dem Nautilus der Südsee in größeren Wassertiefen bis heute überlebt. Im Erdaltertum waren ihre Gehäuse oft noch gestreckt, sie heißen dann »**Orthoceraten**«.

Die **Ammoniten** sind eine sehr formenreiche Gruppe, die 350 Millionen Jahre lang, vom Devon bis zur Kreide, die Weltmeere beherrschte. Ihr meist planspiral aufgerolltes Gehäuse ist wie das der Nautiliden gekammert. Zur Optimierung ihrer hydrostatischen Eigenschaften haben sie aber die Kammerscheidewände wellblechartig gebogen und ihre Nahtlinien, die Sutur oder Lobenlinie, wo sie auf der Gehäuseinnenseite auftreffen, zunehmend gefältelt. Die bei Steinkern-Erhaltung sichtbare Lobenlinie ist ein wichtiges Bestimmungsmerkmal. Der dünne Sipho ist stets randständig und gewährleistet einen einheitlich gerichteten Wasserfluß in den Kammern. Im Verlauf des Erdmittelalters haben viele Ammoniten ihre papageischnabelartigen Kiefer als Freßwerkzeug aufgegeben, den Unterkiefer zu einem Deckel, dem Aptychus, umgebaut und sich auf das Fressen von Plankton verlegt. Diese Spezialisierung, die besonders in der Kreidezeit auch heteromorphe, oft trochospirale oder hakenförmige Gehäuseformen sinnvoll gemacht hat, wurde den Ammoniten am Ende der Kreidezeit, einer weltweiten Planktonkrise, zum Verhängnis.

Die **Belemniten** sind im Erdmittelalter weitverbreitete Gruppen der Coleoideen mit einem gestreckten, gekammerten Innengehäuse und mit randständigem, zarten Sipho. In seinem hinteren Bereich wurde das Innengehäuse von einem fossil gut überlieferbaren, massiven Rostrum aus Kalk umwachsen. Es diente als Tariergewicht, um das Tier von einer vertikalen in eine horizontale, schwimmfähige Position einzukippen. Ammoniten und Nautiliden haben denselben Effekt durch die Spiraleinrollung ihres Gehäuses erreicht. Die ebenfalls am Ende der Kreidezeit ausgestorbenen Belemniten-Verwandten hatten an ihren zehn Fangarmen kräftige Hornhäkchen oder Onychiten, während die heutigen zehn- und achtarmigen Vertreter Saugnäpfe entwickelten.

Die seit dem Altpaläozoikum, dem Kambrium, verbreiteten **Stachelhäuter** oder Echinodermata sind durch ein wachstumsfähiges Innenskelett aus einzelnen, beweglich zueinander angeordneten Kalkplatten charakterisiert, die bei manchen Gruppen, etwa den Seeigeln, auch zu kompakten Kapseln verwachsen können. Während die planktonisch lebenden Larven noch deutlich bilateral symmetrisch sind, lassen alle modernen Vertreter im Adultstadium eine mehr oder weniger deutliche fünfzählige Radial-Symmetrie erkennen. Sie wird besonders durch die Anlage des sogenannten Wassergefäßsystems sichtbar, des Ambulakralsystems. Dies ist ein nur bei dieser Gruppe vorkommendes hydraulisches Organ, das zur Fortbewegung, Atmung und Nahrungszufuhr verwendet werden kann. Wir unterscheiden zwischen gestielten, strudelnden und frei beweglichen Vertretern, die sich oft durch Abweiden des Substrates oder durch das Fressen von Detritus ernähren. Zu den am Untergrund fixierten Formen gehört eine Reihe nur aus dem Erdaltertum bekannter Formen, so die scheibenförmigen und armlosen **Edrioasteroideen**, die mit ihrer abgeflachten Dorsalseite dem Untergrund auflagen. Die größte Formenvielfalt unter den festsitzenden Echinodermen erlangten die **Seelilien** oder **Crinoidea**, deren kelchartige Kronen mit langen, fächerartigen Armen auf einem beweglichen Stiel an eine Blume erinnern. Die isolierten Skelettelemente, insbesondere die Stielglieder, die Trochiten, treten sehr häufig auf und sind dann gesteinsbildend. Seit dem Mesozoikum haben sich auch frei schwimmende Seelilien entwickelt, Haarsterne wie *Saccocoma* und *Comatula.* Dies geschah durch eine Reduktion der Stiele.

Zu den frei beweglichen Echinodermaten oder »Eleutherozoa« gehören verschiedene am und im Meeresboden lebende Gruppen, wie etwa die sehr beweglichen **Schlangensterne**, die Ophiurioidea, die stammesgeschichtlich näher mit den Seelilien verwandt sind. Sie haben ihre Organe auf die zentrale Körperscheibe konzentriert, so daß ihre langen, dünnen Arme ausschließlich der Fortbewegung dienen. Bei den behäbigen, räuberisch lebenden **Seesternen**, den Asteroidea, beherbergen die fünf Arme dagegen einen Teil der Organe.

Bei den **Seeigeln**, den Echinoidea, ist ein Teil der Skelettplatten zu festen Coronen verwachsen, mit Stacheln, die über Muskeln bewegt werden können. Die Mundöffnung der streng pentamer-symmetrischen Gehäuse der »regulären Seeigel« liegt im Zentrum der Unterseite, die Afteröffnung im Zentrum der Oberseite. Diese Seeigel sind bevorzugt Weidegänger der Substrat-Oberfläche. Entsprechend haben sie auch einen sehr kräftigen, aus zahlreichen kalkigen Elementen zusammengesetzten Kiefer-Apparat, die sogenannte »Laterna Aristotelis«, mit dem sie auch in den felsigen Untergrund Kuhlen schaben können.

Die sogenannten »Irregulares« haben im Zuge ihrer Umstellung auf ein Leben im Inneren des weichen Meeresbodens ihre Gehäuse umkonstruiert und mit einer bilateralen Symmetrie überlagert, indem sie die Mundöffnung, in der der Kieferapparat zunehmend reduziert wird, nach vorne, die Afteröffnung dagegen an den Hinterrand verlegt haben. Das atmungsaktive Ambulakralsystem wird dorsal konzentriert (Petaloide), während es auf der Unterseite kaum erkennbar der Fortbewegung im Sediment und dem Transport von Sedimentpartikeln dient. Zarte Hohlstacheln bedecken die Oberfläche mit einem elastischen »Pelz« und können zusammen mit langen Ambulakralfüßchen schlauchartige Siphonen bilden, die den Kontakt mit der Sedimentoberfläche halten.

Die **Graptolithen** sind eine auf das Erdaltertum beschränkte Gruppe kolonial lebender Tiere, die mit modernen Branchiotremata, den Hemichordata verwandt sind. Ursprünglich lebten die strauchförmigen Kolonien, die **Dendroidea**, am Boden, während sich im Ordovizium die **Graptolithina** durch die Entwicklung von Schwebvorrichtungen das planktonische Leben eroberten. Ihre zarten Kolonien aus organischen Skleroproteinen haben sich besonders in sogenannten »Schwarzschiefern« erhalten, die unter sauerstofffreien Bedingungen abgelagert wurden. Sie waren dort weder der normalen Verwesung noch am Boden lebenden Aasfressern ausgesetzt. Die Einzelindividuen konnten in millimeterkleinen Theken ein- oder mehrzeilig an den Ästen der Kolonie angeordnet sein, sie standen über ein Schlauchsystem, das Stolon, miteinander in Verbindung.

Die primär im Wasser lebenden **Wirbeltiere** oder **Vertebrata**, die **Fische**, erscheinen mit den kieferlosen Panzerfischen oder Agnatha bereits vor knapp 480 Millionen Jahren im frühen Ordovizium. Ihr gemeinsames Merkmal ist die durch Knorpel, wie bei Haien und Rochen, oder durch Knochen stabilisierte Wirbelsäule. Eine an das Süßwasser angepaßte Gruppe der räuberischen Quastenflosser, der Crossopterygier, stellt mit ihren paarig angelegten, kräftigen Bauchflossen die Ausgangsform aller landlebenden Wirbeltiere, der Tetrapoden, dar, die seit dem Ober-Devon vor etwa 370 Millionen Jahren mit zunehmender Unabhängigkeit vom Wasser das Festland erobert haben. Während die Amphibien oder Lurche ihre frühe Jugend, die Entwicklung der Larven, noch im Wasser verbringen, legen die Kriechtiere oder Reptilia und alle von ihnen abgeleiteten höheren Wirbeltiere amniotische, will sagen flüssigkeitsgefüllte Eier, welche die Embryonalentwicklung vom aquatischen Milieu unabhängig machen und den verschiedenen Saurier-Gruppen die flächendeckende Besiedlung des Festlands ermöglichen. Der Erwerb der Warmblütigkeit macht schon die Flug- und Dinosaurier zunehmend unabhängiger vom Klima und ebnet den Weg für die globale Entfaltung der Säugetiere, der Mammalia, seit der Obertrias vor etwa 220 Millionen Jahren und der Vögel, der Aves, seit dem Oberjura vor 150 Millionen Jahren.

Die **Spurenfossilien** oder Lebensspuren, die auf der Sedimentoberfläche oder im Sedimentkörper angelegt werden, können nach dem vermuteten Zweck der verursachenden Lebensäußerung klassifiziert werden. *Scolithos* sind senkrecht im Watt-Sediment angelegte Wohnbauten, während es sich bei *Cosmoraphe* um mäandrierend auf der Sedimentoberfläche angelegte Weidespuren handelt. Fucoiden und Chondriten sind im Weichsubstrat angelegte Freßbauten. Lebensspuren, die im Gegensatz zu Körperfossilien nicht umgelagert werden können, geben zuverlässige Auskunft über die Umweltbedingungen zur Ablagerungszeit, über die Beschaffenheit des Substrats, über Nährstoffangebot, Sauerstoffgehalt und Hydrodynamik.

Auf den Schichtflächen des feinkörnigen Sandsteins der jungprotozoischen Ediacara Formation Australiens, etwa 800 Millionen Jahre alt, findet sich eine reiche Überlieferung von Lebensspuren, darunter auch Ruhespuren von in ihrer systematischen Stellung unklaren Organismen wie zum Beispiel *Dickinsonia*, deren Körperkonfiguration detailliert überliefert ist. Derartige **Vendobionta**, die offensichtlich bilateral symmetrisch, also keine radial gebauten Polypen waren, sind bisher nur in Form solcher Phantom-Fossilien bekannt.

Helmut Keupp
Glossary

Fossils of ancient forms of life are often preserved in very different ways in sedimentary rocks. We use the term »body fossils« when the configured fossil remnants of earlier organisms have been preserved either in their original substance or, as is generally the case, chemically changed: mummified remains, bones, shells, leaves, etc. The remains themselves have often been dissolved over the years; in such cases their direct moulds – impressions and casts – in the surrounding rock also count as body fossils. In the case of chemofossils, decay products of organic substances (amino and fatty acids or bitumens, for example) are finely dispersed in the sediment. But an organism's activities can also leave traces in the sediment even if the organism itself has not actually been fossilised. These trace fossils can supply important information about the organisms and the environment in which they lived.

Photoautotrophic organisms

Their metabolisms rely on photosynthesis; that is, they use pigments and the energy of sunlight to convert inorganic matter (carbon dioxide and water) into organic products such as sugars and starch and to release oxygen. They are the first link in the food chains and the precondition for animal, for heterotrophic life.

Blue-green algae (Cyanobacteria) are mat-forming bacteria without a nucleus, now widespread in the sea, in freshwater or on land. With the help of green and blue pigments that collect on membrane systems known as thylakoids beneath the cell wall, they are able to conduct photosynthesis, primarily by means of the low-energy red light spectrum that penetrates only a few metres into the water column. They count as the »inventors« of photosynthesis. Their activity can be traced back for just under four thousand million years: on the one hand, their removal of CO_2 is responsible for the deposition of the first limestones in the primal ocean, the finely laminated **stromatolites** and **loferites**, dense carbonates with banded cavity systems; on the other hand, permanent O_2 production is responsible for oxygenating the Earth's originally anoxic atmosphere over the past two thousand million years. If bodies rotating in the waves are coated with cyanobacteria films, concentrically laminated calcium carbonate structures known as **oncoids** are formed.

Red algae belong to what are known as eukaryotic organisms: their cell structure consists of a complex organisation of cells with clearly defined compartments, for example a nucleus. Because of their red pigments, red algae primarily use high-energy blue and purple light for photosynthesis. In this way they can penetrate to depths of more than 200 m, given optimal light conditions. Some groups calcify their cell walls, so the relatively simple multicellular structure, the thallus, may be preserved in fossil form.

In the terminal Ordovician period, about 450 million years ago, plants started to conquer the mainland, paving the way for land animals that first appeared in the subsequent period of the Earth's history, the Silurian.

Evolution of the higher terrestrial plants began with simple vascular plants, which developed their cell structures into true tissues, especially vascular tissues or vessels. The vascular plants evolved from green algae (thallophytes), which have no such cellular differentiation. Green plants use short- and long-wave light for photosynthesis. Of the three main groups of land plants (mosses or Bryophyta, ferns or Pteridophyta, and seed plants or Spermophyta), the last two occur most frequently in the fossil record. Mosses, »thallophytes«, adapted to wet terrestrial habitats, tend to be of minor importance.

Fern-like plants are vascular plants with a special mode of reproduction, a complex alternation of generations involving spore formation. This group includes, first, various groups of **ferns** such as silver ferns, true ferns, and seed ferns such as *Pecopteris, Sphenopteris, Neuropteris* and *Mariopteris,* second, **club moss plants** such as *Lepidodendron* and *Sigillaria*, and, third, **horse tail plants** such as *Annularia* and *Mesocalamites*. During the late Palaeozoic, these three groups produced large trees for the first time in the Earth's history; together with the first seed plants, the gymnosperms, they created large swamp forests that were the basis for coal formation during the Carboniferous period, for example.

Seed plants are divided into **gymnosperms**, **conifers**, and **angiosperms**. The more primitive gymnosperms have produced such prominent **cycadean**-related species as *Glossopteris, Nilssonia, Thinnfeldia* and *Ginkgo*. Conifers dominated the flora of the late Palaeozoic and the Mesozoic. In the early Cretaceous, angiosperms started to develop great morphological diversity. In particular the evolution of grasses has fundamentally changed the earth's landscapes and its animal world, leading to open grasslands and subsequently to grazing herds.

Heterotrophic organisms

Animal organisms feed on already existing organic matter. Because of their eukaryotic cell structure, all animals obtain energy by breathing oxygen.

Foraminifera are unicellular organisms. Like the amoeba cell, the foraminiferan cell is divided into a granular endoplasm and a transparent ectoplasm. The cells are mostly only fractions of a millimetre in size, but in exceptional cases may be as large as 20 cm; they build a multichambered test of calcium carbonate, cemented fine detritus, or polymeric organic substance (tectin). An often complex pore system in the test walls and between the chambers ensures communications between the chambers. Because of their morphological diversity the foraminifera are classic index fossils in micropalaeontology, enabling reliable dating of the surrounding sedimentary rocks.

The intricately built **radiolarians** have been an important component of heterotrophic marine plankton for more than 500 million years. Their skeletons are composed of silica (biogenetic opal) and display a wide array of shapes. There are two main groups: spumellarians, shaped like radial latticed spheres, and nassellarians, with pole-centred, bell-shaped bodies. On very deep ocean floors, where the high CO_2 content dissolves all calcium carbonate, they are the principal components of **radiolarites**, the often colourful siliceous shales.

Sponges (Porifera) represent the primary organisation level of multicellular animals, possessing neither true tissue nor complex organs. By means of choanocytes, they create a water current that pumps water through the complex pore system of their sponge walls; hence they belong to the suspension feeders. Sponges build scleroskeletons composed of individual spicules made of silicic acid ($SiO_2 nH_2O$) or organic spongin in the original forms and of calcium carbonate in the case of the phylogenetically derived calcareous sponges. Irrespective of this primary scleroskeleton, many sponges are able to use their outer layer of cells (pinacoderm) to produce an additional, always calcareous basal skeleton. These secondary basal skeletons have assumed the function of primary support skeletons in the case of the **coralline sponges**, the Archaeocyatha, Stromatopora and Chaetetids, for example. The »**boring sponges**« such as *Cliona* do not produce their own basal skeletons; instead, they protect their bodies by boring into calcareous substrates.

Chancellorians are a group of suspension feeders of uncertain affinity occurred only in the Cambrian. Because of star-shaped, calcareous sclerites in their leathery outer membranes an affinity with sponges was originally presumed. Deviating morphology of the sclerites (they consist of hollow individual elements) and differences in the outer membrane structure suggest they may be polyps of more highly developed cnidarians. They may even be at the phylogenetic base of the deuterostomes, which also include echinoderms and vertebrates.

Among the radially symmetrical organisms (Radiata), the **corals** are most likely to be preserved because their polyps or polyp colonies are supported by combined internal and external calcareous skeletons. The basic sac-like shape of their polyps consists of a central gastric cavity, with tentacles surrounding a single central opening for both mouth and anus. The thick-walled **Rugosa**, whose radial septa evolved in four-fold symmetry to strengthen their gastrovascular cavity, were common during the Palaeozoic Era and were major reef-builders, together with coralline sponges. They became extinct at the end of the Palaeozoic. Their role was taken over by **Scleractinia**, modern thin-walled stony corals that appeared during the early Triassic. They have a consistent sixfold radial symmetry. **Tabulata** were another group living only during the Palaeozoic; their twelvefold radial symmetry is now barely recognisable owing to reduction of their calcareous septa.

Bilateralia, bilaterally symmetrical organisms, have two different body openings, mouth and anus; their bodies are located along a longitudinal axis, allowing food to be digested in successive stages: a much more effective construction than that of Radiata.

The bodies of **Annelida** (segmented worms) are a sequence of identical segments. The Sedentaria group are sessile, suspension-feeding annelids, some of which (e. g., the genus *Serpula*) build hard tube-like casings of secreted calcium carbonate.

Brachiopods (Brachiopoda) are a diverse group of two-shelled, filter-feeding marine animals, which was most abundant during the Palaeozoic Era. Today they live by preference in hidden habitats, where they are attached to a substrate by a fleshy stalk (pedicle) or one shell, often in very deep water or rock crannies. Their

central organ, the paired lophophore, is both a filter-feeding structure and a breathing organ, but is not used for locomotion, as was originally assumed and their name suggests. In the primary forms, the two shells, which often seem horn-like owing to their high organic content, are not joined by an interlocking hinge. The shells are opened for feeding by a complex system of diductor, adductor and adjustor muscles that squeeze the soft body and let the shells open, creating an indirect opening. By contrast, more modern, articulate brachiopods shifted their diductor muscle attachments posteriorly in front of the hinge and so were able to lever the shell open. A hinge with teeth and sockets prevents the shell from lateral dislocation. For leverage to be effective, Articulata require hard calcareous shells. Their shells are often mistaken for bivalve shells. Yet brachiopods have a smaller dorsal and a larger ventral shell; the latter often has a pedicle opening, so the plane of symmetry runs through the middle of both shells. Bivalve shells are on the right and left sides of the body, so the plane of symmetry is generally parallel to the hinge line and the two shell halves are mirror-symmetrical.

Bryozoans (Bryozoa) have existed since the Ordovician period and are sometimes only a fraction of a millimetre in size. They always live in colonies, which are often calcified and sometimes grow vertically in the shape of a small tree (hence their German name, Moostierchen, which means little moss animals), but sometimes form only flat crusts. The individuals (zooids), which live in colony tubes, communicate with each other via a channel system (stolon). They have evolved to manage very different tasks (nutrition, defence or reproduction) and often have very different anatomies. The main organ of the bryozoans – like that of the brachiopods, to which they are related – is a lophophore whose tentacles surround the mouth opening in a circular or horseshoe pattern.

Arthropods (Arthropoda) derive from ancestors that were segmented like worms. Their success story is due to the »invention« of jointed legs which made them the most successful predators of the Palaeozoic, in conjunction with their excellent all-round vision due to compound (facetted) eyes. The body is fused into three large parts: cephalon, thorax and pygidium. A hard outer armour made of chitin, sometimes strengthened by calcium carbonate, supports the muscles of the limbs. Because these polymerised chitin exoskeletons do not grow, arthropods moult periodically as long as they continue to gain size. Their limbs were originally biramous, with a side branch acting as a gill. Arthropods can be classified into various major groups according to their specialised appendages, especially in the cephalon region.

Trilobites, which were most abundant during the early Palaeozoic, correspond almost completely to the basic arthropod pattern: a clearly three-part body with a calcareous dorsal plate (tergite). The cephalon has one pair of antennae and five pairs of appendages on its underside. Like all the other pairs of appendages in the thorax and pygidium, they still function mainly as »walking legs«.

Chelicerates (Chelicerata) have reduced antennae and their bodies are divided into two segments: prosoma and opithosoma. Their front limbs have evolved into pincer-like chelicerae and a pair of sensory appendages (pedipalps), and the appendages of the prosoma have been reduced to four pairs of walking legs. During the Palaeozoic already, the first spiders and scorpions adapted to terrestrial life by developing tracheal breathing.

The large Mandibulata group mainly comprises water-dwelling crabs (= Crustacea, Diantennates), and the terrestrial insects. They all have a complex biting mechanism consisting of upper and lower jaws, mandibles and maxillae resulting from the transformation of what were originally three pairs of appendages in the head area. They retain their primary three-part body division.

Crustaceans (Crustacea) are a very diverse group that is primarily water-dwelling but can also live on land. All of them have two pairs of antennae. In many cases, the sometimes strongly calcified dorsal plate covering head and thorax has fused into a carapace, but only externally. Modern decapods (Malacostraca) have developed sometimes strong pincers on the five pairs of walking legs of the thorax, whereas cirripeds such as **barnacles** (= balanids) are cemented to the substrate by their carapace and have transformed their walking legs into long ciliary feeding tools.

Insects adapted extremely successfully to a terrestrial lifestyle, developing tracheal respiration – evolved independently of spiders – and forming two pairs of wings that evolved from dorsal extensions of thoracic body segments. The phylogenetic evolution of insects benefited repeatedly from close interaction with the evolution of terrestrial plants: a coevolution. For example, the spread of Carboniferous forests meant that many, sometimes giant insects were able to develop, including dragonflies with wing spans of up to 70 cm. With the development of flowering plants and rainforests came the vast multitude of still-extant forms. There are two reasons why insect fossils are mainly found only in fossil »lagerstätten« with good conservation conditions, such as anoxic black shales deposited near the coast or in terrestrial depressions, fine-grained platy limestones, or trapped in fossilised resin (amber). First, chitin armour does not contain any calcareous deposits. Second, the terrestrial environment rarely provides suitable conditions for fossilisation over long geological periods.

Molluscs (Mollusca) have bodies which are divided into three parts: the head with a radula, the foot, and a visceral sac, all of which are enclosed by a muscular mantle and have no internal supports. Instead, most molluscs secrete calcium carbonate, primarily as an external skeleton and protective shell. The three major groups of these conchiferous (shell-bearing) molluscs were formed during the Cambrian owing to their respective specialised feeding habits:

Snails (Gastropods) graze while gliding along the ground. Their gills were originally located on the ventral side of the posterior body. To obtain enough fresh water, the rear body turned sideways (torsion) over the head and positioned the gills in front of the dorsally located heart; this is how »Prosobranchia« evolved. This torsion led to asymmetrical or only one-sided location of the gills and to a spiral shape of the body and the one-piece shell. In the course of evolution some species became active swimmers or drifted passively in the water (planktonic lifestyle). They reversed torsion again, but most of them kept asymmetric gills; they are known as »Opisthobranchia«. Snails are now among the most diverse classes of animals and inhabit almost all terrestrial and aquatic environments.

Bivalves (Bivalvia) have become successful filter feeders, first optimising the sessile lifestyle. This involved not only developing their gills as suspension and filter mechanisms, but also forming a two-part shell that opens during the active phase via a tension spring, the ligament at the interlocked hinge, and is closed by the muscle system for protection during rest periods.

Cephalopods (Cephalopoda) are primary predators and the most advanced and intelligent group of molluscs. Their eggs have large yolks, making a larval stage outside the egg superfluous. They have four other major characteristics:

1. The foot was transformed into originally ten tentacles and a tube-shaped funnel, used to eject respiratory water out of the gill cavity and thus jet-propel themselves forward.

2. They have complex brains, permitting them to develop intelligent hunting and camouflage strategies.

3. In addition to the radula, a strong jaw mechanism developed, resembling a parrot's beak.

4. The one-piece shell served as an energy-saving hydrostatic buoyancy mechanism, offsetting the animal's weight in the water. At regular intervals septa were created in the phragmocone, the posterior part of the shell. The siphuncle, a tube of tissue with a good blood supply, connects the individual chambers both among themselves and with the soft body. It supplies nitrogen-rich gas that provides the necessary buoyancy and adjusts depth according to the submarine principle, by pumping water in or out of the chambers.

Primitive representatives of the cephalopods (the modern *Nautilus* and the extinct ammonoids) still retain external shells; they are termed Ectocochlia. Most modern sepia, the Coleoidea, developed internal shells (belemnites, *Sepia* or *Spirula*, for example). In the course of phylogeny the shells were then largely or completely reduced, as in the case of the squid or octopus. Thus, coleoids became quick and agile swimmers.

Since the early Palaeozoic cephalopod shells have been one of the most common and generically diverse fossils in marine deposits. In the case of Echtocochlia we distinguish between primary nautilids and derived ammonites. Both initially had elongated, conical shells; independently, both groups then developed coiled shells to create a more favourable floating position for the soft body in the last shell segment, the living chamber.

The chamber partitions (septa) of **Nautilids** are generally simple and convex; the siphuncle is thick and often runs through the chamber centres. Like the modern Pacific *Nautilus*, they have survived in deep water up to today. In the Palaeozoic their shells were often still long and straight; they are then called **Orthoceratids.**

Ammonites are a generically very diverse group that ruled the world's oceans for 350 million years, from the Devonian to the Cretaceous. Their shells are generally planispiral and chambered, like those of the nautilids. To streamline their hydrostatic features, they developed wavy septa, and the sutures are increasingly folded where they meet the inner side of the shell.

Visible suture lines in cast fossils are important aids to identification. The thin siphuncle is always peripheral and permits unidirectional water flow within the chambers. In the course of the Mesozoic many ammonites abandoned their parrot-like jaws as feeding mechanisms; the lower jaw was transformed into an operculum, the aptychus, and ammonites then became plankton-feeders. Heteromorphic, often trochospiral or hook-like shell shapes developed as a result, especially in the Cretaceous. However, this planktotrophic specialisation had disastrous results when a global plankton crisis occurred at the end of the Cretaceous.

The **Belemnites** were widespread in the Mesozoic. This group of Coleoidea had an elongated, chambered internal shell and a peripheral, thin siphuncle. The back part of the shell is surrounded by a compact calcite rostrum that preserves well in fossil form. It serves as a counterweight to move the animal from a vertical to a horizontal position for swimming. Ammonites and nautilids achieved the same effect by coiling their shells. The belemnite relatives, which also became extinct at the end of the Cretaceous, had small and strong horny hooks or onychites on their ten arms, whereas the present ten- and eight-armed species developed suckers.

Widespread since the early Palaeozoic (Cambrian), **Echinoderms** (Echinodermata) possess an internal skeleton that is capable of growth and consists of flexible calcite plates that, in some groups such as sea urchins, may fuse to form compact capsules. Whereas the planktonic larvae are still clearly bilaterally symmetrical, modern adult specimens have a more or less distinct pentaradial symmetry. This is easily visible in the structure of their unique water vascular (ambulacral) system that can be used for locomotion, respiration and feeding. We distinguish between attached suspension-feeders and free-floating echinoderms that often graze on the substrate or feed on detritus. The sessile group includes a series of forms known to have existed only in the Palaeozoic, such as the disc-shaped, armless **edrioasteroids** whose flat dorsal sides lie directly on the sea floor. The greatest generic diversity among the sessile echinoderms is achieved by the **sea lilies** or **crinoids**, whose cup-like crowns with long fan-like arms on a mobile stalk resemble flowers. Isolated skeletal components, especially stalk segments (trochites) are often very frequent and are then rock-forming. Since the Mesozoic, free-floating sea lilies, feather stars such as *Saccocoma* and *Comatula*, have also developed as a result of stalk reduction.

The motile echinoderms or Eleutherozoa include various groups living in or on the sea floor, such as the very motile brittle stars (**Ophiuroidea**), which are more closely related to sea lilies in phylogenetic terms. A central body disc contains all their organs, their long thin arms being used purely for locomotion. By contrast, the five arms of the sedate and predatory **sea stars** (**Asteroidea**) contain some of their organs.

In the case of the **sea urchins** (Echinoidea), some of the skeletal plates have fused into rigid coronae with spines worked by muscles. The mouth opening of the pentaradially symmetrical shell of the »regular sea urchin« is in the centre of the lower side, the anal opening in the centre of the top side. By preference, this sea urchin grazes the substrate surface. Accordingly, it has a very powerful jaw (known as Aristotle's lantern), which consists of many calcitic elements and is capable of scraping hollows in the rocky substrate.

The »irregular urchins« have adapted to life within the soft sea floor by developing bilaterally symmetrical shells: the peristome – in which the jaw mechanism is increasingly reduced – is brought towards the anterior and the periproct (= anal opening) is moved to the posterior edge. The respiratory part of the ambulacral system is concentrated on the topside (petaloids), whereas the underside part acts for locomotion in the sediment and for transporting sediment particles. Slender hollow spines cover the surface with an elastic »coat«; in conjunction with long ambulacral feet they can form tube-like siphuncles to maintain contact with the sea floor.

Graptolites are a group of colonial animals known only from the Palaeozoic. They are related to modern Branchiotremata (Hemichordata). Initially the many-branched colonies, **Dendroidea**, inhabited the sea floor, whereas during the Ordovician **Graptolithina** developed floating equipments and adopted a planktonic lifestyle. Their slender colonies of organic scleroproteins have been preserved especially in »black shales«, which were deposited under oxygen-free conditions. There they escaped exposure to normal decay and benthic scavengers. The individuals were arranged in one or more rows of millimeter-sized thecae on the colony branches and were connected to each other by a tube system, the stolon.

Primarily aquatic **vertebrates**, **fishes**, appeared in the early Ordovician already, just under 480 million years ago, the first known example being the jawless fish Agnatha. Their shared characteristic is a backbone stabilised by cartilage (like sharks or rays) or bone. A freshwater-adapted group of the predatory crossopterygians, with their powerful paired pelvic fins, are the ancestors of all terrestrial vertebrates, the tetrapods, which invaded the land in the Upper Devonian, some 370 million years ago, and became increasingly independent of water. Whereas amphibians spend their larval phase in water, reptiles and all the higher vertebrates descending from them lay amniotic (fluid-filled) eggs, enabling embryos to develop outside aquatic environments and various saurian groups to settle anywhere on land. Becoming warm-blooded made pterosaurs and dinosaurs increasingly independent of climate and paved the way for the global evolution of mammals (Mammalia) since the Upper Triassic about 220 million years ago and birds (Aves) since the Upper Jurassic about 150 million years ago.

Trace fossils, traces of biological activity, on the sediment surface or in a sediment body can be classified according to the assumed purpose of the behaviour causing them. *Skolithos* are vertical dwellings burrowed in tidal flat sediments, whereas *Cosmoraphe* are grazing trails winding across the sediment surface. Fucoids and chondrites are feeding constructions preserved in soft sediment. Unlike body fossils, trace fossils remain in their original locality and so provide reliable information about environmental conditions at the time of deposition, about the state of the sediment, the supply of nutrients, the oxygen content, and hydrodynamics.

The finegrained sandstone beds of the late Proterozoic Ediacara Formation in Australia, some 800 million years old, exhibit a wealth of trace fossils, including resting places of organisms of unclear affinity such as *Dickinsonia*, whose body plan is preserved in detail. These **Vendobionta** were evidently bilaterally symmetrical and hence not radially aligned polyps; up to now, such phantom fossils are the only evidence of their existence.

Geologische Zeittafel in Millionen Jahren (Ma)
Geologic time scale in million years (Ma)

	heute	today
– 0,01	Holozän	Holocene
0,01– 1,8	Pleistozän	Pleistocene
1,8– 5,3	Pliozän	Pliocene
5,3– 23,8	Miozän	Miocene
23,8– 33,7	Oligozän	Oligocene
33,7– 54,8	Eozän	Eocene
54,8– 65	Paläozän	Paläocene
65– 99	Oberkreide	Late Cretaceous
99– 144	Unterkreide	Early Cretaceous
144– 159	Oberjura	Late Jurassic
159– 180	Mitteljura	Middle Jurassic
180– 206	Unterjura	Early Jurassic
206– 227	Obertrias	Late Triassic
227– 242	Mitteltrias	Middle Triassic
242– 248	Untertrias	Early Triassic
248– 256	Oberperm	Late Permian
256– 290	Unterperm	Early Permian
290– 323	Oberkarbon	Late Carboniferous
323– 354	Unterkarbon	Early Carboniferous
354– 370	Oberdevon	Late Devonian
370– 391	Mitteldevon	Middle Devonian
391– 417	Unterdevon	Early Devonian
417– 423	Obersilur	Late Silurian
423– 443	Untersilur	Early Silurian
443– 458	Oberordovizium	Late Ordovician
458– 470	Mittelordovizium	Middle Ordovician
470– 490	Unterordovizium	Early Ordovician
490– 500	Kambrium D	Cambrian D
500– 512	Kambrium C	Cambrian C
512– 520	Kambrium B	Cambrian B
520– 543	Kambrium A	Cambrian A
543–2500	Proterozoikum	Proterozoic
2500–3800?	Archaikum	Archean

Quelle / Source: The Geological Society of America,
Geologic time scale, 1999.